D1599553

IMAGES AND RELICS

Primitivism, Radicalism, and the Lamb's War
The Baptist-Quaker Conflict in Seventeenth-Century England
T. L. Underwood

The Gospel of John in the Sixteenth Century
The Johannine Exegesis of Wolfgang Musculus
Craig S. Farmer

Cassian the Monk
Columba Stewart

Human Freedom, Christian Righteousness
Philip Melanchthon's Exegetical Dispute with Erasmus of Rotterdam
Timothy J. Wengert

Images and Relics
Theological Perceptions and Visual Images in Sixteenth-Century Europe
John Dillenberger

IMAGES AND RELICS

Theological Perceptions and Visual Images in Sixteenth-Century Europe

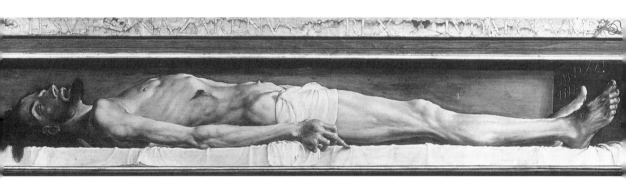

JOHN DILLENBERGER

New York • Oxford • Oxford University Press • 1999

Oxford University Press

Oxford New York
Athens Auckland Bangkok Bogotá Buenos Aires Calcutta Cape Town
Chennai Dar es Salaam Delhi Florence Hong Kong Istanbul Karachi
Kuala Lumpur Madrid Melbourne Mexico City Mumbai Nairobi
Paris São Paulo Singapore Taipei Tokyo Toronto Warsaw

and associated companies in
Berlin Ibadan

Copyright © 1999 by Oxford University Press, Inc.

Published by Oxford University Press, Inc.
198 Madison Avenue, New York, New York 10016

Oxford is a registered trademark of Oxford University Press

Library of Congress Cataloging-in-Publication Data
Dillenberger, John.
Images and relics: theological perceptions and visual
images in sixteenth-century Europe / John Dillenberger.
p. cm. — (Oxford studies in historical theology)
Includes bibliographical references and index.
ISBN 0-19-512172-4
1. Reformation in art. 2. Art, Renaissance.
3. Artists—Europe—Psychology.
4. Reformation—Europe. I. Title. II. Series.
N7862.D56 1999
704 9'482'09409031—dc21 98-17078

9 8 7 6 5 4 3 2 1

Printed in the United States of America
on acid-free paper

For Jean,

who helped nourish the rebirth of this work

from the flames and ashes that once consumed it.

PREFACE

THIS VOLUME IS AN OVERALL ACCOUNT of the nature and place, and sometimes lack of place, of visual images in sixteenth-century European religious reformations. While no such book currently exists, this may be an appropriate time to provide one. The extensive number of excellent monographs and books on specific topics, as well as on specific players in the field—artists, theologians, academics, common people, clergy, popes, emperors, and princes—provide a wealth of materials unavailable even fifteen years ago. The welter of details cries out for a comprehensive account.

But the book is more than a summary. It is also, I hope, a way of seeing the whole from a theological perspective that simultaneously accepts the cultural and socially conditioned nature of events, while striving for a critical eye that may further illumine the whole. Inasmuch as ideas are historically embedded, I early on in my career moved from ethics and systematic theology to historical theology. But theological ideas, ideas as ideas, also move the human heart and mind. Such ideas, in their varying contexts, are also part of the evidence one needs to take into account. Exactly that variety led me to join those who speak of reformations rather than Reformation and Counter Reformation.

Interest in this project began when I was asked to write a paper on the Reformation for a meeting of the Pacific Coast Theological Society in April of 1990. Having continually encountered the issue of images and having developed extensive notes and bibliographical materials in the preceding years, I decided to center on that subject for my paper, which, in turn, became the basis for my preoccupation in the ensuing years. The question of what the theologians had to say about the visual arts, ranging through various forms of approval and disapproval is obviously involved. But about the artists who actually worked for the church, and whose specific works were part of the data in question, theologians were conspicuously quiet. That gap was eventually filled by art historians. However, it seemed to me that from the standpoint of theology the artists themselves and their works deserved more attention. While treating them from the standpoint of overarching theological issues, I hope I have not violated or distorted the domain of art history and that some art historians, as well as other historians, may profit from what I have done.

While there are many studies of iconoclasm centering in particular countries and cities, there are no histories that both detail the movements and address overall patterns. I have tried to provide a picture of what happened and the various agendas that were pursued.

In addition, I have given attention to popular and professional art, to woodcuts and engravings as well as paintings and sculptures (many of the artists working in both realms) and to clergy and lay orientations. Such differentiations can and should be made without placing undue value on one or the other. Hence, it became necessary to give some attention to the diverse functions played by different media.

In the fall of 1991 all my notes, photographs, slides, and books were lost in the Berkeley/Oakland fire. Fortunately, a copy of the paper for the Pacific Coast Theological Society was found in the Graduate Theological Union library, and copies of rough drafts of major sections on some of the artists were available from extra disks stored elsewhere. But the time spent in reestablishing a working household and in reassembling documents, photographs, and so on, represented a daunting challenge. In the meantime, scholarship in the field seemed to proceed at a hastening pace, particularly in the last five years. I am glad that the attendant delay gave me the opportunity of taking more recent scholarship into account.

Organizationally and summarily, the introduction sets the stage and provides the context for reading the succeeding chapters. The five chapters on eight artists, while covering the relevant works of art, give considerable space

to the theological settings in which the artists worked. The chapter "Icono-clasm and Beyond" covers both the major iconoclastic developments and the religious forces at work. The concluding remarks succinctly suggest that we are still in the grip of the reformation formulations.

I am dependent, of course, on a wealth of printed and visual materials. The bibliography of this book mainly consists of publications I have found particularly helpful on various facets of this study. The more important ones for my work are acknowledged in the notes and I gladly acknowledge the help of various scholars. A listing of paintings, sculpture, visual prints in various media, and documentation of art objects that form part of this study would take too much space, though in my own mind they are as important as the articles and books mentioned in the bibliography. But it has not been part of the scholarly apparatus to call attention to visual materials one has seen as well as read about. So along with the books, I am providing a section that lists the institutions that have been particularly important for visual as well as printed material.

For Michelangelo, I am deeply indebted to Leo Steinberg. His persistent and discerning eye, coupled with prodigious scholarship, has changed the landscape for understanding Michelangelo. Not all art historians would agree with Steinberg, nor would he necessarily agree with what I have said. But no one else has provided interpretations of Michelangelo that so well fit the changing theological understandings of the time. In recent months, I have had the opportunity to read two recent books by Loren Partridge, *Michelangelo—The Last Judgment: A Glorious Restoration* and *Michelangelo: The Sistine Chapel Ceiling*. His eye for detail, thoroughness, and proportion, coupled with the use of the latest color photographs, provide instruction and delight.

For Grünewald, I am indebted to Ruth Mellinkoff for her identification of the plumed figure in the choir of angels as the devil or Satan. It provided a clue that, for me, made possible a unified understanding of the *Isenheim Altarpiece*. For Cranach the Elder and Dürer I am grateful to Joseph Leo Koerner, both for his works and for conversations we have had on the issues of this volume. John W. Cook, through his writing and in personal conversation, provided my initial orientation to Cranach, including helping me locate some of his work. Jane Daggett Dillenberger, Margaret R. Miles, and Michael Morris have my thanks for reading the manuscript and for written and verbal comments that helped me make revisions and additions to the text. My once anonymous readers, R. W. Scribner and David Steinmetz, have also been of great help, and I am glad that the latter considered the manuscript appropriate for the series, Oxford Studies in Historical Theology.

The process of securing photographs and permissions continues to be tedious, slow, and unnecessarily complicated. But there are individuals in so many places who, when confronted with my problems, went out of their way to cut bureaucratic red tape, and I hope I have been able to express my appreciation to them. My gratitude also goes to the Henry Luce Foundation, Inc., the Center for the Arts, Religion, and Education, and the Graduate Theological Union for financial assistance at various levels of the project, particularly with respect to securing the various photographs.

Cynthia Read, Jessica A. Ryan, Marion Laird, and Gene Romanosky, editors at Oxford University Press, have my special thanks. From the earliest to the latest phases of publication, their cheerful and professional expertise has guided me. My thanks to Sylvia Coates for creating the index.

With this volume, my academic interests can be said to have come full circle. My earliest scholarly love was the Reformation period, particularly the theology of Martin Luther. While there is much in Luther with which I disagree, his thought and spirit have found a lifelong resonance in my own being. My early writings were in the reformation arena or had that period as their origin. Later excursions into theology and the natural sciences and into areas in which religion and the arts intersected were, in my own mind, somehow related to that earlier interest. But in this volume, the world of art and reformations directly coincide. So in one sense it can be said to be a coming home that is also full of new horizons.

Graduate Theological Union　　　　　　　　　　　　　John Dillenberger
Berkeley, California
September 1998

CONTENTS

PART I. CULTURAL AND THEOLOGICAL SETTINGS

1 Setting the Stage for the Image Question 3

 The Chronology of Reform 5
 Iconoclasm, Images, and Relics 13
 The Role of Popular Culture 15

PART II. ARTISTS AND IMAGES

2 Matthias Grünewald: Extending the Medieval World 25

 Orientation to the Person and His Work 25
 The Isenheim Altarpiece 27
 The Medieval Background 32
 More on the Isenheim Altarpiece 36
 Works after 1520 49

3 Albrecht Dürer: Renaissance Humanist Reform 53

 Early Life and Work 54
 Selected Works to circa 1515 55
 Dürer's Early Interest in Luther 64
 Dürer and the Reformation in Nuremberg 69

4 Lucas Cranach the Elder: A Reformation Artist 79

 Cranach the Elder until circa 1528 80
 Luther's Views of the Visual Arts and Theology 89
 Law and Gospel in the Art of the Cranachs 96
 Individual Works after 1530 109

5 Michelangelo Buonarroti: Catholic Reformation Piety 115
 Michelangelo and Reform 115
 The Sistine Ceiling 117
 Reforms in the Life and Thought of the Church 127
 Religious Currents and Michelangelo's Last Judgment *132*
 Notes on the Pauline Chapel 139
 Religious Conflicts and the Emergence of the Nicodemites 141
 The Florentine Pieta *and the Last Years 143*

6 Three Artists with Distinctive Accents 149
 Hans Holbein the Younger: The Cult of the Portrait 149
 Hans Baldung Grien: Misogyny and the Devil 157
 Albrecht Altdorfer: Artist of Many Stripes 166

PART III. ICONOCLASM AND BEYOND

7 The Rejection and Repositioning of Visual Images 173
 Reformation Theologians and Iconoclasm 174
 Reconstitution of the Catholic Tradition 186

Conclusion: Thoughts in the Wake of the Reformation 189

Notes 193

Bibliography 211

Credits and Permissions 231

Index 233

PART I • *Cultural and Theological Settings*

SETTING THE STAGE FOR THE IMAGE QUESTION

I

THE SPECTRUM OF REFORMING RELIGIOUS currents ranging from the last decades of the fifteenth century into the sixth decade of the sixteenth, represents myriad opinions and historic shifts that enveloped most of western Europe. Nations and emerging national cultures carried mind-sets that understood common terms in theology and art in differing ways. Nuremberg, Wittenberg, Zurich, Strasbourg, Geneva, and Rome widely differed from each other. Yet similar concerns were part of the fabric of each place, manifest alike in theology and in artistic styles. People learned from each other, though conflict was everywhere as older boundaries were crossed and challenged.

The Renaissance characterizes much of the period. But the Renaissance in the south is different from that north of the Alps. The Italian Renaissance was informed as much by the rediscovery of classical sculpture as by the new attention to classical documents. Northern Renaissance sensibilities were formed more by attention to the reinterpretation and accuracy of texts, classical and theological, than by attention to the arts. Renaissance influence on reforming currents in the north accounts in part for the reformation being so firmly grounded in the interpretation of texts. In the south, texts were but a part of a wider matrix that defined the life of the church.

The late Gothic style of art in the north was affected, but seldom sup-planted, by the influence of Renaissance forms from the south. Steeped as he was in Italian art, Dürer, who so influenced the development of northern art in the first decades of the sixteenth century, still disclosed a preoccupation with detail characteristic of northern sensibilities. The contrast is most obvious when one compares Grünewald's *Isenheim Altarpiece* (ca. 1512–16) with Michelangelo's *Sistine Ceiling* (1508–12), completed within a few short years of each other.[1] Both are Renaissance works influenced by similar theologies; but the accents are so different that one wonders how the two works could have emerged within a common Christendom.

Christendom, of course, was never as monolithic in outlook in the medieval and late medieval period as historians, until recently, considered it to be. Theologies, too, were diverse—a world in which Aquinas and Bonaventure reflected diverging Scholastic theologies, and in which Scholastic theology as it had been known was challenged by the Nominalist tradition. Simultaneously, mysticism was transformed from the role of individuals with intense experiences that ravaged the human soul into less intense and communal identifications with the divine. Lay associations of men and women emerged, living under semimonastic rules, alongside the continuing monastic tradition. These groups represented societal bodies that lived somewhat uneasily within the church. Among most of these mystical and lay groups was an awareness of the corrupting influence of wealth and power in the church, and an identification with the sufferings of Christ and the saints as the core of the Christian life. Both the issues of wealth and identification with the life of Christ became forces feeding the push for reform. These programs occurred alongside, not in opposition to, the historic core affirmations of the church.

The call for reform of the practices within the church, particularly in relation to the lives and financial expenditures of the popes, had a long history, ranging from Savonarola through Contarini, Erasmus, Luther, and Zwingli, to name only a few of the more prominent early figures. For some, it was a matter of correcting practices in the church, hardly a matter of theology; for others, actual practices exhibited a wrongheaded theology. The impossibility of reconciling the two, in spite of various attempts, led to the formation of reformation churches, groupings that themselves were so much at odds with each other that some of them theologically stood closer to the continuing reformed Catholicism than to fellow reformation parties.

The Chronology of Reform

It may be helpful to divide the reforming movements into three sequential, but also overlapping, patterns: from about 1500–1517, a period of about seventeen years; from 1517 to 1525/1530, from eight to thirteen years, depending on the particular issue; and from about 1530 to 1570, a period of forty years.

The first period covers the initial stirrings of reform, ending with Luther's Ninety-five Theses of 1517, when reform became a very public issue. It was a time in which those who called for reform focused on the financial and dubious moral practices of the papacy, cardinals, bishops, and priests. But the first period is also one in which artists both reflected and stretched traditional understandings, as in Grünewald's *Isenheim Altarpiece* (1512–16 [Figure 1]) and Michelangelo's *Sistine Ceiling* (1508–12 [Figure 2]).

Symbolic for this study is the place of Cardinal Albrecht of Brandenburg, whose views on indulgences precipitated Luther's Ninety-five Theses. Money secured from the sale of indulgences financed the Cardinal's art projects, as well as the pope in completing the new St. Peter's in Rome. For large numbers of those in the less advantageous segments of society, such money would have gone a long way in alleviating their condition. Reform in such areas among some members of the curia were proposed in conclaves, such as the Fifth Lateran Council of 1512.

Throughout this and subsequent periods, financial and moral questions were frequently intertwined. Not only was there the problem of expending funds for works of art; there was also the issue of spending it for art with an overabundance of sexuality.

The second stage extends from the time of Luther's Ninety-five Theses in 1517 until about 1528/1530, a period of only a few years. Reforming issues now included issues of doctrine. Indulgences and the role of the saints were questioned, and justification by faith and the Word as formed by Scripture became the prime foci for understanding Christianity. But the debates, while fierce and often mean-spirited, still took place within the context of the Roman Catholic Church.

The intertwined foci of relics, indulgences, and images, related to the increasing emphasis on Mary and the saints, took center stage within the Catholic tradition. Even Catholics such as Erasmus wrote sarcastically on the proliferation of relics, remarking on the number of buildings erected from the cross on which Jesus was crucified. Major collections of relics, as those assembled by Cardinal Albrecht of Brandenburg and the German prince, Frederick the Wise, represented resources that could be drawn upon for

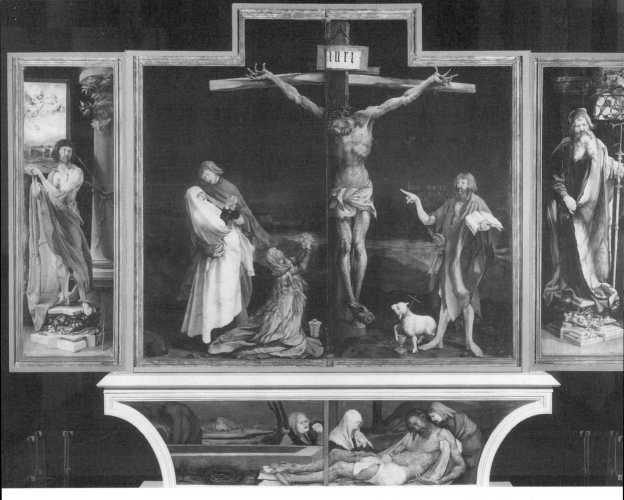

FIGURE I. Matthias Grünewald, *Isenheim Altarpiece*, closed position: Crucifixion (center), St. Sebastian (left wing), St. Anthony (right wing), Lamentation (predella), Unterlinden Museum, Colmar.

dramatically reducing the time spent in purgatory. Their power could be drawn upon by touch, and since touch threatened their preservation, also by seeing them in their reliquaries. Such reliquaries could be seen in situ or in grand processions at designated times, sometimes related to the alleged birth date of the saint being celebrated. In another form, the power of the relics could be drawn upon by the purchase of indulgences, presented to the believer through images of Christ, Mary, and the saints. Relics, indulgences, and images could not be readily separated in their common understanding.

In the first two periods under discussion, there was an ever increasing emphasis upon the grace-bestowing power of the saints and the ways of

drawing upon it. During these periods, the number of paintings and sculptures of Christ, Mary, and the saints added to churches dramatically increased. The theological distinction between veneration and adoration was blurred in the western church, and images were seen as if they were relics. Already in the Carolingian documents relics were affirmed as the genuinely real, as contrasted with mere images. But the net effect was to see images as if they were relics. That development lies behind the pronounced fury against images on the part of various lay persons and reformers, beginning in 1522. It makes intelligible the notion that images in and of themselves are idols.

Luther, whose shifting views of images will concern us later, tried to cut through all elements of claims on, or brokered access to, the merits granted

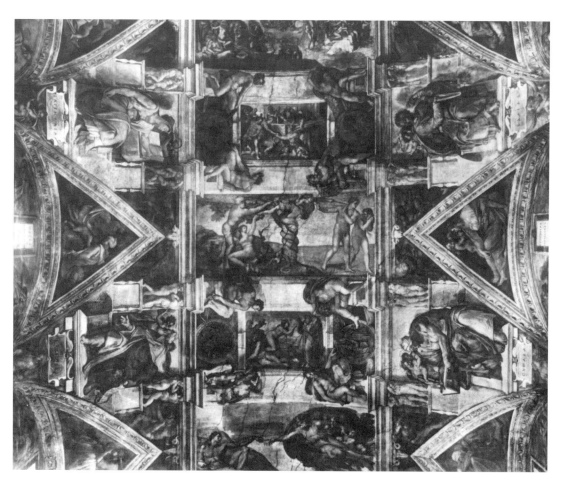

FIGURE 2. Michelangelo Buonarroti, *Sistine Ceiling*, central panels, Vatican Museums.

by the saints. That is why the gratuitous mercy of Christ, being justified by faith alone apart from works, became so central to his thinking. That approach is already hinted at in the Ninety-five Theses of 1517, but more fully elaborated in the Reformation treatises of 1520, particularly *The Freedom of a Christian*.

On the other hand, Luther's thinking could still have been incorporated into the Catholic Church. Indeed, prior to the end of the Council of Trent, similar motifs were incorporated into segments of Catholicism in Italy without calling the authority of the then constituted church into question. North of the Alps, however, such incorporation faced obstacles that after about 1530 led to the development of new churches that supplanted Catholic churches as they had been known, or developed alongside them in uneasy religious and political situations. But by 1540 both north and south of the Alps, the Catholic Church decisively rejected the new views.

As was noted previously, specific religious choices and decisions were not necessary until the 1530s in the north and the 1540s in the south, and the works of both Grünewald and Dürer antedate that period. Grünewald, Dürer, and even Cranach the Elder worked for Catholic clients until 1526, chief among whom was Cardinal Albrecht of Brandenburg. Even Dürer's *Four Holy Men* (Figure 3) usually considered a Protestant painting, belongs more to the humanist, Renaissance mentality of reformed Nuremberg than to the more theological Luther.

The third period, from about 1530 to 1570, is characterized by the emergence of movements outside the Catholic Church, ranging from what became Anabaptist movements, Reformed, Lutheran, and Anglican churches, and by the movement from resistance to reform on the part of the Catholic Church itself. In this period the papacy is not only criticized; it is considered the Antichrist by factions from many quarters. Between circa 1525–1530, more radical reformation thinking expressed itself. In the midst of nonacceptance of reform views by the Catholic Church on the one side and sectarian theological views on the other, Luther's view of faith was increasingly spelled out in terms of a fully formed theology that rejected both paths and demanded forms of the church grounded in the early church.

Justification by faith now was fleshed out through the category of law and gospel (Figure 4), forcefully expressed in wrestling with the text of Galatians in the late 1520s and 1530s. Surely, Lucas Cranach the Elder's Law and Gospel sketches and altarpieces, beginning in 1529, were no less than an attempt to visually express a total conception of faith in a single visual format. The subject matter was undoubtedly worked out among Cranach the Elder,

FIGURE 3.
Albrecht Dürer,
Four Holy Men (apostles),
Alte Pinakothek, Munich.

Luther, and Melanchthon. But already in 1522 Luther faced the opposition not only of the papal church but also of those who insisted that a true understanding of the gospel required the rejection of the practices of the Catholic Church, particularly expressed in painted and sculptured images of the saints as direct sources of divine power. While Luther was in protected hiding at the Wartburg, Andreas Karlstadt abolished the traditional approach to the sacraments, using both elements, rejected clerical garb, and began the destruction of images because they were idols. Luther returned to Wittenberg to oppose destruction of the images, though at that time he was open to their being removed as a result of preaching of the gospel. While the destruction of images was stopped in Wittenberg, Karlstadt's views were shared by others, such as Ludwig Haetzer and Ulrich Zwingli. Indeed, the reforming activities of Zwingli in Zurich, based on a reading of Scripture that was as far removed

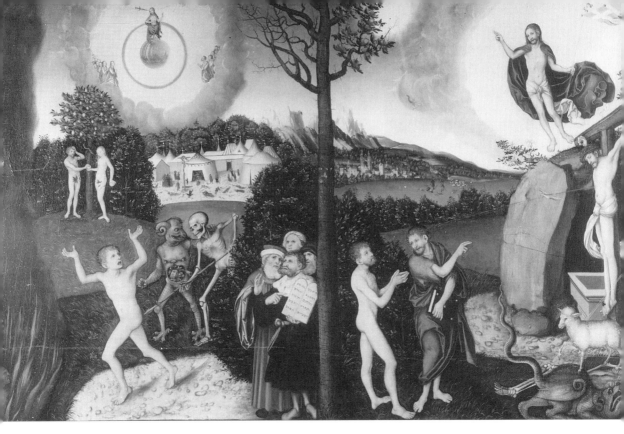

FIGURE 4. Lucas Cranach the Elder, *Law and Gospel*, Schloss Museum, Gotha.

from Luther as Luther was from Catholicism, led to the systematic destruction in 1524 of the art in the Zurich münster. That iconoclastic impulse, so characteristic of the reformed and Anabaptist traditions, played itself out in the north in the destruction of images from the 1520s into the 1560s. That history will concern us in the last chapter.

In Italy the paths of reform are most clearly shown in the art and life of Michelangelo, ranging from Savonarola's early influence upon him, through associations with reforming movements in the Italian church, and his apparent identification of himself with the Nicodemites who kept their evangelical convictions secret. By 1542 Italian religious reform movements began to be suppressed with the reemergence of the Inquisition, a direction that was gradually formalized in the Council of Trent (1542–64).

While these three phases are cumulative in what they cover and therefore in their effect, it is important not to read the new developments of the second period into the first, nor of the third period back into the first or second. For

example, the artists Matthias Grünewald and Albrecht Dürer died in 1528, that is, just in the period of transition from phase two into phase three. In the case of Grünewald, we are left with the question of whether Luther or other iconoclastic persons influenced Grünewald's later years or whether he continued to stand squarely in the late medieval development. On the other hand, Dürer identified himself with Luther, but the Luther he espoused seems closer to the Christian humanism of Erasmus and of Melanchthon than to what one should have known of Luther at the time. Or, to put it another way, before 1525–1530 the lines of demarcation were neither totally clear nor demanded. In the instances of Cranach the Elder and Michelangelo, who lived throughout the three periods, their human and artistic lives reflect aspects of all three periods.

In summary, then, calls for reform in the life, manners, and morals of the church were manifesting themselves in the period from the 1490s until about 1517. Between about 1517 and 1530, theological currents arose that challenged the center of Catholic thought with respect to the saints and their role in salvation history. In that period, however, reform of both life and thought within the Catholic Church was considered difficult though not impossible. It was not until the early years of the Council of Trent, that is, in the early 1540s, that it became clear that various church bodies would go their own way, that a theological consensus could not be reached. Already by 1530, breakaway communities emerged that became constituted churches.

Overall, this is a complex picture. It could hardly be different with respect to the art and artists of the time. Theological changes influenced the art. But sometimes the art itself set new patterns. Occasionally, the art reflected doctrines that were so taken for granted that they were hardly covered in the literature of the time. Still other theological understandings were responsible for the destruction and/or removal of art from the churches.

While emphasis is placed on the importance of three separate though related sequential periods for understanding the entire period, I have opted for keeping that frame of reference in mind throughout, rather than organize the materials in terms of the periods. The latter would separate the organic nature of human development even as changes occur. So I have elected to discuss each artist as a whole, keeping the three stages in mind. The threads of iconoclasm have much in common, but for them, too, it is important to keep the progression in mind. But given that the iconoclastic movements started in the second period and continued through the third, while the artists belong already to the first phase, I chose to start with the artists and then move to the iconoclastic developments.

The individual artists include Matthias Grünewald (1470/80–1528), a bridge figure toward reformation in the late medieval world; Albrecht Dürer (1471–1528), whose self-identification with the Protestant Reformation and with Martin Luther has overemphasized his role in relation to maturing reformation ideas; Lucas Cranach the Elder (1472–1553), who rather late in his career became the genuine Protestant painter, along with his son, Lucas Cranach the Younger (1515–1586), who grew up in the Reformation context; Michelangelo Buonarroti (1475–1564), who in his long life (from a contemporary of Grünewald to outliving Cranach the Elder) represents a restless Catholic mind and spirit confronting the reform of his time; Hans Holbein the Younger (1497/98–1543), whose disaffection with the push for reformation in Basel led him to England and to the genre of portraiture, though several religious subjects related to the Reformation appear in his work; Hans Baldung Grien (1484/85–1545), student of Dürer, whose work discloses a movement from the ideal figures so dear to his teacher to the underside of humanity, only inchoately present in Dürer; and Albrecht Altdorfer (1480–1538), whose artistic and social life centered in Regensburg. Of these artists, Cranach the Elder and Michelangelo particularly cover the entire span.

Cranach the Elder died in 1553 at the age of 81 and Michelangelo died in 1564 at the age of 89. Hence both of them lived long enough to have come to terms with issues of reform. Cranach the Elder, while a friend of Luther, carried on his life as a painter to Frederick the Wise, a Catholic prince who defended Luther. As late as 1526 he was doing works for Cardinal Albrecht of Brandenburg, whose proclaiming of indulgences and relic collection had precipitated Luther's Ninety-five Theses. It is surprising that Cranach's public identification with the Reformation as a painter occurred as late as it did, that is, in 1529. After that date, Cranach was identified with the Reformation and later went into exile to Weimar with his prince, the Protestant John Frederick, who had lost electoral support.

Michelangelo, while remaining a faithful Catholic, was sympathetic to the evangelical stirrings that affected both the upper and lower classes in Italy. While such directions are less evident in the *Sistine Ceiling*, they became prominent in the *Last Judgment*, the *Florentine Pieta*, and the *Rondanini Pieta*. While there was some suspicion that Michelangelo harbored heretical thoughts, his fame and friends probably protected him. His apparent sculpting of himself as Nicodemus in the *Florentine Pieta* connects him with the Nicodemites, against whom Calvin wrote several treatises.

Iconoclasm, Images, and Relics

The iconoclastic impulses, which started in the 1520s, were based on social realities and theological perceptions, and continued with vehemence into the 1570s. Most of the Protestant groups were uneasy and frequently antagonistic to the visual arts in the church, creating an ethos that continues in part to this day. Only among Lutherans and Moravians did a more extensive and positive view of the visual arts find an early home.

The increase in the number of saints, as well as the physical embodiment of the saints through works of art, was not challenged outright in the medieval church. In some of the monastic communities, it was affirmed that monks did not need the props of works of art, particularly works that seemed overly sensual. But it was believed that the church at large did need them, as Gregory the Great and subsequently Bernard of Clairvaux suggested. On the other hand, with groups such as the Brethren of the Common Life and a series of societies of women, the accent fell on personal, private expression of faith, in which the saints, as themselves, appeared as fellow believers. That could be expressed in art.

The distinction between images and that to which images refer had been part of the tradition in both East and West and was clearly expressed in the Council of Nicaea in 787. But the western tradition is different. In the western Carolingian document, the *Libri Carolini*, one reads as follows: "They [the Greeks] place almost all the hope of their credulity in images, but it remains firm that we venerate the saints in their bodies or better in their relics, or even in their clothing, in the ancient tradition of the Fathers."[2] Surely such a statement suggests that images are ephemeral in contrast to relics, that is, material realities that directly express the divine presence in their power of healing and deliverance. Relics, not images, belong to the resurrection.

Hans Belting has documented that from the early period on into the Renaissance, images and relics are so closely associated that it is difficult to distinguish between the two. While one might assume that images not made by human hands, such as the well-known Veronica veil, can be distinguished from relics, Belting shows that such images directly disclose that which they image through touch and sight. Thus even images not made by hands center not in the one who made them but in how the images function as redemptive forces allied with the senses, such as touch and sight.[3]

Understanding images as if they were relics is evident even among such mystics as Henry Suso in the thirteenth century; he compared images with relics and with God's signs to the people of Israel.[4] That images were eventu-

ally understood in the light of relics is evident even after the beginning of the Reformation, as in the articles agreed upon by the faculty of sacred theology in Paris in 1542. Article sixteen states, "for if relics and garments are honored in memory of saints, the reason is not less applicable to images."[5] So the devaluation of images in favor of relics ended in relics becoming the basis for understanding images.

In the iconoclastic developments, images and relics were seldom distinguished. John Calvin frequently used both terms in the same sentence, noting that there was no difference between them. Yet it would seem that an image points to that which it images, while a relic claims powers in its own right. That distinction is absent in the iconoclastic debates. As will be noted later, the Swiss reformer Heinrich Bullinger suggests that the cult of images was dependent on the cult of relics. That conjunction is new to the Reformation period and accounts, as previously noted, for the vehemence in the iconoclastic developments.

Quite apart from the problem of whether or not the *Libri Carolini* influenced subsequent developments, the accent on relics became pervasive. Relics were required for altars or cornerstones of church buildings. Hence, a major relic trade developed. Churches vied with each other for relics, and those that had important relics of saints became pilgrimage centers. Sometimes the relics of saints were associated with the disciples, such as in St. James Compestella in Spain, or with local saints such as St. Foy at Conques, France, or where there were collections of items associated with the saints, such as a drop of milk from the Virgin Mary or relics associated with Christ, such as a thorn from His crown or a piece of wood from the cross.

But behind what might be called the abuses stood a theory of the power of the saints, their intercessory and healing roles. Relics served to represent the full function of the saint, in which a part was equivalent to the whole. Even transubstantiation could be understood in this sense. Too crudely put but in line with this way of thinking, in the mass the priest makes a relic. Indeed, a consecrated element placed in the cornerstone of a church being built could serve as a relic when other relics were unavailable.

Lest we think too easily of the term *magic* in connection with such events, we should recall that precisely such connections were considered to be the refutation of magic. Intercession was an event, in which hopes abounded but nothing was guaranteed, as contrasted to magic, where, if one did things correctly, the results were guaranteed. The connection of the relic and the saint or Christ himself was an active event, not an exercise in manipulation. Granted, for later reformers, that distinction was no longer viable.

But even those who made the distinction between the saint and the relic saw the relic as having a power of holiness. So much was this the case that relics became objects invoked in taking oaths. The issue was how one drew on such holiness. Primarily, that occurred through the modalities of touch and sight. But since touch was not appropriate for relics of small size or for their preservation as hordes of people touched them, they were placed in reliquaries, reducing the modality of appropriation from the power of touch to the power of sight. Such reliquaries were frequently placed in crypts, where people could enter and leave without the whole church being accessed. These relics, however, were brought into the church for special occasions, or used in processions. In these occasions, one had to do with power and availability through sight. Surely the elevation of the host, with the attendant sighting by all present of the body of Christ, both as full divinity and as relic, belongs to the category of the power of the visible. Transubstantiation, while based on metaphysical assumptions, included the modality of sight. The close association of relic and sacrament in the medieval period has recently been extensively documented by G. J. C. Snoek in his volume, *Medieval Piety from Relics to the Eucharist*.[6]

The unique conjunction of images and relics led to the Western iconoclastic developments. While the connection between the two had a long history, Eastern and Western perceptions were different. In an oversimplified way, one can say that the eastern church looked at relics as if they were images, while the western church looked at images as if they were relics.

The Role of Popular Culture

The removal of paintings and sculptures from churches did not mean that all visual objects disappeared from such groups. While it is true that faith being born through the preaching of the Word was central to Lutheran and Reformed groups, woodcuts and engravings became a medium of using the visual for instructional and propaganda purposes among emerging Protestants and to a lesser extent among Catholics as well.

The place of woodcuts and engravings among those who had problems with paintings and sculptures rests on the fact that the former did not suggest idolatry. By contrast, there had been debates about the place of sculpture, because a piece of sculpture appeared as a remnant of Greek and Roman paganism. The freestanding figure, which one could walk around, seemed inappropriate, as it made the human figure into a godlike creation. It was

considered safer to place sculpture in niches, or display them as reliefs, that is, place them in formats in which a pagan identification with the full figure was not possible.

With the advent of perspective, paintings presented problems not dissimilar to those for sculpture. The hieratic, more frontal, and less fully refined human forms of Eastern art in both East and West did not present the human as godlike. But it did present the divine through human creations that seemed at the same time to transcend the human. Renaissance perspective made paintings more like sculpture, that is, the human form was more directly identifiable with the human body. Historians such as André Malraux used the word "secular" to describe that development. At one level, one could say that painting lost its transcending characteristics the moment the human as ideal form came to the fore or the moment human figures, even in degrading forms, too directly mirrored the human.

Before the discovery of perspective and reconstitution of ideal form, both so characteristic of the Renaissance, the human body as such was usually not identified with the Godhead. Art then was not distinguished from craft, while in the Renaissance the artist as genius comes into play. Dürer has the courage to present Adam and Eve as God created them, a kind of imitation of God's work. The hubris and glory of such work, itself a theological problem, was not at the forefront of the problem of images. Rather, the problem for the reformers centered in the association of relics and indulgences with paintings and sculptures. For the Reformed and other evangelical bodies, that meant the elimination of painting and sculpture from the church, while for Luther, and for some Catholics as well, it required the elimination of abuses.

Woodcuts and engravings, media at which Dürer excelled and which he promoted, did not have relics and saving events connected with them. At best, they were creations of genius; at the ordinary level, they functioned much as printing did, presenting materials to us in a didactic rather than enticing way. Hence, they fit the Reformation agenda, one in which education took on both positive and negative forms, teaching us both what to believe and what to reject.

In the succeeding chapters, woodcuts, engravings, paintings, and sculpture all take their place, particularly since most artists worked in all of these media. Multiple copies of visual prints and pamphlets were made available separately, but frequently the two are combined. That combination was a powerful force in the social-political arena.

Prints, as paintings, range in their quality of excellence. While subjects for prints that are mainly propaganda pieces may attain quality, often that is not

the case. In propaganda pieces, caricature is at a premium, so that the quality of form is not a foremost concern. The message is meant to be direct.

The most extensive use of prints stemmed from Luther and his allies, though Catholics responded in kind. Here the message, whether through images or words, was carried out by all parties in terms of the cultural milieu of the time. Both visual and print discourse was forceful in its message, so that from early on, what I call the second stage, the pope is caricatured by Luther and his allies as the whore of Babylon, while in the third stage, he is the personification of the Antichrist, the enemy incarnate. In turn, Luther too is presented in monstrous forms, in one case as a seven-headed monster (Figure 5). Further, in accord with the vulgarity of the period, a considerable number of prints are scatological in nature (Figure 6). A similar context may be assumed in seeing the works of Hans Baldung Grien, and to a lesser degree, Lucas Cranach the Elder, in which misogyny and eroticism are prominent.[7]

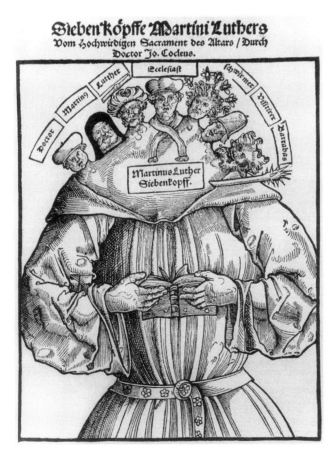

FIGURE 5.
Hans Brosamer, *Luther as Seven Headed Monster*, woodcut, title page for Johannes Cochlaeus's *Sieben Köffe Martini Luthers* (Leipzig: Valentin Schumann, 1529).

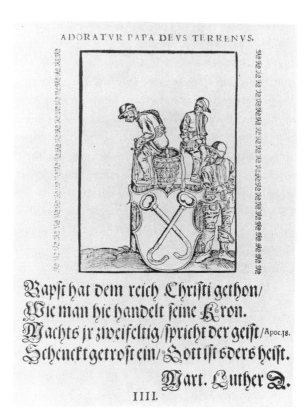

FIGURE 6.
Pope Adored as an Earthly God, 1545, Warburg Institute, London.

While the pamphlet literature of the educated reformers have been standard fare in scholarly interpretation of the Reformation, recent scholarship, particularly that of Paul A. Russell and Miriam Usher Chrisman, has unearthed pamphlet literature from various strands of society.[8] Russell has concentrated particularly on laypeople, while Chrisman has dealt with documents that represent knights, the nobility, the urban elite, city secretaries/magistrates, artisans, and the lower levels of society. From this material, several conclusions can be drawn that are important for this study.

First, one is impressed by the amount of pamphlet literature read and written by laypeople. While only about 5 percent of the populace was literate in an overall sense, it is probable that 30 percent of city dwellers could read. Moreover, because pamphlets were short, they were read aloud to those who could not read.

Second, the documents as a whole disclose an extensive knowledge of scriptural content on the part of laypeople. Chrisman's analysis leads her to write that "24% of the nobility used scriptural references, 45% of the

patricians, 50% of the learned and lower civil servants, and 80% of the artisans."[9] With respect to quotations from various reformers, Luther could not be avoided, having triggered a public response; but for the laypeople, other reformers, from Zwingli to less learned preachers, were frequently more important. While Luther was quoted by upper educational levels, the artisans, whose quotation of Scripture was 80 percent, only referred to Luther 15 percent of the time. Important, then, is that there was a wide knowledge of Scripture among laypeople, particularly just above the lowest strata and below the highest levels of social stratification. Hence, there was a biblical culture the reformers did not create but which instead became the context they worked in.

The nature of the biblical knowledge was late medieval, a mystical strain of personal devotion that was simultaneously directed to society, with a concern for the poor and oppressed.[10] For them, indulgences were a problem, not primarily because they were theologically suspect but because they turned the gift of grace into something to be purchased. In part, Luther would have agreed. But the concept of justification by faith, so central to biblical understanding for Luther, contrasted sharply with the righteousness claimed through grace in the late medieval world, a piety that manifested itself in good works.

Third, that biblical approach was accompanied by a deep strain of anticlericalism. But there is no single definition of what it meant, for it ranged from the relative social status of clergy to the outright rejection of the clergy role.[11] Clergy lived well, its critics said, buying up the best food and drink in the markets before others had a chance. Immorality was widespread, that is, clergy either living with concubines since they were not allowed to be married, or violating the vows of celibacy in other conspicuous ways. Greed manifested itself in having various livings, benefices, and landholdings assigned to them, while hiring others at a lower rate to fill the requisite requirements or outrightly abandoning responsibility with respect to the benefits they received. Clergy were also considered lazy, that is, saying masses but taking no responsibility for preaching and teaching, sometimes because they did not have the requisite learning and training. Hence, laypeople who knew Scripture felt that their own ministrations served congregations better than did the clergy. While the pope and papal curia were included in many of these criticisms, the average layperson experienced the problems with clergy in their own parishes.

Anticlericalism was also a factor in the peasant uprisings. Monastic communities frequently dominated the agricultural scene, exacting rents and

fees, just as did nobles and princes. Wrote Tom Scott and Bob Scribner, "One way or another . . . many peasants faced a tenuous economic existence, despite the evidence of wider economic conjuncture. Feudal dues or rents often accounted for as much as forty percent of production, along with ten percent in tithe. Taxation was often levied at the rate of five to ten percent of assessed wealth. In this light, the succession of poor harvests and the vagaries of the weather assume considerable causal significance. In the two generations before the outbreak of the Peasants' War there were fifteen years of failed harvest in Alsace, nine in Franconia, and ten on the upper Rhine. Taken with freak weather conditions such as hail or floods which hindered full production, the peasants of southwest Germany could count on considerable hindrances to agrarian production every third year. It is not surprising that contemporary observers linked the outbreak of revolt in 1524 to the great hailstorm which devastated the crops in the Hegau in July that year."[12] To this one might add, it is not surprising that hailstorms were considered the work of witches; such a persistence of disaster called for explanations and scapegoats, for only a few theologians were willing to attribute such disasters to the work of God.

Taken as a whole, the factors just mentioned—the extent of woodcuts, engravings, lay pamphlets, the scriptural content of such documents, the late medieval lay piety connected with the concerns of the poor, the anticlerical mood, and the marginal existence of the peasants—created an expectant atmosphere in which reform of the church also meant social reform. Through their eyes, the writings of both Erasmus and Luther focused issues that comprised their own experiences, and Luther in particular seemed to call for action. Hence, the peasants who revolted in 1524–1525 in the regions north of the Alps were unprepared for the swiftness with which governments and reformers, such as Luther, vigorously opposed what appeared as anarchy, a situation that ended in the total suppression of the peasants. For the peasants, Luther had abandoned the very reform he had encouraged, while for Luther, the peasants had confused religious with social-political reform. Indeed, many current historians read the social history in which the peasants were defeated as the betrayal of the Reformation.

After the defeat of the peasant uprising, pamphlets and popular prints decreased, as printers were more closely supervised. Reading and viewing the popular materials of the preceding period impresses one by the extent of the knowledge of biblical content. But it is also clear that the counsel to rest on biblical content rather than what the church had decreed did not solve problems, for Scripture does not interpret itself without help. Here the artist Hans

Greiffenberger of Nuremberg is an example. In his writings, biblical quotations abound, but much of his writing is rather unintelligible. No wonder that Andreas Osiander, the preacher and theologian of Nuremberg who had been asked to evaluate Greiffenberger's outlook, gave a mixed verdict for the city council. Impressed by the sheer amount of biblical content but the lack of clarity of it all, Osiander proposed that Greiffenberger needed instruction in the true faith.[13]

The so-called magisterial reformation figures faced a double problem. On the one hand, they had to deal with a church that maintained that its doctrine, while decreed by itself, was in accord with Scripture. On the other hand, they faced a populace whose familiarity with scriptural materials was fairly extensive but unfocused. It was in this context that proclamation of the Word as a teaching as well as a converting enterprise, the creation and transformation of liturgies, and the publication of catechisms became very important in the life of emerging Lutheran, Reformed, and even some Anabaptist groups. In the light of the Council of Trent, similar strategies were used by a renewed Roman Catholicism.

The attentive reader may have wondered why, when considering dominant thoughts of the time, I have not commented on widely held views that the end of the world or the age was imminent. Except for a few groups that acted out the consequences of what the end for them would entail, the surprising thing is how little difference in the lives of people that concept brought.[14] More important, it seems, was how the end of the age was related to the activities of the devil and the subservient powers under the control of the devil. Only God's decisive defeat of the devil, who seems to enslave and activate humans in his behalf, could bring on the end of the old age and the beginning of the new. It is surely not by accident, as we shall see, that artists such as Grünewald and Michelangelo, and theologians such as Luther and Calvin, stressed the role of the devil and his legions. The battle between God and the devil, the two powers that are unleashed in the world, is the drama in which God's overcoming of the derivative powers that have gone astray is going on. In that struggle, things might get worse before they get better; that is the meaning of the end.

The culture of religion as outlined in this chapter is the background to be kept in mind for the more concrete dealing with images in the succeeding chapters. In this setting, images do not stand by themselves but emerge as powerful ingredients with which the religious communities must come to terms.

PART II ● *Artists and Images*

MATTHIAS GRÜNEWALD

Extending the Medieval World

Orientation to the Person and His Work

Among the artists being considered in this volume, Grünewald is probably less known than the others. Long eclipsed in the history of art and religion, Matthias Grünewald has come into his own in the twentieth century. Before that time, some of his works were ascribed to others, including Dürer; some, by their apparent strangeness, were ignored. Even his name was a puzzle, having been discovered at the beginning of the twentieth century to have been Mathis Gothart Nithart.

But the *Isenheim Altarpiece*, which had been stored in Munich during World War I, soon caught the attention of twentieth-century art historians and eventually theologians as well. Among the art historians were Heinrich Alfred Schmid, the first thorough scholar of Grünewald, followed by such well-known figures as Erwin Panofsky, Heinrich Wolfflin, Walter Friedlander, and Wilhelm Worringer.[1] The noted German-Swiss theologian Karl Barth had a reproduction of the Crucifixion panel in his study, and the German-American theologian Paul Tillich considered the Crucifixion panel to be "the greatest German picture ever painted" and the Resurrection panel to

be the only great rendering of that subject.[2] Artists, too, acknowledged the power of the Grünewald Crucifixion. Pablo Picasso, who did drawings of the Crucifixion in 1927, 1929, and 1930, as well as drawings in 1932, acknowledged that his later drawings of the subject were based on the Grünewald Crucifixion.[3] Additional European artists for whom the *Altarpiece* was important included Arnold Bocklin, Max Beckmann, and Emil Nolde. In the United States, the contemporary artist Jasper Johns appropriated motifs from Grünewald.[4] Nor has the power of the *altarpiece* been absent from other fields, as is evident in Paul Hindemith's opera *Mathis der Maler*.

All of this is to say that in the twentieth century Grünewald emerged as an artist who, with respect to his religious subjects, belongs to the orbit of Dürer, Cranach the Elder, and Michelangelo. Unlike these three artists, Grünewald's works are few in number and the subject matter is religious. While that in itself should make it easier to deal with him than with the others, the reality is that the sources for his religious imagination are harder to ascertain with certainty than in the case of the others.

In part, that is due to the fact that so little is known of his life. He was probably born in Würzburg in about 1475, and died in Halle in 1528, which makes his birth approximately contemporary with Dürer, Cranach the Elder and Michelangelo. But unlike Cranach and Michelangelo, who lived into old age, Grünewald died the same year as Dürer. Grünewald was provincial in the sense that his life was confined largely to the Rhineland south of Mainz and west of Halle. In addition to his painting activities, he may have been involved in the manufacture of paints and soap, as well as working on engineering projects, apparently having been involved in a major way in the rebuilding of the Aschaffenburg palace. As a painter, his major patron from the sixteenth century on was Cardinal Albrecht of Brandenburg, who was associated with Mainz, Aschaffenburg, and Halle. The cardinal, who had an extensive collection of relics, was also the person whose promotion of indulgences aroused Luther's protest. Moreover, the cardinal also commissioned works by Dürer and Cranach the Elder. There is evidence suggesting that in the last years of his life, Grünewald was no longer employed by Cardinal Albrecht, possibly because there were differences of opinion on religious matters, whether about Luther or sectarian religious figures. By 1526, individuals were choosing and sometimes forced to choose on issues of reform.

Among the relevant remains of Grünewald's estate was a sealed box that included some twenty-seven sermons of Luther, a New Testament, a rosary, and an explanation of the twelve articles of the Christian faith. This material, no longer available, is difficult to interpret. There are no known dates for the

sermons of Luther. But one can reasonably assume that they expressed an outlook which, while not congenial to the papal powers, was far from the later positions espoused by Luther.[5] Nor do we know which twelve articles are meant.[6] It is possible that Grünewald was exposed to sectarian groups within the late medieval period. But within his late paintings no themes or stylistic clues of a reforming nature are present. Uniquely Catholic themes, however, are less prominent. That should not be overemphasized, inasmuch as artistic or commissioning, rather than religious, factors may be involved. A more appropriate way of viewing Grünewald's work, as the subsequent analysis of some of his paintings will show, is that he was influenced by late medieval religious currents that prepared the ground for subsequent developments, including the Reformation.

Late medieval Catholicism exhibited an experiential piety made up of various components. While not antitheological, it stressed the experience of Christ and identification with his sufferings. While that Catholicism stood against the abuse of power, it was faithful to the teachings of the church, including the intercession of the saints, the unique role of Mary, and the place of images and relics. While the Catholicism of the time was wider in membership than the monastic communities, as is evident in the emergence of lay communities with differing requirements for life and thought, its theology was frequently grounded in monasticism. That general outlook is expressed in the *Isenheim Altarpiece*.

The Isenheim Altarpiece

Grünewald began his work on the altarpiece about 1512 and probably completed it in 1516, the year before Luther posted his Ninety-five Theses. We have no evidence as to why Grünewald was chosen, but we do know that the altarpiece was commissioned by Abbot Guido Guersi for the high altar at the Anthonite monastery in Isenheim, a small town about twenty miles south of Colmar, the latter being its present location. As a result of the French Revolution, the altarpiece was given to the government headquarters in Colmar. In moving it to Colmar, first to the Jesuit College and then in 1852 to the former chapel of the Unterlinden Dominican convent, which just three years before had been converted into a museum, some of the framework was destroyed or lost, as well as some sculptural figures executed by Nicolas Haguenau. Nevertheless, the paintings by Grünewald, which comprise the first or closed state of the altarpiece as well as the second or middle position,

and the wings of the third position or shrine, are probably assembled in their rightful position.

Best known is the first and closed position of the altarpiece (see Figure 1). The central panel of this first position takes up more than half of the space and consists of Christ on the cross in the center, John the Baptist with the Lamb near his feet on the right side of Christ, and Saint John, Mary, and Mary Magdalen on the left side of Christ. The predella below the Crucifixion consists of the lamentation of Christ. The figure on the right wing is St. Anthony, and the figure on the left wing is Saint Sebastian.

In the second position of the altarpiece (Figure 7), the predella is the same. Then there are four panels, the left being the Annunciation, the second the so-called Angelic choir, the third the Nativity, and the fourth the Resurrection.

As indicated previously, the third position, the completely opened altar-piece (Figure 8), has only two paintings by Grünewald, the right panel, the Temptation of Saint Anthony, and the left, the Meeting of Saint Anthony with Paul the Hermit. The central panels and the predella consist of sculptural works by Nicolas Haguenau. In the center of Haguenau's work is a seated St. Anthony, with St. Jerome standing on his left and St. Augustine on his right. The predella below consists of Christ and the twelve apostles.

It is thus evident that Grünewald's work completes the sculptural frame-work with painted panels on left and right for this third and completely open position of the altarpiece. But the most open position does not mean that it is seen most of the time. The first or closed position, in which the Crucifixion panel is so prominent, was seen more often than the second and third positions, in line with the tradition that the closed position is generally on view when no special liturgical times are being celebrated.

This cursory review of the subjects does not give us a clue as to the relation of the three positions to each other. Nor do we have documents telling us of the relation of the three positions to each other or if there were liturgical determinations dictating which position was on view at any given time. But an examination of the hospital order in which the altarpiece was located and the theological currents of the time do provide materials that enrich our visual perceptions of the work of art. Moreover, recent discoveries provide clues for the interrelation of the three positions of the altarpiece.

While the Anthonite order in France had no direct contact with the monastic communities of the East, it was based on the life of Saint Anthony by Athanasius. According to the tradition, Anthony was among the first to become a desert hermit. He lived a life of contemplation and stood firm against the demons that tempted and assailed him through physical

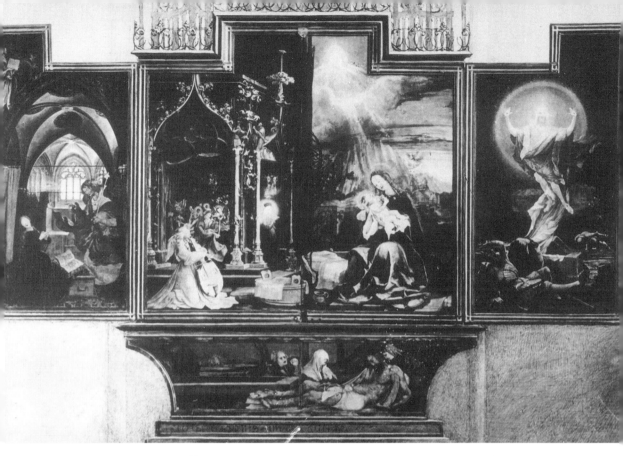

FIGURE 7. Grünewald, *Isenheim Altarpiece*, middle position: Annunciation, Concert of Angels, Nativity, Resurrection, Unterlinden Museum, Colmar.

suffering and hallucinations. That he prevailed against forces that could have destroyed faith itself indicated his sainthood, one who could be counted on to help others in distress of body or mind.

Athanasius's life of Saint Anthony was translated into Latin and had an extensive influence on the West. This was supplemented by a collection of sayings of the eastern anchorites assembled by John Cassian, and by the life of the holy saint, Paul, written by St. Jerome. Hence, long before the Anthonite nursing order was created in the eleventh century, the writings of St. Anthony were known. But in the eleventh century the relics of St. Anthony were said to have been moved from Constantinople to a chapel in south central France, Saint-Didier-la Mothe, leading a number of nobles to set up a brotherhood that was subsequently confirmed as a nursing order. From this location, the Anthonites spread out to other localities, including Isenheim. On the eve of

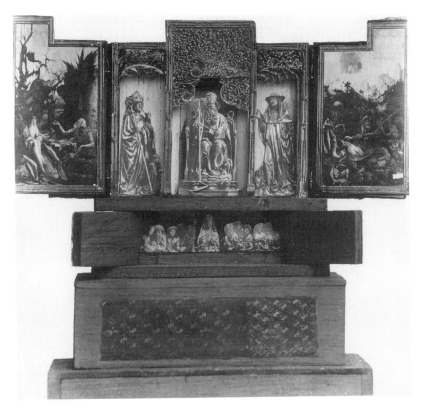

FIGURE 8. Grünewald, *Isenheim Altarpiece*, open position: carved shrine with St. Anthony, St. Jerome, St. Augustine, predella, and two wing paintings—St. Anthony, and the hermits Paul and Anthony, Unterlinden Museum, Colmar.

the fourteenth century, the Anthonites became a part of one of the branches of the Augustinian order.

Given this history, it is no accident that St. Anthony appears four times in the *Isenheim Altarpiece*, first as the dominant standing figure of the first position and three times in the third or open position: as the central sculptural figure; on the right panel, as the one who encounters demons and diseases; and on the left panel, where he is communing in the wilderness with the hermit St. Paul.

The pervasive visual presence of St. Anthony is essential to understanding the altarpiece in its own time. That Grünewald painted most of the altarpiece should not blind us to the project as he inherited it. The hospital agenda and St. Anthony are inseparable. The hospital was concerned with diseases that manifested themselves in visible ways, such as lesions of the skin, distensions

of the body, the gangrenous loss of limbs, fiery pains, and bouts of hallucination. Illnesses of this nature were known as St. Anthony's fire.

Interpreters have had a field day in designating the diseases involved. Leprosy, the plague, syphilis, and other sexually transmitted diseases have been suggested. While these cannot be excluded, the predominant basis of the disease was caused by bread made of fermented rye, an ergot that ravaged the body in ways described above. While the basis for these sufferings was not known until late in the sixteenth century, it is known that epidemics raged through whole populations from the eleventh century on. That the hospital centered on this particular form of disease is evident in that an examination of potential patients involved determining whether or not they had the characteristics manifest in this disease. There are suggestions that viewing the altarpiece helped diagnose the disease, as well as providing an identification with the sufferings of Christ as the medium of redemption.[7]

Positively, the relics of St. Anthony—the invoking of the saint through prayers; identification with him, as well as with Christ, through the medium of images; the use of herbs (some of which can be identified through books published at the time)—all were considered agents of balm in a world in which medical care was more alleviation than cure. Given that the hospital did not use rye in its bread, deterioration could be arrested or slowed, though cures were hardly the order of the day.

The ravages of St. Anthony's fire, to use the term for the disease or diseases of the time, are evident in the altarpiece in three places: the central Crucifixion panel of the first position; the Lamentation in the predella just beneath the Crucifixion; and the Temptation of St. Anthony, the right panel of the third position.

In both the Crucifixion and in the lamentation, the body of Christ, except for the face, is literally peppered with lesions of the skin. In the Crucifixion, the head and face show the marks of what has been done to it, as, for example, the intensity of pain suffered in the way in which the crown of thorns was forced on the head. The mouth is gapingly open, as if death had just taken place and the ravages of pain were still present. In the Lamentation, the face is in repose, life having been spent, and the marks of cruelty, reminding us of what happened, no longer have their ravishing character. The hands of the crucified on the cross disclose the splayed fingers as they might have been at the moment of death, while the lamentation shows the wounded hands in repose. In both Crucifixion and lamentation the feet are deformed, a deformation perhaps as characteristic of the effects of the diseases treated by the hospital as of the Crucifixion itself.

If this description is correct, both the Crucifixion and the lamentation dis-
close suffering at more than one level. The Christ figures bear the marks of
St. Anthony's fire, but, in addition, they show the intensity of Christ's suffer-
ing quite apart from the depiction of the particular diseases. Such intense suf-
fering stands in marked contrast to the then contemporary Crucifixion
depictions of Dürer or Cranach, in which physiognomical distortions and
suggestions of pain are mainly absent; in their work, the story rather than the
image portrays the meaning.

The Medieval Background

Medieval thought and practice were varied and complex, united only in the
conviction that the Christian faith is the clue to all of reality. But there was a
growing emphasis on the imitation of the life of Christ, such as in the life and
thought of Saint Francis. Moreover, such imitation increasingly centered in
the sufferings of Christ, that is, ways of entering into his passion. The stig-
mata of Saint Francis, of course, is such an example. Meditation on the suf-
ferings of Christ dictated accepting one's own sufferings, indeed extending
them through physical penitential acts, thereby directly identifying with the
crucified one. Such meditation was an active orientation, one in which the
experience of suffering was itself the liberating act, as faith helped one endure
the diseases, tribulations, and sins of one's being.

Such an identification with the sufferings of Christ led to seeking out and
delineating stages in the Passion: places, so to speak, where one paused to
meditate and identify. Given that the Scriptures were sparse in their elabora-
tion of the Passion, other avenues, such as extracanonical ones or particular
ways of reading Old Testament passages as referring to Christ, were utilized.
James H. Marrow has pointed out that "the *Meditationes vitae Christi* of the
late thirteenth century and the *Vita Christi* of Ludolph of Saxony of the early
fourteenth century are the first comprehensive biographies of Christ contain-
ing regular and extensive interpolations of extra-Gospel narration."[8] He also
points out that vernacular and expanded German tracts of this type appeared
in the fourteenth century and in devotional literature in the Netherlands in
the fifteenth.

The use of Old Testament narratives in relation to Christ's Passion are the
familiar passages from Isaiah 53, the man "despised and rejected, . . . stricken,
. . . wounded for our transgressions, . . . oppressed and afflicted." But one can
also add passages of considerable concreteness, as Isaiah 1:6, "From the sole

of the foot even to the head, there is no soundness in it, but bruises and sores and bleeding wounds; they have not been drained, or bound up, or softened with oil"; or Isaiah 50:6, "I gave my back to those who struck me, and my cheeks to those who pulled out the beard; I did not hide my face from insult and spitting."

Howard Creel Collinson has shown that such traditions are at work in connection with Grünewald's 1503–1504 panel *The Mocking of Christ* (Figure 9). In a German mass commentary of 1488, one reads: "They sat the Lord Jesus down on a chair and laid a linen cloth on his head that hung down past his head or face; they laced it closed at the bottom." Later, the mass book also states that the cloth represents the Crown of Thorns.[9] In addition, James H. Marrow points out that in Grünewald's *Mocking of Christ*, Christ is also seated, in a posture reminiscent of Job. "The seated figure of Christ, enduring

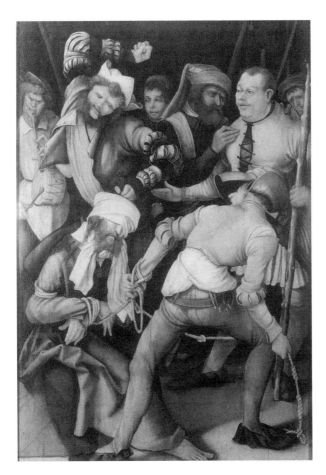

FIGURE 9.
Grünewald, *The Mocking of Christ*, Bayerische Gemälde Sammlungen, Munich.

the attacks and mockery of His tormentors with resignation, recalls numerous depictions of Job on the dung-hill. The presence of a drum and fife player in the left background brings to mind the words of Job 30:9; *Now I am become their son, and am become their by-word.*"[10] Hence, the head cloth described in a mass book and the seated figure with musical instruments based on Job are both directly evident in *The Mocking of Christ*, illustrating the expansion of the Passion tradition.

The elaboration of the tradition in this way provided additional incidents or happenings through which one could identify and experience the life of Christ and the Virgin Mary. One formalization of the development is the Stations of the Cross. Richard Kieckhefer has documented this development. First, the sequence of the life of Christ is extended in terms of events before the Crucifixion (the agony in the garden, arrest, flagellation, Veronica's veil) and those after it (deposition, lamentation, and burial). Second, the cast of characters at the Crucifixion increases, with not only Mary and John, but also Mary Magdalen, the Virgin's companions, soldiers, and officials, thieves, and postbiblical saints. Third, the Pieta and Man of Sorrows subjects increase. Fourth, an emphasis on the instruments of the Passion come to the fore.[11] Likewise, Kieckhefer delineates the development of subjects for the Virgin Mary. First, there are the events of her childhood (conception and birth, presentation and betrothal), infancy (annunciation, visitation, nativity), the Passion of Christ (Mary at the foot of the cross, versions of the Pieta, lamentation, and burial), and events after the life of Christ (dormition or death, assumption, and coronation).[12]

While various developments at the popular level are not present with the same degree of specificity in the *Isenheim Crucifixion* as in the *Mocking of Christ*, it is clear that Grünewald stands in the tradition where the Crucifixion is a reality in which one participates as a contemporary event.

Such an approach is concrete, and religious experience is directly related to the corporeal world, not to a separated realm of the Spirit. Strange as it may seem initially, it also expresses itself in the mystical tradition. While the highest goal for the true mystic may be an intellectual, contemplative imagination, spiritual and corporeal elements, sometimes relegated to a lower level, are also present. Only a few gifted monks, such as St. Bernard, were considered free of the corporeal, encountering the Godhead head on, so to speak.

The Dominican mystic, Henry Suso, in his autobiographical account the *Exemplar*, records that he used a stylus to engrave the name of Jesus on his heart and that he wore a nail-studded cross. Suso also suggests that images are like relics in exercising the imagination to move beyond what is only present.

There is evidence that Suso's private chapel contained a cycle of paintings from the life of the church fathers, and that in particular many Dominicans, both male and female orders, identified themselves with the eastern church fathers, such as the hermit Paul and St. Anthony. Both of whom, as we have already noted, were prominent in the *Isenheim Altarpiece*.[13] In addition, there are references to the sufferings and coronation of the Virgin, to the attendant sufferers—the apostle John, the Virgin, and Mary Magdalen—all present in the Isenheim work.

Suso's educational work with women Dominican orders involved the role of images and identification with the desert fathers, as in the case of Elsbeth Stagel. Even Catherine of Siena tried to model her life in terms of the desert fathers. Julian of Norwich, during an illness, was comforted by the image of the cross and in her *Sixteen Revelations*, she begins with the vision of the bleeding Christ.[14]

From fairly early on, research on Grünewald centered on Birgitta of Sweden as the source for Grünewald's *Isenheim Crucifixion*. It is true that there are many passages in her writings that describe the Crucifixion in graphic images, similar to but not always equatable with Grünewald's depiction. For example, "On the cross your blessed body was emptied of all its strength; your kindly eyes grew dark; as your blood decreased, a pallor covered all your comely face; your blessed tongue grew swollen, hot, and dry; your mouth dripped from the bitter drink; your hair and beard were filled with blood from the wounds of your most holy head; the bones of your hands, of your feet, and of all your precious body were dislocated from their sockets to your great and intense grief; the veins and nerves of all your blessed body were cruelly broken; you were so monstrously scourged and so injured with painful wounds; that your most innocent flesh and skin were all intolerably lacerated."[15] Perhaps a better case can be made, as will be shown later, that her adoration of the Virgin Mary is descriptively more akin to Grünewald's Virgin both in the *Isenheim Altarpiece* and in the *Stuppach Madonna* of 1520 than that depicted in the Crucifixion.

The possibility that John Geiler of Keiserberg, the great preacher at the Strasbourg cathedral from 1478 to his death in 1510, had some impact on Grünewald should not be ruled out. He was widely known among the populace and by the emperor. Geiler's preaching and writing stressed living one's life by entering into the sufferings of Christ. E. Jane Dempsey Douglass writes of him: "In Geiler's sermons on preparation for death, he teaches how one should conform his death to that of Christ by imitating his prayer, agony, remission of sins, weeping, crying out, commendation of his mother, and

yielding his soul to God."[16] Further, there is a parallelism between Geiler and Grünewald in that while the Virgin Mary is revered and in a pivotal position, and classical saints are honored, neither disclose an interest in the plethora of saints that had emerged in the Middle Ages and were so dominant at the turn into the fifteenth century.

Finally, Georg Scheja suggests that the authentic theological source of the *Isenheim Altarpiece* is St. Bonaventura. Indeed, the passages he quotes cannot be ruled out.[17]

Overall, the sources for Grünewald's *Isenheim Altarpiece* range from the most popular devotional tracts, ones dealing with the art of dying and popular images in books of hours, to sophisticated theological tracts. The extremes range from images which frequently have indulgences connected with them, such as the Veronica veil, the Man of Sorrows, the Virgin of the Sun or the Virgin of the Rosary, to the views of John Gerson, the prereformer theologian who accepted images but rejected their abuses.[18] In Grünewald, to whom we now directly return, the indulgences and the overly miraculous are filtered out, while the crucified Christ discloses suffering without sentimentality.

More on the *Isenheim Altarpiece*

Surely, the preceding account indicates how crucial and central the sufferings of Christ were to the faith of the time, sufferings that believers saw both as punishment and as hope. The Christian felt it was necessary to live out, physically and spiritually, the sufferings of Christ, the Virgin, and the saints, with confidence that such good works and faith in the redemptive processes of the church would see one through.

Hence, the altarpiece was not an irrelevant creation in the life of the community. It functioned in the liturgical life of the community, and seeing it was a special form of identification with Christ. One was plummeted into sufferings akin to those depicted in the altarpiece. Christ suffered as one of them, and he had been there first.

The crucifixion in the *Isenheim Altarpiece* (see Figure 1), as indicated earlier, had a double-sided character. With considerable verisimilitude, it shows the wounds Christ suffered on the way to and on the cross. In most situations, that was enough. But the Isenheim Christ also has the marks of those who have the diseases to which the hospital ministers.

The heavy body of Christ, with head down and to the side and a conspicuous crown of thorns, hangs there as if at the moment of death. To his right,

John the beloved holds up the Virgin with his arm surrounding her monastic attire, while she, with clasped hands and her head positioned in the direction of the crucified head, has her mouth open and eyes closed, as if she were swooning in her grief. The more diminutive Mary Magdalen kneels with arms and head posturing in the direction of the cross, fingers intertwined in a gesticulating manner, mouth and eyes open. To the right foreground, with a river seen in the darkness behind the figures, stands John the Baptist, with elongated forefinger of his right hand pointing to Christ, with open book in his left hand, and in the space between his forefinger and his head, the Latin inscription, "I must decrease, he will increase." Historically, of course, John the Baptist is no longer alive, but for theological reasons, he has been resurrected for this event. To the right of the Baptist's right foot, stands the lamb of God, with staff, and chalice into which its blood is flowing, echoing, "Behold the lamb of God, that takes away the sins of the world." In short, in this one kaleidoscopic panel, Grünewald has captured the core of faith for his time.

In Grünewald's *Small Crucifixion* panel (Figure 10) in the National Gallery, Washington, D.C., of about 1510, that is, just prior to the *Isenheim Altarpiece*, Christ's sagging arms form a V design; the head is not as far down or as much to the side, while Mary is looking down in distress and prayer, with the beloved disciple John looking straight ahead, with clasped hands. But Mary and John have their mouths closed. Mary Magdalen is in a similar position as in the *Isenheim Altarpiece*, but her crouching position is more prominent, her face more straight ahead, and her hands open as if to bless or to be blessed.

In the undated Basel version (Figure 11), Mary again stands to the right of the crucified and the Magdalen kneels at his feet; but both of their faces look more in our direction than toward the cross. Immediately to the right of the crucified figure, the beloved John stands with folded hands, but to his right stands the converted centurion, pointing to the Christ figure. In the much larger 1520–1526 Karlsruhe version (Figure 12), the Christ figure is immediately in front of us, with a crown of thorns notable for its size. On the right stands Mary, with folded hands, head slightly bowed, eyes closed, with a countenance of sadness. To the right, the beloved John seems agitated. But in this version, neither the Magdalen nor the centurion are present. Here, the crucifixion is center front, making it the center of attention rather than the total ensemble.

While the body of Christ in the Washington, Basel, and Karlsruhe Crucifixions disclose intense suffering with great authenticity, the Isenheim

FIGURE 10. Grünewald, *The Small Crucifixion*, oil on panel, 1511/1520, National Gallery, Washington, D.C.

FIGURE 11. Grünewald, *Crucifixion*, Kunstmuseum, Basel.

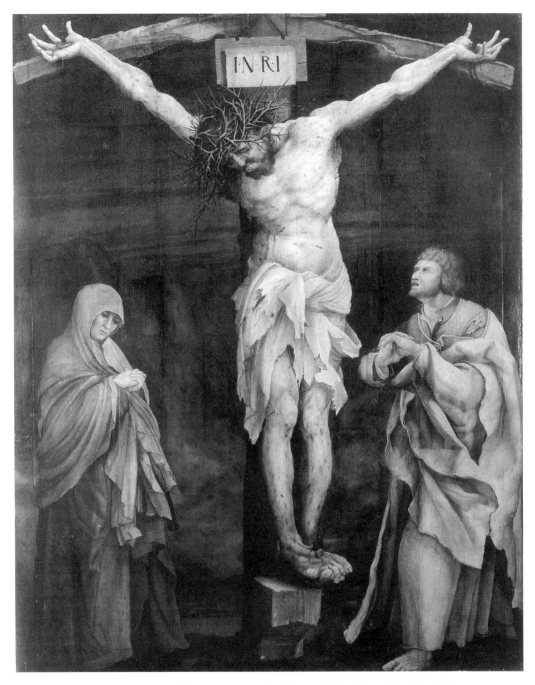

FIGURE 12. Grünewald, *Crucifixion* (Karlsruhe), Staatlichen Kunsthalle, Karlsruhe.

Crucifixion conveys a wider range of suffering. Undoubtedly, that is the direct result of the hospital context.

In the Anthonite order, John the Baptist and John the Evangelist represent helpers in times of need, particularly in instances of epilepsy. Thus, even in the central Crucifixion panel, one in which the roles of John the Baptist and John the Evangelist need no further justification, the extra meaning of their role is inescapable. Likewise, St. Sebastian is the helper with reference to the plague, and St. Anthony to St. Anthony's fire.[19] (See Figure 1.)

St. Sebastian, shown as just having been martyred, stands on what appears to be a sculptural base, a device that may be a way of tying this figure through the illusion of painting to the sculptural forms of the third or open position. This is given additional weight in that St. Anthony, the figure on the right panel, also stands on a sculptural base. Both St. Sebastian and St. Anthony stand before us as victors in a suffering world, St. Sebastian as the honored martyr and St. Anthony as the one whose faith was triumphant precisely in overcoming the demonic world.

The right wing painting of the third position, attached to the sculptural shrine in which St. Anthony is centrally seated like a reigning, judging figure, depicts the temptations Anthony faced (Figure 13). While the top of the painting is full of light, relative darkness pervades the larger space below, until our eyes focus on St. Anthony, prone on the ground, with demons attacking and grimacing, all threatening in their ugly fierceness. St. Anthony appears as one who is simultaneously frightened and composed, the latter anchored in a reality not visible to human eyes. In the lower left-hand corner is a seated human figure, apparently with Capuchin cape, head thrown back and distorted, webbed feet, and a prominently distended abdomen, full of sores characteristic of the diseases treated in the hospital. In this figure, the demonic and the diseased are joined, and for this life all hope has disappeared.

The painted left wing, in which St. Anthony visits the older hermit Paul, stands in marked contrast to the temptation scenes. Here the two saints, who have successfully overcome temptation, commune with each other (Figure 14). While Paul lives in a cave-like place, akin to the desert, a verdant world of nature is glimpsed in the distance. Above the two saints, one sees the raven, which each day had brought a half-loaf of bread, but today has brought enough for both. Taken as a whole, this panel glorifies the lives of the saints who have persevered and won the battle with the demonic forces.

It has been noted that in the first or closed position of the altarpiece and in the third or fully open position, St. Anthony plays a major role, represented as both a helper in the midst of disease and a saint who has overcome the

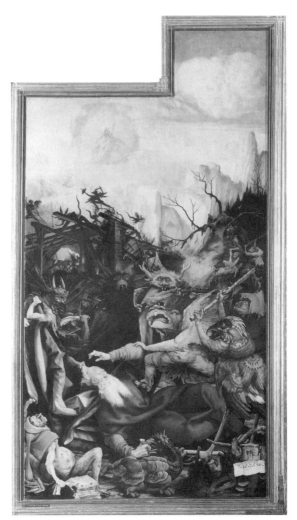

FIGURE 13.
Grünewald, *Isenheim Altarpiece*,
St. Anthony Panel, Unterlinden
Museum, Colmar.

demonic powers, powers that also used disease as their own weapons. It may
be that the victory of the Christian faith over the demonic powers who felt
they ruled the world ties the first and third positions to the second. In that
respect, the second position may represent Christianity's triumphant victory
over the powers that believe they control the world.

With that problem in mind, we directly turn to the second or middle posi-
tion (see Figure 7). Here the themes are the annunciation, the angelic choir,
the Virgin and child, and the Resurrection. While the case can be made that
the composition of the annunciation is unique, taken as a whole it is hardly
special, though the text in the open book is that of Isaiah 7: 10–15 rather than

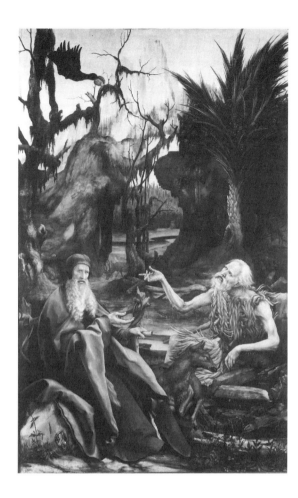

FIGURE 14.
Grünewald, *Isenheim Altarpiece*,
St. Anthony and Paul the Hermit,
left panel in open position of altar-
piece, Unterlinden Museum, Colmar.

Luke 1:26. Interesting is the fact that the annunciation and the choir of angels
both are staged inside ecclesiastical-style buildings, while the nativity and the
Resurrection are set in the midst of nature (see Figures 7 and 15).

The interpretation of the second or middle position of the altarpiece has
always floundered on the inability to understand the choir of angels. But in
her 1988 volume, *The Devil at Isenheim*, Ruth Mellinkoff has identified the
conspicuous figure in the choir as Lucifer, the fallen angel.[20] (See Figure 16.)
The identification is made on the basis of the feathers and the peacock's crest.
Lucifer, or the devil, while having a flesh color akin to the crucified Christ, is
not an ugly figure; rather, echoes of the angelic nature remain. Essentially,
Lucifer has control of humans, having succeeded in tempting Adam and Eve,
the progenitors of the human race, to rebel against their creator. At the same
time, according to an ancient tradition, Lucifer is not sure that his sway over

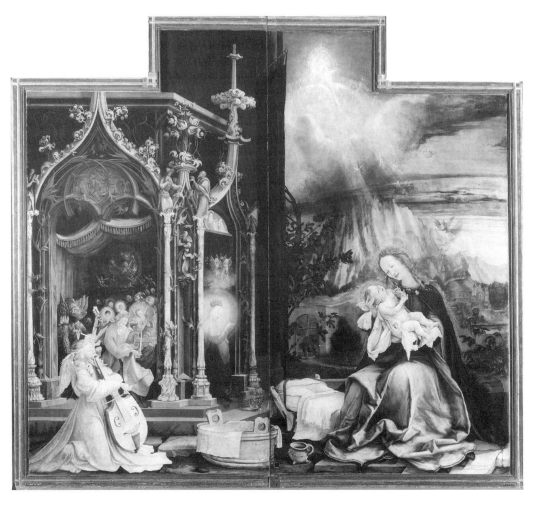

FIGURE 15. Grünewald *Isenheim Altarpiece*, Concert of Angels, Mary/ecclesia, Nativity, Unterlinden Museum, Colmar.

humans can be maintained against God, and so he is always on the lookout for signs of impending defeat.[21]

Hence, one can now understand the choir of angels as celebrating the birth of the one who will deliver the human race. At the same time, Lucifer, having fallen, knows of a birth but has no knowledge of what it means. Lucifer looks toward the God figure, watching for clues, but none are forthcoming.

The Lucifer motif, as Mellinkoff suggests, must be understood in terms of the tradition of God fooling the devil, namely, that the incarnation is the humanity that has divinity hidden within it. This the devil does not know or

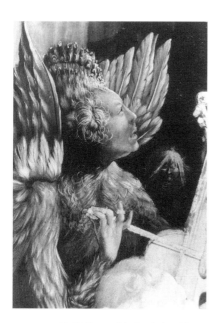

FIGURE 16. Grünewald, *Isenheim Altar-piece*, Lucifer detail, Unterlinden Museum, Colmar.

FIGURE 17. Grünewald, *Isenheim Altar-piece*, Mary/ecclesia detail, Unterlinden Museum, Colmar.

see, and so he is tricked into defeat. In some of the literature, the hidden Christ is the fish hook the devil swallows, causing him to be caught or defeated. Sometimes, a mouse trap analogy is suggested. Indeed, the rescuing of humanity from the devil by this kind of deception is prominent in Luther's thought. As Gustaf Aulen has pointed out, that tradition was strong in the history of the church but has been largely sidetracked by more recent historians. In Grünewald's time, it was well known.[22]

Hence, the angelic choir is the clue to the meaning of the annunciation and the nativity, namely, the celebration of Redemption, the meaning of which, however, is not clear to the unfaithful or those who do not have the eyes of faith.

Looking out from the side of the same architectural canopied structure, in which we see the angelic choir from the front, is a small, glowing figure, wearing a crown (Figure 17), whose visage is turned to the large seated Virgin and the Christ child she holds in her arms. This small figure has been the subject of considerable speculation, with declarations that she is the crowned Mary, raised to another level of existence. Mellinkoff rejects that appellation, instead making the case that the figure is Ecclesia, the Church. It seems to me that given the history in which Mary and Ecclesia are identified, we can conclude that the two are one in Grünewald's version.

This figure must be seen as analogous to the resurrected Christ of the right panel (Figure 18). Here Christ is indeed

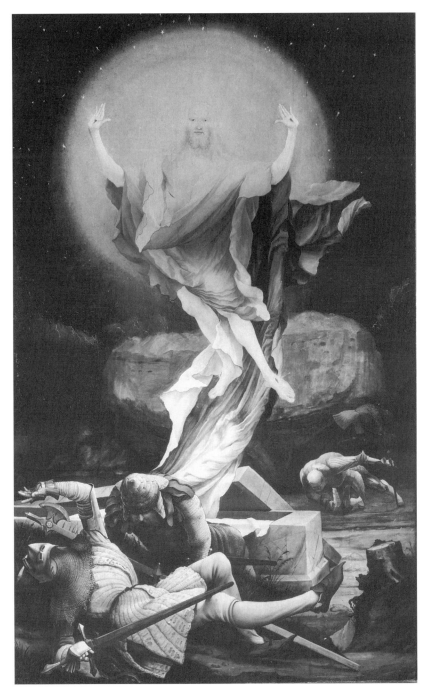

FIGURE 18. Grünewald, *Isenheim Altarpiece*, Resurrection panel, Unterlinden Museum, Colmar.

transfigured, a form of corporeality that suggests another mode of existence, one not characteristic of this world. The Christ figure emanates light, a light as indigenous to the figure as the light of the sun is to the sun. That light is equally characteristic of the small crowned figure. In both Christ and the crowned figure, the transfigured corporeality represents divinity, in contrast to the ordinary corporeality that had deceived the devil and the attendant demons with its hidden divinity. This is in line with the way in which Mary is perceived, that is, as elevated to heaven, and, in some ways, as a coredeemer at the side of Christ and prominent in the church, which in itself is considered to be the continuation of the incarnation. Whether the depiction of Mary is a direct expression of Mary's role alongside that of Christ, or the vision of the seated Mary as to her own future, does not change the role she plays in redemption.

In summary, then, using the key Mellinkoff provided but did not develop, the middle position of the altarpiece discloses the history by which God overcomes the devil and the demons that seem to rule the world. It represents the theological foundation of Christianity, and can be said to be related to the ways in which the demons are encountered in the first and third positions of the altarpiece. Hence, there is a manifest unity in the different positions of the altarpiece, a unity based in God's triumph over the devil and the powers of evil. The powers of evil encompass the encounter with the demonic world, a world in which one may be assaulted by demons, by hallucinations, by disease. Over such powers, God has been victorious, and by identification with Christ in his ordeal and sufferings, we too may share in that deliverance.

Mary's prominent role, already clear in the second position of the *Isenheim Altarpiece*, is also evident in the *Stuppach Madonna* (Figure 19), a panel that originally may have been part of an altarpiece in the collegiate church in Aschaffenburg that included the *Miracle of the Snow*. Also, as suggested earlier, the influence of Birgitta of Sweden may be more prominent in this work than in the *Isenheim Altarpiece*. For example, Mary as the guardian of the church and the rainbow seems to echo Birgitta. The work is full of symbolism. The beehives and the closed gate are characteristic of the Madonna, and the fig tree symbolizes Christ. Concretely, the church facade is that of Strasbourg cathedral as it appeared in the early sixteenth century.[23]

The *Miracle of the Snow* (Figure 20), whether or not a part of an altarpiece that included the *Stuppach Madonna*, also focuses on Mary, celebrating the first church dedicated to her, namely, Santa Maria Maggiori in Rome. According to legend, a patrician by the name of John and Pope Liberius had both dreamed that a new church should be placed on the spot where snow

FIGURE 19.
Grünewald, *Stuppach Madonna*,
Parish Church, Stuppach.

FIGURE 20.
Grünewald, *Miracle of the Snow*,
Augustinermuseum zu
Freiburg im Breisgau.

appeared. The painting shows the pope dreaming in his bed, while John and his wife look at the apparition in the sky. In the foreground, John and his wife kneel before the snow, while the pope, with his hoe, marks the spot for the church. In the background, one can see the Lateran church.

Since the legend was popular in Germany and particularly in the diocese of Mainz, it is not strange that Grünewald would be commissioned to do this work.[24]

Works after 1520

In this final section, attention will be given to four paintings. Two of them form the front and back of the central panel of a work done for a church, now destroyed, in Tauberbischofsheim in southern Germany. These two panels, the *Crucifixion* and the *Carrying of the Cross*, dated about 1522, were separated and both of them are now in the Karlsruhe Kunsthalle.

Mention was made of the Karlsruhe Crucifixion (see Figure 12), as well as other Crucifixion panels, in our discussion of the *Isenheim Altarpiece*. Among

FIGURE 21.
Grünewald, *Carrying of the Cross,*
Staatlichen Kunsthalle, Karlsruhe.

the Crucifixion panels, which can be said to be like signature pieces for the recognition of Grünewald, the Karlsruhe one is simple and direct in its portrayal of the Christ who has just been crucified. The crown of thorns is pushed tightly on his bowed head, with open mouth and dark beard. The body hangs from the bowed cross beam and the crossed feet rest on the small platform attached to the main beam, with the result that the body is taut but not distorted. The lesions of the skin testify to the ordeal leading up to the Crucifixion.

Only two additional figures are present, Mary on Christ's right, and the beloved disciple, John, on Christ's left. Mary's eyes and mouth are closed in her grief, with a tear falling down her cheek, while John's mouth is open and his eyes look intently at the Christ figure. Both Mary and John's hands are clasped, as if in an act of adoration. Taken as a whole, the suffering of the crucified Christ stands before us; no other point of reference is suggested.

In the *Carrying of the Cross* (Figure 21), the suffering of the living Christ is more vivid than in the lingering traces of acute suffering in the dead crucified Christ. Perhaps it is for that reason that believers participated in the steps of the passion as a way of realistically identifying with Christ. But precisely that development was dubious in Luther's eyes. For him, the Crucifixion itself is the medium through which the hidden God is revealed, as well as revealed in hiddenness. What God has done is the basis of faith and participating in the sufferings of Christ is not in itself redemptive.

By contrast, the painting of the *Meeting of St. Erasmus and St. Maurice* (Figure 22) returns to a theme in which historic saints and their contemporary significance are featured. The painting was probably done in about 1522 for Albrecht of Brandenburg, whom we noted was also the artistic patron of Dürer and Cranach the Elder.

On the left side of the painting is St. Erasmus, former bishop of Antioch, who holds the instrument of his own martyrdom, the windlass by which his intestines are drawn from his body. He is elegantly dressed, and the facial features are those of Albrecht himself. On the right is St. Maurice, a black knight in armor, accompanied by Theban legions, all of whom suffered martyrdom. With jeweled headdress and a halo, he gestures with his right hand, as if in speech. Nothing is known of an incident or event that the meeting symbolizes or represents. But we do know that St. Maurice is the patron saint of the church in Halle, while St. Erasmus was a natural favorite of Albrecht, for he had the St. Erasmus relics moved to Halle in order to augment his relic collection.[25] An additional factor may have been that St. Erasmus was the patron saint of the Hohenzollern dynasty.[26] Below and in front of St. Erasmus are

the insignias representing Mainz, Magdeburg, and Halberstadt, all associated with Albrecht.[27]

Finally, the last known painting of Grünewald is the *Lamentation* (Figure 23), probably between 1524 and 1526, and now located at the end of the right aisle of the Collegiate Church, Aschaffenburg. To the left of Christ's head are the insignia of Cardinal Albrecht, and to the right, those of the previous revered archbishop Dietrich von Brandenburg. Essentially, the figure, lying prone before us, is the familiar Christ of the Crucifixion, with the thorns still on his head and his mouth open. The Crucifixion figure, with no noticeable change, has been given the lamentation posture. In this sense, it is also in the tradition of the lamentation painting in the *Isenheim Altarpiece*.

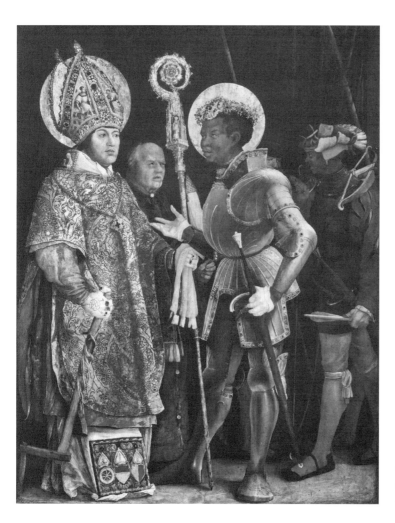

FIGURE 22.
Grünewald, *Meeting of St. Erasmus and St. Maurice*, Alte Pinakothek, Munich.

FIGURE 23. Grünewald, *Lamentation*, Collegiate Church, Aschaffenburg.

It has been noted that during the last years of Grünewald's life he was no longer in the employ of Cardinal Albrecht. The reasons for this rupture cannot be determined, though various conjectures have been made. We do know that soon after 1526 events began to change and the ambiguous attitude Albrecht had toward the emerging Protestant movement turned into outright opposition. It is possible that Grünewald had come under the influence of the circle of Luther or the other more radical reformers. Eugenio Battisti reports that Grünewald appears to have been officially charged with inciting the peasants to revolt, and James Luther Adams suggested that he may have had sympathy with the bitter Christ doctrine of Thomas Müntzer.[28] But this cannot be proved, though it would not be unusual for those whose outlook still belongs to a medieval piety to also be involved in the social turmoil of the time. For example, Tilman Riemenschneider, the great wood sculptor whose works were executed in Catholic contexts, was tortured for having taken part in the Peasants' War.[29] Unlike the case of Dürer, who had identified himself with the Reformation, there is no such evidence for Grünewald.

Whatever Grünewald may have believed, all that we can say is that the Crucifixion motif, so prominent in Grünewald, took on new life in the Reformation. But it was freed from the lives of the historic saints, and Mary's role was diminished. We do not know whether Grünewald would have rejected or accepted that development.

3

ALBRECHT DÜRER

Renaissance Humanist Reform

AT THE TIME OF LUTHER'S ISSUANCE OF THE Ninety-five Theses in 1517, Albrecht Dürer had already been an artist of note for three decades. While one may say the same of the Wittenberg artist Lucas Cranach the Elder, after 1517 the life spans of Dürer and Cranach were quite different. Cranach the Elder lived another twenty-five years under the full impact of the Reformation. By contrast, the Nuremberg Dürer lived only another eleven years after the posting of the theses. He died in 1528, a year before the beginning of Cranach's Law and Gospel woodcuts and panels, the first full-blown works of art representing Luther's thinking.

Dürer's historic relation to the reforming currents represented by Luther is chronologically limited and confined to the period before the implications of Luther's thinking were widely known. Nevertheless, in the writing of history, Dürer is widely identified with Luther and the Reformation. Perhaps that is the result of Dürer's personal identification with Luther and that some of his early works reflect the widely felt need for reform, as reflected, for instance, in the writings of Erasmus.

Given Dürer's association with the Renaissance humanist leaders in Nuremberg, as, for example, his friendship with Willibald Pirckheimer who

translated early classical documents, one can assume that Dürer lived in and breathed the air of that humanist development. Moreover, with respect to the visual arts, he was the creator of northern Renaissance art, partly as the result of his exposure to the arts of Italy. The quality of his work and his vision for the role of the artist soon made him one of the best-known artists of Europe.

Dürer represented both Renaissance humanist thinking and Renaissance art. As a result, he came to Reformation issues with an orientation that was sympathetic but not fully cognizant of the theological scope of Luther. Given his premature death at the age of fifty-seven and that the implications of Luther's thought at that time were not fully evident, Dürer represents an in-between figure, one no longer at ease in the orbit of medieval Catholicism but not yet fully within the developing Protestant ideas, ideas that emerged full blown only after his death.

Early Life and Work

While a product of the relatively progressive school system of Nuremberg, Dürer had a good grounding in mathematics and the natural sciences, though not in literature or languages. His knowledge of Latin was spotty, for he required the help of others in forming the Latin inscriptions on his paintings, and he requested German rather than Latin copies of Luther's works. Withdrawn from school at about the age of ten, he was trained in the goldsmith's craft. Dürer's father, bowing to his son's wishes and obvious talent at age fifteen, apprenticed him to the painter Michael Wolgemut, who also taught him to do woodcuts, the medium in which Dürer later excelled.

At the age of nineteen, his father sent him off on a bachelor's jaunt, which Dürer extended to four years instead of the standard one year. While there are gaps in our knowledge of his pilgrimage in this period, Dürer did spend time in the Frankfurt/Mainz area, Strasbourg, and Basel, working with and learning from artists, particularly in the area of woodcuts and engravings for books. It is believed that Dürer had a role in illustrating Sebastian Brandt's *Ship of Fools*.

Upon his return, Dürer entered into an arranged marriage. But a few months later he went to Italy, spending considerable time in Venice, where German merchants gathered to sell and buy their wares. Possibly accompanied by Nuremberg humanist scholar Willibald Pirckheimer, he was among the first German artists to travel to Italy for the sake of studying Italian art and getting to know Italian artists. He was introduced to the world

of antiquity and its mythological subjects, to the nude, and to antique drapery, all of which left their mark on him.

Upon his return from Italy, Dürer established himself as an engraver, and a maker of woodcuts with a quality no one had achieved before. Indeed, Dürer favored these media, for such multiples could be printed and sold individually at fairs, and through porters or book sellers. It is not too much to say that these media subsequently became the vehicle for the Reformation, a means of propaganda in which, as Mark Edwards, Jr. put it, the Protestants, as contrasted to the Catholics, excelled.[1]

In 1505–1506 Dürer returned to Italy, and we have glimpses of that visit through the letters he wrote to Pirckheimer. But upon his return Dürer remained in Nuremberg, except for the important one year's trip fifteen years later to the Netherlands, this time accompanied by his wife, Agnes, and her friend and assistant. For this visit, his personal contacts, attitudes, and observations of events are known to us through the diary he wrote.

From about 1494 to 1515, Dürer's artistic career developed rapidly, as he excelled in executing woodcuts and engravings with a quality heretofore unknown and in giving classical form to paintings, so that they were free of the display of human agony and suffering, so characteristic of much medieval painting as well as of the work of Grünewald.

Selected Works to circa 1515

Dürer's early fame emerged from his woodcuts on the *Apocalypse*. Several factors were involved. First, Dürer printed them in large sheets, thereby creating an impact new to woodcuts. Second, the turn into the sixteenth century interested people, as does the turn of a century generally. But this turn of the century particularly seemed an ominous sign of the end of the world, though for Dürer it also had positive aspects. It is interesting that Luther, who shared in such expectations, nevertheless warned against speculations on the Book of Revelation. Still, when the September Bible of Luther appeared in 1522, the Book of Revelation was the only one copiously illustrated.

The fourteen large folio sheets of the *Apocalypse* were published in book form in 1498 with a German text, and again in 1511, this time also with a Latin text. Best known to us of the subjects, both because of its gripping visual character and its having been reproduced frequently in a format that derives from Dürer, is the *Four Horsemen of the Apocalypse* (Figure 24). Dürer was the first to show the four horsemen together, mounted on their steeds,

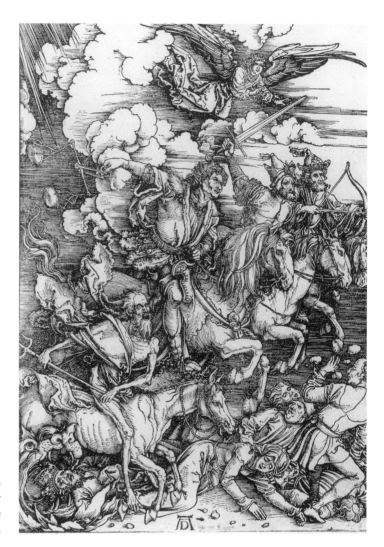

FIGURE 24.
Dürer, *Four Horsemen of the
Apocalypse*, woodcut from the
Apocalypse series, 1497–98.

and sweeping everything to destruction before them. According to Revelation 6, the first, a white horse, had a rider with a bow, who came out conquering; the second, a red horse, had a rider who would take peace from the earth, and was depicted by Dürer with a sword; the third, a black horse, had a rider with a scale, depicted by Dürer as floating in the air as it trailed from the hand of the rider; the fourth, a pale green horse, had Death as its rider, with Hades following. To the fourth rider, authority was given over one-fourth of the earth, to kill with sword, and conquer famine, pestilence, and wild animals. In Dürer's version of the fourth horse, the horse itself seems emaciated, too

small for its grim rider. Below the horse, in the extreme left bottom corner, the mouth of Hades seems to be scooping up those strewn on the earth. Above the horses, an angel with wings appears to be directing the entire operation.

In the story and in Dürer's version, the first two horses and their riders seem to create the conditions of destruction on the earth; the third horse and its rider signal judgment; and the fourth horse and rider represent the grim reaper, so to speak, carrying out the total destruction in terms of war, pestilence, hunger, and some wild beasts.

The *Apocalypse* seems to be the one project that required Dürer to deal with a situation in which major action is taking place. But even here his preference for composure is apparent. While the front legs of the horses are raised, signifying movement, they seem arrested. Indeed, the whole is as if all action had been temporarily stopped. The man in the lower right has his left hand raised, not so much in shielding himself but as if the whole action could be stopped. The faces of the riders show no obvious emotional strain, rather a calm, determined look of individuals doing their jobs. Hence, the action and its consequences are not so much obvious as potentially imminent. A subject obviously laden with action has been transformed into a composed, reigned-in potential for destruction.

A second series of woodcuts, entitled the *Large Passion*, was begun at the same time as the *Apocalypse*, but it was not completed until 1511. The subjects are the traditional ones, The Agony in the Garden, the Flagellation, Ecco Homo, Christ Carrying the Cross, and the Crucifixion (Figure 25), Lamentation, and Entombment. While the style changes from the early to the later compositions, the transition can be said to be Dürer's increasing mastery and transformation of the Renaissance style he had encountered in Italy. The faces of the figures, even in grief, show their feelings, not in the contortions of their physiognomy, but in pent-up interiority. Here one sees the stark contrast between the Mary of the *Isenheim Altarpiece* and the Mary of Dürer's *Crucifixion*. In addition, the drapery of the figures discloses the modeling so characteristic of the Renaissance. One could say the same of the engravings of the *Passion*, executed during the latter half of the same period.

While the *Life of the Virgin* (Figure 26) woodcuts were published in 1511, they were executed a few years earlier. In this series, aid to the viewer in meditating on the life of the Virgin is intended, an attitude that accords with Dürer's own predilections. Indeed, adoration of the Virgin was particularly characteristic of the piety of the citizens of Nuremberg, and Dürer himself continued to paint the Virgin to the end of his life. Dürer's new Renaissance style was most appropriate to that subject.

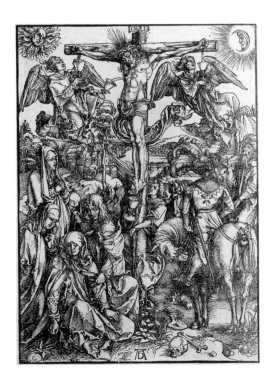

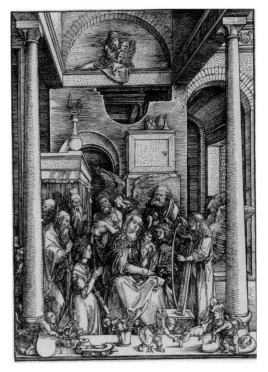

Although Dürer's woodcuts outnumbered his engravings and etchings in the ratio of three to one, some of the most eloquently executed works belong in the latter category. From this period, some of the more distinctive subjects are *The Prodigal Son*, where the courtyard setting is the appropriate barnyard scene, and *St. Jerome in Penitence*, a prominent subject in Italy which Dürer appropriated. Important with respect to Dürer's theological understanding are his 1504 engravings of *Adam and Eve* (Figure 27). Knowing that individual persons are not ideal and represent the rent in creation, Dürer combines ideal parts to create a whole, using theories of proportion. At the same time, as Joseph Leo Koerner suggests, they are "surrounded by animals emblematic of the four humors and their moral connotations: the rabbit denoting sanguine sensuality; the elk, melancholic gloom; the cat, choleric cruelty; and the ox, phlegmatic sluggishness."[2] Thus, what humans have become can be

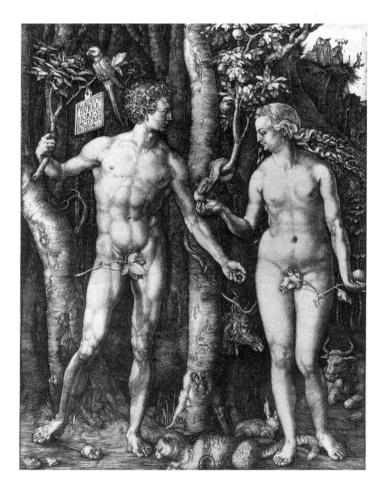

FIGURE 27.
Dürer, *Adam and Eve (Fall)*,
1504, line engraving.

redone, a new Adam and Eve, who in their
new conscious harmony are aware of their
new state. Like the early fathers, redemp-
tion made them greater then they were in
their original created state. Dürer functions
as God once functioned.

Interesting in the light of the Cranach
use of blood flowing from the side of Christ
on Cranach's own head in the Weimar
altarpiece is the first sheet of Dürer's 1509
engraved *Passion of The Man of Sorrows*, in
which blood from the wound of the man of
sorrows flows on the head of Mary and John
the disciple (Figure 28).

Well known is Dürer's 1513 engraving
Knight, Death and the Devil (Figure 29).
While it is widely assumed that the subject
of this engraving is directly appropriated
from the Christian knight found in the
Handbook of the Christian Soldier by Eras-
mus, Jane Campbell Hutchison reminds us,

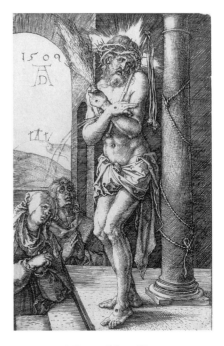

FIGURE 28. Dürer, *Man of Sorrows*,
Engraved Passion scene, 1509.

however, that Dürer's title for the work was simply "the rider." Moreover,
she calls attention to Italian equestrian monuments Dürer knew, and to the
Rider in the Bamberg Episcopal Cathedral, Bamberg being the diocese that
included Nuremberg. Finally, she calls attention to Burgmair's woodcut
depicting Emperor Maximilian as the last knight.[3]

Whatever the source or series of sources, the rider looks neither right nor
left, up nor down, while from all sides the legions of death and the devil
abound. One of the powers of a Christian humanity over the darker powers
of evil was to defy that they were genuinely real. The northern Renaissance
figures affirmed the nobility of humanity, its grandeur in the light of God,
but never knew what to do with the darker powers it could not deny or sup-
press. Such an approach contrasts sharply with Luther's own struggle with
the powers of evil, even, according to tradition if not fact, hurling his ink well
at the devil.

While Dürer was attracted primarily to woodcuts and etchings, he also
did some paintings. Since Dürer preferred to work for himself, he shied away
from doing many paintings, since they required being commissioned. Never-
theless, he did a few altarpieces and portraits for the Elector, Frederick the

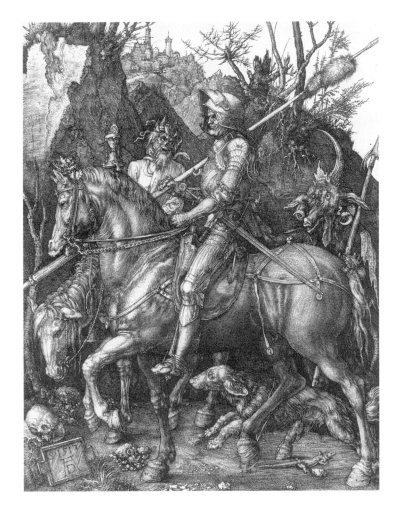

Wise. Early altarpieces, such as the *Seven Sorrows of Mary*, parts of which remain in Dresden, or the *Assumption and Coronation of the Virgin* for the St. Thomas Chapel of the Dominican Church, Frankfurt am Main (which burned in a fire in Munich in 1729) show Dürer's virtuosity, but they never secured the standing accorded his etchings and woodcuts. Only his later paintings competed with his works on paper.

Exceedingly important for understanding Dürer are the self-portraits executed between 1484 and 1503. The silverpoint self-portrait of 1484, when Dürer was thirteen (Figure 30), discloses his early ability as an artist and an absorption with self that marked his entire life. In the 1493 oil sketch (Louvre) and, in the same year, the pen-and-ink *Self-Portrait at the Age of*

Twenty-two (Figure 31) his self-confidence is apparent. In the oil painting, the elegant face is set off by appropriate clothing, while in the pen-and-ink drawing a more mature and determined face is delineated through the pen lines and the slight beard. Moreover, through the placement of his hand, next to the face, the dexterity of working with a mirror is suggested. In the oil painting of 1498 (Prado) the clothing is akin to the painting of 1493, but the hair on his head is more evident and the beard is now prominent.

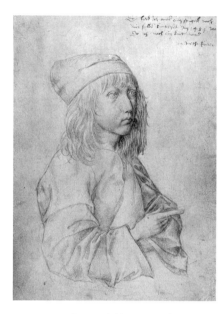

FIGURE 30. Dürer, *Self Portrait*, silver point, Graphische Sammlung Albertina, Vienna.

But the self-portrait that serves as an icon of Dürer is the oil portrait of 1500 (Figure 32). Here the head faces us directly, eyes directly toward us, the full head of brownish hair immaculately curled, the beard carefully nurtured, and his right hand conspicuously in front of his body. To the left side of his face is the Dürer monogram and to the right, the Latin inscription that reads, "Thus I, Albrecht Dürer of Nuremberg, painted myself with indelible colors at the age of twenty-eight years."

It is obvious that the blond Dürer has here painted himself in terms of the alleged physiognomy of the Christ figure as detailed in a letter attributed to Publius Lentulus, governor of Judea just before Pontius Pilate, though it later proved to be the product of the 1300s. In Dürer's time, the letter was considered authentic and became the source for depictions of Christ both south and north of the Alps.[4]

The self-identification with Christ in his sufferings had a long history, an identification Dürer also followed. In his own illness, Dürer uses the Christ figure to depict himself, as in the *Head of the Dead Christ* of 1503 (charcoal, British Museum). But that identification is derivative of the positive identification with the beauty of Christ as the form of God's presence, the beauty that is the image of God. While the Renaissance never lost the undertow of evil, fundamentally it believed in the goodness and beauty of creation, personified in the Christ figure. The imitation of Christ means participating in the grandeur of this person, the one in whom our lives are reconstituted. Physical and moral beauty form a whole.

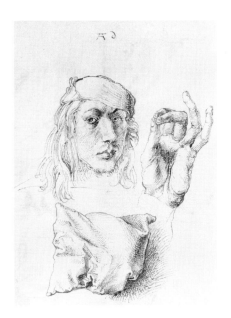

FIGURE 31. Dürer, *Self Portrait at the Age of Twenty-Two*, pen and ink, Metropolitan Museum of Art, New York.

For Dürer, that perception implied a special role for the artist. Until his time, the artist had been an artisan, one who belonged to those who labored among laborers. But for Dürer, real artists possessed genius, so that a quick sketch by such an artist was worth more than a year's work by one less talented. He contended that instruction and practice may help all artists but that great artists are born with a talent that cannot be learned. Such artists stand out, taking their place among the learned in society. From Venice, Dürer had written that in Italy he was a gentleman, at home only a parasite. But that situation changed in his lifetime.

For Dürer, the gift or talent of the artist placed him or her close to the divine. The artist participates in the imagination that belongs to the creator, and as a result the artist can disclose humanity as it was created, that is, in its pristine state. The image of God is especially evident in the genius of the artist.

The artist strives to mirror creation in presenting it, just as God has done, without the marks or traces of the creator. Here Dürer stands in the tradition of images not made with hands, such as the images of the face of God, as in the imprint of Christ on the Veronica veil. Dürer strove to remove every trace of the working marks of the artist from his works of art. Ironically, in seeing his works we are so enamored of his gift that we look for the traces of his hands, traces which, in his mind, should not be apparent in the creative work of one who, like God, leaves no traces, except a quintessential essence. Ideally then, the work of art is a pure image, which when seen has the restorative power akin to an appropriate regard for relics.[5]

In this period, Dürer belonged to the Renaissance humanist vision of an ordered world, beautiful in form and harmony, in which those favored with gifts of intellect and imagination would govern society, raising the mass of humanity to new levels. It was a vision of the world in which the artist had a special place in the divine economy. This "conceit" of Dürer had elements of narcissism, as Renaissance culture generally did.

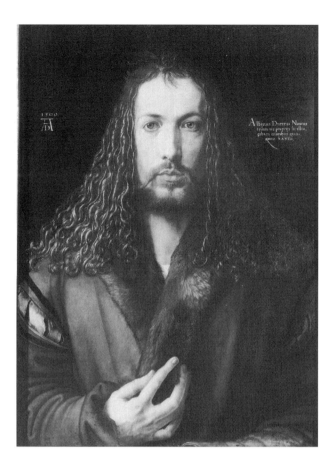

The problem that confronts us is, how does this Christian humanist out-
look correspond with the Luther in whom he became interested. To what
extent were his Renaissance views modified and to what extent did they con-
tinue even as the Reformation unfolded in Nuremberg?

Dürer's Early Interest in Luther

The Renaissance Christian humanist group in which Dürer participated, of
which Willibald Pirckheimer and Lazarus Spengler were Dürer's closest
friends, was critical of the moral abuses in the church and of the papal use of
power, particularly in extracting funds from the north for use in Italy. Fur-
ther, like Erasmus, they wanted to reform the church by returning to sources
in the early church and by returning to a simple gospel, freed of the overlap
of levels of ritual and theology. In short, this group was interested in reform

that both abolished abuses and established the nobility and grandeur of the human as the image of God, expressing in their own lives the grace-filled life of Christ.

In that setting, Dürer and his friends welcomed the publication of the Ninety-five Theses. It was in accord with their conceptions of reform, as were many of Luther's early publications. They seemed to fit and give eloquent expression to the needs for reform.

Within the confines of Nuremberg, Dürer and his compatriots fell under the spell of the preaching of Johann von Staupitz, former dean of the Wittenberg faculty. Staupitz had appointed Luther as his successor in Bible at the University of Wittenberg. Further, Staupitz was head of the branch of the Augustinian order to which Luther belonged, was Luther's confessor, and the person who subsequently released Luther from his monastic vows.

Staupitz had been preaching advent services on repentance in Nuremberg in 1516, the year before Luther posted his Theses. These were well received and the group of patrician humanists met frequently with Staupitz. Upon his departure from the city, they organized themselves into a group called the "Sodilitas Staupitziana." In 1519, the group called themselves the "Sodilitas Martiniana," under the influence of the Augustinian Wenceslaus Linck, a close friend of Luther.

We know that Staupitz was an evangelical Catholic, who stressed the graciousness of God and who tried to keep Luther from confessing trifling offenses, once telling Luther, according to tradition, to find a serious sin to confess, like murder. Staupitz, however, still defended the Sacraments as the agency of grace in traditional terms, that is, the grace that creates a sanctified life. Theologically, that view was not in accord with justification by faith, as Luther conceived it. It is probable that the "Sodilitas Martiniana" was more an expression of personal identification with Luther than a further change in their own thinking.

In a 1518 letter to Christoph Scheurl in Nuremberg, Luther sent his thanks to Dürer for the gift of some of his prints, and in a letter to Spalatin, secretary to Frederick the Wise, Dürer called on the elector to defend Luther for the sake of Christian truth. He also asked the elector to send him writings of Luther, and announced that he, Dürer, hoped to do a portrait of Luther as a "lasting remembrance."

The hope of doing Luther's portrait was more than a personal wish; it was part of a public campaign, instigated by Saxon princes, to recommend to the public those who are to be trusted in religious matters.[6] Apparently, Dürer and Luther never met, though Luther passed through Nuremberg twice in

1518, staying on his return from Augsburg with Pirckheimer in Nuremberg just after having been released from his monastic vows by Staupitz.

Among the Dürer manuscripts in the British Museum, dated about 1520, is a list of sixteen early works of Luther that Dürer had in his possession or that had been recommended to him. A perusal of this list indicates that the subjects are on indulgences, the ban, penitence, confession, sin, marriage, and the translation of some psalms.[7] Taken as a whole, they indicate subjects in which many agreed that reform was necessary. They do not include central, emerging themes in Luther, namely, his conception of justification and works. They were well within a Catholic understanding.

In 1517 Dürer did extensive work for the Emperor Maximilian and secured a pension from him at the time. When Maximilian died in 1519, the pension was in doubt. One of Dürer's reasons for going to the Netherlands was to be able to go to the coronation of Charles V in Aachen and to secure the continuation of the pension. In addition, Dürer felt he needed a change. He took prints that served as gifts and sales (sometimes a gift, which in terms of the custom of the time implied a financial gift) and as introductions to other artists and persons of note. On this trip, which lasted more than a year, his wife Agnes accompanied him, but most important for us, he kept a diary, which has survived.[8] The diary leaves the impression that Dürer succeeded in seeing those of note in culture, society, and politics, and that he participated in many of the events that occurred in that year, from political conclaves to religious rites and celebrations, to conversations with those in religious orders and ecclesiastics in general.

In the diary, he recalls giving money to a priest for confessing his wife. Among gifts he gave away were a series of studies of St. Christopher, which, given Erasmus's negative views of the saint in *The Praise of Folly*, confirms that in some ways, Dürer was more traditional than Erasmus. He also recounts going to Catholic religious processions, all with a sympathy Erasmus would not have had. In 1519, and again in 1523, Dürer did an engraving of Cardinal Albrecht of Brandenburg, whose selling of indulgences had precipitated Luther's theses. But the latter should not be overstressed. Artists needed to work both sides of the street, and with respect to the Cardinal, Cranach the Elder, more closely allied with Luther, depicted Albrecht as late as 1526.

Startling in its passion is Dürer's reaction to the news that Luther, returning from the Diet at Worms, had been captured and probably killed, when in point of fact he had been taken in protective custody and delivered to the Wartburg. He castigates the new emperor for not protecting Luther;

describes Luther as one who has suffered for truth as Christ did; and laments the state of the church, a church that rules by papal ban and edict, and burdens people by laws. In contrast, Luther is the herald of the gospel. "Every man who reads Martin Luther's books may see how clear and transparent is his doctrine, because he sets forth the holy Gospel. Wherefore his books are to be held in great honor and not to be burnt. . . ."[9]

Immediately thereafter, Dürer turns toward Erasmus as the one who should take Luther's place. "Oh Erasmus of Rotterdam, . . . Hear, thou knight of Christ. Ride on by the side of the Lord Jesus. Guard the truth. Attain the martyr's crown. Already indeed art thou an aged little man, and myself have heard thee say that thou givest thyself but two years more wherein thou mayest still be fit to accomplish somewhat. Lay out the same well for the good of the Gospel and of the true Christian faith, and make thyself heard. So, as Christ says, shall the Gates of Hell (the Roman Chair) in no wise prevail against thee. And if here below thou wert to be like thy master Christ and sufferedst infamy at the hands of the liars of this time, and didst die a little the sooner, then wouldst thou the sooner pass from death unto life and be glorified in Christ. . . . Oh Erasmus, cleave to this that God himself may be thy praise, even as it is written of David. For thou mayest, yea verily thou mayest overthrow Goliath."[10]

We do not know if Dürer approached Erasmus on this issue. That Erasmus did not take Luther's place is in line with the conciliatory posture Erasmus took on most issues, even though his writings are often biting in their criticism of Catholic views and practice. Perhaps Dürer was only expressing a spirited call for leadership. There is, however, some evidence that Dürer was disappointed with Erasmus to the point of delaying the completion of the latter's portrait.

But there is another problem. Was Dürer's vision of Luther such that he could conceive of Erasmus taking Luther's place? Granted that the lines are not as clear-cut in 1521 as they became, it is hard to believe that a thorough knowledge of Luther would have led one to think of Erasmus as his successor even at that early date.

A similar ambiguity is manifest in Dürer's works during the next two years. We know that Dürer postponed publication of his St. Philip engraving, created in 1523, to 1526. It has been suggested that Dürer now had questions about doing saints at all.[11] However, in 1523, Dürer did execute engravings of St. Simon and St. Bartholomew.

Still more ambiguity is evident in his work on the Last Supper. A 1523 woodcut of the *Last Supper* (Figure 33) is often pointed to as an example of

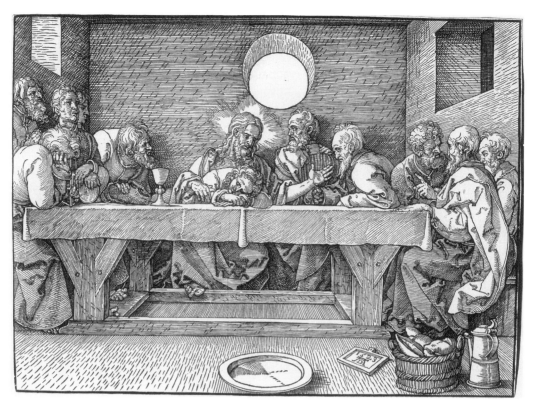

FIGURE 33. Dürer, *The Last Supper*, 1523, woodcut.

Dürer's reformation outlook, for the Paschal lamb is absent and a chalice is
conspicuously present.[12] But one can point to Last Supper representations
before the Reformation era in which the Paschal lamb is absent and the chal-
ice is present. In addition, Jane Campbell Hutchison has pointed out that this
woodcut probably belongs to the tradition in which John is depicted as lean-
ing his head on Christ's chest.[13] Moreover, in the same year, Dürer executed
another woodcut, *Christ on the Cross with three Angels* (Figure 34) in which, in
medieval Catholic fashion, blood flows from the hands, feet, and side of Jesus
into chalices held by the three angels.

 Since so much of Dürer's work was not commissioned, the argument that
artists took work from whatever source commissions could be found is not as
applicable for him as for other artists. It is rather that Dürer's religious per-
ceptions at the time did not call for the clear-cut differences that emerged
later. For Dürer, such distinctions were not a part of his world.

FIGURE 34.
Dürer, *Christ on the
Cross with Three
Angels*, woodcut, 1523.

Dürer and the Reformation in Nuremberg

It was noted previously that Willibald Pirckheimer, the distinguished Renaissance scholar, was a close friend of Dürer. He was a member of the Sodilitas Staupitziana, and he had Luther as a guest in his home in 1518. In addition, Pirckheimer was also a longtime member of the city council. But by 1523, his frequent and irascible disagreements with members of the council sidetracked his prominent role. In addition, he was having doubts about the reformation directions, and in 1524 he withdrew from the council, stating that the new reformers in the city were as corrupt as those of the Catholic Church. In addition, he sided with Erasmus in defense of the freedom of the will in opposition to Luther. Apparently, Dürer shared some of these thoughts, but he never abandoned his interest in the ongoing reformation developments.

In the period from 1518 to the time of Dürer's death, Lazarus Spengler, secretary to the city council and in fact its leader, was undoubtedly Dürer's closest friend. Spengler combined a scholarly interest in Luther with astute leadership in the city's affairs. In 1519, he wrote a pamphlet, the *Defense and Christian Reply of a Lover of Divine Truth as Contained in Sacred Scripture, Against Several Opponents*. In this document, as well as in response to papal

pressures, he steadfastly maintained that he was defending the Gospel, the grace of God apparent in Scripture rather than the opinions of Luther. Nevertheless, both Pirckheimer and Spengler found their names included in the papal bull excommunicating Luther.

What was it, one might ask, about the proclamation of the gospel that brought about the interest of so many individuals and groups? First and foremost, it was the deliverance from the fear of damnation. Luther himself took seriously the demands for confession in relation to the series of Sacraments that governed all facets of one's earthly pilgrimage and that functioned under the jurisdiction of priests in direct lineage from the first pope, St. Peter. Since the demands and requirements related to each sacrament had to be met, Luther was anxious as to whether or not he had confessed all his sins, since the theory was that for a sin to be forgiven it had to be confessed. While Luther, as Staupitz suggested, may have had too many scruples, many experienced an undertow of anxiety and the fear of damnation as they faced the strict demands surrounding the liturgical life of the church. It was from this fear that Luther's preaching delivered them, for it set the gospel of grace and liberating freedom over against the enslaving and unmet demands in relation to the sacraments. It is in this context that Dürer, in a letter to Spalatin as early as 1520, referred to Luther as "the Christian man who has helped me emerge from such terrible fear."[14] Such deliverance, however, does not mean that individuals generally understood or accepted Luther's developing ideas on justification and works, or law and gospel. Dürer wrote, "there is nothing good in us except it become good in Christ. Whoever therefore will altogether justify himself is unjust. If we will what is good, Christ wills it in us."[15] Even the most cursory reading of a passage such as this discloses a sanctificationist understanding of grace, closer to the medieval Catholic tradition than to Luther's ideas on justification and the imputation of the grace of God. For the mature Luther, one would not dwell on the good that one does, even if its basis is claimed to be the work of Christ.

Spengler, along with his religious interests and sensibilities, was a master of the political process in Nuremberg. First of all, Nuremberg was an imperial free city, zealous in the defense of its prerogatives and role. Given that Nuremberg was in the diocese of Bamberg, ecclesiastical supervision had always been from afar. Moreover, in the gradual and sometimes jarring shifting of political power from the papal church to princes and then back to the empire, Nuremberg was in a position in which it could consolidate its own power. In the last analysis, Nuremberg did not side with the princes against the empire.

Internally, the governing authorities represented a patrician class, a group of individuals joined in a common history of leadership and frequently also of learning. They saw it as their responsibility to govern well, with a civic responsibility for all aspects of society. They never doubted that they had the right to fashion the religious scene.

Given the reforming convictions of many members of the council, the increasing popular support for reform, and the inclination of leading clergy, many of whom had been appointed because of their Wittenberg connections, the soil for reform had been prepared. The council itself made a statement as to the basis from which it made its decisions. "It has always been the Council's thought and opinion to conduct itself as pious Christians and obedient members and subjects of the Christian Church and the Holy Empire, to follow neither Luther's nor any other man's teachings or to allow such teachings to deflect it from Christian obedience, but only to remain true to the Holy Gospel and the word of God on which alone our faith, our consolation, our salvation depend. In this we will remain resolute until death."[16]

In the Fall of 1525, Nuremberg, alone among the cities in the northern part of the empire, made the transition to the Reformation without major iconoclasm or violence. But it was a reformation in the tradition of Luther, and one in which other religious alternatives were not permitted. Visually, there was little change. Some paintings were returned to donors; others were temporarily covered; a few side altars were removed. Essentially, the churches remained as they were, their art objects intact. Even today, the relics of St. Sebald are still in the church that bears his name, present as a part of history but of no liturgical meaning.[17]

With respect to the Catholic heritage, the Augustinians willingly disbanded, while the properties of other orders were taken over for secular purposes. In a few instances, as in the order headed by Charitas Pirckheimer, permission was granted for an order to continue until the current members died, new admissions having been forbidden.

But as the transition to the Reformation was taking place, there were also stirrings from without and within Nuremberg on the part of those who wanted more dramatic reform. In Wittenberg, Andréas Karlstadt had presided, without wearing the traditional vestments, at a communion in which both bread and wine were distributed. Karlstadt dedicated his 1521 book on this and other issues to Dürer. Dürer was undoubtedly embarrassed by the dedication, as it became apparent that Karlstadt stood for the destruction of images, and was banished in 1524 from Saxon lands. This period could not have been easy for Dürer. On his return from the Netherlands he already had

the debilitating malady contracted there, probably malaria, from which he died in 1528. As a person so interested in Luther, he would probably have known of Luther's reservations about the place of the visual arts in the church. It was only after 1525 that Luther wrote positively about the visual arts in the church.

In Nuremberg, some of the residents were influenced by Thomas Müntzer and social unrest seemed on the horizon. In 1525, the Peasants' Revolt occurred, though the unrest in Nuremberg was not extensive, probably due to minor concessions to the peasants and the firm hand of the city council. In addition, there were those who, while not socially revolutionary, did not accept the new theology and preached against it. For example, Hans Denck, who had been the major schoolmaster in Nuremberg, was sympathetic to the prerevolutionary writings of Müntzer and was permanently banned from the city.

Finally, that some of the artists in Nuremberg did not subscribe to the Catholic or the new Lutheran approach must have distressed Dürer. In 1524, Hans Greiffenberger, a painter who also wrote religious tracts, was summoned to appear before the council both because the subjects he painted (none of which survive) and his writings were in question. The theologian/ preacher Andreas Osiander, at the request of the Council, interrogated Greiffenberger and reported that the painter repented of his views. But Greiffenberger's role remained ambiguous.[18] More difficult for the authorities was the case of the Beham brothers (Sebald and Barthel) and George Pencz, artists who had been associated with Dürer. The three were arrested and interrogated about their views. Given that they denied the teachings of the church on doctrine and Scripture, and affirmed only that they believed in God but refused to say what God meant, they could hardly escape punishment.[19] They were banished from the city, though subsequently, those who wished to return could do so. Barthel Beham, while banished from Nuremberg, immediately became court painter in Munich.[20]

In the midst of these events, the council was firm and in control. As power goes, it was benign. The council tried to avoid severe penalties and preferred banishment to torture and death. In any case, it succeeded in making the transition from Catholicism to a Lutheran position while at the same time it excluded those for whom the gospel meant the creation of new communities, either against the established order or in its place. By 1526, the council had safely won its victories and a new period of order had been established.

While it is in this context that Dürer's gift of *The Four Holy Men* (see Figure 3) to the city of Nuremberg needs to be understood, attention must first

be given to the issues surrounding the gift, a description of the painting, and the various interpretations given to it. In his letter to the council, Dürer said: "I have been intending, for a long time past, to show my respect for your Wisdoms by the presentation of some humble picture of mine as a remembrance. . . . Now, however, that I have just painted a panel upon which I have bestowed more trouble than on any other painting, I considered none more worthy to keep it as a reminiscence than your Wisdoms."[21] The text, as well as the response of the council, would indicate that it was meant as a remembrance of the artist himself. That the city council paid for the painting, a practice not unusual with respect to such gifts, does not change the humanist idea that greatness was to be honored and remembered, and that it was thus appropriate for Dürer to provide a painting as a memorial to himself. After all, Dürer's achievements as an artist placed him among the town dignitaries to be remembered. Later, in dealing with various interpretations, it will be noted that Gerhard Pfeiffer believes that the remembrance deals with other notables in Wittenberg's history, not with Dürer himself.[22]

The painting consists of two panels, similar to side panels of an altarpiece. Indeed Erwin Panofsky so interpreted the origin of the painting, speculating that it might originally have been intended for an altarpiece.[23] While that theory is mainly discredited, it is also evident that we do not know why this format was chosen.

When the two panels are appropriately placed side by side, the two outside persons take up most of the space, with the central figures recessed. Thus, while the heads of the figures are all clearly given, only the two outside figures command total attention, partly because of their posture and the color of their capes. We know the names of the four men, three of whom are apostles, for under the figures, but as part of the painting, Dürer had written "All worldly rulers in these dangerous times should give good heed that they receive not human misguidance for the Word of God, for God will have nothing added to His Word nor taken away from it. Hear therefore these four excellent men, Peter, John, Paul and Mark, their warning."[24] Then below each apostle is a biblical passage. According to Conway, the texts, apparently selected by Dürer from Luther's 1521 German translation of the New Testament, are given in the same order as the listing of the four men.[25] Visually, however, that is not the order, for the left figure is John, with open bible, pointing to the text from the Gospel of John, "in the beginning was the Word." Next is St. Peter, obviously identifiable through his attribute, the key. Mark has a scroll in hand, with his name visible. Paul, in addition to the book in his left hand, clasps a sword in his right hand.

It is obvious that, unlike the early church, the prominent figures are not Peter and Paul but John and Paul. John and Paul were Luther's favorite writers, those in whom the Gospel is most apparent. Some have observed that Peter is looking at the Gospel, as if he were now making a reformation point; but this seems to me to be a doubtful observation. In the biblical texts under the paintings, that is, warnings the council should heed as it faces the future, Peter points to the destructive problems caused by false prophets and teachers. In an analogous fashion, John makes the point that not every spirit is the spirit of God, that spirits must be tried, that we must know the Spirit of God and not be led by false prophets. In the passages associated with Paul, the point is that the loves of humans, sometimes with the forms of godliness, must not be confused with the love of God. The passages from Mark want us to beware of those who keep the formalities of faith in their leadership role but in point of fact are unethical in their practice. All in all, the written passages point out the different ways in which true and false religion are confused; hence, the need for continuous watchfulness and discernment. Indeed, visually, the four men convey an atmosphere of calm and ordered perception, but with a wary eye.

While the visual and verbal form a unity, there is a difference between the two. The painted figures disclose the new serene order in Nuremberg, one based on the gospels as represented in these four figures. The biblical documents at the bottom of the painting point out potential hazards in the future, dangers that have just been defeated in Nuremberg.

The question arises, however, as to which particular group or groups were intended in the warnings. An obvious possibility, proposed by Ernest Heidrich, is the radical reformers to the left of the Lutherans, from Zwinglians to Anabaptists. He also sees the christological facets of the Johannine passages as warning against the godless painters, to whom previous reference has been made. On the other hand, Ludwig Grote believes that they refer to the just defeated Catholic Church.[26]

A totally different approach is that of Gerhard Pfeiffer, who believes that the individual figures are in fact modeled on contemporaries, so that the prominent figures, John and Paul, respectively represent Philip Melanchthon, the founding genius of Nuremberg's educational system in 1525–1526, and Joachim Camerarius, Melanchthon's choice to head the school, Melanchthon himself having declined that position. According to Pfeiffer the painting is a memorial to the founding of that educational institution. Surely Dürer would not himself, suggests Pfeiffer, have taken on the task of issuing warnings for the city fathers to follow.[27]

Melanchthon's role as the genius behind the educational system designed for the new Protestant outlook, of which Nuremberg was the star, is uncontested. In fact, Melanchthon spent considerable time in Nuremberg on educational issues, and on many of these occasions Dürer was present. In a letter by Melanchthon of September 7, 1526, he states, apparently with reference to the painting, that the size of the painted figure exceeds his actual size.[28]

In Dürer's own time, Johannes Neudorffer suggested that the four men are associated with the four temperaments. The sanguine, phlegmatic, choleric, and melancholic represent a long tradition, one still dominant in the Renaissance humanist heritage of Dürer. In that tradition, Dürer is connected with the melancholic, a characteristic of genius, for the person of genius so transcends his contemporaries and his time that loneliness and elements of despair become characteristic.

Ordinarily, it is too simple to state that there are elements of truth in each of so many theories. But in another sense, any or several could well be true. Carl Christensen suggests that the central meaning of the painting is that it is "a monument to the orderly and constructive way in which the Reformation had been introduced into the community."[29] In association with that central thrust, Christensen also suggests that the memorial painting is at once a self-affirmation of Dürer's role as an artist but also to the role of Christian art, which role had been threatened by the godless artists. The memorial then represents the safe resurrection of art along with other elements of social, governmental, and religious policy and polity.

In this, as well as his suggestion that it may be better to use the word evangelical rather than Lutheran or Protestant for Dürer,[30] Christensen is moving in the right direction. Jane Campbell Hutchison, in addressing whether Dürer was a Protestant, suggests that the issue is both "unanswerable and anachronistic."[31]

But with respect to both Dürer's religious outlook and the painting *The Four Holy Men*, a still wider frame of reference is essential, involving how Dürer saw the world when he did the painting and what the painting as a work of art conveys. Dürer's outlook and associations were formed by and were akin to those who governed Nuremberg. He believed in order, proportion, harmony. Precisely in the period leading up to the events of 1525, Dürer was working out his theories of art; theories that emphasized measured harmonies that understood art as being analogous to the concord that joined government and religion at their best. Dürer believed in the Word of God, that is, the grace of God; but he understood that as enabling the ethics and virtues essential to the body politic. The new religious understanding freed

one from the anxieties of a church that managed life in terms of salvation and damnation.

In *The Four Holy Men* of 1526, Dürer celebrated all that had happened in Nuremberg. A switch to the Reformation had happened without tearing the social fabric. The firmness of the city council had headed off individuals and groups that might have created dissension in the city by the expedient of banning them, rather than executing them. Even peace had eventually been made with the artists who had been banned from the city. In short, all the hopes of humanity, expressed in a Renaissance Christian humanism, but laced with a new Protestant consciousness, had been met. Moreover, with proper diligence and a discerning faith, true and false religion might be distinguished and the latter excluded. Such an outlook, while not that of the philosopher king, bears some analogy to that perspective. The city council ruled with a religious philosophy that equated its views of peace and harmony with the good, excluding other alternatives. Dürer joyfully identifies the new world of art that he had created in the north with that approach.

While the verbal texts under the painted figures of *The Four Holy Men*, as indicated previously, are appropriate to the work as a whole, the work as art rests in the painted figures. The drapes of John and Paul are colorful in the Renaissance sense, that is, recognizable in terms of colors we know but with a brilliance that we might characterize as "of color." Hence, the colors are arresting in their power, and the capes fall from the body and the hands as if they were sculpted. Below, the sandaled feet have their own beauty. John and Peter are focusing on a text, divining what it means, totally oblivious that they are seen by others. Paul and Mark, respectively with closed book and rolled up scroll, seem deep in thought and conversation, with one of Paul's eyes darting out but unseeing.

In this last exceptional painting, Dürer has returned, stylistically and formally, to the world of the Renaissance. But in its emphasis on the examination of texts, it belongs to the new Reformation consciousness. In Dürer, that Renaissance world and the new emphasis on the Word coincide, in ways opposite to Luther's thought as it developed.[32]

Finally, such an understanding of Dürer is underlined by Philip Melanchthon, Luther's classically grounded colleague in Wittenberg. The mutual admiration of Dürer and Melanchthon is well documented; Melanchthon, for instance, commented on Dürer's capacity for disputing issues with Willibald Pirckheimer, and Melanchthon had sets of woodcuts done by Dürer. Conversely, Dürer's regard is evident, for instance, in the magnificent engraving he did of Melanchthon in 1526 (Figure 35).

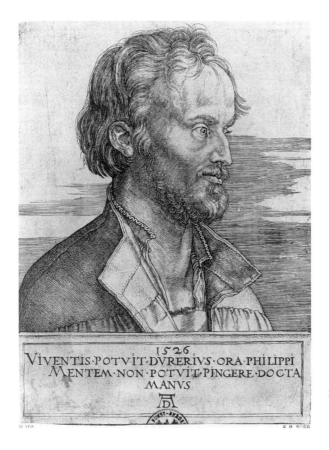

FIGURE 35.
Dürer, *Melanchthon*,
1526, engraving.

More important, subsequent to 1531, Melanchthon reflected on Dürer's style as an analogue to the rhetorical style needed in theology. Although this might lead one to think that Melanchthon saw art through verbal modalities, in point of fact he was looking for help from the arts and particularly Dürer. In his reflections he wrote: "Dürer painted everything in the Grand manner, variegated with innumerable lines. The paintings of Lucas [Cranach] are Simple; although they are charming, a comparison will show how far removed they are from the works of Dürer. Matthias [Grünewald] remained more or less in the Middle style. These styles intermingle with one another, just as musicians mix their notes; even those which are rather thin occasionally give rise to something which is quite full. Then, too, at the same time, some *loci* (topics) are full, others thin, according to the variety of matter which one is discussing."[33]

As an art historical judgment, the contrasts between Dürer, Cranach, and Grünewald are superb. But as Donald Kuspit has shown, Melanchthon's

sympathy with Dürer was based on the mutual humanist Christian vision they shared. Melanchthon was distressed that the Reformation produced so many warring parties—that religion did not have the unity, order, and harmony of the art exhibited in Dürer, an art which in its style was simple and grand, but which also, beneath and through its surface, disclosed religious perceptions. Moreover, even if art did not have one style, as in the contrasts among Dürer, Cranach, and Grünewald, it seemed that there was greater unity among the styles of art than among the various religious sects.[34] In short, Melanchthon, in midlife, saw a greater model for life, thought, and faith in Dürer's harmonious view and style than elsewhere.

The Christian humanist ideal is universal and international. That for Melanchthon was represented by Dürer. By contrast, Cranach and Grünewald were provincial artists, representing the peculiarities of a particular time and place with few transcendent graces.

Melanchthon, the classicist in Luther's camp, preferred peace and harmony, and to the chagrin of Luther, too easily sought compromise. For example, in the debate between those who believed that good works were detrimental to salvation and that good works were necessary for salvation, both foreign to the spirit of Luther, Melanchthon proposed that one simply said that good works were necessary. Melanchthon was irenic, looking and longing for an ideal world of form and order. Increasingly distressed by the sectarian and theological battles, he saw in Dürer a paradigm in which the classical humanist and reformation ideas form a natural unity. In that sense, Melanchthon, in retrospect, saw Dürer as he himself would have wanted to be represented.

A Reformation Artist

LUCAS CRANACH THE ELDER (1472–1553) and his son, Lucas Cranach the Younger (1515–1586), are the two artists most closely related, both in friendship and work, to the Lutheran reformation figures Martin Luther and Philip Melanchthon. Cranach the Elder, born in Kronach and from which city he took his name, lived half his life in the orbit of the Catholic Church and the beginning of Reformation currents, and the last half within the emergent Lutheran church in Saxony.[1] By contrast, his son, Cranach the Younger, was only two when the Ninety-five Theses were published, fourteen when his father began the series on Law and Gospel, and twenty-four when the first major altarpiece was installed in 1539 in Schneeberg. Hence, while Cranach the Elder made the transition from Catholicism to Protestantism, Cranach the Younger grew up within the Lutheranism of Wittenberg.

Given the Cranach Workshop in which various artists worked within a common framework and style, it is frequently impossible to disentangle who did what. This is particularly the case with respect to the father, whose initial influence is paramount, and the son Lucas, who developed on the basis of his father's style. While the paintings and woodcuts before 1530 can safely be ascribed to Cranach the Elder, for the twenty years between 1530 and 1550

the lines are not always clear. For instance, when the Schneeberg altarpiece of 1539 was being made in the Wittenberg Workshop, Cranach the Elder and Cranach the Younger could both have been involved. While the Weimar altarpiece of 1555 was obviously completed by Cranach the Younger, the Elder having died in 1553 and his effigy having been prominently included in the painting, the work of the elder Cranach cannot be ruled out for the early stages of the work. But it can be said that the iconographical and stylistic format of Protestant Lutheran art was set initially by Cranach the Elder.

Cranach the Elder until circa 1528

Cranach the Elder made his initial impact on the art scene for works done in Vienna in the early 1500s, a city in which he had also reached considerable personal prominence. Indeed, it was Cranach's eminence as an artist that led Frederick the Wise, the most prominent German collector of his time, to appoint Cranach as court painter in 1505, a position he held under Frederick until the latter's death in 1525, while continuing thereafter as court painter to Frederick's successor, his brother John, and to John's son, John Frederick, whom he followed into exile.

Cranach's work for Frederick the Wise involved the decoration of various residences, appropriate trappings for public events, and works of art for churches. In the works for churches, it was not unusual to have the princes, as donors, depicted in the work of art. Indeed, that was tradition. Newly dominant, however, was that the donors, and then also the reformers, became part of the drama being depicted. Hence, Frederick the Wise and Luther not only kneel before the crucified Christ; they are present for the Crucifixion. In the 1509 *Altarpiece of the Holy Kinship*, probably part of an altarpiece for the church at Torgau but now in the Frankfurt Museum (Figure 36), Alphaeus has the features of Frederick the Wise, and Zebedee, those of Duke John. Artists had been known to disclose their own features in depicting persons of the past, but here it is done programmatically. In the side wings of the *Altarpiece of the Holy Kinship* of 1510–1512 (Figure 37), Frederick the Wise is shown with St. Bartholomew, and Duke John with St. James the Greater. Hence, the later depiction of princes and reformers as participants in biblical events is not a new invention, though it undoubtedly took on new religious meaning; it gave biblical events a contemporary cast.

Prominent already in these early paintings is the role of the princes in forging religious directions and taking responsibility for the church. In 1520,

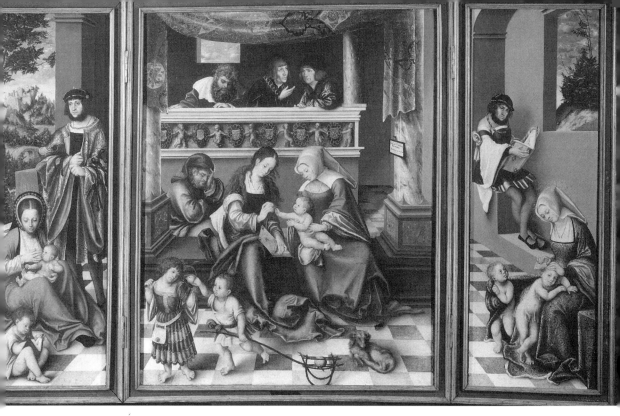

FIGURE 36. Cranach, *Altarpiece of the Holy Kinship*, 1509, Städelisches Kunstinstitut, Frankfurt am Main.

Luther called on those in positions of authority to reform the church, using secular power against churchly power that resisted reform. From the standpoint of some of the princes, such as Frederick the Wise, the issue before them was both the reform of the church and political security for themselves in the midst of the competing claims within the political structure of the empire on the one hand and the power of the church on the other. Hence, religious conviction and political aims were consciously joined. In the case of Frederick the Wise, the promotion of reform and political power worked hand in hand, while for his nephew, John Frederick, it can be said that reformation convictions led to his loss of political power.

In the German reformation struggles, words, spoken or written, became powerful and central. Yet the new movements for reform utilized the inherited role of the visual in powerful ways. The Saxon princes, for example, commissioned and utilized portraits of themselves, or of themselves in religious contexts. Carl Christensen has shown that such works served propaganda

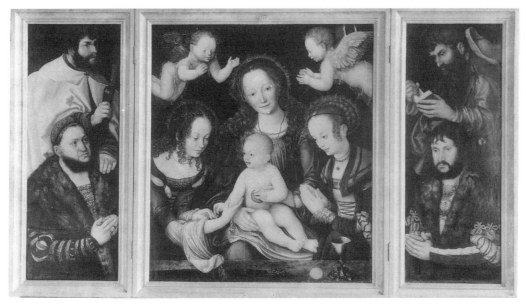

FIGURE 37. (top)
Cranach, *Altarpiece of the Holy Kinship*,
1510–12, Anhaltische Gemäldegalerie,
Dessau.

FIGURE 38. (right)
Cranach, *Christ Driving the Money
Changers from the Temple*, 1509,
Staatliche Kunstsammlungen
Gemäldegalerie Alte Meister,
Dresden.

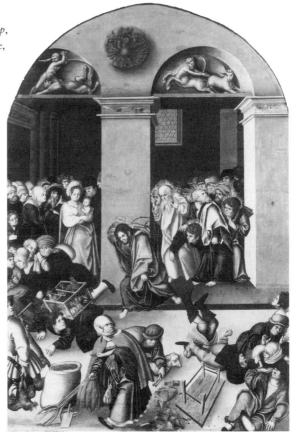

purposes and were designed to strengthen their role and place as custodians of the social fabric.[2] In this sense, the German reformation may be unlike the other reformations of the sixteenth century.

Until the period between 1519–1521 Luther could be understood as part of the wider struggle for reform, centering mainly in the conduct of clergy and the papacy with respect to manners, morals, and money. In this category belongs Cranach's 1509 *Christ Driving the Money Changers from the Temple* (Figure 38). But after the Leipzig Debate of 1519, the three Reformation Treatises of 1520,[3] and the Diet of Worms of 1521, after which Luther was carried away to protective hiding in the Wartburg, it was becoming clear to the public that Luther's conception of faith and the church, as understood from Scripture and church history, signaled issues more fundamental than morals and money.

Nevertheless, the art of this early period centered not in the new conception of faith but in the contrast between the opulence, power, and morals of the papacy as contrasted with the simplicity, powerlessness, and right conduct of faith as delineated in Scripture. Utilizing the format of a passional book, entitled *Passional Christi und Antichristi*, Cranach and Melanchthon collaborated in 1521 in showing the contrast between the papal church and the Scripture through the former's woodcuts and the latter's verbal texts. In a series of thirteen pairs of contrasts, the difference between Rome and Scripture was visually and verbally laid out for all to see. The first contrast is between Christ refusing to be made king, while the pope claims his kingship even over the secular world (Figures 39 and 40). In the second, Christ is crowned with thorns, while the pope wears the triple tiara. And so the contrasts continue, with the last one demonstrating the consequences of the contrasts, for Christ ascends to heaven, and the pope, that is, the antichrist, descends to hell.[4]

Likewise, the illustrations for the publication of biblical books that Luther translated at the Wartburg followed the tradition of contrasts. In the first 1522 edition of New Testament writings, Cranach the Elder did the illustrations. For the gospels the artworks consist only of an embellishment of the first letter of the gospel, and his large woodcuts were for the Book of Revelation, which Luther had separated, along with Hebrews, James, and Jude, in a distinct section, possibly suggesting a less important status than the gospels. But as in the *Passion of Christ and the Antichrist*, the papacy is depicted in negative terms, that is, identified with Babylon and the red dragon of Revelation 12, the latter having been given the papal tiara. The latter usage had already been depicted in the Cologne Bible of about 1480.

Moreover, many of the woodcuts of Cranach for the September Bible were used by Luther's enemy Jerome Emser in his own translation of the New Testament. In the instance of the red dragon, Emser simply had the tiara shorn of its triple crown, while Frederick the Wise, for political reasons, saw to it that in the second edition of the Luther September Bible, the tiara was removed.[5]

Succeeding volumes emerged as Luther translated more biblical books. Finally, the entire Scripture was published in Luther's translation in successive and varied editions. Probably both Cranach the Elder and Cranach the Younger had a hand in seeing to it that the publications were carried out, though the illustrations can only be assigned to the Cranach workshop.[6] Of note is the woodcut of Joshua, which served eventually as the frontispiece of the whole Bible. In 1541, the title page of the Luther Bible carried Cranach's Fall and Redemption motif. But that is rather late, since the centering in law and gospel had been prominent from 1529 on.[7] Biblical illustrations for the most part continued the pre-Reformation tradition. Comparatively speaking, the new subjects were few. At this level, Cranach broke little new ground.

But the year 1520 and immediately thereafter was an important time for Cranach in relation to Luther. Beyond the undeniable friendship between the two, it was the time when Cranach had to begin to come to terms with what Luther was writing and saying. But Cranach still worked in the context of the tradition of Frederick the Wise, in which portraits were used to promote a

FIGURE 39. Cranach, *Passional Scene* (Christ figure), 1521, Warburg Institute, London.

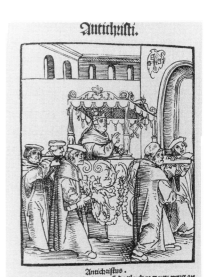

FIGURE 40. Cranach, *Passional Scene* (papal figure), 1521, Warburg Institute, London.

subject in a desired framework before the public. Just as Cranach's portraits of Frederick the Wise presented him as a reforming prince to the public, so Cranach's numerous portraits of Luther in the 1520s presented him to the public as a man to be trusted on matters of faith and the church. R. W. Scribner has pointed out that Cranach's early depictions of Luther saw him as monk, doctor, or church father, and as a man of the Bible.[8] Indeed, one could say that these designations had a rough chronological sequence, for when Luther was no longer a monk, he still was a doctor of the church, and fundamental to his whole life was the interpretation of Scripture. Hence, Luther was visually given to the public in portraits that indicated he should be trusted on issues of biblical interpretation and the church, and, for that matter, for the body politic. Affairs of the church were also matters of state.[9]

Apparently, Cranach the Elder and Luther had a friendly and personal relation with each other from early on in Wittenberg. Cranach, wherever he lived, found his way into the dominating intellectual, cultural, and political elite of his time, though there is no evidence of intellectual powers of his own. Having been appointed official artist to Frederick the Wise, who had a keen interest in the arts and had an extensive art collection, Cranach was center stage. By 1510 he even eclipsed Dürer, whom Fredrich had originally employed. He was definitely in the circle of the elector. At the same time, Luther, who was not a personal friend of Frederick the Wise, nevertheless gained considerable prominence in the new university and was prized by Frederick for that reason. Indeed, the relation of Frederick and Luther was widely mediated by Spalatin, who had an increasing role in advising Frederick. But given their mutual prominence and place in the scheme of things in the small town of Wittenberg, it was natural enough that Cranach and Luther should see each other and that a friendship developed, including being godparent to each other's children and sharing mutual sorrows and joys. The friendship and regard is surely evident in that Luther informed Cranach of his protected stay at the Wartburg and that Cranach painted Luther as Junker Georg upon his interim return to Wittenberg.

Further, Cranach and Luther, next to Frederick the Wise and his successors, John and John Frederick, were the two most prominent persons in Wittenberg. It is even conceivable that Cranach, as well as Spalatin, was a conduit from Luther to Frederick the Wise. It was only after the death of Frederick the Wise that Luther had direct contact with the princes. Moreover, both Cranach and Luther, for similar and different reasons, knew that their futures were dependent on the princes. That recognition may have been another bond in their relationship.

Between 1517 and 1525, reforming issues and directions had come to the fore, but one could not say that matters had been settled. Frederick protected Luther, in part because he did not readily accept pressures from those outside his territory and in part because he had sympathy for some of Luther's ideas. Under pressure from Luther, Frederick reluctantly abandoned his extensive relic collection, but he never accepted or perhaps did not fully understand Luther's theological views.

Upon Frederick's death, he was succeeded by his half brother, John, who had less interest in art than had Frederick but who was a definite disciple of Luther. Hence, for most of this period Cranach worked for both the Catholic Church and emerging Protestantism. By the early 1520s, however, it must have become clear to him that choices needed to be made.

Surely difficult to understand was Cranach's portraits of Cardinal Albrecht of Brandenburg as late as 1526. At the time of the indulgence controversy of 1517, Albrecht, a Hohenzollern, was an elector of the empire, bishop of Mainz and Magdeburg, administrator of the diocese of Halberstadt, and about to be Cardinal of the church. Surely, church and state had never been more closely joined, or symbolically expressed. Indeed, the indulgence controversy was precipitated by the indulgence preachers sponsored by Albrecht, the result of a financial arrangement with the Vatican in connection with both the financial needs of Albrecht and the Vatican needs for funds to complete St. Peter's in Rome. In this setting, Luther, as reported by Mark U. Edwards Jr., asked Albrecht to stop the extensive peddling of indulgences and sent him a copy of the Ninety-five Theses.[10]

In 1521 Luther wrote an attack on Albrecht's collection of relics at Halle with their indulgence claims, a work held up for publication by Spalatin, advisor to Frederick the Great. But Luther wrote the cardinal privately and received a reply in which Albrecht admitted mistakes, maintained that he had overaccented the relics, and was a poor sinner needing grace. Luther took his word and did not attack Albrecht in the immediately ensuing years. Albrecht sent money to Luther as a wedding gift, and Luther urged Albrecht to marry and create a secular land. Luther hoped, as did others, that Albrecht's apparent middle position between the Catholics and Protestants would lead him to a positive role at the Diet of Augsburg in 1530; at least that he would see to it that peace continued and Protestants were not molested. But by 1531, it became clear that such hopes were in vain, and Luther was ready to attack the cardinal again. But that did not happen openly until 1539, when he published *Against the Bishop of Brandenburg, Cardinal Albrecht*.

Cranach's paintings of Cardinal Albrecht mainly fall in the period around 1525. The first of these, *Cardinal Albrecht of Brandenburg*, a casualty of World War II, was probably done between 1520 and 1525. The second, dated by Ruhmer as 1524, is *Cardinal Albrecht of Brandenburg Kneeling before Christ on the Cross* (Munich). Then there are three versions of *Cardinal Albrecht of Brandenburg as St. Jerome*, one an outdoors scene dated 1527 (Berlin), two indoor scenes, one 1525, the other 1526. (Darmstadt, Germany, and Sarasota, Florida (Figure 41). In the paintings of Albrecht as St. Jerome, the crucifix scene is always incorporated; in the one instance the Crucifixion is seen in the field beside the desk at which Albrecht as St. Jerome is writing, and in the other two instances a crucifix is on the writing desk.

FIGURE 41.
Cranach, *Cardinal Albrecht of Branden-burg as St. Jerome*, 1526, John & Mabel Ringling Museum of Art, Sarasota.

Werner Schade suggests that princely reciprocity between Frederick the Wise and Albrecht may have been responsible for the Cranach portraits. One could further argue that Frederick the Wise and Albrecht, both having agreed to elements of reform and curbing their interest in relics, may have understood each other. In addition, artists often work for parties in contention with each other. Perhaps all of these factors are involved. But by this time Cranach was a disciple of Luther, just two or three years away from the law and gospel panels and drawings. For this reason, Mark U. Edwards's showing that Luther and Albrecht were on good terms during the 1520s provides an additional compelling reason for Cranach having no difficulty in doing the Albrecht portraits.[11] Finally, painting Albrecht before the cross and as St. Jerome represented subjects that were congenial to both the Catholic and the Protestant traditions, and could be executed without offense.

During the 1520s and 1530s, Albrecht was occupied in creating the Neue Stift in Halle, the most ambitious artistic project of the time. Reliquaries, paintings, sculpture, and altarpieces abounded, in which prominent artists of the time were employed. In addition to Cranach the Elder, one should note Matthias Grünewald and Albrecht Dürer, both of whom are also part of this study.[12] The project was meant as a vehicle for rehabilitating the place of the saints in the life of the church, including the dominance of St. Peter. In that sense, the cardinal was leaning more and more toward the traditional Catholic Church, in which his own role and that of Charles V were the complementary pillars. But in the late 1530s the cardinal's financial burdens increased and the venture was doomed. Many of the works of art were dispersed, with much of it split between Mainz and Aschaffenburg. What could have been a monument that competed with the glories of Rome was instead abandoned in 1540.

Until the end of the 1520s Cranach the Elder broke little new ground theologically in the illustrations and paintings that compared the papacy and Scripture respectively as false and true religion; in illustrations for Scripture; or in the portraits of Luther or those of Cardinal Albrecht. Carl Christensen has pointed out that portraits of the princes and coins of the time contain texts that could only come from Reformation influences.[13] At the same time, the subject matter of woodcuts and paintings had not yet taken on a new iconography or style. Perhaps that is due in part to the fact that Luther himself was of little help to Cranach in terms of the role of painting and what should be painted in the early period of the Reformation.

Luther's Views of the Visual Arts and Theology

Luther did not come to a genuinely positive view of the visual arts until after the mid-1520s, and only then began to address himself to how the visual might be of service to the Church.

Various writers have detailed that history, though seldom, with the exception of Carl Christensen, with due regard for the chronology.[14] Repeating some of the material here in strictly chronological order will show the shifting nuances of Luther's views of images. In the early lectures on Romans, 1515–1516, Luther made two comments bearing on the subject. First, in commenting on Romans 1:19–21, he dealt with the claim that the invisible things of God, God's eternal power and divinity, which should be evident to us in creation and therefore leaves us without excuse, were instead turned into images of ourselves and the world. Such images were idols. God was not worshiped as God but as individuals imagined God to be.[15] Second, in his comments on Romans 14, Luther makes the case that the new law, that is the gospel, does not require specific practices. For instance, there is no requirement "to build such and such churches and to adorn them thus and so and to sing in them one way or another. Nor are organs, altar decorations, chalices, or pictures required. . . . All these things are mere shadows and tokens of reality; indeed, they are childish things. . . . Everything is free as long as there is practiced in it moderation and love and whatever else the apostle teaches."[16] In the Ninety-five Theses of 1517, Luther centers on the sale of indulgences to complete St. Peter's in Rome. In numbers 50 and 51, Luther suggests that if the pope really knew the amount of money extracted through the proclamation of indulgences, it would be appropriate for him to abandon St. Peter's, if necessary, in order to take care of the needs of those from whom the money is extracted. In number 86, Luther suggests that if St. Peter's is to be completed, the pope should use his own money.[17] In his *Explanations of the Ninety-five Theses* in 1518, he wrote that the first good work is to give to the poor, lending to a needy neighbor, or coming to the aid of anyone who suffers. When these needs have been met, one should contribute to the building of churches and hospitals, then to public buildings that serve the public.[18] In his writing on trade and usury in 1520, the issue of indulgences and their use for St. Peter's is still before him; he adds, however, that "we would not disallow the building of suitable churches and their adornment; we cannot do without them. And public worship ought rightly to be conducted in the finest way. But there should be a limit to this, and we should take care that the appurtenances of worship be pure, rather than costly."[19] On the other hand,

in his 1520 *An Appeal to the Ruling Class* he calls for the destruction of some extra parochial pilgrimage churches, considering the attendant excesses and misguided stress on merit.[20] The merit issue involved at least two facets; first, a donor thinking of a gift as a good work before God, and second, a person on a pilgrimage thinking of it as a good work, one in which merits are particularly available through seeing and having physical contact with specific works of art.

In the early period extending from 1515 to 1520, Luther showed a balanced view in the midst of diverse criticisms of the church. In the immediately ensuing years, he moved from criticizing abuses to doubting the validity of the visual arts in the church while at the same time standing against those who wanted to remove and/or destroy images without authorization by constituted authorities. This direction was precipitated by events in Wittenberg while Luther was still in seclusion at the Wartburg under the protective custody of Frederick the Wise.

Luther had returned to Wittenberg from the Wartburg in December 1521 for a conference with trusted friends on how to deal with those in Wittenberg who wished to proceed rapidly and thoroughly in changing the liturgical life of the church. Upon Luther's return to the Wartburg, Karlstadt, who was allied with the Zwickau prophets of an even more radical bent, took the initiative for reform in Wittenberg. Karlstadt was among those who believed that one was to pay attention to the immediate impact of the Holy Spirit, that learning was unnecessary (though he was learned) to understand Scripture, and decreed that one must act on the basis of the dictates of the Spirit. He announced that confession was unnecessary before communion, distributed both of the elements in a service without wearing the standard vestments, declared that fasting was not necessary, and decreed that images must be removed from the churches. The latter led to wanton destruction of images and altars. In the midst of the attendant chaos, Luther returned to Wittenberg in March 1522, at some risk to himself, and preached eight sermons, one specifically on images, that were aimed toward restoring order in the church.[21]

From early on, Luther rejected the notion that images must be removed from the churches and affirmed that such demands and actions made the gospel into another law, one that took away the freedom that faith gave on such issues. But he now added that while "we are free to have them or not, . . . it would be better if we did not have them at all."[22] Again, Luther notes that those who give works of art to a church generally believe that it is a good work, while others worship and adore such objects.[23] Both are counter to a correct view of life. Nevertheless, images may be useful to some, and so we

should not outlaw them. Moreover, abuses are never a legitimate reason for destroying them. That some worship the sun and the moon does not mean that we pull the stars from the sky, or that while wine and women make a fool of many a man, that we kill the women and pour out the wine. No, the abuses must be corrected by the preached Word, the Word that must capture our hearts and enlighten us. That is our ministry rather than the actual removal of images by believers.[24]

Luther's sermons and actions brought some stability to Wittenberg, and the princes banished Karldstadt from Saxony. But Luther's stormy relations with him continued. In a letter of 1524 to the Christians at Strasburg, who had sought Luther's opinion, Luther wrote: "I might well endure his [Karlstadt's] uproar against images, since my writings have done more to overthrow images than he ever will do with his storming and fanaticism. But I will not endure any one inciting and driving Christians to works of this kind, as if one cannot be a Christian without their performance."[25] In the following year, 1525, appeared Luther's extensive work against Karlstadt and similar believers, titled "Against the Heavenly Prophets in the Matter of Images and Sacraments." In this work, several points, previously affirmed by Luther, are more fully elaborated. Again, it is the Word that puts images in their place, namely, that takes them out of the heart and makes them worthless before God. By contrast, Karlstadt, states Luther, takes images out of the church and leaves them in the heart. What Luther means is that Karlstadt does not see the radical nature of faith, in which works of any kind, prohibiting images or commanding them, as the papacy does, are to be rejected. In short, it is the overvaluation of the images, their past place in salvation, that is wrong. But to demand that they be destroyed, in order to correct an abuse, is to make a new law out of the gospel. Hence, Luther is willing to see images disappear but he is also open to their being used in a setting in which their former relation to works can be set aside. Images are appropriate when their power is curtailed, when they are neither necessary nor necessarily abolished. In that setting, Luther suggests that images may be removed if it can be done without rioting and by the proper authorities. Only the worship of images is forbidden, not their being made or rightly placed.[26]

Even the iconoclasts, suggests Luther, read his German Bible, in which there are many pictures, "both of God, the angels, men and animals, especially in the Revelation of John and in Moses and Joshua." Then he adds: "Pictures contained in these books we would paint on walls for the sake of remembrance and better understanding, since they do no more harm on walls than in books. It is to be sure better to paint pictures on walls of how

God created the world, how Noah built the ark, and whatever other good stories there may be, than to paint shameless worldly things. Yes, would to God that I could persuade the rich and the mighty that they would permit the whole Bible to be painted on houses, on the inside and outside, so that all can see it."[27] In the previous year, Luther, in a less controversial setting, had written: "I would like to see all the arts, especially music, used in the service of Him who gave and made them."[28]

Obviously, there is some ambiguity in Luther as to whether images should be removed as a result of right preaching and with rightful authority, or whether they serve a positive purpose, such as a teaching role. Luther claims both to have done more than others to have images removed and that the visual can serve a useful purpose.

Further, in his work against Karlstadt, Luther gives attention to the Old Testament and to the role of the law and the gospel, a motif that comes center stage with respect to Cranach's art in 1529. In the 1525 Commentary on Deuteronomy, considerable attention is given to the image problem within the Old Testament, separating what is permissible and what is not.[29]

But the period from 1525 on involved developments that led to an emerging Protestant church. Symbolically, Luther's abandonment of the garb of a monk and his marriage signal new directions. Such directions also come to the fore in the liturgical life of the church, such as the German Mass and order of Service of 1526, in which it is stated that "we retain the vestments, altar, and candles until they are used up or we are pleased to make a change. But we do not oppose anyone who would do otherwise. In the true mass, however, of real Christians, the altar should not remain where it is, and the priest should always face the people as Christ undoubtedly did in the Last Supper."[30] In the 1528 Confession Concerning Christ's Supper, Luther states: "Images, bells, eucharistic vestments, church ornaments, altar lights, and the like I regard as things indifferent. Anyone who wishes may omit them. Images or pictures taken from the Scriptures and from good histories, however, I consider very useful yet indifferent and optional. I have no sympathy with the iconoclasts."[31] In his personal prayer book of 1529, Luther repeats that he has always opposed the misuse of images but that he has also urged their use for "beneficial and edifying results." He again repeats that stories might be painted on walls, along with appropriate biblical verses, so that we might have "God's words and deeds constantly in view and thus encourage fear and faith toward God." Moreover, since children and simple folk are apt to retain stories when "taught by picture and parable than merely by words or instruction," one might even illustrate the important stories in the Bible in

a small book, something that might be known as a "layman's Bible."[32] That language, of course, had been used from Gregory the Great on.

In his commentary on Psalm 111, dated 1530, Luther connects images with the Lord's Supper. He writes: "Whoever is inclined to put pictures on the altar ought to have the Lord's Supper of Christ painted, with these two verses written around it in golden letters: 'The gracious and merciful Lord has instituted a remembrance of His wonderful works.' Then they would stand before our eyes for our heart to contemplate them, and even our eyes, in reading, would have to thank and praise God. Since the altar is the designated place for the administration of the Sacrament, one could not find a better painting for it. Other pictures of God or Christ can be painted somewhere else."[33]

It is apparent, then, that between 1525 and 1530, Luther's view on images changed from cautious acquiescence to thinking that a positive use existed. That development is related to theological orientations forged in the development of Protestant churches.

Theologically, Luther's views were consolidated at several points. Central to Luther's views was the notion that the grace of God, while freely given, was given to humans in their historic, finite existence. Hence, the benefits of Christ were not spiritual in the sense that they represented another realm over against the material but that, indeed, such benefits came to humans through fleshly, bodily realities. While it may not have been gracious for Luther to say so, he was probably correct in saying to Zwingli that the two of them were of different spirits. For Luther, the benefits of God, the graciousness of God, was present for believers in the Lord's Supper. For this reason, the Lord's Supper and paintings related to the altar are congenial with each other. Such paintings make visible, along with the preached word and the elements, the gift God offers to us. Here the Sacraments are not central in remembrance but in participation, where the infinite is received through the finite. Painting then becomes another reinforcement of the verbal, that is, another possibility for contemplation, whether before, after, or during the administration of the Sacrament. In this sense, Luther maintained that paintings were appropriate to sacramental realities.

Finally, a further development of Luther's thinking affected Cranach's art. It was noted earlier that Luther began to deal with the law, its use in making humans recognize themselves as sinners, its positive role in holding society together, its character as expressing the law within human beings (moral law), and its relation to the Gospel. In thinking of the new order of the church, Luther believed that Christians had to come to terms not only with what was central to faith but also to express what faith meant through cate-

chisms, commandments, and theological documents. He moved from the problem of faith and works, where the battle was originally waged, to an analysis and development of the law and gospel theme as the wider locus of the Christian faith.

Since Luther's *A Commentary on St. Paul's Epistle to the Galatians* of 1531 centers on law and gospel, reflecting thoughts developed from 1519 on attention will be given primarily to that document. With respect to salvation, law and gospel are portrayed as opposites, for it is only by the free gift of grace that humans can stand before God. But in the light of grace, law is understood in a new way and remains part of life and faith. Believers understand that the law, having left them in despair, is also an instrument that can, in making humans aware of sin, place them before the possibility of faith. Commenting on Romans 7:13 in his introduction to Galatians, Luther writes: ". . . the law is most excellent: yet it is not able to quiet a troubled conscience, but increaseth terrors, and driveth it to desperation; for by the commandment sin is made exceeding sinful. Wherefore the afflicted and troubled conscience hath no remedy against desperation and eternal death, unless it take hold of the promise of grace freely offered in Christ, that is to say, this passive righteousness of faith, or Christian righteousness."[34] But for Luther it is also clear that to be placed before the Gospel does not mean that one will become a believer. In the "Bondage of the Will" of 1525 he leaves the question of how it is that some become believers and others not as a mystery that cannot be fathomed. Those who have become believers know that the grace they know is a gift, for which the appropriate response is thanksgiving. Luther further suggests that if free will or living by the law produced results, he would not want that burden placed upon him.[35] The grace given to humans, or imputed to them, provides the freedom, out of which good works are done, without trusting in them or believing them so worthy as to free one of sin.

Nevertheless, as believers humans still live with the law, the law that reminds them that even as believers they are still sinners. For example, even if persons do not actually engage in murder, they are reminded that the fulfillment of the law requires that the heart be free of malice and belligerent orientations. One could add, writes Luther, carnal lust, but also pride, wrath, heaviness, impatience, incredulity, and such like.[36] So Luther states that "the holiest that live, have not yet a full and continual joy in God, but have their sundry passions, sometimes sad, sometimes merry, as the Scriptures witness of the prophets and Apostles. . . . Thus a Christian . . . is both righteous and a sinner, holy and profane, an enemy of God and yet a child of God."[37]

The possibility of faith, of grace known, of sins covered, rests in what God has done in Christ. ". . . Jesus Christ the Son of God died upon the cross, did bear in his body my sin, the law, death, the devil and hell."[38] In this context, Luther makes much of the notion that God has taken on human sin, that sins are buried with Christ, who has become sinner, thief, adulterer, murderer. Quoting and then commenting on Paul in II Corinthians 5:21 and then on John 1:29, Luther writes: " 'Christ was made a curse for us;' 'God made Christ which knew no sin, to become sin for us, that we in him might be made the righteousness of God.' After the same manner John the Baptist called him 'the lamb of God' . . . He verily is innocent, because he is the unspotted and unde-filed Lamb of God. But because he beareth the sins of the world, his innocence is burdened with the sins and guilt of the whole world. . . . To be brief: our sins must needs become Christ's own sin, or else we shall perish for ever."[39] Then, in faith, one is "dead to the law, justified from sin, delivered from death, the devil and hell . . ."[40] Or in a similar vein: "This is then the proper and true definition of a Christian: that he is the child of grace and remission of sins, which is under no law, but is above the law, sin, death and hell. And even as Christ is free from the grave . . . , so is a Christian free from the law. And such a respect there is between the justified conscience and the law, as is between Christ raised from the grave, and the grave. . . ."[41]

More than most of his other writings, Luther's *Commentary on Galatians* zeroes in on the center of faith, here expressed in an analysis that is almost dizzying in its dialectical turns on law and gospel. Given that everything the Christian needs to know is found for Luther in a faithful understanding of law and gospel, it is not surprising that this motif should become the corner-stone of Cranach's reformation understanding in the late 1520s. All the ele-ments found particularly, though not exclusively, in the Galatians com-mentary find their way into Cranach's works on law and gospel, sin and redemption. These include, among others, the Lord's Supper, Baptism, the Crucifixion, death and the devil, Moses, the lamb of God, the brazen serpent, which Luther even refers to as "that brazen serpent Christ hanging upon the Cross."[42] Indeed, if the Galatians commentary is a kind of summing up in which the entire Scripture is mirrored, the emerging Cranach paintings can be said visually to display what Luther has delineated as the pivotal points around which faith gravitates.

Law and Gospel in the Art of the Cranachs

While attention will be given later to other works of art that may be identified with the Reformation, here the focus is on what is the fullest expression of the new reformation outlook on the part of Cranach the Elder, followed by his son, Lucas the Younger. While the subject of these works, begun in 1529, may be said to be sin and redemption, the vehicle of that expression is law and gospel.

Lucas Cranach the Elder, the Cranach workshop, and Lucas Cranach the Younger executed many versions of the Law and Gospel theme in various media and formats—woodcuts, panels, paintings.[43] There is no doubt that the early versions stemmed directly from Cranach the Elder. While the assumption is that Luther and Melanchthon played a role in determining the inclusion of the various subjects in the scheme, there is no known extant evidence that conclusively shows this to be the case. But the parallelism between the materials previously quoted from Luther's *A Commentary on St. Paul's Epistle to the Galatians* and the actual works of art surely indicate that a connection of some kind exists. Nor do we know who, if anyone, commissioned the earliest works, though we do know that in the Schneeberg, Wittenberg, and Weimar altarpieces, the Saxon princes were involved.

The major elements of the law and gospel works include under the category of the Law (usually the left side of the work) God as ruler and judge, Adam and Eve and the Fall, death and the devil chasing the sinner into hell, Moses and the two tables of the law. On the right side, that is, the Gospel side, the subjects usually are the annunciation, the Crucifixion, the lamb, the Resurrection, the destruction of death and the devil, John the Baptist pointing to the Crucifixion, with blood flowing from the side of Christ, along with the dove representing the Holy Spirit. Usually the two sides are divided by a tree, the left side of which is barren, the right side verdant. One subject, the Hebrew encampment and the lifting of the serpent, is sometimes depicted on the left and sometimes on the right.

Most versions include biblical texts along the bottom of the visual materials and occasionally within the work of art itself. While heavily drawn from Romans, other Epistles of Paul, Matthew, and the Gospel of John are included. Although the texts are from the New Testament, they include references to the law, understood, of course, from the standpoint of grace as both judgment and norm. Moreover, while texts were sometimes used in conjunction with works of art before the Reformation, the extensive use of texts is a Reformation phenomenon. There is no doubt that Luther preferred the

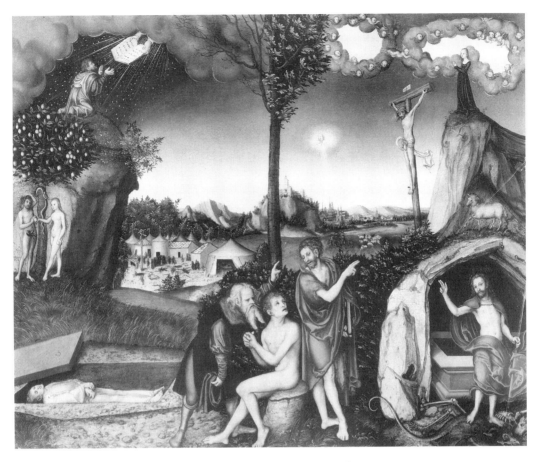

FIGURE 42. Cranach, *Law and Gospel*, National Gallery, Prague.

preached word, that is, the oral, lively word, over both the written text and the image. Yet he looked on both text and the visual as avenues, when perceived by the Spirit, of knowing God. The law and gospel woodcuts, paintings, and altarpieces made visual the core of the gospel, an additional means of sensing the parameters and center of the gospel. The visual lets humans, as their eyes focus and wander, see the totality of faith.

While the various versions of the law and gospel theme usually include the same subjects, no two of them are identical. Two painted panels of 1529, one in Gotha, Germany (see Figure 4) and the other in Prague (Figure 42), disclose significant differences. In the Gotha panel, on the left side, death and the devil chase a nude person (Mensch, everyone) toward hell, and on the right side, John the Baptist points the nude person toward the Crucifixion. In

the Prague panel, a nude body in a coffin manifests death under the law, while a second nude person sits in front of the centrally placed tree, his body turned toward the law side, while his face is following the finger of John the Baptist pointing toward the Crucifixion.[44] Two pen-and-ink drawings of 1529, one in Dresden and the other in Frankfurt, and a woodcut of 1530 in the British Museum more closely follow the Gotha work, in which two nude figures personify each person on her/his journey of faith. In this sense, the Gotha panel becomes the norm, perhaps because it was closer to what Luther meant. It provided a picture of the ramifications of law and gospel for each person, rather than a demand that either law or gospel be accepted.

Another difference between the Gotha and Prague versions is that in the former, the lamb tramples on death and the devil, while in the Prague version Christ stands on death and the devil. In this instance, the other versions follow both traditions, with a slight preponderance of the Christ figure.

The placing of the Hebrew encampment and the brazen serpent, recorded in Numbers 21: 4–9, discloses an important theological point. The Gotha and Prague works place the scene on the side of the law. A Dresden pen-and-ink sketch places it in the center, slightly nearer the gospel side, while the Frankfurt and London works place it on the gospel side. Panels of the law and gospel in Weimar (Figure 43) and Nuremberg museums also place the scene on the Gospel side. The first major altarpiece in Schneeberg, Germany (Figure 44), in 1539 places the scene on the gospel side, as does the Weimar altarpiece of 1555.[45] (Figure 45). Indeed, in the Weimar altarpiece, even Moses and the law are placed in what would be the gospel side. On the other hand, the 1541 German Bible version places the Hebrew encampment on the law side.

Nevertheless, it seems apparent that this event was moved, over time, to the gospel side. One can only conclude that it was for theological reasons, probably reasons conveyed to the artist by Luther or Melanchthon; there could hardly be another source.

Luther did not distinguish between law and gospel in terms of Old Testament and New Testament, for there was law in the New Testament, and gospel in the Old. The other subjects fell easily into either the Old or New Testament divisions. But law and gospel did not easily fall into one or the other testament, thus requiring a decision. The scene of the serpents that devoured the people, who then were saved by their looking at the elevated serpent, is recorded in the Old Testament; but it is actually the symbol of grace. The church had interpreted the serpent being lifted up as a prefiguration of Christ having been lifted up. Luther, looking at the Cross, could, as we noted previously, speak of the "brazen serpent Christ," thereby showing

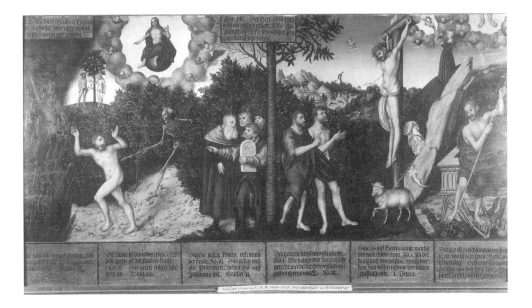

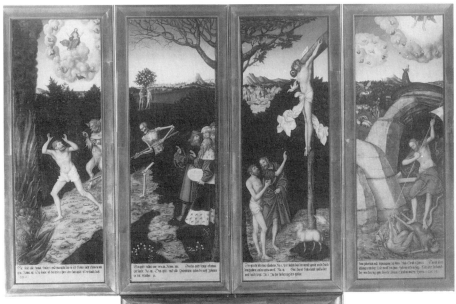

FIGURE 43. (*top*)
Cranach, *Law and Gospel (Fall and Redemption)*, Castle Museum, Weimar.

FIGURE 44. (*left*)
Cranach, *Schneeberg Altarpiece, St. Wolfgangs Kirche* (1996 reinstallation), Schneeberg.

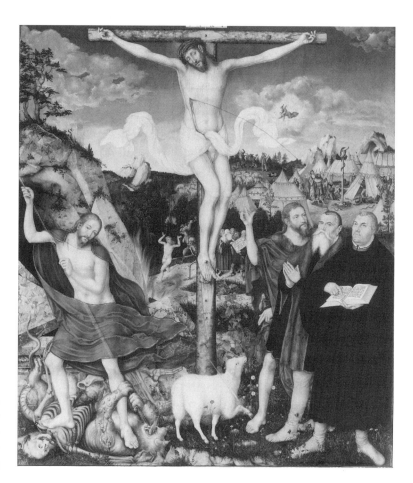

his radical reading of the Old Testament from a christological perspective.
Hence, while the Hebrew encampment and the brazen serpent were origi-
nally placed on the law side, they needed, for theological reasons, to be placed
on the gospel side.

While the law and gospel drawings, woodcuts, and paintings provide an
outline version of the Gospel, the altarpieces themselves show the gospel
theme of law and gospel in its liturgical or church setting. As Christensen has
pointed out, Luther modified his view with respect to altars, for he had previ-
ously encouraged a free-standing altar, from behind which the minister faced
the people.[46] Given the placement of altarpieces over and toward the rear of
the altar, this was no longer possible. But such altarpieces did focus the altar,
and the predella or lower panel along the bottom of an altarpiece, usually a
Last Supper subject, was the first subject seen just above the altar.

The Cranach altarpieces, representing both father and son and others from the Cranach workshop, are particularly important, for they represent the ancient tradition given a new form in the Reformation context. Moreover, notable versions are extant in their original locations, as in Wittenberg, Weimar, and Kemberg, the latter totally by Cranach the Younger. The earliest altarpiece, done for the church in Schneeberg, was reinstalled upon completion of current restorations in 1996. The Dessau single panel altarpiece, also by Cranach the Younger and recently restored, now hangs on the side wall near the chancel in the St. Johannis church in Dessau.

While the altarpieces come from the Cranach workshop and are mainly attributed, in more recent scholarship, to Cranach the Younger, the basic concept rests on the earlier drawings, woodcuts, and panel paintings by Cranach the Elder. Given the constancy of the subjects in the law and gospel altarpieces, no serious consequences follow from not knowing which Cranach was most involved. But it does seem likely that Cranach the Elder also had a major hand in the 1539 altarpiece, created in Wittenberg and carried some 150 miles south to Schneeberg by wagon, where it was then installed in St. Wolfgangskirche. The altarpiece was a gift of John Frederick, who is commemorated in the left wing of the altarpiece below a scene from Gethsemane, and his half brother, John Ernst, seen on the right wing below the Resurrection.

Central to the open altarpiece is the Crucifixion of Christ, with the two thieves on their crosses, the centurion on his horse, and Mary (Figure 46). In addition there are many figures, some being attacked, others in rapt attention, and with horses on the right balancing the centurion on his horse on the left. It is a scene the Cranachs repeat with slight variations in other works. Beneath the Crucifixion, the Lord's Supper is seen on the predella. Indeed, this placing of the Crucifixion in a large central panel, with the Last Supper below, is repeated in other works. Christ's sacrifice on the cross is coupled with his presence in the Lord's Supper.

When the side panels are pulled inward, a series of four panels emerge that replicate the law and gospel woodcuts and paintings. The two panels on the left side disclose Christ as judge, Adam and Eve, Moses and the prophets, and an almost nude person being chased toward hell by death and the devil. The right two panels disclose John the Baptist pointing to the cross, encouraging the almost nude person in that direction. There is also the lamb with banner, the Hebrew encampment and the raised brazen serpent. In addition, there is the annunciation, the shepherds, and Christ destroying death and the devil. Beneath each panel are passages from the New Testament, almost identical with the image prototypes.

FIGURE 46.
Cranach, *Schneeberg
Crucifixion*, central
panel, Schneeberg.

When the panels are in this position, two panels on the back side are, respectively, the flood, and Lot and his daughters (Figure 47), both involving major catastrophes. In the central back part is Christ as judge, with the saved and damned, and below, that is, the back side of the predella, we see the resurrection of the dead.

Thus in this altarpiece, the open version places humans, along with the princes, before the Crucifixion and the Lord's Supper. In the second arrangement, the law and gospel themes are repeated. In the back side of the altarpiece, natural and human catastrophes are connected with judgment and resurrection.[47]

The Wittenberg altarpiece of 1547 (Figure 48), sponsored by the congregation and completed a year after Luther's death, is a kind of visual picture of

the church as the place where the word is preached and the Sacraments rightly administered, as expressed in the Augusburg Confession of 1530. On the right side of the predella (Figure 49) Luther is preaching from the pulpit to those assembled on the left, including Cranach, Luther's wife and children, and others unknown. At the same time, he points to Christ on the cross in the middle of the room.

Here, as in the Schneeberg altarpiece, the cross of Christ is God's gift. But the placements of the cross and the Lord's Supper are different. In Schneeberg, the cross is in the center, and the predella of the Lord's Supper is below it. In Wittenberg, the predella, or lower painting, has Luther preaching pointing to the cross. Then above the cross is the Lord's Supper.

That reversal makes it possible to see the center painting and the two wings flanking it as joined in presenting the three sacraments, the Lord's Supper, baptism, and confession, the latter having been accepted by Luther as sacramental in nature. The center larger panel of the Lord's Supper has a round table, with the paschal lamb in the middle, Christ at the left, with the disciple John having his head on Christ's chest, and Christ giving the sop to Judas, who sits at his right. Across the table from Christ is a seated Luther facing a servant who has just given him the cup. In the left panel, Melanchthon is baptizing an infant by sprinkling water over it

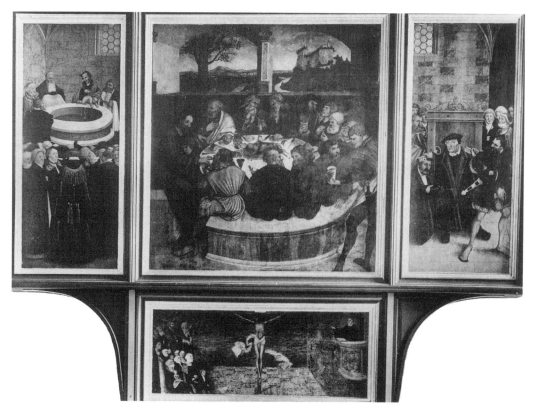

FIGURE 48. Cranach, *Wittenberg Altarpiece*, Stadtkirche, Wittenberg.

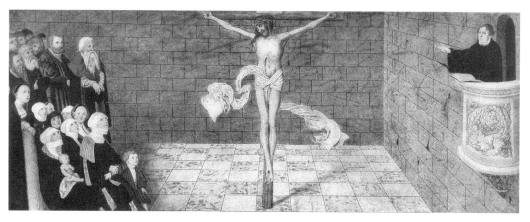

FIGURE 49. Cranach, *Wittenberg Altarpiece*, predella, Stadtkirche, Wittenberg.

from a large container that is larger than a bowl but smaller than a walk-in baptistery. In the right panel Bugenhagen, pastor of the Wittenberg city church, in which Luther also preached, stands before us holding keys in each hand while a penitent is kneeling before him. Obviously, here the keys are symbols of the role of the pastor in the congregation as contrasted with the papacy.

The center of the back side of the altarpiece shows the hand of God and the dove of the Holy Spirit; but more prominently, it shows Christ, with feet on a tomblike grave, in which death and the devil have been slain by the spear in Christ's hand. On the tomb is a biblical passage from Matthew 28, which in English translation reads, "All authority in heaven and earth has been given to me. Go therefore and make disciples of all nations, baptizing them in the name of the Father and of the Son and of the Holy Spirit, and teaching them to obey everything that I have commanded you. And remember, I am with you to the end of the age."[48] But it may also be noted that in this altarpiece, it is the only scriptural passage.

The left panel on the back side depicts the sacrifice of Isaac. On the right, Moses points to the raised serpent, while those standing nearby look at the serpent; but on the ground are those who were bitten by serpents and for whom death followed. While the raised serpent is to be found in most of the altarpieces, it is this version that rather directly mirrors the text in Numbers 21.[49] But it can be noted that the brazen serpent, in whatever form, is a visual theology, for the victims are saved by seeing as well as by hearing.

The presence of Luther, Melanchthon, and Bugenhagen in biblical events was noted above. The same is true for the altarpieces in Weimar, Kemberg, and Dessau. For example, in the Wittenberg altarpiece, Melanchthon takes the place of John the Baptist, and Bugenhagen the place of Peter. In the place of the saints, scriptural or postscriptural, the new altarpieces show that the biblical events are also events for those who are now living. Hence, Luther is as contemporary to the Lord's Supper as one of the twelve disciples. The affirmation is that the Sacraments are now real in the congregation in Wittenberg.

If the point is stretched in the Wittenberg altarpiece, it is made even more clear in the Weimer altarpiece of 1555 (Figure 45), for Luther and Cranach, now dead, are both pictured as present at the Crucifixion. The main painting of this altarpiece is a conflation of the Crucifixion, and of the law and gospel panels. Instead of a tree dividing the old and new dispensations, the cross of Christ stands in the middle. Toward the left of the cross, the risen Christ is slaying death and the devil. In the background, the nude man is being chased toward hell. At the foot of the cross is the lamb with banner; to the right,

Moses and the prophets, the Hebrew encampment, and the raised serpent. Most prominent on this side is John the Baptist pointing to Christ, with Cranach next to him and Luther next to Cranach. Luther is pointing to the open Bible, to passages which indicate that humans are cleansed, saved by the blood of Christ, and that Christ as the raised serpent is the source of eternal life.

The connection with the blood of Christ is literally evident in that the stream of blood flowing from Christ's side lands squarely on Cranach's head.[50] Blood flowing from Christ's side onto a part of the body of persons associated with the Crucifixion represents one strand of an early tradition. In that early tradition Longinus and Mary Magdalene are prominent. Mary and John sometimes are shown together as recipients of such streams of blood and Dürer so depicts them in the 1509 engraving of the *Man of Sorrows*. In the Weimar altarpiece, the contemporary Lucas Cranach the Elder, rather than an ancient figure, is the recipient of the direct flow of the blood of Christ. Here, too, the lamb is pictured with banner but without a chalice into which blood is flowing. Theologically, the suggestion appears to be that the absence of a chalice eliminates the necessary administration of a priest, and directly incorporates the believer without priestly action. Needless to say, both the older tradition and this version make their point, but in the time in which we live, such literal depiction cannot easily be overcome even through theological sophistication.

The predella in this instance is a memorial tablet, with passages from the poet John Stigel. When the altar is closed, one sees the Baptism of Christ and the Ascension of Christ, which, according to Thulin and Christensen, suggest the time of Christ's ministry on earth. When the altarpiece is open and the main scene of Crucifixion and law and gospel is in front of us, the left side wing shows John Frederick and his wife Sibyl,[51] and on the right, their three sons. The altarpiece can be said to be both a memorial to Cranach and to John Frederick.

Whatever the role of Cranach the Elder may have been in the beginning of the Weimar altarpiece, he died two years before its completion. Undoubtedly, much of the execution of the piece and certainly its completion stems from Cranach the Younger. Moreover, two important altarpieces come from Lucas Cranach the Younger: the altarpiece in Kemberg of 1565, a dozen miles south of Wittenberg, and the altarpiece, also of 1565, associated with Dessau, Dessau being about twenty miles west and slightly south of Wittenberg.[52] One could also add the 1584 wing altars, in heart form, now in the Nuremberg National German museum.

Finally, the new chapel in Schloss Hartenfels in Torgau under the auspices of John Frederick should be noted, for it brings together motifs characteristic of Luther and of Cranach. Luther himself consecrated the church in 1544, two years before his death. While not executed by Cranach, the pulpit and entrance portal reliefs were based on sketches and works by him. The chapel itself is frequently characterized as the first church structure built for Protestant worship (Figure 50), as contrasted to the taking over of existing Catholic churches for Protestant worship. There is no doubt that the building became a model for many subsequent German Protestant church buildings.

The space itself is not distinguished, and its end arches do not provide an appropriate area to place liturgical objects. Indeed, it is doubtful that Luther

FIGURE 50.
Torgau Castle Church,
Cranach designs, 1544, Torgau.

was interested in spatial architectural issues as such. The space itself seems to have been determined by the architectural necessities of the castle rather than by the requirements for worship. Luther's primary influence undoubtedly extended to the interior arrangements of a given space.

The most distinctive feature of the chapel is the pulpit, attached to a side wall demarcking the nave. While much has been made of the pulpit being placed among the people, it was not unusual for pulpits to be so placed in cathedrals, whatever the reasons may have been. In Torgau the pulpit is relatively small in scale, and the altar is a simple stone slab, supported by sculptured legs in the form of angels. Sometime after the dedication, an altarpiece was placed behind the altar, but it is not clear whether the altarpiece, destroyed during World War II, was originally intended to be placed there or was an unplanned addition.

FIGURE 51. Torgau Castle Church Pulpit, Torgau.

The sandstone reliefs on the pulpit (Figure 51) were executed by Simon Schröter, possibly from a model prepared by Lucas Cranach the Elder. The central subject shows a young enthroned Christ speaking with the teachers in the temple, based on Luke 2:41–42. This vignette discloses the centrality of the teaching of the Gospel, that the word is Christ. The next two subjects, while they stand on their own, are apparently directed toward the rejection of Judaism and Catholicism. In Christ and the Woman who committed adultery, the gospel as forgiveness is focused over against the condemnation and steps required by the Law. Here, the law and gospel motif reenters, though in Luther's 1544 sermon[53] at the consecration of the chapel those terms are not used, perhaps because the text for the day from the Gospel of Luke made the point in another way. But it is clear in the sermon on John from 1531 that Luther so interpreted the biblical story of the woman taken in adultery, for he clearly states that "this story is related to show the clear distinction between the Law and the Gospel, or between the kingdom of Christ and that of the world."[54]

In the Expulsion of the Money Changers from the Temple composition, the financial abuses of the Roman Catholic Church, including the selling of indulgences, are obviously in the background.

The carved portal of the chapel in which angels hold the instruments of the Passion, also executed by Schröter, is based on Cranach's 1513 pre-Reformation woodcut of 1513. Apparently this work, plus Stephen Hermsdorf's *Lamentation* immediately above the portal, portray how central identification with the Passion of Christ continues to be for believers. But it should also be noted, as R. W. Scribner has pointed out,[55] that the instruments of the passion were originally popular in connection with the sale of indulgences. Perhaps that was Cranach's original setting for the 1513 woodcut, which is here reused in another setting.[56]

Given the Cranach altarpieces noted previously, the 1544 chapel is modest indeed. Nevertheless, the close identification of Luther with the place of the visual in the church is clearly attested. But it is an identification in which the saints have disappeared and the central themes of the gospel are correlated with biblical texts in the tradition of teaching.

Individual Works after 1530

Some subjects span Cranach the Elder's entire painting career, such as the many versions of Adam and Eve (Figure 52). Among them there are no ascertainable differences of a theological nature, though there are some stylistic changes in the presentation of the two figures. Prominent, too, are the many versions of the Virgin and child, though here the religious changes manifest themselves. In the period between 1520 and 1530, the saints that populated these paintings began to disappear. Sometimes in their place, appears John the Baptist, so that we have paintings of the Virgin, the Christ child, and the child John the Baptist. Given that John the Baptist is the central figure linking law and gospel in the Fall and Redemption paintings, the identification of the two from infancy on is more than a quaint picture. It signifies that the connection always existed.

Between 1525 and 1530, a series of individual subjects appear, sometimes repeated later, such as the Woman Taken in Adultery (Figure 53), David and Bathsheba, Christ as the Man of Sorrows, the Crucifixion, the Last Judgment, Samson and Delilah, the Garden of Eden, Pharaoh's Hosts, and the Sacrifice of Abraham. For some of the subjects, the reasons for them are apparent enough. The Woman taken in Adultery belongs to the category of sheer

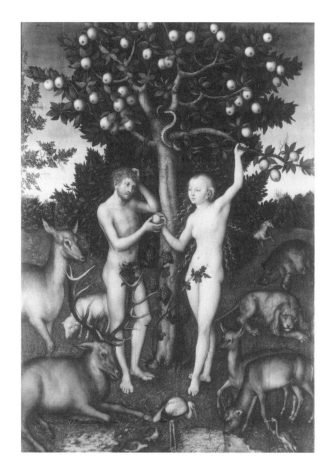

FIGURE 52. (*right*)
Cranach, *Adam and Eve*,
1526, Courtauld Institute
Galleries, London.

FIGURE 53. (*bottom*)
Cranach, *Woman Taken in
Adultery*, Schlossmuseum,
Weimar.

grace. The Sacrifice of Abraham, that account of apparent blind obedience and unaccountable grace, makes the same point. The Garden of Eden, while an obvious biblical subject, in Cranach's mind may bear a relation to the various periods of history, or the human ages that so fascinated Cranach.

In 1530–1531 several versions of Judith and Holofernes appeared, chief among them being the 1531 Gotha paintings, *Judith at the Table of Holofernes* (Figure 54) and the *Death of Holofernes*. The story, not in the Old Testament or the New but in the apocryphal book of Judith, relates how the Assyrian leader had maneuvered the Israelites into a hilltop encampment from which the former cut the water supply. Among the Israelites were those who wished to surrender, for it would be better to be slaves and live than to die. In that conflict Uzziah, their leader, asked for five days' time to see if God would deliver them, and if not, they would then surrender. Then enters Judith into

FIGURE 54.
Cranach, *Judith at the Table of Holofernes*, 1531, Schlossmuseum, Gotha.

the story: a widow of repute, who with permission but without divulging her plans finds her way to the tent of Holofernes, where, when the guards are dismissed and Holofernes is drunk, she decapitates Holofernes and takes his head with her in a bag. Returning to the Israelites, she urges attack, for the Assyrians will flee once they find the dead Holofernes. In the ensuing confusion, the Israelites win, and Judith has the praise of everyone.

In the one painting, Cranach depicts Judith dining with Holofernes; in the second Judith and her servant place the severed head of Holofernes in a bag while standing at the edge of the tent, out of sight of the Assyrian soldiers. Actually, the latter painting is an expanded segment of the top right corner of the first painting. In both paintings, Cranach includes himself, surely an identification with the interpretation of the story.[57]

After 1537 a number of versions of Christ Blessing the Children (Figure 55) were done by both of the Cranachs. There seems no reason to challenge the standard interpretation for Cranach's use of a subject that was not used very much in previous art, namely, that it presents a counterthrust to the Anabaptist movement and its emphasis on believers' baptism. Anabaptists were already present in the empire from the 1520s on, but only later did they seem to present threats to order. The identification of Anabaptists with the Peasants' Revolt and the events at Münster, while characteristic of only a small

FIGURE 55. Cranach, *Christ Blessing the Children*, Schlossmuseum, Weimar.

fraction of the Anabaptists, nevertheless made them appear as a threat to the Lutheran position. As Christine Kibish has shown, the interpretation of letting the children come to Jesus, with the injunction that they are not to be hindered in doing so, was used by Luther and his followers as meaning that children should be baptized.[58] To that should be added that for Luther, faith was more than moral or rational consent; rather it was a gift, which in that sense could be ascribed to children. Thus, while sacramental aspects were not evident in the paintings, one can assume that they were implied. This issue was at the core of his differences with Zwingli and the Anabaptists.

An understanding of Lucas Cranach the Elder in relation to the reforming currents unleashed by Luther requires that one pay attention to the progress of reform, as indicated already in the Introduction. In the early period, say from 1510 to 1525, Cranach joined in the general mood of reform of the life and practices of the church, and the subjects of his woodcuts and paintings are not dissimilar from those of other artists. Between 1525 and 1529, the nature of Luther's reform with its attendant attention now to the actual life of new congregations, began to make its major impact on Cranach. One can only conclude that Luther and Melanchthon provided some of the ideas for the newly emerging works, chiefly personified in the law and gospel motifs.

Before that time, Luther himself, as we noted, was not interested in the promotion of images in the church. But in the period between 1525 and 1529, he saw a role for paintings in the church, especially for altarpieces. Cranach, in spite of his friendship with Luther, must have wondered in this early period what it would mean for him as an artist. While Luther, unlike Karlstadt, did not want works wantonly destroyed, his views of the visual arts were not encouraging. After 1525, that situation changed. Luther began to see an educational role for paintings, provided they corresponded with the preached word. He hinted that the pictures in altarpieces could serve a supplemental role, in which believers were visually confronted by the totality of faith as evident in law and gospel, the Crucifixion, and the administration of the Sacraments. While Scripture was central, visual depictions of the scope of Scripture, as in law and gospel, were like Scripture in that they provided the possibility of joining text and picture so that both the verbal and the visual were present. The power of both the text and the visual images required the proclaimed, oral word, that situation in which grace could become the lively reality of faith. Thus, the visual, while subservient to the text and lively proclamation, was like Scripture in its role in relation to proclamation.

Catholic Reformation Piety

Michelangelo and Reform

Michelangelo's entire working life, from the beginning of the sixteenth century into its sixth decade, occurs in the midst of reforming religious currents that, for all their different shapes, characterized the life of the Roman Catholic Church of his time. While the early period centered more on issues of morality, wealth, and abuse of traditions than on strictly theological issues, they nevertheless signify that from the very beginning of his life's work, reform issues were not foreign to the church Michelangelo knew. He never forgot Savonarola and his powerful, fiery, sometimes vividly detailed apocalypticism. While Savonarola's death in 1498 came because he defied papal power and also because he lost popular support in the political setting of Florence, Michelangelo remembered his impact, though Savonarola died when Michelangelo was only twenty-three years old.

Given Michelangelo's later history, one wonders if he was at all influenced by theories of justification, albeit in a Catholic context, or by affirmations of the resurrection of the body over against the immortality of the soul, found in Savonarola's *The Triumph of the Cross*.[1] Moreover, Michelangelo's

older brother, Lionardo, was a Dominican who lived in Pisa, Viterbo, and Florence, and was in trouble with the order, perhaps because of his sympathies with Savonarola.[2]

It is also clear that Michelangelo did not accept Savonarola's negative views on the nude body in art; indeed, in the period of Savonarola's dominance he received no commissions from the state and instead depended on the Medicis.[3] Of particular artistic importance to Michelangelo was Lucas Signorelli, whose nudes of the *Resurrection of the Flesh* in the Cathedral at Orvieto influenced him. Such dependence is evident in the nudes of the *Sistine Ceiling* and particularly in the extensive nude figures in the *Last Judgment*. But while the nudes in Signorelli, as Margaret Miles has shown, are distinct from the mortal bodies through their weightlessness and in the showing of affection without lust, such characteristics are only partly evident in Michelangelo.[4] For Michelangelo, the nude is also ideal form but with an undertow of concrete power. In fact, this is one of the tensions in Michelangelo, one that apparently troubled him as the theological shift from the nude as particularly appropriate to express the creation gives way to the rejection of the nude as pagan idolatry on the part of many of his contemporaries.

As a generalization, it is possible to say that theological reform became a more dominant part of Michelangelo's own life by the end of the third decade of the century and continued until his death in the 1560s. For our understanding of the last two decades of his life, it is important to note that while the Inquisition had been revived, and individuals suspected of the new heresies of theological reform were brought before it, such actions were sporadic and many were saved from trouble by friends in the curia. Moreover, while the Council of Trent (1543–64) was intermittently in session during this period, even some prominent cardinals thought that its rigid doctrinal decrees might be modified subsequently and that their own alternative voices would find a place in the life of that church. In this, they were wrong. Nevertheless, it must be noted that the papal victory over the reforming currents, whether grounded in Italian ideas or northern reforming documents circulating in Italy, was not self-evident during Michelangelo's art and life. Thus, the rigid adherence to papal doctrine that was later demanded should not be read back into the fabric of Michelangelo's life, or for that matter into that of the church of his time.

The sources and nature of the reforming currents of Italy were complex and wide ranging. It is a mistake to rest the case for reform solely in one or several of the following: Renaissance Humanism, Neo-Platonist thought, mystical contemplative currents in the Italian states, or northern writings

circulating in Italy, whether those of Luther and Melanchthon or of Zwingli, Bucer, Calvin, and others. In some ways, all of these alternatives are involved. More important, however, the need for reform was deeply felt in the life of the church; it was encouraged by specific popes on occasion and always by countless individuals who were caught up in the new life and thinking. While such currents were pervasive, they also differed, ranging from limited reform, such as making bishops live and work in their dioceses, through various versions of justification by faith as the starting point for thinking of other doctrines, to Socinian currents in which the Trinity itself was challenged. Some have suggested that reform was more diverse and widespread in Italy than anywhere else in Europe. Perhaps that is one of the main reasons for the widespread and vigorous suppression of reforming currents in Italy through the reconstitution of the Inquisition.

Reforming currents started earlier in Italy than in the north, though they were confined at first to the conduct of the papacy and ecclesiastical officials. In the early period, which runs from the early 1500s to the 1520s, the immoral practices of clergy, the neglect of religious direction for dioceses and parishes, and the use of resources for other than religious purposes were attacked. Those who opposed such practices were not interested in doctrinal change but rather in what might be designated spiritual and mystical dispositions that brought new life to those within the church. Thus it has frequently been suggested that it would be more strange to exclude Michelangelo from any involvement in reform than to assume that he, too, was sympathetic to reform and to the new theological ideas.

The *Sistine Ceiling*

In the decade before the *Sistine Ceiling*, Michelangelo executed a series of well-known works that do not touch on matters of reform. Moreover, they disclose no special setting, though the colossal *David* was originally intended for a cathedral facade. Similarly, the early *Pieta* in St. Peter's; the *Taddei Madonna* in the Royal Academy, London; the *Bruges Madonna*; and the *Pitti Madonna* in Florence do not require a specific place. But they do disclose a piety that is self-contained, in tableaus that do not require an ecclesiastical place. They reflect acceptable subject matter, without a requisite setting; time and place are irrelevant.

By contrast, the *Sistine Ceiling*, Michelangelo's prodigious labor between 1508–1512, belongs to a liturgical, theological setting, for the chapel had been

designed under Sixtus IV for the special, public events connected with papal usage. Before Julius II (1503–13) commissioned Michelangelo to paint the ceiling, the walls, starting from about ten feet from the floor, and stretching from the center of the altar along one side of the wall to the center of the entrance, had scenes from the life of Moses, and on the other side, also extending from the center of the altar to the center of the entrance, scenes from the life of Christ. These works, executed by distinguished artists of the time, including Botticelli, show humans as living under the Law and under the Gospel. Still, they generally do not follow the dominant typological parallels, in which Old Testament subjects prefigure New Testament ones, such as the serpent's being lifted up on a pole (Numbers 21:4–9) being understood as prefiguring Christ being lifted up on the cross. Specifically, the two series, Law and Gospel, appear relatively independent of each other. Granted that the Gospel is central, the two are related mainly in that the Gospel is already seen in the Law. The movement is not from Law to Gospel; rather, there is Law (which includes Gospel) and there is Gospel.

In addition, incidents in both series are selected to show Moses and Christ as leaders, prophets, and priests. The figures are depicted as leaders who are to be honored and who prefigure the popes who, not surprisingly, are to be seen in chronological order, just above the paintings starting with Peter on the altar wall.[5]

While it is reported that Julius II suggested the twelve apostles be the subject for the ceiling, that Michelangelo replied that would be a "poor thing," and that the Pope then gave him carte blanche to do what he wished, it is clear that such reports, even if mainly true, tell us little about the project. While Michelangelo had a habit of turning small commissions into large ones, he would hardly have had the iconographical knowledge embedded in the completed ceiling, particularly since the literature on the subject was largely in Latin, which he did not read. Granted that knowledge of biblical subjects may have been more pervasive than in our own day and that Michelangelo in particular perused Scripture, the scheme for the ceiling suggests an interpretive framework that does not automatically spring out of scriptural knowledge.

Frederick Hartt and Esther Dotson have found answers in documents of the time. Hartt calls attention to a kinsman of Julius II and a fellow Franciscan, Marco Vigerio della Rovere, who was papal treasurer and elevated to the cardinalate, as a person of considerable theological knowledge. In the background, he also sees Filippo Barbieri and Hrabanus Maurus, the latter a ninth-century writer. Further, he also mentions Giles of Viterbo.[6]

Dotson, who extensively documents the heritage of Augustine in the ceiling,[7] also explicates the thought of Giles, an Augustinian of whose role as reformer even Luther had positive things to say. As head of the Augustinians, Giles undoubtedly met Luther on the latter's visit to Rome in 1510–1511.

Giles preached the opening sermon at the Fifth Lateran Council in 1512, in which he called on Julius II to institute reform. While Giles was critical of the displays of wealth on the part of the curia, he supported the expenditures for both the new St. Peter's and the Sistine project.

One can reasonably assume that Michelangelo was aware of such reforming accents, just as he was of Savonarola. But as to the specific iconographical sources, we can only make conjectures. That task is made all the more difficult in that the form and style the work took under Michelangelo's imagination undoubtedly transformed his sources.[8]

De Tolnay, in his comprehensive volumes on Michelangelo, published in the 1950s,[9] had already pointed out that the central panels of the *Sistine Ceiling* antedate, as subjects, the concepts of Law and Gospel. From creation to Noah, such events are prior to the giving of the Law. If one accepts this interpretation, the inclusion of prophets and sibyls (Figure 56), and the ancestors of Christ in the spaces between the ceiling proper and the walls, create a kind of religious harmony among the three distinct but related dispensations, namely, that which occurs before the giving of the Law, that is, the giving of the Mosaic dispensation, and the emergence of the Gospel.

When Michelangelo alternatingly placed the sibyls and the prophets on the lower parts of the ceiling, that is, between the still lower Law and the Gospel walls and the center of the ceiling, he spatially connected the three parts—creation before the Law, the Law, and the Gospel—into a theological whole that made sense of all the mosaics and paintings. Many of the early church fathers had spoken of the sibyls as the pagan witnesses to the new dispensation, the function of which in the Old Testament was associated with the prophets. Indeed, that pre-Christian world, together with its association with the Roman empire, was considered a preparation for the Gospel. Thus, the empire existed to create a stable world in which the Gospel could thrive, in which the popes functioned as the new emperors, finally combining earthly and churchly functions and powers. But while Giles of Viterbo adumbrated such views, there is no evidence that Michelangelo shared them. His interest in the sibyls was undoubtedly related to the Renaissance interest in the rebirth of the ancient world, related as it was to artistic remains as well as to literary documents. Here, the sibyls were the analogues to the prophets, in some sense hinting at what was clearer

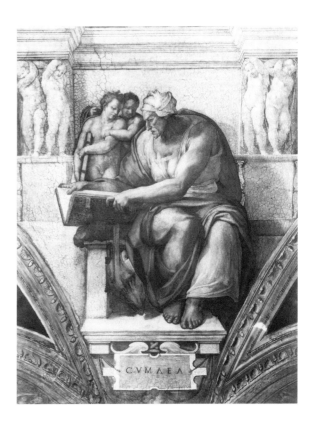

FIGURE 56.
Michelangelo, *Cumean Sibyl*,
detail from the *Sistine Ceiling*,
Vatican Museums, Vatican City.

in the prophets but became clearest, with respect to both, in the incarnation, Jesus Christ.[10]

Wittingly or unwittingly, Michelangelo, in his work on the ceiling, ignored the predominant accent on the papacy so evident on the walls.[11] With the subsequent destruction of the altar end when the *Last Judgment* was executed, this change was, as will be shown later, even more prominent. For now, it is more important to see the way in which the three series, Moses, Christ, and the period before the Law, form a unity. Indeed, that unity is most manifest in the declaration that it is the Spirit which gives life to and manifests itself in all three dispensations.

While God's pointing finger, animating but not touching the finger of Adam (Figure 57), is undoubtedly the most remembered detail of the ceiling; that finger is identified with the Spirit. Charles Seymour Jr. has shown how that symbolism is part of the medieval memory, as in the hymn "Come, Holy Spirit, thou finger of the hand divine." Moreover, in Augustine's *On the Spirit and the Letter*, he writes:

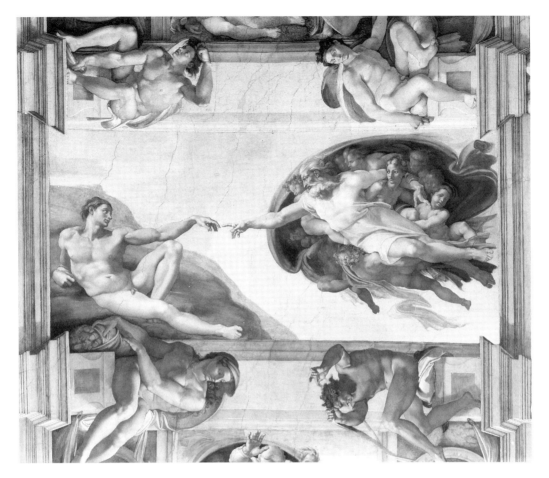

FIGURE 57. Michelangelo, *God Giving Life to Adam*, detail from the *Sistine Ceiling.* Vatican Museums, Vatican City.

That Holy Spirit, through whom charity which is the fullness of the law is shed abroad in our hearts, is also called in the Gospel the finger of God. That those tables of the law [Moses] were written by the finger of God, and that the finger of God is God's Spirit through whom we are sanctified [Gospel], so that living by faith we may do good works through love—how striking here is at once the agreement and difference! Fifty days are counted from the celebration of Passover, which was commanded through Moses to be a figure, signifying, by the killing of a lamb, the Lord's passion that was to be, unto the day when Moses received the law on tables written by the finger of God; and in like manner after the fulfillment of fifty days from the killing and the resurrection of

him who was "led as a lamb to the slaughter," the faithful assembled together were filled by the finger of God which is the Holy Spirit. [12]

Here it may be added that the identity of finger and spirit is suggested in that Matthew 12:28 refers to spirit, while Luke 11:20 refers to finger, in a sentence in which the two have identical meanings, both being the instruments of deliverance from demons.

Thus, in the ceiling we are taken backward from Pentecost to the giving of the Law, both fruits of the spirit, to Creation itself, where, from the brooding wind of God over the waters to the breathing of life into Adam, we have the spirit at work.

The central row of paintings in the ceiling discloses the creation of nature and then of Adam and Eve in all their grandeur, followed by the fate of humanity, as evident in the expulsion, and in the drunkenness of Noah. Simultaneously, the sacrifice made by Noah represents the feeble attempt of humans to find their way in their new state, while the Flood represents both judgment and redemption. Hence, creation and fall symbolize a kind of indeterminacy, answered both in Law and Gospel.

Edmund R. Leach divides the nine central paintings of the ceiling into three groups. The first is creation out of chaos, the third, the chaos that human beings have made, and the second, or in-between state, as "the imaginary Paradise where Man converses both with God and the Evil one. . . . In the [creation of Adam] panel, Adam is separated from God but an uncreated Eve and a pre-incarnate Christ nestle in the womb of time, the left arm of God."[13]

But Leach does not identify "the Evil one." Leo Steinberg not only fills in the void by identifying Lucifer as one of the figures near the left arm of God; he also provides the wider context for understanding what is going on.[14] For Steinberg, it is essential that we abandon concentrating only on the right arm and finger of God in relation to Adam and see what is happening with the left arm, where a host of figures have been ignored or misinterpreted for centuries (Figure 58). There the Eve to be is looking at Adam while cradled by God's arm, and the Christ who becomes incarnate has his shoulder pressed firmly by the thumb and forefinger of the same arm of God, the same digits used by a priest in holding the alleged corpus in the Eucharist. On the other side but close to Christ's body are two figures whom Steinberg identifies as Lucifer and possibly his attendant, Beelzebub. Unlike the other figures, with their angelic approval of what seems to be happening, these two are sour, surly, unaccepting of, and hiding from, what is transpiring.

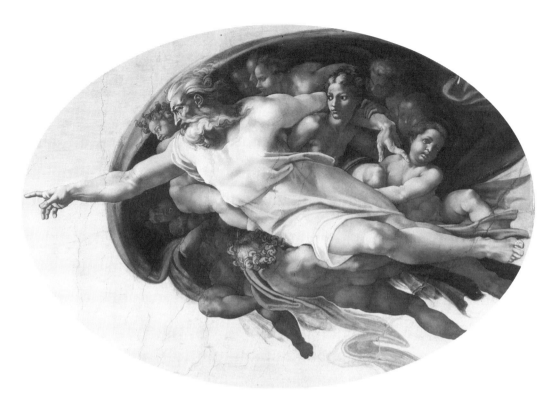

FIGURE 58. Michelangelo, *God*, detail of God and adjacent figures in Figure 57.

Loren Partridge reminds us that this theme may also be present in the Separation of Light and Dark section of the ceiling, which in Augustine's thought is seen "as a sign of the creation and division of the clean and unclean angels." Still more important, Partridge points out that twenty-four bronze-appearing nudes above the pendentives "awkwardly twist, kick, and squirm" (Figure 59) and that two of them have the "conventional pointed ears of devils."[15] Hence in addition to the figures surrounding God, we also have the Separation of Light and Dark and the twenty-four figures as manifestations of the devil.

Historically, there are two traditions with respect to Lucifer. In one of them, Lucifer and a third of the fellow angels, rebelling against serving God, fought with St. Michael and his fellow angels, and in defeat, fell from heaven. Then, human beings were created to fill in the numbers lost in the angelic host. Steinberg rejects this view as Michelangelo's source. Rather the glory of the human creation is the basis of the envy of Lucifer and his companions, a

FIGURE 59. Michelangelo, detail from the *Sistine Ceiling*, Jesse and bronze nudes (devils) above triangle, Vatican Museums, Vatican City.

tradition that seems to be more dominant in western church history. It also makes sense of what Michelangelo has painted, particularly when one also adds that Lucifer's revenge before God was a plot to "maintain as subjects those whom he scorned as companions."[16] The latter problem, Lucifer or Satan's control over humans, according to tradition, is overcome by the hidden presence of Christ whom Lucifer does not recognize as the source of his own defeat.[17] Sometimes this conflict is called the christological foundation of creation, namely, that redemption is implicit in creation; sometimes theologians talk of a prelapsarian understanding, that God has covered the future, and that redemption is not a second thought of God, an improvisation

in the light of the Fall. Another way of putting it is to say that in creation God has covered all the possibilities, that there is nothing that falls outside God's encompassing activity. Concretely, that is expressed in Eve as the incipient Virgin and in Christ as the second Adam. In this sense, the future may be open; but all that may happen is already covered by God's provision. Moreover, phrasing it that way avoids the language of determination and preordination, which became so prominent a century after Michelangelo.

While Creation is logically and ontologically prior to human history, Michelangelo actually started working at the opposite end of the ceiling, and, indeed, visually the scenes are best read from that vantage point. Probably because the smaller and multiple figures in these early scenes could not be seen as clearly as desired from the floor of the Sistine chapel, he moved to fewer figures, with greater volume in the Creation and Fall scenes. Such a necessity led to a reenvisioning that changed the narrative modality into one of mythic grandeur, human and divine, similar to, but not identical with, impulses drawn from Greek sculpture. But while the newly discovered Greek sculptures were contained, that is, had their energy confined as if ready to burst forth, Michelangelo in his delineation of God takes the containedness for granted but symbolizes God as active, as if God's greatness meant that things easily came into being, without effort or stress, as, for example, in the creation of the sun and the moon (Figure 60).[18]

The use of the human figure in such contexts is grounded in the Renaissance understanding of the human as indeed the image of God, that is, a body that mirrors the divine in all its beauty and glory, the nakedness of Creation. Such exalting of the human should not be misunderstood, for Renaissance individuals, as Michelangelo himself, knew the anxiety and fatedness of the human lot. Indeed, the Noah scenes here do not so much prefigure the future as disclose the human lot prior to law and gospel. But that did not detract from the glory that was the human, the human in the image of God. And precisely because the human was that image, the human could be used, by analogy, to express the divine. It was precisely that which offended Lucifer.

In such renderings, God is not to be understood as an old man, but rather God in human form. The form we know is the medium for disclosing, for the unveiling of the veiledness of God. For Michelangelo, if we can see God incarnate in Christ, we can image God in human form without identifying the two in the human sense.

Because the human form is that image, the nude was not a problem for many in the Renaissance and particularly for Michelangelo. Given that ten years later the nude, as we shall see, had begun to be a problem, it may be

FIGURE 60. Michelangelo, *Creation of the Sun and the Moon*, detail from the *Sistine Ceiling*, Vatican Museums, Vatican City.

important to recall that in some medieval cathedrals the saved are unclothed while those in hell are clothed. Here Michelangelo is the heir of a long history. Even the nudes or ignudi (Figure 61) in the ceiling, each of which has a function of some kind, such as literally and symbolically holding an architectural construct, holding medallions in place, or supporting the garlands of oak leaves and acorns (at once symbolic of eternal life and the heraldic device of the pope), were historically used to fill in empty spaces.

At the time the *Sistine Ceiling* was completed, the chapel had a unity based on three historic configurations: Creation and destiny before the time of the Law, the giving of the Law as itself an instrument of Grace, and the advent and life of Christ, the coming together of history in terms of its center. The power of God as Spirit, working in each segment of the human drama, forms a powerful unity. Insofar as the church represents that history, the chapel can be read as an epitome of the church and its message. Emphasis on the popes as the guarantors and historic custodians of that tradition is evident in the chapel walls and the thirty papal figures, chronologically starting with Peter. But that aspect is only indirectly a part of the ceiling. It is as if the papal claims were not of direct interest to Michelangelo. Instead, he includes the ancestors

FIGURE 61.
Michelangelo, *Ignudi* figure,
detail from the *Sistine Ceiling*,
Vatican Museums, Vatican City.

of Christ and Mary, the latter probably because the Sistine chapel was dedi-
cated to the assumption of Mary.

At the end of the Sistine ceiling project, one can say that Michelangelo was
not at odds with the thinking of the church. But he was aware of the reform-
ing efforts and probably sympathetic to them. Given the changes beginning
to be felt in Italy after the first decade of the sixteenth century, Michelangelo's
future involved exposure to the new reforming currents in thought and in
practice.

Reforms in the Life and Thought of the Church

While the idea of reform in the morals and manners of the church was not
foreign to Michelangelo in the period through the Sistine ceiling, reform with

respect to what the church believed was not yet on the horizon. The desire on the part of many for a more spiritual life sometimes issued in changes in moral conduct, with a new accent on appropriating, imitating, contemplating the life of Christ. It was a quest for renewal in the church, a renewal that challenged neither the doctrine nor authority of the church, though on occasion it appeared as if the latter were being ignored.

The first inklings of a theological shift occurred in Gasparo Contarini, the distinguished statesman of Venice who took holy orders and was appointed a Cardinal, from which advantaged position he attempted to influence reform in high places. But as early as 1511, Contarini recorded a conversion experience centering in justification by faith, not dissimilar to that enunciated by Luther several years later.[19] From 1511 forward, Contarini stressed that faith, living under the gracious presence of Christ, was the basis of one's relation to God, and that while works followed faith, they were not the basis of one's relation to God. Moreover, Contarini, as did Luther, had periods of doubt that were overcome only by trusting the faithfulness of God.[20] But unlike Luther, Contarini never worked out or drew theological conclusions that required a change in the nature of the church, a change Luther felt would bring the church back to the practices and outlook of its early days. Contarini, like most of the reformers in Italy, did not see the need to change the nature of the church as constituted in order to repair its morals or modify its orientation to faith. For him, emphasis on justification by faith and active reform of the practices of its hierarchy would revitalize the church and make it possible to end the split caused by developments north of the Alps. Contarini, who had firsthand acquaintance with developments in the North as papal ambassador to Emperor Charles V from 1521–1535, longed and hoped for a reunion of the church. His hopes were dashed when the 1541 Diet of Regensburg, the last official attempt to forge a reunion of the church (a meeting in which Melanchton and Bucer were also present) did not succeed. His expounding of double justification at the conference, in which he was the major participant from the side of Rome, was an attempt to mediate between Rome and the Protestants by emphasizing both the gratuitous mercy of God and the actual difference such grace makes. But that view was finally unacceptable both to the pope and to Luther.

For over two decades, Cardinal Contarini,[21] who died in 1542, had pressed for change from within the citadels of power, and was associated with a number of others, also well placed. Symbolic of this attempt was his leadership, upon the request of Pope Paul III, in preparing a document on reform for a proposed general council. Among those involved were Reginald Pole, cousin

of Henry VIII but resident in Italy because he did not agree with Henry on the divorce issue; Gianpietro Carafa, later the conservative pope, Paul IV; bishop Jacopo Sadoleto, who engaged in correspondence with John Calvin over events in Geneva; and Gian Matteo Giberti, bishop of Verona. In 1537 they issued a Proposal Concerning Reform of the Church, which placed the blame for the problems of the church squarely on the pope and the curia. While the document received considerable attention, Paul III was not an active advocate of reform, and the more conservative members of the curia did not feel that the issues delineated in the document needed attention. Luther, who had received a copy translated into German, published it with his own negative comments, mainly based on his belief that its authors were not seriously concerned with reform.[22] The *Consilium de emendanda ecclesia*, as the document was called, would have made a difference had its provisions been followed.

Although figures such as Pole, Contarini, Giberti, and Sadoleto were serious in their proposals, in hindsight it is clear that they could not move the popes and the curia in their direction in the long run. But in the late 1520s in Rome, the 1530s in Naples, and the early 1540s in Viterbo, there were strong movements of reform, affecting both behavior and doctrine, in which Contarini and Pole remained central figures. In the early period in Rome and then in Naples particularly, the influence of Juan Valdes was dominant. In him, ideas similar to Luther's on justification were evident, and the accent fell on living lives solely anchored in the grace of Christ. Scriptural study and preaching from biblical sources were taken seriously, especially the epistles of Paul, which had taken a special place in Renaissance scholarship.

Associated with Valdes, in addition to Pole and Contarini, were individuals who either lived or spent considerable time in Naples, such as the noble widows Caterina Cibo, Giulia Gonzaga, and Vittoria Colonna (Gonzaga a scholar of note, and Colonna a writer of sonnets and a friend of Michelangelo); Bernardino Ochino, a noted preacher and head of the Capuchins; Peter Martyr Vermigli, an Augustinian and a noted preacher; Pier Paolo Vergerio, controversial bishop of Capo d'Istria of the northern Adriatic area; Marcantonio Flaminio, the eminent Italian poet and final drafter of the *Benefits of Christ*; and Pietro Carnesecchi, whose trial in the late 1540s, which ended in his execution, became the source of information about reforming heresies.

Apart from Carnesecchi, these prominent individuals either died before the Inquisition was revived in 1542, fled the country and went into Protestant territories, or managed to survive by falling into line with Trent or by dissimulating, that is, becoming Nicodemites, Christians in secret of the new

persuasion. But that is ahead of our story. At this juncture, concern is limited to the time when Michelangelo's *Last Judgment* was completed in 1541, the year prior to the beginning of forceful attacks upon the reforming movements.

Moreover, it would be a mistake to pay attention only to the above prominent individuals, largely clerical men or educated women of prominence. Indeed, the overwhelming evidence is that reforming currents, in which justification by faith and personal transformation in life and thought were central, were spread throughout the cities of Italy. One would expect that to be the case in Venice, where feelings of Venetian independence had been strong for a long time and the book-publishing establishment was an avenue of knowledge about reforming movements in the north. Indeed, Lutheran writings, Luther's and Melanchthon's in particular, found their way into Venice and surrounding cities soon after their publication in Germany. Melanchthon wrote letters of advice to Italians, but was disappointed that so little happened. The writings of Bucer and Zwingli were also circulated in Venice. Calvin's writings, too—particularly the first edition of the *Institutes* in 1536—were to be found in Italy, but since this is a relatively late date, Calvin, being a second generation reformer, is not found among the books circulating in the first decade and a half.[23]

While most cities saw such writings as encouragement for reform within the church, in Vicenza as well as a few other cities, the proposals were radical enough to challenge accepted doctrine, such as the Trinity. In Padua, foreign students, particularly from Germany, fed the new currents. In Siena there were French Huguenots and more German students. Lucca, under the tutelage of Peter Martyr Vermigli, was heavily under the influence of reforming ideas and was one of the cities under early scrutiny by the Vatican. Milan, too, and Como, further to the north, also had reforming communities, and the more traditional cities, such as Bologna and Florence, were not without such groups. Rome, Naples, and Viterbo, the latter associated with Pole, have already been mentioned.[24]

Ferrara deserves special mention, for Calvin, under the pseudonym of Charles d'Espeville, visited Renée, the French Duchess of Ferrara, in 1536. It was his only excursion into Italy, of which he himself noted that he entered Italy only to leave it, a remark that probably reflects his unhappiness with the fact that those in Renée's circle were unwilling to be open Christians of the new persuasion. The situation in Ferrara was not an easy one, for Renée's husband, the duke Hercule D'Este, had to enforce the policies of the Vatican, even though his political alliances frequently lay elsewhere. Renée, daughter

of Louis XII of France, had a Protestant orientation and eventually returned to France. For all his disapproval of affairs in Italy, Calvin continued a life-long correspondence with Renée.[25]

The direct influence of Protestant individuals and writings in Ferrara is clear enough. But the situation is less clear elsewhere. Hence, scholars have debated whether the reforming currents in Italy were indigenous Italian stirrings, as certainly was the case originally with Contarini, or were really the product of Protestant writings that were found throughout Italy. Two decades ago, Philip McNair made the case that the source of genuine reforming currents in Italy was the Protestant writings, while four decades ago, Eva-Maria Jung, in her groundbreaking article "On the Nature of Evangelism in Sixteenth-century Italy," insisted that it was a short-lived, Italian-spawned movement among the aristocracy of Italy.[26] In the hindsight provided by more recent work, we know that the movement was not confined to the upper levels of society, though it may have been more visible there. Nor is the word *Evangelism* a happy term, particularly because of its association with the term *evangelical*. More accurate probably is the word *spirituali*, a term used by various participants in the movement about themselves. More recent consensus is that the roots of the reforming currents lie deep within the Catholic tradition itself, which helps explain why it is that their new theological ideas were not developed in ways that basically challenged the hierarchy, such as papal supremacy, or the mass. On the other hand, the ideas of reform within the church were strengthened and clarified by the writings from the north. Still, they were read within the confines of a traditional and church-dominated outlook.[27]

While it has been pointed out that Valdes and the Naples group had little to say about the church, one need not interpret that as a sign of its irrelevance. Quite to the contrary, the church's place was naturally assumed; hence, there was no need to reject the church. But precisely that assumption puzzled those Protestants in the north who looked at the Italian scene. Neither Luther nor Calvin understood the Italian psyche in relation to the church. Ochino and Martyr, both of whom defected to the north, did so not because they wished to reject the Catholic Church but because the church no longer had a place in which they could survive. For Calvin in particular, the issue became that the Italian reformers did not see the Roman church as being the enemy of the Gospel. He maintained that the choice was martyrdom or fleeing the country. To live as secret Christians in the Italian church was a denial of the Gospel. But many Italians with reforming ideas and sensibilities did not see it that way, not because they were afraid but because they still believed it was

possible to hold the reforming ideas and remain in the church. For them, doctrine remained generally intact, though justification by faith had taken on a new life and some doctrines, such as purgatory and the necessity of confession, could be challenged as having insufficient biblical foundations.

Religious Currents and Michelangelo's *Last Judgment*

Because the *Last Judgment* (1536–41) (Figure 62) was executed at the time when the reforming currents just delineated were at their apogee, and opposing forces, while on the horizon, were not yet countervailing powers, it may be assumed that they played a part in its iconographical agenda. This is given particular credence in that various cardinals, such as Cardinal Contarini, were themselves on the forefront of reform and were part of the curia in Rome, precisely at the time when the fresco was being conceived and begun. During this period Michelangelo spent considerable time in conversations with Vittoria Colonna, and engaged in common literary activities with her; they were both "addicted" to the sonnet as a form of literary discourse.[28] Vittoria Colonna's association with the Valdes circle and the overwhelming influence which Ochino, the eminent Capuchin preacher of his time, had on her are well attested. Upset by Ochino's flight north in 1542, she turned to Reginald Pole, who himself was coming under suspicion for heresy, just as had Contarini before his death in the same year. Moreover, at the time of her own death in 1547, Vittoria Colonna too had come under the scrutiny of the Inquisition. Hence, the *Last Judgment* of Michelangelo was completed just before attacks on the reforming religious currents were beginning to occur.

In the light of this history, as indicated previously, it would be more difficult to disassociate Michelangelo from the reforming currents than to associate him with them. But, as will be indicated later, while the iconography of the *Last Judgment* confirms his identification with the views of Contarini, Colonna, Valdes, and others, we have no more direct evidence of how these views became the basis of the *Last Judgment* than we have about the exact and precise sources for the Sistine chapel.

Apparently, the original program for Pope Paul III was to consist of a resurrection on the altar wall, high enough so that it would not have obliterated the Assumption, while on the entrance wall was to be the fall of the rebellious

FIGURE 62. *(facing page)* Michelangelo, *The Last Judgment*, Sistine chapel, Vatican Museums, Vatican City.

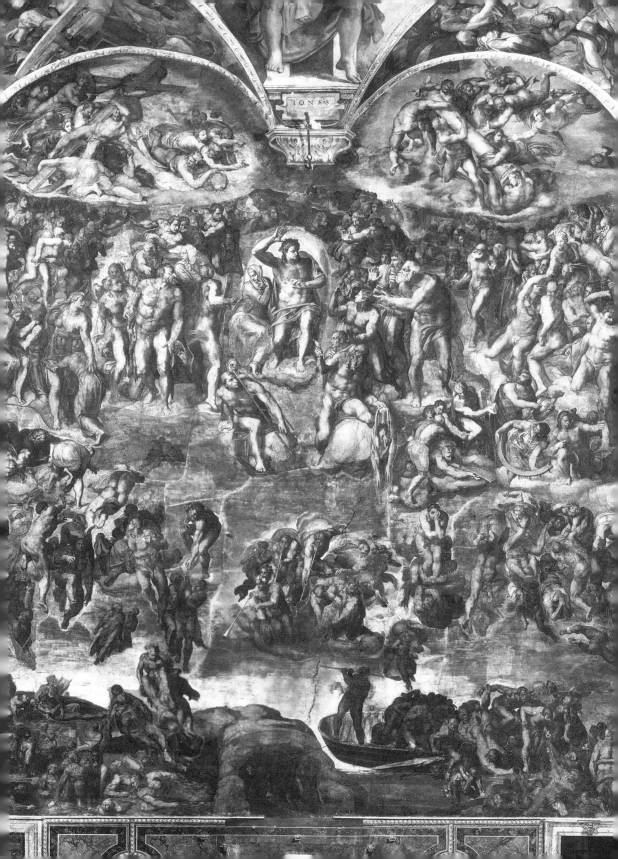

angels, a theme related in subject matter to the Lucifer scene on the ceiling. Subsequent developments, about which we have little information, resulted in the fall of the rebellious angels being abandoned and the altar end becoming the place for the present painting of the *Last Judgment*. Moreover, the scale of the *Last Judgment* took over the entire wall, thereby obliterating the *Assumption*, one of the paintings of the Moses cycle, one of the Christ cycle, and two papal figures, one of them the first pope, St. Peter. For a chapel dedicated to the Assumption and to the central place of the papacy, this appears to be a departure from the original plan of the Sistine chapel as a whole— indeed, a violation of the entire scheme. If the *Last Judgment*, on the other hand, represents more than its own iconography and has some orientation to the rest of the chapel, its walls and ceiling, that has not yet become apparent.[29]

Taken by itself, the *Last Judgment* of Michelangelo has been readily acknowledged as departing from the tradition of levels and tiers of activity, such as the heavens, the earth, and spheres beneath the earth. By contrast, Michelangelo's creation, while divided into groups of figures by the bright blue ribbons of color, has no suggestions of divided levels. It is as if one overarching event was taking place, in which each group of figures is a part.[30]

Stylistically, this departure from tradition did not lead to a new theological interpretation on the part of contemporaries and successors. Interpreters of Michelangelo, such as Vasari, whose first edition of the *Lives of the Artists* was published in 1550, some nine years after the unveiling of the fresco, interprets the painting in terms of what was emerging in the Council of Trent. That, as Steinberg points out, became the pattern. Whether the reason is that Michelangelo's friends wanted to protect him from heretical attacks, or genuinely saw the work of art in terms of the return to the older tradition, we do not know. But as Steinberg points out, careful scrutiny of the work does not permit interpretation in terms of Trent but rather as a visual document in accord with the religious, reforming currents that only later were declared heretical.[31]

Yet the *Last Judgment* was attacked more for its immorality with respect to its explicit and unsqueamish nudity and sexuality than for alleged heresy. In connection with the activities at Trent, it was ordered that the offending nudity be covered. Michelangelo assented but would not himself undertake the task.[32]

A perusal of some of the copies made by other artists of the *Last Judgment* before the changes were made does present a plethora of nudes beyond what even modern eyes are accustomed to seeing. Moreover, some of them, such as St. Blaise towering over and behind the back side of the nude, plump St.

Catherine (Figure 63), undoubtedly offended many, with the result that mere covering would not do. Instead, St. Blaise has been repainted so that he is turned toward and looks at Christ, and St. Catherine's bulgy body is covered. Here, the problem was solved by vandalizing the fresco (Figure 64) to the point where it could never be restored.[33]

Obviously, the changing mores of the time had something to do with the objections, though it is difficult to understand how such changes occur, sometimes in a short period of time. Part of it may have related to the perceived need for changes in human conduct, with the argument that the nude is pagan and seductive.[34]

Michelangelo's own view of the nude is obviously involved. At the time of the *Sistine Ceiling*, the nude in all its grand, ideal form was paramount. In the *Last Judgment*, the ideal nude is still partly present, as in the Herculean, dominating figure of Christ (Figure 65). But nudes of all shapes, sizes, and forms, some in lascivious positions, are also present. What are we to make of this? Perhaps Michelangelo, not being aware of or not understanding the emerging new orthodoxy in both thought and manners, made mistaken judgments. But what he did was consistent with the subject of the *Last Judgment* as he then understood it.

The same can be said of the content of the *Last Judgment*. Traditional Last Judgments clearly showed the saved and the rejected in separate scenes. That is also the way in which Michelangelo's *Last Judgment* was seen until recently. Leo Steinberg and Marcia B. Hall, however, have shown that Michelangelo had departed from that viewpoint.[35] Instead of Matthew 24 and 25, where the saved and the damned are separated, the textual sources, according to Marcia B. Hall, are I Corinthians 15:35–38 and I Thessalonians 4:16–17. The Corinthian text has to do with the resurrection of the body rather than the immortality of the soul, the latter having been prominent among early Renaissance scholars. In the debates in the 1520s and early 1530s, the rational arguments for the immortality of the soul gradually lost ground, with accent placed instead on what could be grounded on revelation, such as the Trinity, and in this instance the resurrection of the body. Thus the shift was from the notion of immortality of the soul, officially adopted at the Lateran Council in 1512 to the resurrection of the body, as affirmed in the 1520s for example, by Cardinal Catejan, a respected conservative scholar who on this issue did not differ from the emerging Protestants. Here it should be noted that the debate biblically centered on the Pauline epistles, which for all of the participants within the Renaissance framework seemed more central than did the Gospels in terms of the scholarly attention they had received, both north and south of

FIGURE 64.
Michelangelo, detail
of Figure 62.

FIGURE 65.
Michelangelo, *The Last
Judgment:* Christ and the
Virgin, detail of Figure 62.

FIGURE 63. (*facing page*) Marcello Venusti copy of Michelangelo's *Last Judgment*, executed for Cardinal Alessandro Farnese, Museo Nazionale di Capodimonte, Naples.

the Alps. Here it should be noted that Signorelli's *Resurrection of the Flesh* at Orvieto, which influenced Michelangelo, was based on the Pauline epistles and was executed already during the early stages of the debate.

The text from I Thessalonians 4:16–17, together with the concluding sentence from verse 18, reads as follows: "For the Lord himself, with a cry of command with the archangel's call and with the sound of God's trumpet, will descend from heaven, and the dead in Christ will rise first. Then we who are alive, who are left, will be caught up in the clouds together with them to meet the Lord in the air: and so we will be with the Lord forever. Therefore encourage one another with these words."

It is at once apparent that no other text of Scripture so clearly fits the subject matter of the fresco. It helps explain the posture of Christ, who has emerged on the scene from the heavens, with the sound of trumpeters below him. Christ is seen both as beckoning and lifting, and as gesturing to those in the turmoil of coming back to life. In the front part of the group of trumpeters are two figures, one holding a small book of the good deeds and the other a large book of the evil deeds of humans. Nevertheless, most of the painting focuses in on those who are redeemed in the resurrection process, with only two groupings on the lower right side facing the despair of rejection, the most prominent of which seems based on Dante's vision rather than the scriptural text so characteristic of the rest of the painting.

The concluding verse of the I Thessalonians passage, "therefore, encourage one another with these words," is important. It echoes what Michelangelo intended, that the resurrection announcement is a vehicle of encouragement. Michelangelo's faith centered in a bedrock of hope about God's forgiveness, an actuality that made it possible for him to live with continued doubts, discouragements, and a strong feeling of unworthiness. The heralding of the resurrection unto judgment represented a positive posture. The resurrection of the body is clearly the dominant motif. Of course, there are bodies sent to final death. But the movement is based on the new reality of resurrection.

Moreover, in Michelangelo's eyes, the nude and the resurrection belong together. But here, in contrast to the Sistine ceiling, the nude included both the classical ideal form, as in the Christ figure and the Virgin, and the bodies of all of us, with their aspects of beauty and ugliness. Could one even venture to see in St. Blaise and St. Catherine, saints to be sure, the facets and features of all of us—human estrangement and destructive passions of many stripes— now being brought into the orbit of grace.

The Last Judgment now has a positive undergirding, but the avenue toward it is full of pathos, agony, and struggle, as those brought from death

to life are drawn toward Christ. All of this Michelangelo depicts with dynamism, a scene of physical action affecting and including humans who in life had reflected its various conditions. It is not all pleasant, this portrayal of hundreds of figures in so many guises; but it is directed to the future.

In this imaginative portrayal, Michelangelo again disclosed the power of his art, for in visual terms the texts are both reflected and taken to new levels. If the ceiling disclosed the mythic dimensions of creation, the *Last Judgment* is a mirroring of the beginning of the end time, an enveloping myth about the end and new beginnings. Surely, in this sense, the ceiling and the Judgment form a new unity for the chapel, this time based not on manifestations of papal religious and imperial supremacy but rather on creation and destiny, both in the hands of God, where predestination and grace come together, where works and merit are no longer central, however important they may be.

In its most positive sense, the *Last Judgment* reflects current religious reforming currents that were later suppressed. Moreover, it does not contain reference to doctrines that had previously been affirmed in the medieval period and that became important again at the Council of Trent. Purgatory, for instance, does not appear to be present, and hell does not seem to have a final hold on humanity (the Dantesque hell at the bottom right represents only the last works of the devil who, even now, does not admit total defeat).[36] There is no intercession for sins, a role so important in relation to the Virgin Mary. Rather, the Virgin is physically close to Christ, as if participating in his work of redemption, also drawing the resurrected to their destiny.[37]

Notes on the Pauline Chapel

Upon the completion of the *Last Judgment*, Michelangelo was commissioned to do paintings for the Pauline chapel, under the auspices of the new pope, Paul III. This chapel, adjacent to the Sistine, was the private chapel of the pope. It served and epitomized the special role of the papacy, for in it the papal conclaves met and the investiture of the pope took place. In every respect, it represented papal priority and power.

Michelangelo was commissioned to do works that paid homage to the two pillars of the Roman Church, Paul and Peter, subjects that were already part of the Vatican tapestries designed by Raphael. In the theological and artistic tradition, a series of scenes from the lives of both were usually included. The conversion of Paul was usually connected with the giving of the keys to Peter, and the beheading of Paul with the crucifixion of Peter. In this commission,

as in the *Sistine Ceiling* and the *Last Judgment*, Michelangelo again pushed for and won his own agenda, though it is difficult either to document what he proposed or to clearly understand what he intended.

The first painting, begun in December of 1542, was the *Conversion of Paul* (Figure 66), in which Paul, in accord with medieval tradition, was thrown from his horse, Christ having confronted him like a meteor soaring through the sky, so that Paul lies helpless, blinded, and overcome, but his head and upper body are already lifted from the earth. Rather than a gift of faith, the scene is more like an assault, one in which the martyrdom of his past is the precondition for his mission to the Gentiles.

The scene selected for the other painting, *The Martyrdom of Peter* (1547–49), in accord with the tradition in which Peter does not count himself worthy of being crucified upright, shows him upside down on the cross, his face toward us, as the cross is being lifted into position.

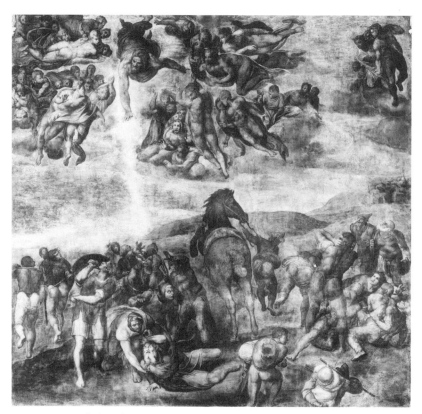

FIGURE 66. Michelangelo, *Conversion of Paul*, Pauline Chapel, Vatican Museums, Vatican City.

Leo Steinberg has made the case that this painting is Michelangelo's testament to the notion that the church rests on the martyrs.[38] The same, I think, can be said of the *Conversion of Paul*. Several factors favor that interpretation for both paintings. First is Michelangelo's recognition of the suffering of the church as it tries to reclaim its life in the face of internal decay and the aggressive attack of the northern Protestants. Second is his recurring and increasingly stronger feeling of the unworthiness of his own life, making a form of self-sacrifice important. Without calling the role of the papacy into question, Michelangelo moved the subject matter of a papal chapel to fundamental religious issues in the life of the church.

Religious Conflicts and the Emergence of the Nicodemites

The 1540s, '50s, and '60s represented the gradual but increasing pressure of the papacy against alleged heresies, all in behalf of conformity to the doctrines being articulated at Trent. This pressure is symbolized in the reconstitution of the Inquisition, papal opposition to the document *The Benefits of Christ*, rapid growth of the new Society of Jesus, and the further consolidation of papal prerogatives.

While Contarini died in 1542 and Vittoria Colonna in 1547, both had come under suspicion of heresy but died before charges could be brought against them. The reforming religious societies, first the one at Naples, inspired by Valdes, and then the circle at Viterbo led by Reginald Pole, evaporated, because of death, pressure, or flight. In 1542, Peter Martyr Vermigli and Bernardino Ochino, having learned that they were to be prosecuted by the Inquisition, had fled to the north. Also, pressures at such reformation centers as Lucca, Milan, and Ferrara visibly sidetracked reforming groups.

In 1543, *The Benefits of Christ* was published in Venice and was soon attacked as heretical. The document, originally drafted by a Benedictine monk, was further developed by the poet-reformer Marcantonio Flaminio. It reflects both indigenous Italian sources and the more explicit reforming ideas stemming probably from Flaminio's reading of Calvin. Reading the document in our day hardly raises an eyebrow for either Roman Catholics or Protestants. But in its own time, it signified a view of justification by faith that was being rejected at Trent.[39]

Among some of the cardinals, hope continued in spite of adversities. Reginald Pole, whose views on justification were part of the debate in the early sessions of Trent, was conveniently absent with illness when the pressure at

Trent was at its height. But in spite of the suspicion that he was not orthodox, he lost election to the Papacy in 1549 by only one vote. Returning to England under Queen Mary to consolidate the English church, he died with the cloud of suspicion surrounding him, even though he rigorously enforced the decrees of Trent against opponents. Cardinal Morone, under suspicion initially because he did not suppress alleged heretics in his diocese of Modena, presided at sessions of the Council of Trent. But before Trent was adjourned, he was held in prison and given a trial but not condemned by the Inquisition.

In such a climate, the hope for reform within the Italian scene meant being careful and biding one's time. For instance, while Cardinal Carafa had been a colleague and friend of the cardinals, as Paul III he became very conservative. But care in that situation meant not being too public about one's convictions. Hence, those who had promoted reform in public associations either capitulated or, keeping their thoughts to themselves or to small private groups, kept the practices of the church in terms of outward conformity, hoping for a better day. Such individuals became known as Nicomedites, Christians who held their conceptions of the gospel in secret.[40] The term is based on the biblical Nicodemus who came to Jesus by night (John 3:1ff).

In 1543, Calvin began his stern writings against the Nicodemites, initially addressed to such Christians in France. But the term was also associated with the Italian scene, as is evident in the letters of Martinengo, a pastor of the Italian group in Geneva.[41] Indeed, he echoed Calvin's thought that out of love for the neighbor, that is, not creating public conflict, one should not dishonor God. In Calvin's and Martinengo's minds, God's honor required a consistent, public confession of faith, no matter what the consequences might be.

Calvin and the Nicodemites represented viewpoints that could not be reconciled. Calvin had hoped that reforming currents would succeed in France, and perhaps initially, without much evidence, in Italy as well. One recalls that the first volume of the *Institutes* appealed to Francis I to reform the church, and Calvin also counted on the influence of noblewomen with Protestant sympathies to make a major difference, particularly in France.[42] Thus, three factors seem to lie behind Calvin's stringent views. First, a true faith means abandonment of the Catholic Church and the papacy. Second, his conviction is that reform could have been accomplished if believers had publicly witnessed to the faith, without compromise or dissimulation. Third, true faith must be expressed in public ways, in deeds and worship that glorify and honor God.

By contrast, those who worked for reform within the Catholic Church of Italy never felt that they needed to challenge the papacy. They could stress

justification by faith and the centrality of grace within the church as constituted. Given that orientation, it was natural to lie low, waiting and working for change in the midst of papal pressure.

But in the light of the conservative victory in the Council of Trent, such hopes were no longer realistic by the end of the 1560's. Those interested in reform were silenced, and being a Nicodemite was no longer a viable alternative. The trial and execution of Pietro Carnesecchi, who had been associated with the major cardinals interested in reform, was a dampening influence. More positively, the development of the Society of Jesus as the agency for the aggressive propagation of the Tridentine faith through preaching and educational activities, provided a climate of faith that coincided with the papal pressure for uniformity and the suppression of heresy. But that part of the development takes us past Michelangelo's life. Nor should one confuse Michelangelo's interest in Ignatius of Loyola or his making of a sketch for the Jesu in Rome with the subsequent Jesuit developments.

The *Florentine Pieta* and the Last Years

It should be noted that while the *Martyrdom of Peter* was being painted, Michelangelo was also starting to sculpt the *Florentine Pieta* at night. In and of themselves, the Pauline paintings were largely ignored by the public, perhaps because of the privacy of the chapel, partly also because there were no obvious reasons for objecting to either their content or style.

The *Florentine Pieta* (Figure 67), which Michelangelo intended for his own tomb, reflects his own religious outlook in a time when the first wave of the suppression of heresy was under way. But it was also a time when hope for reform had not been extinguished, Cardinal Pole having almost been elected Pope in 1549, while Popes Paul III and Julius III were supportive of Michelangelo's work. It was also a time to be careful, however, for Michelangelo had been accused of heresy by anonymous sources, while negative judgments about the nudity of the *Last Judgment* continued. Surely, he was aware of the suspicions surrounding the life of Vittoria Colonna, who had died in 1547, and her friends, some of whom he may have known.

De Tolnay, in his early and masterful work on Michelangelo, states that the artist ". . . remained faithful to his religious ideas. He was almost the only important representative of this older, liberal, and humanistic Catholicism after the establishment of the Inquisition."[43] Being faithful to his religious ideas, however, did not mean for Michelangelo what it meant for John

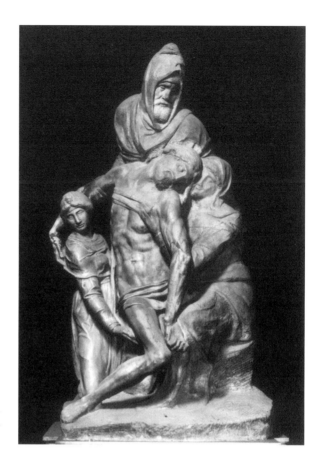

FIGURE 67.
Michelangelo,
Florentine Pieta, Duomo
museum, Florence.

Calvin. Michelangelo's conception of faith never called for new structures of
the church, as did Calvin's. While his was a faith that he would not deny, he
did not feel called on to confront opposing currents. Rather, he was willing to
express his faith in his sonnets and works of art, away from clerical or theo-
logical expression and responsibility.

For those who had eyes to see, the *Florentine Pieta* disclosed his identifica-
tion with the new reforming currents through a self-portrait in the guise of
Nicodemus. Given that the term Nicodemite at this period was a form of pos-
itive identification for those so inclined, and negative for those who saw it as
heretical, the self-identification with Nicodemus represents his own
testimony of faith.[44] Michelangelo at once identifies himself with the Chris-
tians who secretly go their way, avoiding if possible the new forces of repres-
sion, and with the faith that Nicodemus embodies. In the biblical story of
Nicodemus, the birth of faith has the character of a gift, not a decision to be

made or something to be earned. Hence, in the Pieta, Michelangelo as Nicodemus, the symbol of faith, embraces the fellow believers, Mary the Virgin mother, and Mary Magdalene, the repentant sinner, the trio simultaneously encircling and disclosing the dead Christ in adoration and lamentation. The left hand of Michelangelo as Nicodemus is placed on Mary's back but embraces Christ through the posture of Mary's body holding Christ's armpit. The right hand of Nicodemus is holding Christ's right arm, but that arm is encircling Mary Magdalene. Hence, Nicodemus encircles the whole in the way in which the two women are positioned in relation to Nicodemus and to Christ.[45]

Intended for his tomb, and uncommissioned, it is a personal testimony. Nicodemus, a secret Christian who yet takes responsibility, along with Joseph of Arimathea, for the burial of Christ, is a person of faith, a faith that was born in the dramatic encounter with Christ. Hence, the secret practicing of faith is also a confession of faith, one that can survive as popes come and go. This personal testimony is not the whole of faith but its center. It can thus be practiced in many settings.

But it is a faith deepened and changed to such an extent that it finally leads Michelangelo to doubt the wisdom of having done what he did in the Sistine chapel. The extent to which the change is a matter of developing faith or changing cultural perceptions demanding differing expressions is not easy to assess. Elements of both are undoubtedly present. It is clear that the depiction of human bodies generally, and of Christ and the Virgin in particular, are different in this Pieta than in the earlier works. In the Sistine ceiling, the bodies are ideal, mirroring a beauty that is not characteristic of any one person. In the *Last Judgment*, the bodies, in the process of being resurrected, range from the Christ figure, whose perfection is apparent, to the distorted bodies writhing in the process of redemption. In the *Florentine Pieta*, the figures are less grand in scale, with a humanity that is focused on the Christ whose life, and now death, had focused their faith.

Gone is the total nude. The change is not related to the difference between fresco painting and sculpture. The David of 1501–1504 in the Accademia in Florence, is nude, as is the Resurrected Christ of 1519–1520 in Santa Maria Sopra Minerva in Rome, though the latter now has a large bronze drapery covering the genitals. Something has transpired that made the difference between the earlier figures and the Pieta, something unrelated to the medium employed by the artist.

Probably Michelangelo no longer lived in the orbit of the classical world that had formed the ambience of his art, nourished initially both by the dis-

coveries of antique sculpture in Rome and by Renaissance literature. Michelangelo had now appropriated the new and different moral tone that equated the nude with paganism.

But if that is the case, he may have recognized by 1555 that the tradition of the slung leg, about which Leo Steinberg has written, was also no longer acceptable. In great detail, Steinberg delineates the tradition in which Christ's leg over Mary's is a sexual allusion, standing for the Virgin as the spouse of Christ or for the mystical marriage of the church and Christ that is expressed in such bodily perceptions.[46]

In 1555 Michelangelo tried to destroy the *Pieta*, splintering the arm of Mary and a leg of Christ lying across one of Mary's legs. Prevailed upon, Michelangelo stopped and permitted the arm to be restored. But the

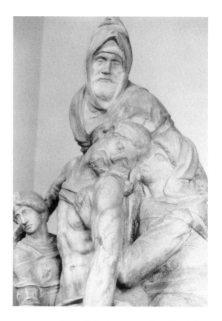

FIGURE 68. Michelangelo, detail of the *Florentine Pieta*.

leg was never replaced, the hole for that sculptural member being evident in the sculpture to this day (Figure 68). Steinberg's opinion is that Michelangelo, who had followed a tradition in Christian art in using the "slung leg," now came to the conclusion that he had pushed the carnal analogies past the limit of what is appropriate for art, and that the attempted destruction was a form of renunciation of his work.

Various reasons were given by Michelangelo's early biographers, particularly Vasari, for the attempted destruction of the sculpture, such as the marble having a flaw, the marble being too hard, and his despair of doing it well enough. None of these seems convincing.

Others have also alluded to the possibility that by 1555 it had become apparent to Michelangelo that his view of faith was now technically heretical. Perhaps being a Nicodemite was no longer possible, demanding a public confession or abandoning his personal convictions. Still, he did not attack the figure of himself as Nicodemus, though he may have intended to destroy every figure. We do know that several events happened by 1555, including the advent of Paul IV, who dismissed Michelangelo, whom he did not like, as architect to the Vatican, and instituted strict measures such as hangings, scourgings, and banishment for the repression of heretics. Also in that year,

as Valerie Shrimplin-Evangelidis reminds us, the Diet of Augsburg ended all possibilities of one religion by recognizing that territories would be either Protestant or Catholic, depending on the ruler.[47] These factors, Shrimplin-Evangelidis further suggests, combined to create a situation of fear, certainly of disappointment, regret, and resignation, that led to the attempt to destroy the sculpture.

We may never know with certainty why Michelangelo tried to destroy the *Florentine Pieta*. Steinberg's analysis does account for his destroying the leg but not for the destruction of the arm. "Off with their heads" does not seem to have been operative, though if the Nicodemus identification now was the problem, would that not have been the logical place to start? Moreover, if Michelangelo was really determined to destroy the sculpture, he could hardly have been dissuaded; and he would have had other occasions to do it. The most that can safely be said is that the sculpture does identify Michelangelo with those who believed in justification by faith in ways that are analogous to those of the Protestants, whether based on them or on Italian sources, and who at that time increasingly had to keep a low profile. Perhaps Michelangelo decided that the actual destruction of the sculpture would mean denying where he stood, and that having to deny that he was a Nicodemite would be to deny his faith. So, the motivation could be similar to that of Calvin but with a totally different context and conclusion.

Eight years later, Michelangelo was working on the *Rondanini Pieta* (Figure 69), and in the next year, 1564, while still at work on this much-revised composition, he died. In this work Michelangelo identifies himself not with Nicodemus but with Christ, a conceit used by other artists such as Albrecht Dürer as well. The motif is that of identifying with the life and sorrows of Christ, the willingness to know suffering and its redemptive possibilities. It is clear, in any case, that in this last uncompleted work, Michelangelo still stood in the faith that had formed the last half of his life, one in which he believed in spite of his doubts and with the feeling that he was unworthy of salvation.

Although the subject matter of the last two Pietas does not in itself suggest heretical views even as later defined, there is no doubt that his associations, thoughts, and renderings could have put him in danger. Possibly because of his fame, and possibly also because his friends surrounded him with orthodox interpretations, he was never a subject of the Inquisition.

In the range of his work, Michelangelo was the master of the male human figure. From the classical ideal of the *Sistine Ceiling*, through the grand and tragic figures of the *Last Judgment*, to the more somber delineations in the *Florentine Pieta*; from the bolder massive yet ethereal figures to the smaller,

faith-driven figures, Michelangelo had a respect for the human figure, male and female, that in itself was a form of devotion. In Michelangelo's works there are no gruesome details in which the body is riven and torn. Rather, the perceived meanings are in the total composition rather than in details that impinge upon the human figure. That the human mirrors the divine meaning never changed in Michelangelo's mind. But that idea changed form as his biblical understanding became more central in his life.

It has been noted that in the last decade of his life, Michelangelo increasingly felt that his work as an artist had been frivolous, inappropriate for a Christian, whose allegiance was to Christ. In one of his poems, he states that the "impassioned fancy . . . that made art an idol and a king to me, was an illusion and but vanity," and then concludes, "painting and sculpture satisfy no more, the soul now turning to the Love Divine, that opted, to embrace us, on the cross its arms."[48] With advancing years, Michelangelo felt more keenly that his life, so full of misguided loves of every kind, was so unworthy that only the grace of God was adequate. But that grace was simultaneously beyond his grasp and the only reality on which he could count.

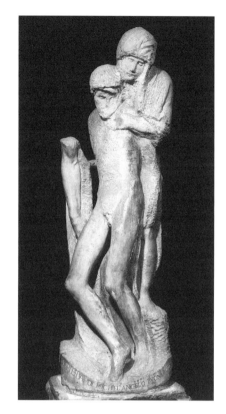

FIGURE 69. Michelangelo, *Rondanini Pieta*, Castello Sforzesco, Milan.

The poems, like his art, reflect a pilgrimage in which the fruit of his younger years looked decayed in the retrospect of age. He doubted what he had done, yet he kept on doing it. It is evident that until the end he continued to sculpt the Rondanini *Pieta*. That creative contradiction is well expressed by Rolf Schott in his section on the poetry of Michelangelo. "All his days he was a beggar at the feet of Eros, filled with the desire to be absolved in the infinite love of God."[49] But he also knew that his art, whatever the nature of the love that prompted it, would outlive him. And so we are the heirs of gifts that graced both his life and his art.

THREE ARTISTS WITH
DISTINCTIVE ACCENTS

WHILE GRÜNEWALD, DÜRER, CRANACH THE ELDER, and Michelan-
gelo each reflect a lifetime of wrestling with the religious currents of reform
in relation to their art, Holbein the Younger, Hans Baldung Grien, and
Albrecht Altdorfer represent unique accents in their art, though each of them
also executed works with traditional religious subject matter. Holbein turned
an aversion to the religious conflicts of his time into a new arena of work,
what we might call the cult of the portrait. Baldung stressed the fateful con-
sequences of human sin, which in his art is interpreted mainly in sexual,
misogynous terms. Altdorfer manifested the problems of an artist who was
also an important citizen in the politics of Regensburg, with the consequence
that his art mirrors his own cultural/religious pilgrimage. Both Baldung and
Altdorfer reflect the darker side of human nature, which might be termed
the undertow of Renaissance humanism.

Hans Holbein the Younger: Toward the Cult of the Portrait

Hans Holbein the Younger (1497/98–1543), known mostly for his portrait
paintings of the English court during the reign of Henry VIII, also did a large

number of paintings of traditional religious subjects, particularly before he settled permanently in London. Living in Basel from 1514 on, he also took many side trips in Switzerland; in 1524 particularly, he traveled in France, everywhere picking up new stylistic innovations. In 1526 he went to the Netherlands but continued on to London, probably at the urging of Erasmus. In 1528 he returned to Basel, but within three years he returned to London, where he lived until his death from the plague in 1543.

In Basel, Holbein befriended Erasmus and executed several portraits of him. Already in 1515 Holbein had illustrated Erasmus's *Praise of Folly*. From his 1517 *Adam and Eve* to his first trip to England in 1526, Holbein did an extensive number of works with religious subject matter, among them *Christ as the Man of Sorrows*, *The Virgin as the Mater Dolorosa*, *Body of the Dead Christ*, *The Oberried Altarpiece*, *The Solothurn Madonna*, and *Noli me tangere*, as well as woodcuts for *Images from the Old Testament* and the *Dance of Death*.

As subjects, none of these is surprising, though the execution, as in the *Body of the Dead Christ* (Figure 70), is startling in its anatomical rendering of the dead figure.[1] Some of them are executed from 1522 on, a time when reforming currents were under way in most parts of Europe. Some of the works were commissioned by persons who continued loyal to the Catholic Church. In any case, there is no indication that reforming influences had an impact on him or his work before about 1525. Even then, Holbein was confronted more by the fact that the reforming currents dried up commissions than by convictions about the religious ideas. Surely one of the factors that led him to England was the possibility of a more favorable climate in which to work. Still, this was an experiment, for Holbein was bound by the city council to return for work in Basel.

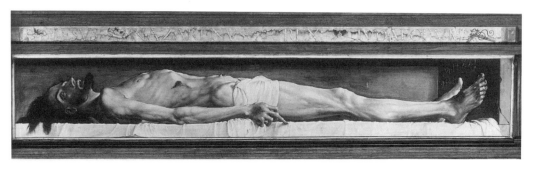

FIGURE 70. Holbein the Younger, *Body of the Dead Christ*, 1521, Kunstmuseum, Basel.

Apparently, Holbein's path in London was facilitated by a letter from Erasmus to Thomas More, who not only provided contact that led to work for the crown but also commissioned him to do portraits of himself and his family. By now his livelihood increasingly depended on his gift for portraiture.

Upon his return to Basel in 1528, the religious climate had changed, and a year later, Basel became a Protestant city. The iconoclasm, as will be noted in the next chapter, occurred later than in many cities, but when it did it was fierce, leading Erasmus to leave Basel for good. Some of Holbein's works were destroyed in the process, though many of them had been retrieved by donors. In 1530 Holbein himself was asked to conform to the new faith, though he did not do so without asking to be convinced on matters having to do with the Sacraments. By that time, he had already executed woodcuts that identified him with reform, particularly one on the Sale of Indulgences.[2] But it was clear that the future did not lie in Basel.

When Holbein returned to London, changes there, too, were happening. By the time he left England in 1526, the public already knew of Henry VIII's association with Anne Boleyn. When Holbein returned to England, probably early in 1532, Henry VIII had been acknowledged as Supreme Head of the Church of England, and in 1533 Henry VIII married Anne Boleyn. Since Thomas More, who had been Holbein's introduction to English life during his first visit, stood against the divorce of Henry and Katherine of Aragon, he was executed in 1535. In the same year began the events that led to Anne Boleyn's execution the following year, 1536.

But in the years between 1532 and 1535, Boleyn's influence on Henry and his directions for the church was pronounced. She was also anticlerical in outlook, urging Henry to claim revenues she felt belonged to the crown. For the same reason, she also encouraged the closing of many religious houses. While she favored the traditional liturgy, she defended Protestants who were in trouble. Not a single heretic was burned while she was Queen.[3] While it is not known when and to what extent Holbein was directly within the orbit of the monarchy, it is clear that he worked for a group of individuals, particularly Thomas Cromwell, who were for reform. Cromwell was probably responsible for Holbein's doing two works of art identified with reform: the English compilation of verses from the Bible by Miles Coverdale, for which Holbein did an elaborate woodcut in which the king is represented as head of both church and state, appropriately crowned; and the grisaille miniature *Solomon and the Queen of Sheba* (Figure 71), meant to be a presentation piece to the King at an unknown event. Here Solomon has the features of Henry

himself, while the queen of Sheba, through an odd use of II Chronicles 9:6–8, symbolizes the church as subservient to the Crown.

Both the Coverdale Bible and the Solomon miniature justified the role of the English sovereign with respect to both church and state. Only the oil painting *The Allegory of the Old and the New Testament* (Figure 72) can be said to reflect the full Reformation context. It is obviously dependent on Cranach the Elder's law and gospel sketches and paintings, which were discussed previously. Hence, the date could not be before the early 1530s. In Holbein's version, we see the tree of good and evil in the center, bare at the left, verdant at the right, with the word "homo" and the human figure in front of the tree—the latter being urged by Isaiah and John the Baptist to concentrate on the

FIGURE 72. Holbein, *The Allegory of Old and New Testament*, National Galleries of Scotland, Edinburgh.

area of Redemption. On the left side, from top to bottom, one sees Moses receiving the commandments, the brazen serpent as symbol of the impending crucifixion, Adam and Eve being expelled, and the figure of death. On the right side, from bottom to top, is Christ trampling on death as he emerges from the tomb, Christ as the lamb of God with disciples, the crucifixion, and finally the kneeling Virgin with the levitating Christ child carrying the cross.[4] Each figure, or combination of figures, has a Latin identification of the subject. Hence, above Moses is Lex, and above the Virgin and Christ child at the right is Gratia.

The question remains, who commissioned this work? It does not represent the thinking of Henry VIII. Nor is it evident that Holbein himself identified with the subject. One may venture that it represents the viewpoint of

the commissioner, probably the viewpoint of one of the English reformers who was closer in theological outlook to the continental reformation than was Henry VIII. The changing political alliances, in which the Germans were counted on briefly as allies, may be in the background. Moreover, we know that there was considerable contact between some of the German reformers and individuals such as Cranmer and Cromwell.

This may well be the context in which Holbein did the *Portrait of Philip Melanchthon* (Figure 73), which was painted at the bottom of a wooden box with an ornamental lid. But it may also represent the close identification of Erasmus and Melanchthon, both of whom as scholars saw reform in more humanist contexts.

The double portrait of Jean de Dinteville and Georges de Selve, known as *The Ambassadors* (Figure 74) also seems to encourage reform. The occasion for the painting was the visit of de Selve to his friend de Dinteville, the French envoy to London under Francis I. Whether de Selve brought special instructions from Francis I for de Dinteville is not known. What is known is that the French were involved in unsuccessful negotiations with the Vatican with respect to Henry's marriage and succession problems. But Holbein's portraits of the figures, probably arranged for by persons in the reform movement in Henry's government, place the two men before us as worthies, who

FIGURE 73. Holbein, *Portrait of Philip Melanchthon*, Niedersächisiches Landesmuseum, Hannover.

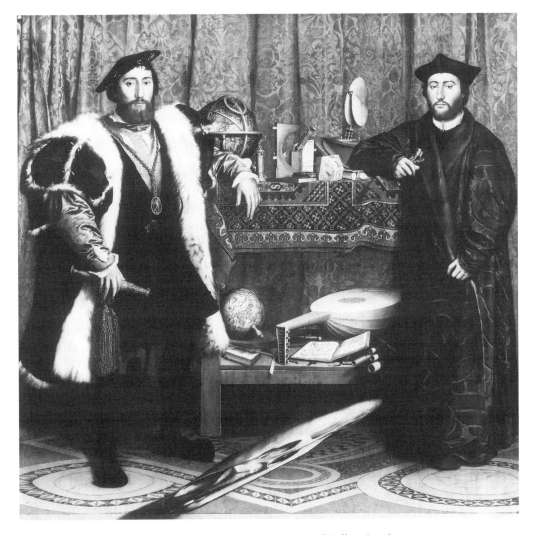

FIGURE 74. Holbein, *The Ambassadors*, National Gallery, London.

in their being exemplify a noble role of support for reform in England. That is confirmed by the objects conspicuously placed between the two: a lute with a broken string, itself a symbol of discord, and behind the lute "a copy of Luther's translation of *Veni Creator Spiritus*, and the beginning of his text of the Ten Commandments, both of which texts indicate the direction of their religious sympathies as well as a timely appeal to the guidance of the Holy Spirit at that critical juncture."[5] On the floor in front of the ambassadors is a radically distorted skull, a momento mori.

Such comprise the sum total of the works that touch on religious subject matter while Holbein was in England. Given that they are so few in number, one should not exaggerate their significance. Moreover, they all have a social, political setting, with reference to the place of Henry VIII in religious affairs. Hence, they should not necessarily be read as expressing strong religious views on the part of Holbein himself. It would be more accurate to say that Holbein followed the fortunes of Henry VIII without getting into trouble.

While definite documentation of Holbein's work for the crown occurs after Anne Boleyn's execution, there is circumstantial evidence that Holbein was definitely in the picture before that event. Thomas Cromwell had promoted Holbein before Henry and Anne Boleyn. Holbein drew Boleyn's portrait and participated in designing pageants having to do with her coronation. Her role in reform coincides with the period in which Holbein did the works with religious subject matter.

But it may not be by accident that after Anne Boleyn's death, in the works that Holbein continued to do for Henry VIII the subject matter of religion disappeared. Holbein did portraits of Henry's successive wives and, more important, traveled to both France and Germany to do portraits of women who might be considered a potentially appropriate wife for Henry. Upon Jane Seymour's death after giving birth to the future king, Edward VI, Archbishop Cranmer suggested Henry's betrothal to the German Protestant Anne of Cleves. Holbein was sent to Germany to do a portrait of Anne of Cleves but apparently made her more physically pleasing than she in fact was. While Henry did marry her, he found her so unappealing that he could not consummate the marriage and it was annulled. Important to note is that Holbein was not blamed by the king for having made her appear attractive.

Final confirmation of Holbein's special place with Henry VIII rests in the fact that he survived the latter's favor even though the persons who had promoted him, Sir Thomas More in 1535 and Thomas Cromwell in 1540, were executed.

Holbein's fame rests on his portraits, particularly those done in England. Indeed, portraits took the place of saints in the emerging Protestantism on the continent and in England. In the section on Cranach the Elder, attention was given to the place that portraits played in the German reformation. In England, the portrait tradition became even stronger, for the English nobles loved to walk in winter in the long halls of their houses, contemplating the portraits on the walls as examples for ordering their own lives. It would not be too strong to suggest that in the English scene the cult of the saints was replaced by the cult of portraits.

Hans Baldung Grien: Misogyny and the Devil

Baldung Grien was a student in Dürer's studio from 1501 to 1507, worked in Halle from 1507 to 1509, and from 1509 on, except from 1512 to 1517 when he lived in Freiburg im Breisgau and executed the *Coronation of the Virgin* for the Cathedral, he spent the rest of his life in Strasbourg. Related to an eminent family of lawyers and public officials, Baldung himself did not follow in that tradition. Nor were he and his wife part of the upper class, though they were secure enough financially, mainly as the result of land deals, to be able to live with the loss of regular church commissions. In the last year of his life, Baldung was a member of the city council, surely an indication that he was not without standing in the social order. That, too, is evident in his doing portraits of the leaders of Strasbourg's social and civic life.

It is clear that Baldung participated in the movements of reform in Strasbourg as they became more pronounced and prominent. What is not clear is the extent of his own religious convictions. Thomas A. Brady suggests that he was not deeply involved in religious questions.[6] Perhaps at this level he was akin to Holbein. Linda C. Hults and Joseph Leo Koerner, while not commenting on Baldung's own religious thoughts, make the case that theological understandings of the time provide a necessary background for understanding him.[7] What seems clear is that the Reformation in Strasbourg did not represent a dividing line with respect to Holbein's subject matter, though it did lead to limited church commissions and to portraits as a substitute.

In 1507, Baldung executed a triptych, *The Martyrdom of St. Sebastian* (Nuremberg Museum), as a commission for a church in Halle. The subject is a standard one, as is evident in Grünewald's *Isenheim Altarpiece* some five years later. In Baldung's version, St. Sebastian stands frontally toward us, but his face is turned sideways toward the two executioners whose bows are strung and aimed at him. Behind both, Baldung has placed himself, with one eye looking out toward us and with no apparent involvement in the event he is depicting.

Two years later, Baldung, while still in Strasbourg, did the *Madonna and Child with St. Anne* (Basel) and the *Trinity with the Virgin and St. John* (London). But Baldung's most important directly commissioned work is *The Coronation of the Virgin*, executed in Strasbourg in Breisgau between 1512 and 1516, a work still present in the cathedral. In 1521, he did a woodcut of *Luther with Nimbus and Dove*, but in and of itself that need mean no more than that Baldung identified himself with Luther in ways unknown to us. At that date, Baldung could be as close to Erasmus as to Luther. Between 1528 and 1530,

he did the *Madonna with the Parrots* (Nuremberg) and in 1539, *Noli me tangere* (Hessisches Landesmuseum, Darmstadt).

In these traditional Christian subjects done throughout his career Baldung does not follow the tradition of an appropriate piety; rather, his figures stand out on their own, occasionally with sexual overtones, sometimes in strange juxtapositions. For example, in *The Madonna with the Parrots* (Figure 75), the parrot represents virginity but the Madonna exposes her breast for us to see. Writes Linda C. Hults, "Mary, posed alluringly and glancing out at us from almond-shaped eyes, holds her hand to call attention to her bared breast. A parrot nibbles at her jeweled neck, while an angel draws a transparent veil across her carefully dressed hair. The child's puckered mouth rests against her nipple. We are struck simultaneously and equally with the remote ideality of the image, the sense of a refined, elegant and distant world, and by the pointedness of the sensual details."[8]

But in his simultaneous versions of Adam and Eve, death and the flesh, and witches, the sensual has moved from an accompanying to a central motif. With respect to Adam and Eve, the contrast with Dürer is most important, for the latter, after all, was Baldung's teacher and friend. Dürer's *Adam and Eve* of 1507 (Prado, Madrid) are the ideal figures of creation, figures that do

FIGURE 75.
Baldung Grien, *Madonna with Parrots*, Germanisches National-musuem, Nuremberg.

not exist in history but as projected by the artist into a prelapsarian or pre-Fall mode. It is a way of thinking God's thoughts after the fact, an imitation of God particularly reserved for the role of the artist. Hence, Adam and Eve stand before us self-contained, with the pristineness of original creation. They stand before us for our gaze but not for our involvement.

Baldung's *Adam and Eve* panels of 1507–1508 (Uffici, Florence), modeled after Dürer, are of another spirit. They are not self-contained, the bodies are unique rather than ideal, and their gaze meets and involves us, as if we also were part of the drama. In the pen-and-ink drawing of *Eve and the Serpent* (1510, Kunsthalle, Hamburg), Eve stands before us in a provocative posture and her eyes are upon us. In the 1525 *Adam and Eve* (Figure 76) Adam struts before us and Eve reveals her sexuality in the very act of being so demure.

In Baldung's version of the created Adam and Eve, sensuality as a conscious perception is already present. It is as if Creation and Fall coincided, or, at least, as if sensuality as a problem precedes the Fall. History already had its predeterminedness.

FIGURE 76.
Baldung Grien, *Adam and Eve—Fall of Man*, 1525, Museum of Fine Arts, Szepmüveszeti Muzeum, Budapest.

In Baldung's depictions of Adam and
Eve and the serpent, the fatedness is
expressed in the equation of sensuality with
sexuality. In the 1511 woodcut of the *Fall*,
Adam, standing slightly to the rear and yet
beside Eve, reaches up with his right hand
for the apple in the tree and with his left
hand holds Eve's breast from below. In a
1519 woodcut of the Fall, Adam moves
behind Eve, who has an apple in her left
hand, and with his right hand titillates/
covers her pubic area with a twig that still
has an attached leaf. In a 1531–1533 oil
panel (Figure 77) Eve also holds the apple,
while Adam, standing behind her, places
his left arm beneath Eve's arm and grasps
the upper part of her thigh while his right
hand is placed firmly below her right breast,
drawing and holding her close as their
cheeks meet side by side.

It is widely known that in the church
sensuality as sexual expression is one way of
thinking about the Fall, though the Fall is
also interpreted as dulling the pleasures of
sex. Both views are present in Baldung; sex
seems not to deliver what it promises.

Eve is assigned major responsibility for
the Fall. The misogyny that is so character-
istic of much of the history of the church is

FIGURE 77. Baldung Grien, *Fall, Adam
and Eve*, 1536, Thyssen—Bornemisza,
Madrid.

clearly expressed in Baldung's works. It is not that Adam escapes blame, for
he is also shown picking the apple from the tree. But there is no doubt that
their common destiny involves the consequences of Eve's primary role.

For Baldung, as others before him, the consequence of sin is death. His-
torically, the Dance of Death is the symbol that we all must die. While such
depictions are generally conveyed in skeletal form, Baldung opts for showing
us the decay and destruction of the human body. In the 1506 pen-and-ink
drawing of *Death with an Inverted Banner* (Kunstmusuem, Basel), death is
depicted in a figure whose arms and legs are almost skeletal, the upper body
and face show contorted flesh, and the pubic area is riven. The 1510–1511 oil

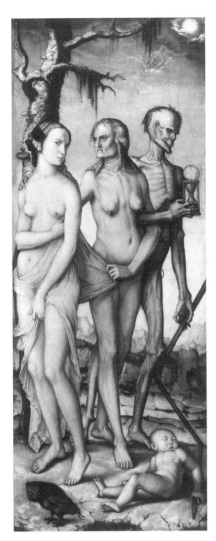


FIGURE 78. Baldung Grien, *Death and Three Ages of Woman*, 1540–43, Prado, Madrid.


panel *Death and the Maiden* (Kunsthistorisches Museum, Vienna) shows Death, a mixture of bare skeleton and partially missing flesh, reaching for the apple; the maiden looks in a mirror, thereby disclosing Vanitas, while a child and older woman disclose that the scenario crosses ages, the latter being more explicitly present in the 1540–1543 oil painting of the *Three Ages of Woman* (Figure 78). The 1530 oil panel *Eve, the Serpent, and Death* (National Gallery of Canada, Ottawa) similarly has the cadaverous death figure reaching for the apple, while the nude Eve has her hand on the serpent. In this work and in *Death and the Maiden*, Death could also be Adam, for the figure is reaching for the apple. The consequences of the Fall are evident before the eating. In the painting circa 1518–1519, titled *Death and the Woman* (Basel), the woman seems to be disrobing, being nude to the pubic area, while Death possesses her from the rear, biting her neck and cheek.

The third and most pronounced area in which sensuality is evident is in his portrayal of witches. The topic is not unusual, for Dürer too sketched them, as did Albrecht Altdorfer, whom we shall discuss in the next section. But the sheer scale of the preoccupation with the subject and the exhibition of witches as women, nude if younger and partially covered if they are older, is unique to Baldung. A 1510 woodcut of the *Witches' Sabbath* (Figure 79) shows three nude women mixing the witches brew, while in the scene just above, a fourth one exhibits the witch's flight. A 1514 pen-and-ink drawing has three nude women picking up sticks, wands, and the like, two of them placing them in their pubic areas, perhaps for satisfaction but probably also as rites in which men are made to have both erections and bouts of impotence. Baldung's *New*

FIGURE 79.
Baldung Grien, *Witches'*
Sabbath, c. 1514, pen and
ink, Louvre, Paris.

Year's Sheet (Figure 80), a gift to a cleric, shows three nude women in acrobatic postures, with the witches brew held aloft by one of them while also stimulating herself with her other hand; another witch is in a crouched position, with her upside-down face leering at us from between her legs. While as a work of art this sheet has considerable charm, precisely the opposite is the case in a pen-and-ink drawing titled *Witch and Dragon* (Kunsthalle, Karlsruhe), in which fluids flow from orifice to orifice.

In 1544, the year before his death, Baldung did a woodcut titled the *Bewitched Groom* (Figure 81). Three figures define the scene. A witch with bare breast leans over a window sill, peering in, and brandishing a flaming torch. Dominating the same plane is a horse, its rear toward the viewer but with the horse also looking back. On a slab, a tomblike floor just before us, lies the groom, feet toward us. Below him lies the groom's pitchfork, and alongside him, the currycomb. Nearby is Baldung's family crest, and the facial characteristics of the groom seem to be those of Baldung himself.

FIGURE 80. Baldung
Grien, *New Year's Sheet*,
1514, pen and ink,
Graphische Sammlung,
Albertina, Vienna.

While the interpretations of this woodcut are numerous, one point is clear. Late in his life, Baldung not only continues to execute the subject of witches but now seems to be the victim of their overwhelming power, a power so great that only a miracle from beyond can save him.

Obviously, the attention given to witches ups the ante on the question of what Baldung conveys or intends to convey. While recent scholarship rejects the notion that witch-hunts were prevalent in this earlier period,[9] and that the major witch-hunts occurred after 1550, it is also clear that early on the most erudite scholars believed in witches. Humanist scholars, reformers, and preachers believed in their reality and that they affected the world through their rites. Apparently, Baldung was influenced by these groups. For example, Johan Geiler of Kaysersberg, the famed Strasbourg cathedral preacher during Baldung's early period in Strasbourg, believed in witches but was not

FIGURE 81.
Baldung Grien,
Bewitched Groom, 1544,
woodcut. Cleveland
Museum of Art, Cleveland.

sure whether they flew or simply gave the illusion that they were flying. As
Levack has also shown, witchcraft became powerful when what the academic
types believed was also increasingly believed among all segments of society.
Baldung expresses a viewpoint that gains rather than loses popularity in the
period that follows him. Baldung is serious about what witches portend.
While it is sometimes said that Baldung is satirical in his depictions, there
seems no evidence to this effect. For Baldung, witches seem to be the final
exhibition of the power of evil, one manifest in sexual expressions that at one
and the same time are enticing but unsatisfactory in what they deliver. For
Baldung, humans seem to have no escape, except the possibility of God's ulti-
mate victory. Still, while witches express ultimate denial of God, Baldung
gives no hints that they should be destroyed. He is at once enticed and caught
in what they indicate about the human situation of sin and death.

When the reality of witches is widely accepted, the question arises, What is the theological context in which the human drama is seen? Here we return to the place of the devil in the thought of the time, which has already been commented on with respect to Grünewald, Michelangelo, and Luther. The assumption is that the devil, as fallen angel, has gained control of the events of life, though he cannot circumvent God's final victory nor perform miracles in his own right. The devil exercises power by claiming others to do his work, indeed by entering into a pact with humans, promising delight and power in exchange for abandoning and defaming what is known of God. Moreover, such work involves deceit, dangling a good that is really evil, or directly influencing the future by determining the lives of people, including making them specimens of evil, as in the case of witches.

The devil, more than those he empowers, is not sure of his final control of the world. He is not aware that God is defeating him in strategies that are concealed to ordinary human sight and expectations. But before the end time, the devil can create quite a rumpus. In his concern not to blame God for the human plight, Luther could refer to the devil as God's devil, so that in a hidden way the work of the devil is also the strange work of God, a work that also serves God's purposes.

The problem with the theological idea is that in its extreme forms it almost leads to a dualism of good and evil, and of excusing humans for their misdeeds inasmuch as they are not of their own doing. But on the other hand, human evil seems so pervasive that it is almost too much to blame it on humans alone.

For modern readers, the nature of that world is hard to comprehend. But it needs to be understood that even the Renaissance humanists believed in magic, or that Melanchthon, to Luther's regret, also did so, particularly with respect to astrological determinants. Magic, sorcery, possessions, witches were part of the fabric of the time. In short, there were demonic forces, structural and living. While Luther probably did not throw his ink well against the devil while at the Wartburg, the story testifies to a world quite different from ours.

Whatever Baldung's own religious beliefs may have been, he seems to have inherited the notion that human evil is so great that it is almost metaphysical by nature. Given that sensuality is the single lens through which he sees the issue, his focus is too narrow and too full of misogyny.[10] For him, human evil is pervasive but so narrowly interpreted that it distorted the very reality he affirmed.

Albrecht Altdorfer: Artist of Many Stripes

Altdorfer spent most of his life in Regensburg, working as an artist while being a member of the Council of External Affairs and of Inner Affairs, an architect for the city, and the person responsible for the city's fortifications. Hence, it appears that Altdorfer was active in many circles.

In the world of art history, Altdorfer is known for his role as one of the originators of the Danube school, particularly the world of nature demarcated by the Danube river. Within his religious subjects, nature uniquely fills the spaces between actors in a drama that is being painted. Nature has a majestic presence, eerie, with elements of disorder in an overall whole. Hence his work has been referred to as "fantastic realism, perhaps surreal."[11]

Buildings too find more than an ordinary place in his works. Perhaps that stems from his work as an architect. Altdorfer's 1518 painting of the extensive Saint Florian Polyptych for the Collegiate Church near Linz, Austria, best reflects both influences. The human drama before God includes many individuals, but one cannot escape that the events take place in intimate relation to nature and architecture. Both seem to be more than a stage for humans, for nature and buildings are integral to the drama being played out.

The question arises, What role did Altdorfer's own religious views play in his art? At one level that is easy to answer. Regensburg moved to being a Reformation city only in 1533, just five years before his death. Hence, most of his life was spent in the Catholic orbit. In 1519, he was active in the group responsible for the expulsion of the Jews from the city over a five-day period. Economic decline was the alleged reason for the expulsion, and it was made possible by the death of the Emperor Maximilian, who had protected the Jews. It helps little to note that Altdorfer did two etchings of the synagogue before it was destroyed.[12]

On the site of the former synagogue, the Church of the Beautiful Virgin (Figure 82) was erected as a place of pilgrimage. On the altar was a Byzantine icon of Mary, and in the courtyard, the sculpture of the Beautiful Virgin, who was the object of the pilgrimage. The 1520 woodcut of the church by the local artist Michael Ostendorfer shows a banner, featuring the pope, and the keys of Peter, both hanging from the tower of the church, while in the courtyard are bands of pilgrims visiting the shrine in the hope that miraculous cures would abound. Both Luther and Dürer criticized the Regensburg shrine in particular.[13]

Apparently, Altdorfer was involved in the decision to create the pilgrimage church. Moreover, he did woodcuts of the Virgin, copies of which were

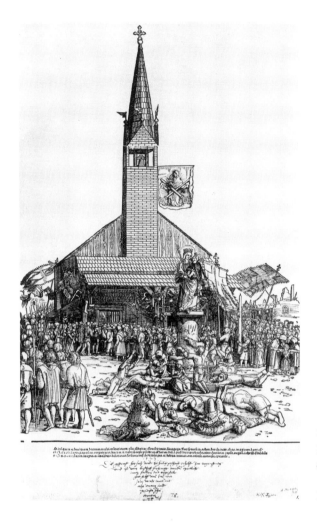

FIGURE 82.
Michael Ostendorfer, *Church of the Beautiful Virgin*, Regensburg, Metropolitan Museum of Art, N.Y.

used for purposes of veneration. In 1520 he also did a woodcut in five tone blocks, in which a simplified Madonna holding the child stands in an architectural niche (Figure 83).[14] In the same year, he also did a panel painting of the Beautiful Madonna in the Church, now to be found in the Collegiate Church of St. John in Regensburg. At a minimum, one can say that by 1520 there is no evidence that Altdorfer was influenced by Protestant reforming currents. But his woodcuts may have been part of the attempt to focus on Mary in a more simple style, free of overelaboration and overprogrammed assemblies of saints to the point of clutter. In this sense, he can be associated with reforming currents within Catholicism, such as those represented by Hieronymus Emser.

FIGURE 83. Altdorfer,
Beautiful Virgin, 1519–20, woodcut,
National Gallery, Washington, D.C.

FIGURE 84. Altdorfer, *Lot and his Daughters*, 1537, Kunsthistorisches Museum, Vienna.

FIGURE 85. Altdorder, *Susanna and the Elders*, Alte Pinakothek, Munich.

Finally, there is an element in Altdorfer's works that ties him to the tradition of Baldung Grien. His drawings of the *Wild Man* and the *Wild Family* both disclose humans in the abundance of nature, in an ambiguous relation to what we could call a civilized state.[15] In both instances, the unclassical nude, the postfallen nude, is the norm. Moreover, as early as 1506 Altdorfer drew a series of prints, among which is the Witches' Sabbath.[16]

In 1537, the year before his death, appears the curious painting *Lot and His Daughters* (Figure 84). One of the daughters sits in the nude before a series of

large green bushes, beyond which Sodom is burning. With her left hand on her head and her right hand held back, as if she had just sat down to face us, she seems bewildered. Between her and Lot and the other daughter is a tree that does not hide either but becomes the dividing line between the two groupings. Lot, also nude, lies on what looks like a hammock, and the nude daughter, also facing us, lies on Lot in such a way that her buttocks rest on his pubic area. In the left hand she holds a glass, while Lot, leering at her, holds her close to him with each of his hands caressing her arms. The context, of course, is the induced inebriation of Lot by his daughters.

By contrast, Altdorfer's painting of *Susanna and the Elders* (Figure 85), or *Susanna Bathing*, can be said to be chaste. In the midst of a large patio in front of a large structure, the old men are assembled. To the side of the patio, but on a lower plane, Susanna sits, her feet in a pan in which they are being washed, while what she wears covers her to her knees. One can imagine the leering men who see but do not see.

Susanna and the Elders is a chaste painting, while *Lot and His Daughters* is provocative. Perhaps the contrast is the difference between the chaste and the lascivious, terms that became so important in the aftermath of Trent.

PART III • *Iconoclasm and Beyond*

THE REJECTION AND
REPOSITIONING OF VISUAL IMAGES

<div style="text-align: right">7</div>

ICONOCLASTIC MOVEMENTS ARE INEVITABLY political, so much so that some historians see religious debates as irrelevant, masking what is essentially a social issue. Surely, religious perceptions are embedded in a social matrix; but a social matrix also has religious ideas as part of its very fabric. There is a difference between destroying an image because it is an idol to be cast aside and doing so because creating art and image requires money that could be used to help the poor. But we face a complexity that calling the situation social does not solve.

Historically, the continental Hussite and the English Lollard traditions formed and expressed a political-religious agenda that continued long after the suppression of the movements. In those settings, theologians both express and distort some of the reasons persons have for the responses they undertake. What we do know is that the Middle Ages had created a symbolism of Christian images unexcelled in Christian history and one that in spirit was analogous to a form of paganism expressed in phases of the Renaissance. But at the same time, countermovements against images were being spawned in wide sections of the population. These groups acted out of differing religious

motivations, social inequities, or a mixture that cannot easily be separated. Hence, the distinction between idolatry and iconoclasm is not valid, for the two are involved with each other.[1]

In what follows, the intention is to accent the religious ideas involved in the debates, whether of lay persons or of clerics or theologians, trying at the same time to be aware of the social setting. In starting that discussion, let us start with Erasmus, who reflected the ideas of a scholar but sensed the pulse of what the public was experiencing and thinking.

Reformation Theologians and Iconoclasm

Criticism of the cult of the saints and of relics was part of the late medieval world and for our purposes can be centered in Erasmus. His linguistic and scholarly interest in the sources of early Christianity laid a groundwork that made possible the very development of ideas that he later repudiated, much as in the case of Luther. He was one of the early voices against the cult of the saints, except when the saints were seen as subservient to the religious center in Christ. Saints were not to receive the adulation appropriate to Christ. Further, Erasmus was one of the major denouncers of relics, sarcastically, for instance, referring to the size of all the collected pieces of the true cross. He did not like the art of Italy and preferred northern art, that is, its Gothic spirit, with an eye for detail and how the world actually looked. Still, he found much of that art to be frivolous.

Erasmus, the classical, humanist Christian scholar, saw doctrine and life in deeply moral terms, serious and simple, free of overall elaboration. While negative about Scholastic theology, he accepted the central core of its parameters. While he was critical of particular ceremonies, he did not believe in their elimination. While critical of painting and sculpture, he was more critical of their destruction. While in the midst of theological battles, he longed for an irenic Christian center, free of strife. Above all, he was for a spiritual Christianity.

It was the latter motif that was picked up by persons such as Karlstadt and Zwingli as a central tenet, but in their cases nourished by a fairly literal reading of Scripture and its demands for reform and action.

The beginning of the actual removal of painting and sculpture in a public sense dates from about 1521 in Wittenberg, while Luther was in hiding at the Wartburg. Attention has already been given to Luther's repudiation of Karlstadt's rejection of images and the mass, though Melanchthon and his

colleagues initially agreed with Karlstadt. Luther's sudden return to Wittenberg and his preaching against the destruction of images indicates Luther's shifting mind in relation to images and reform. Even at this early date, Luther made no claim that images should stay. Luther claimed that his preaching had resulted in the removal of more images than Karlstadt's iconoclastic actions had brought about.

From early on, Luther was for a gospel-centered church, calling on the church to reform itself with respect to indulgences as at once a theological, social, and financial problem. His widely circulated sermons called for a new moral life based on forgiveness and empowering grace, freed of exaggerated claims in behalf of clergy and papacy. In this sense, Luther called for a new freedom for Christians. It is not surprising then that his writings fueled a broadly based anticlerical strand in late medieval thought and practice, and that peasants and other lower levels of society saw the new religious accents as support for change in the social order.

Whatever Luther's initial influence on the public may have been, or even his initial regard for the peasants, he was always in favor of change through established agencies, whether emperors, princes, or, in extreme situations, lesser magistrates. For any group to take matters into its own hands represented an anarchy that he feared more than tyranny. Given that approach, it is possible to make the case, as many historians now do, that Luther betrayed the initial possibilities of reformation. The late medieval world produced a society in which lay common people had never been more powerful, a group that combined a passion for religious associations and social change. Initially, Luther was their champion. But already by the 1520s, it was obvious that such groups made common cause with emerging reformed, Anabaptist, and other radical groups. Luther himself could not make common cause with Zwingli, Calvin, and others on the nature of the Sacraments. Hence, Luther's influence, while initially the most prominent, was increasingly identified solely with parts of the German scene.

Luther saw the pope and all those with him as the Antichrist, powers that serve the devil; on the other hand, Luther believed that God is known in Christ in and through the things of this world. In the latter sense, he was closer to the Catholic tradition than to those for whom God is known through a spiritual world that stands over against the material. But this otherworldly emphasis on the spiritual world was very much this-worldly with respect to how Christians were to live. The gospel found in Scripture had direct consequences; a proper relation to God was expressed in the appropriate ordering of church and society.

Within that overarching framework, however, there were different approaches to what should be done. In the case of Karlstadt, the basis for the rejection of all images was scriptural. In his interpretation of the first commandment, it was not the worship of images that was forbidden but images themselves. Aware that in Numbers 21 the image of the serpent being lifted up has a positive meaning, he addressed the issue directly: "Note that God . . . ordered a serpent to be made which was not the image of him, but was erected for no other purpose than that those who had been bitten or wounded by snakes might look upon that image and be made whole. . . . That image was given by God himself and was not created by a human mind. Nevertheless, Scripture praises Hezekiah (2 Kings 18:4) for breaking the bronze serpent in pieces because the Jews sacrificed to it."[2] For Karlstadt, Hezekiah's action seems to obviate the centrality of the former image. Still, what Scripture said was the key to all interpretation, for all life was to be ordered in terms of the specific directions of Scripture. For Karlstadt, there was no particular focus by which Scripture was to be interpreted; Scripture itself was a kind of map for guiding faith and life. The Spirit enlivens humans, not through material things but through the rubrics that Scripture supplies. Hence, Karlstadt stuck to Scripture, quoting passage after passage, a literal compendium of texts on images. In Scripture, images are forbidden, just as are stealing, killing, and adultery. Moreover, "the commandment forbidding images stands at the head of the list as the principal and greatest one. The commandment forbidding adultery and theft, etc. come after as the lesser and least."[3] He had no sympathy for the historic distinction between veneration and worship, or images being a kind of Bible for the illiterate. Books, that is the book of Scripture, teaches and instructs; images do not. Hence, images must go.[4] His newly won view of Scripture is devoid of patience with the historic church. Major reform is necessary. Anything less exhibits disobedience of the first order.

Karlstadt lost his battle in Wittenberg, was exiled from Saxony, and ended his career as a professor of note in Basel. The extent of his influence on other reformers, particularly in Zurich, such as Ludwig Haetzer and his pamphlet of 1523 against images, or Ulrich Zwingli, or his colleague Leo Jud is not known. Perhaps more influential through its wide circulation was the anonymous 1523 pamphlet "On the Old and New God," in which the sin of humans was described as the elevating of any worldly thing to significance, that is, having an idol in place of the true God.

Idolatry became the key theological issue for theologians in the reformed tradition.[5] But Lee Palmer Wandel calls attention to the fact that some of the

earliest protests against images in Zurich came from lay persons who rejected images because the money involved in creating and maintaining them should be given to the poor instead. She calls attention to the expense involved in providing candles for the illumination of, and prayers before, the saints. Oil from lamps presented a special problem, because such funds came from tithes, that is, monies that had to be collected for the churches.[6] It is clear that major funds were expended on the increasing number of paintings and sculptures of saints placed in churches in the early decades of the sixteenth century. The reformed theologians, however, mainly subsumed the financial point under the general rubric of idolatry.

Zwingli's pilgrimage from being a follower of Erasmus to becoming a radical reformer was gradual. But by the 1520s, he clearly distinguished between true and false religion, and true religion had no place for images. His was a God-centered faith, one in which there was no ambiguity. Without the God who saves us from sin and directs us Godward, the propensity of the human heart toward centering in the material world becomes actualized, as in the cult of the saints. In the true world of the spirit, elements of the world, such as the bread and wine, can become signs that lead us to remember what God has done and promised. Humans can only rely on the Word of God, proclaimed to us in preaching.

The rejection of the cult of the saints obviously undercuts visual images in the life of the church. John 4:24, "God is a Spirit; and they that worship him must worship him in spirit and in truth," is the classical text for the rejection of images. Images that are outside the church and have no religious veneration attached to them are acceptable. Hence, the statue of Charlemagne outside the Zurich Grossmünster that depicts his secular role was allowable, but the one inside the cathedral was removed, for there his religious role is featured and adoration seemed inevitable. On the other hand, decorative subjects, such as trees, vines, selected animals, were permitted inasmuch as veneration had never been associated with them. Within limits, stained glass, too, was allowable, even though such glass could lead to idolatry. But images touching on worship had to go, along with music, incense, and ritual generally. Such sensuous elements distract from the center of worship, in which God in Christ informs the human mind and changes the human heart. That happens as the sensual is blotted out as much as is humanly possible and as the mind centers on what is being proclaimed. That involves a quiet, centered self, in which all the elements of worship are appropriated by each individual. Community, then, is not a shared reality in which one participates but rather an aggregate of individuals, each of whom

shares a unique experience. The parameters of worship are verbal in character, and it is the human mind that is mainly addressed.[7] It is hearing that changes the human heart.

Still Zwingli, unlike Karlstadt, believed that the removal of works of art could only be undertaken by those in authority. The result, however, was that the preaching by reformers against the cult of the saints led individuals and groups to take matters in their own hands before the constituted authorities had come to a clear decision.

Such was the situation in Zurich, where from 1521 on, iconoclastic incidents increasingly began to appear and public disputations were held on the subject of images. In the summer of 1524, the magistrates finally decided that the images must be removed. Those who had commissioned or given paintings and sculptures could remove them, followed by a systematic program of official removal. Seventeen men were designated to remove the idols. Wandel summarizes the procedure as follows: "For the next ten days [July 12, 1524], they moved from church to church in Zurich. Behind closed doors in each church, they took down the sculptures and smashed them up, turning them into cobblestones; they took down the wooden panel paintings and the altarpieces, smashed them and burned them before the churches; they carried out all the objects made of precious metals and stones, broke them up, melted down the metals, and turned them all into money for civic uses, particularly the poor; and distributed to the poor the vestments and various garments of the religious. All the 'images,' the 'idols,' carved, painted, sculpted, gilded, cast, all the objects human skill had made beautiful, were returned to the substances from which they had been made—stone, wood, marble, gemstone, metal—and then were put to use as building material, heating material, and currency for the poor. When the committee members were finally done, they washed the walls white, so that none of the paintings of the medieval church would be visible."[8]

But that was not all. Zwingli himself declared "in Zurich we have churches which are positively luminous; the walls are beautifully white." But the Catholic Hans Stockbar entered the Zurich minster and reported "there was nothing at all inside and it was hideous."[9]

This general direction was also followed by Zwingli's successor, Heinrich Bullinger. His contribution to the debate rests mainly on a historical analysis that suggests that the cult of images rested on the cult of relics, a theological point which, as suggested in the Introduction of this book, colored the entire debate. Bullinger also continued the debate, which had begun in Baden and Berne on the saints as intercessors, and saw to it that the Second Helvetic

Confession of Faith insisted on Christ as the only Mediator, and that the saints have no role for us after their death.[10]

Movement toward reform and the removal of images proceeded at a slower pace in Strasbourg than in Zurich. Reform was encouraged by both ordinary citizens and clergy. Wandel reports that the initial challenges to images came in a series of incidents in which persons took money from boxes used to collect funds for liturgical usage and then placed the money in vessels designed for receiving money to assist the poor. Major iconoclastic destruction of art objects also occurred throughout 1524 and into the first part of 1525, and then from early 1529 into 1530, when the official judgment was that images had to go. But their destruction was haphazardly carried out, with most of the iconoclastic events occurring in places where evangelical preachers had been at work. In part, the relative slowness of the removal of images may have rested on the uncertainty among some of the preachers and teachers themselves as to what they should do. Martin Bucer, for instance, initially stood closer to Luther than to Zwingli, but as the history of reform unfolded in Strasbourg, he came to the point that he found the rejection of images to be necessary for theological reasons. He, as Bullinger, was influenced by his reflections on the history of images.

Reform in Basel started without significant opposition. Reformed churches were being created and the populace was increasingly under the sway of the new religion. But the city council found it hard to do more than try to keep peace between the old and the new, between the Catholic cathedral chapter and reformed churches that believed that only a uniform, reformed church of lay and Protestant clergy extending throughout the city made sense. For these Protestants, the church must be coterminous with the society itself.

The expansion of reform groups among the populace as a whole provides the background for understanding that a group, estimated as over two hundred persons, broke into the cathedral on February 9, 1529, and destroyed all of the liturgical objects. On the following day, other churches were ransacked. The initial hope that the wood taken from choirs and rood screens would be given to the poor as firewood was not fulfilled. Violence led to burning and the wanton destruction of all objects, without making distinctions as to the usage of materials. Finally, Basel, as other Swiss cities, purified its churches by whitewashing the interiors, so that the last traces of the images were obliterated.

In Basel, too, the verdict on reform was not unanimous. Oecolampadius, the distinguished pastor of Basel, was head of a church in which the mass was abolished and in which guild members had removed all images. The

increasing consolidation of the reform obviously pleased Oecolampadius. But Basel was also the home of Erasmus, who found the destruction so distasteful that he left Basel forever.

In the orbit of the Swiss lands, similar stories could be told of iconoclasm and change in Bern and St. Gall in 1528, Scaffhausen in 1529, Neuchatel in 1530, and finally Lausanne and Geneva in 1535. Since Geneva was to play such a significant role with respect to the future of the reformed tradition, a look at reform in the city prior to the arrival of John Calvin is in order. Early iconoclastic acts were engaged in by soldiers from Bern, a city which at the time exercised power over Geneva. Gradually, iconoclastic acts picked up momentum, while the city council tried to keep peace between the Catholics and the emerging Protestant groups. Indeed in 1535–1536 iconoclasm finally accomplished what the city council could not do, namely, destroy the very fabric of the Catholic tradition. The more the council forbade acts of vandalism, the more they happened, so that the council had to agree to the abolition of the mass and to the removal of the images.

The year 1536 was also the year that Farel, who had preached the Word in Geneva and been at the forefront of the struggle against the mass and images, prevailed on John Calvin to become one of the ministers of the city. After less than three years, Farel and Calvin found themselves expelled from Geneva, and Calvin settled in Strasbourg, where he became pastor of a French refugee group until his reluctant return to Geneva in 1541. For the next twenty-three years, Calvin was the center of the reform movement. The 1536 date, however, makes clear that iconoclasm in Geneva was over and that reform had been accomplished before Calvin's arrival. But the shape and nature of the emerging Protestant Geneva was the center of Calvin's work. That involved a new approach to the issue of images.

Understanding the role of Scripture among the various participants may help focus the issues. Catholicism looked at Scripture in terms of how it was interpreted in the church, which interpretation prior to the Council of Trent reflected considerable diversity. Luther looked at Scripture in terms of what he considered its center, the Word manifest to believers through proclamation of the Word and the rightful administration of the Sacraments, leaving much else to be shaped with considerable openness. Calvin, by contrast, believed that Scripture itself was a blueprint for worship and life in all its dimensions. But in that context he differed from other reformers, including Zwingli. While the latter interpreted the Sacraments in strictly commemorative modalities, Calvin talked of a spiritual presence communicated through the elements of bread and wine. Whether such presence is manifest in the

here and now of partaking, or whether we, as it were, are lifted to God's spiritual level through the Sacraments, Calvin does not resolve. Stress fell on God's Word ushering us into another world, the world of the spirit against the flesh and the senses. That is why images had to go, for they inevitably substituted the things of creation for the creator, which is the essence of idolatry. Such idolatry is increased when forms of pleasure are substituted for seriousness, which is one of the reasons he gives for not accepting images.

While Calvin stated that he would not be so superstitious as to exclude all art from the church, he immediately circumscribed that conviction to such an extent that only historical subjects, usable for teaching purposes, were allowed; but even these, he stated, had better be abandoned. Painting as such should be restricted to that which one could see in the world about one. For Calvin, painting could not be used to suggest transworldly dimensions, for by definition that would be an idolatrous act. In references to the visual in his commentaries, tracts, and the *Institutes*, the subverting danger of the arts is more dominant than any use to which they may be put.

But the theological point that Calvin insists upon is that images are strictly forbidden in the first table of the Law.[11] In this he is close to Karlstadt, both of them agreeing that the first table of the law is more important than the second. Calvin stated that out of love for the neighbor, one should not violate one's relation to God. Hence, forms of true worship come to the fore and these cannot be compromised. Purity of worship dictates preaching of the Word, a rightful administration of the Sacraments, and a disciplined Christian life. But it also excludes everything else that has come to the fore in the life of the church. A right relation to God, the honoring of God in God's graciousness, demands true worship, freed of all other accoutrements.

That conviction is the basis for Calvin's rejection of the Nicodemites, to whom attention has been given in the chapter on Michelangelo. The same strictures were evident in Calvin's rejection of the Nicodemites in France. If one is a believer, Calvin maintains, this must be manifest in pure worship. Hence, resistance to the point of martyrdom is one of the two possibilities, the other being emigrating to a place such as Geneva, where true worship exists.

France was Calvin's place of birth, the arena of his studies and of his conversion experience, the latter probably related to the influence of Jacques Lefevre. There had been evangelical stirrings in France from the early 1520s, centered mainly in Meaux, near Paris, where Guillaume Briconnet was bishop. Through the latter's example, others became active, such as William Farel before he too had to flee, Pierre Toussaint, Michel Arande, and Gerard Roussel. Briconnet had also enlisted scholars in the cause, such as Jacques Lefevre.

Writing of Briconnet's work in his diocese, Bainton reports: "He had under him some 200 parishes to which he appointed preachers obligated to stay in residence. These preachers clamped down on indulgences, stopped genuflecting before candles, gave up exhibitions of relics, excluded the *Salve Regina* (Save O Queen) from the hymn to the Virgin, recited the Nicene Creed in French, and commenced sermons by reciting the Lord's Prayer instead of the *Ave Maria*. They would allow representations of Christ but not of the Trinity, because pictures of one head with three faces or one body with three heads suggested three gods. The reform took hold with the common people."[12]

It did not take long, of course, for the Sorbonne faculty to hear of such activities or to condemn Luther's teaching (some of Luther's works had been circulating in French translations). Briconnet had disallowed a statue of St. Francis with the stigmata for a Franciscan group, and some of the reformers in the group began destroying images. But the blow that made Francis I react systematically to the new developments was the posting of Placards in 1534, posters that described the mass as blasphemous. Subsequently convinced that the Waldensians in southern France were in rebellion against the church, Francis I had twenty-two villages and their inhabitants destroyed.

Calvin, in exile from France, wrote a prefatory note to Francis I in his first edition of the *Institutes* of 1536, calling on the King to alleviate the plight of the persecuted Evangelicals. He called on the King not to act in the light of false information and to address the issue of the true nature of the church. Calvin stated that what he himself had written was not subversive but rather was the basis for instruction concerning the true nature of the church.

His counsel went unheeded by Francis I and the subsequent history of the Protestants in France is a sad story. At first, Calvin's relation with the King's sister, Marguerite of Navarre gave him some hope, for she was devoted to reform in the church. Her own religious propensities were more neo-Platonic and mystical than strictly scriptural; moreover, she had a love for the institutional church, including the place of images. Knowledgeable in languages, having read Dante, Plato, and Luther in the original languages, she was also conversant with other reformers in Italy, such as Sadoleto, Contarini, and Vitttoria Colonna. As queen of Navarre, French territory on the border with Spain, she provided refuge in her territories for those who needed it, particularly in the wake of the destruction of Waldensian groups in the south of France.

In spite of the correspondence between Calvin and Marguerite of Navarre their relationship cooled, for she defended individuals whom Calvin called

libertines, a term he used in Geneva for those whose lives did not match the scriptural norms of behavior. Moreover, he considered her to be a Nicodemite, one whose particular faith was secretly rather than openly expressed. As we have noted before, Calvin was unrelenting in his conviction that true religion must be outwardly expressed in worship and in life, and he therefore rejected those who practiced forms of reformation in private, while publicly conforming to the Catholic Church. For Calvin, the issue was clear: accept martyrdom or leave the country. Those who received his letters often felt that such counsel was too simple, coming from one who, for all the problems in Geneva, lived in considerable security. But Calvin was positive in his outlook concerning Jeanne d'Albret, Marguerites daughter, who by 1560 had become a thorough Calvinist under the tutelage of Theodore Beza.

With regard to iconoclastic acts, such activities were practiced not only by reforming Huguenot groups but also by Catholics. Natalie Zemon Davis[13] has convincingly shown that Catholics also engaged in destructive acts with respect to the worship places of reforming groups, such as destroying pews and pulpits. She also pointed out that Holbein's *Dance of Death* engravings were used in both Protestant and Catholic publications in France.[14]

The gyrations within the English scene[15] on the question of images involved the monarchy—Henry VIII, followed by Edward, Mary, and Elizabeth. We need not repeat Henry's problems of succession. What is somewhat surprising is that this monarch, who remained Catholic to the core except for the repudiation of the papacy, confiscated and destroyed so much of the art in the monastic communities. While financial needs were part of the reason, more prominent probably was the fact that such acts gave him the support of countless individuals who continued the Lollard suspicion of the arts. The Lollards, like the Hussites in Bohemia, had met defeat but their outlook continued within the body politic. However, while the Hussites had based their opposition on issues of idolatry, the Lollards based their opposition more on issues of opulence in the church than on idols as such. The wrong use of money had also been an issue on the continent, an issue that had come to the fore in the differences between Bernard of Clairvaux and Abbot Suger and, later, in the Swiss cities.

While the reign of the young Protestant Edward and the Catholic Mary represented their respective religious heritages, it was in Elizabeth's time that the dominant views on the arts crystallized, that is, that the images that remained were to be removed from the churches. Those who now see art in English churches frequently forget that they returned under the nineteenth-century Tractarian movement, and that wall paintings became visible again

as whitewash was removed or older walls were made visible again. It should also be remembered that the amount of art destroyed by the Puritans was minor compared to that under Henry VIII.

The English scene was different from the Lutheran and Reformed tradition on the continent in two major ways. First, the established Anglican church and the emerging Puritan tradition were theologically different from what had developed on the continent. Though Luther and Calvin were read in England, they were seen through a different lens, one that was moral in tone and grounded in the lives of less affluent parts of the population. William Clebsch wrote of the English Protestants that they took ". . . Luther's cardinal teaching on justification by faith as axiomatic. But whereas for Luther faith and justification primarily denoted the humble posture of forgiven sinners in the presence of a compassionate God, the Englishmen construed justification by faith as initiating a morally blameless life characterized by observing God's law in one's daily deeds. For Luther, faith resulted in a trust that could sin bravely, while for the Englishmen faith resulted in an obedience that could eschew sin."[16]

Second, such a theology is more anchored in the total life of a people than was the case on the continent. Iconoclasm in England, while centered in the destruction of art objects in churches and monastic groups, where it was largely lodged, resulted in the loss of art in the general public, except for the upper classes and the Crown. The result was that the visual arts, in the light of iconoclasm, were largely absent from the lives of people generally. Strangely enough, that situation obtained with respect to art objects but not to clothing, drink, and literature. By contrast, while art objects on the continent were destroyed in churches, they were visibly present in life outside the church.[17]

While there were sporadic episodes of iconoclasm in the Netherlands dating from the early days of the Reformation, it hardly became an issue affecting the public until 1544, and then again in 1566 and the years following.[18] Hence, images as a major issue emerged later in the Netherlands than in the lands we have discussed. But, as in France, Protestants (including Anabaptists with Calvinists being prominent) vied with Catholics as positions of power and strength changed from year to year and place to place with respect to Spanish Catholic pressure. But unlike France, the political power in the Netherlands was more evenly balanced, so that neither Catholics nor Protestants could destroy or totally defeat each other. Even with respect to the Council of Trent, its influence on images occurred several decades later.

In Scotland, iconoclastic waves also came late. In 1540, Scotland could still boast of thirteen cathedrals, well appointed and replete with images, ranging

in location from central cities such as St. Andrews to isolated places such as the island of Iona.[19] But by 1580, cathedrals and parish churches lay in ruin, and those that survived had lost much of their splendor. Whatever the reasons—English incursions, Calvinist preachers, or nobles who confiscated monastic properties—"the sobering fact remains that the furnishings of churches in carved wood and stone, in painting, embroidery, and metal work, whether it was of native or foreign manufacture, represented almost the entire cultural heritage and achievement of the nation. . . .The thoroughness with which all accessories of Scottish medieval church worship were wiped out is unparalleled in Europe."[20]

McRoberts goes on to indicate that in Germany and France such iconoclastic developments did not last as long and were not as thorough. Moreover, the length of the period of destruction in Scotland, and to some extent also in the Netherlands, created a climate of opinion that connected images and popery, a viewpoint that has continued well into our own century.

The Scottish reformation hero John Knox vowed that Scotland would have a reformation that echoed what he had learned in exile in Geneva. He preached the Word, including words against images, but shrugged off the consequent destruction as the action of ruffians. But it should also be noted that both in the Netherlands and in Scotland the earliest religious impulses that triggered iconoclasm were Lutheran in orientation. For whatever reasons, Lutherans in Germany were less iconoclastic than Lutheran churches outside Germany.

The situation was not dissimilar in Denmark, Norway, and Sweden. Here iconoclastic incidents occurred after 1525, but hardly on a large scale. In Denmark and Norway, images as such were not at issue, although attendant abuses—that is, ones that could be considered idolatrous—frequently caused actions to be taken against specific images. The conflict between the Catholic tradition and evangelical stirrings rested a good deal on the fact that in these countries Catholic priests were not removed but became part of a new order of church life. Tensions continued and it took time for them to be overcome. In Sweden, it was as late as the 1590s that the Swedish church moved decisively in a Lutheran direction, one in which remnants of the old faith remained.[21]

While the European lands just to the north of the Alps had no political structures in which a total anti-image policy could win, the situation was different in England and Scotland. The visual arts disappeared from public and private life as well as from the churches and monasteries under political policies that were normative for the entire land. On the continent north of the

Alps, the victories were not as total, nor were the arts absent from public as distinct from churchly life. In Italy, by contrast to the north, the reforming movements were never in the hands of dominant political power, mainly the papacy.

Reconstitution of the Catholic Tradition

Just a few months after Karlstadt published *On the Removal of Images* in 1522, the Catholic theologian Hieronymus Emser published his countervolume *That One Should Not Remove Images of the Saints from the Churches Nor Dishonour Them, and That They Are Not Forbidden in Scripture*.[22] Indeed, the latter is a point-by-point rebuttal of the views of Karlstadt, maintaining by contrast that Karlstadt is influenced by the views of Wycliffe and Huss. Emser writes that a correct view of images does not warrant the designation of idolatry, because images of Mary and the saints do not point to themselves but to the reality that undergirds their lives.

Similarly, in the same year the theologian Johannes Eck, who figured prominently in the debates with Luther, published *On Not Removing Images of Christ and the Saints*.[23] In that volume, he rehearses the history of the image question, and focuses on how the church condemned the iconoclast Felix of Urgel at the Council of Frankfurt in 794, probably because the Lollards and the Hussites had not been condemned by church councils. Essentially, Eck defines and defends the place of images, rejecting that Catholics believe what is reputed to them. For example, "we do not believe the martyrs to be our gods, but rather that we and they have one God. . . . Christians do not call venerable images gods, nor do they serve them as gods; nor place hope of salvation in them; nor expect a future judgement from them. We venerate and worship them in memory and recollection of the early martyrs; but we do not serve them or any other created thing with a divine cult."[24]

Images, Eck insists, are correctly used if they are accepted as referring to "what they represent. However, the worship of images is destructive if it is idolatrous, that is, if it involves the belief that something like a divinity resides in the images."[25] Nor should worshippers cling excessively to the image.

While Eck defends images, he is aware that they can be abused. But so can written texts. "Just as we do not worship the material with which the Gospels are written, neither do we worship the material from which the cross is made, but rather what the type and figure express." So, suggests Eck, "the faithful must worship in spirit and in truth, both with images and without images."[26]

Strangely, then, Luther and Eck, such strong opponents, finally are closer together on images than are Luther and the other Protestant developments.

However, the last session of the Council of Trent in December 1563 dealt with the issue of the saints, relics, and images over against the Protestant developments. The Council aggressively affirmed the traditional views of images, without reference to the central issues that most Protestant groups had raised. Instead, they forbade what seemed to be the problems—dubious financial gain, lasciviousness, seduction, revelry, and drunkenness. These had been the issues as the church faced Italian artists and what they were doing, including the work done by Michelangelo. Moreover, northern art of a religious nature was not without similar problems, as the discussions of Cranach the Elder and Hans Baldung Grien have shown.

After affirming the place of images, including the role of the saints, the warning sentence of the Council about abuses follows. ". . . In the invocation of the saints, and veneration of relics, the sacred use of images, all superstition shall be removed, all filthy quest for gain eliminated, and all lasciviousness avoided, so that images shall not be painted and adorned with a seductive charm, or the celebration of saints and visitation of relics be perverted by the people in boisterous festivities and drunkenness, as if the festivals in honor of the saints are to be celebrated with revelry and with no sense of decency."[27] It then adds that appropriate supervision on the part of bishops is expected in all matters having to do with images.

But as in all such matters, the terms themselves are unclear, for what is lascivious to one person may not be to another or seem so in a different juncture of history. The extremes, of course, are easier to detect, but that is usually not where the issues come into focus. In any case, at the juncture of history with which we are dealing, writers began to offer their own interpretations. Even Vasari, painter and writer of the lives of the artists, changed his text in the light of the conclusions at Trent.

Prominent among the subsequent writings that expatiate on the meaning of Trent are the architectural and liturgical suggestions of St. Charles Borromeo and the concrete suggestion with respect to paintings by Molanus in the Netherlands, both in the 1570s. Taking his point of departure from how one looked at the writings in books, Molanus affirmed a parallel understanding for paintings. What is appropriate with respect to the publication or suppression of books, may be said to be correct for works of art. In both media, indecency is to be avoided and must equally be suppressed.

Spelling this out with respect to concrete situations, Molanus opposed showing the infant Jesus nude. Then he adds, "all the more grievous is the sin

of those who introduce shamelessness into objects that are chaste by nature. Why is it necessary to depict in a church David looking at Bathsheba from a window and luring her into adultery? Or embracing the Shunamite brought to him? Or the daughter of Herodias dancing? The subjects are taken from Holy Scripture, but how much wickedness the artists add to portraying the lewd women!"[28] Then he turns his thoughts on depictions of scenes from the Gospels. When Christ is at supper in the house of Martha and Mary, the young John is frequently shown chatting in secret with Martha, with Peter taking a drink, and peeking at Mary. If one does not talk of biblical figures that way—and he assumes one would not—one should not paint them that way either.[29]

Molanus and other writers instructed artists to be clear and chaste in representing images, to be faithful to the text, and to use apocryphal materials only when they accord with Scripture and tradition. Increasingly, too, the saints were considered appropriate for the wings of altars, with only Christ and the Virgin placed on the central panels of altars.

While these views were the reigning ones in Catholicism after Trent, it would be a mistake to assume that the prescriptions were always applied or agreed to. Catholicism, in spite of the Inquisition, was not as single-minded in the sixteenth century as it was in the eyes of nineteenth-century interpreters. Nevertheless, those who viewed the issues differently than what Trent had decreed could not be in positions of leadership. At best they could be Nicodemites.

Positively, the Catholic tradition sharpened its theological agenda, partly under the aegis of the newly created order of the Jesuits. In the exuberance and confidence of the new aggressive faith, baroque art was born and flourished, only to die, perhaps through its own pushing of the boundaries.

CONCLUSION

Thoughts in the Wake of the Reformation

THIS STUDY, WHICH BEGAN AT THE TURN INTO the sixteenth century and ended in its seventh decade, covers a period that had pronounced consequences for the future. After four and a half centuries, the Reformation histories still shape the prevailing forms of Roman Catholicism and Protestantism with respect to visual images generally and the visual arts in particular. Elsewhere I have sketched the lineaments of that history.[1] Here I want only to comment on the power of that history and how difficult it has been to move beyond the ways in which the issues were posed.

In the light of the Council of Trent, the Catholic tradition sharpened its theological agenda, largely under the aggressive work of the newly created order, the Society of Jesus, through which faith formed a culture of vocations and work that touched and frequently transformed all elements of society. In that setting, preaching was combined with what culture could express. The power of that combination was evident in baroque art, an exuberant and triumphant visual expression of faith. Art once again was in the service of faith.

It was as if the only problem was that willful artists continued to insert the nude, which by now was lascivious by definition. Abuses with respect to indulgences were sidetracked, and the saints were restored but considered

subservient to Christ and the Virgin Mary, who required a central place. But in popular religion, much continued as it had, particularly in countries not directly influenced by reformation issues, such as Spain. Only since Vatican II have the number of saints been reduced. To this day, there are differences of opinion about the power of painted and sculptural figures, about their healing power, and about plastic saints that have no power other than to remind believers of elements of faith already known.

Certainly, artists never again had as central a place in the life of the churches as they did on the eves of the reformations or during the temporary revival during the baroque period. Artists lost their role as purveyors of the faith, whether exhibiting the tradition or stretching its horizons. In the Reformation period, artists faced a crisis with respect to their livelihood. The church, once the chief patron of the arts, now played a minor role, except for the Catholic baroque period. This meant that artists had to find subjects sought by more secular patrons. Sometimes they could eke out an existence, but frequently they had to abandon their professions. Other artists continued to create works with religious subject matter but had no commissions for such works.[2] Rembrandt, who did so many religious subjects, had only one minor commission for a private chapel.

In Luther, there had been hints of a wider understanding of the arts than was actually developed. The interpretation of Scripture as well as of the visual arts, in terms of an imagination formed by faith, was full of possibilities that were never actualized. Ironically, the northern humanist dealing with texts fed a literal reading, bereft of imagination. That literalism turned into a new scholasticism in which the arts were not rejected; they simply had no significant role. In the Lutheran tradition, then, the visual was kept where it had been present. But it was peripheral enough so that in new Lutheran churches no need was felt to include or stress the visual.

By definition, the Reformed tradition kept the verbal modalities so central that the visual was rejected. Worship was central but primarily verbal, though music and, to some extent, stained glass eventually found a place. At the core of worship was the Word, where no other intrusions were appropriate. Rood screens, altars, sculpture, paintings, all had to go, for there was one center, the Word, and lay and clergy alike were subject to it. For the Eucharist, a simple table of fellowship was sufficient. Hence, the sight lines of worship were different, all looking at one point, with attention only on hearing. Other sensibilities—seeing, tasting, smelling—had no place. Concentration must be on the Word alone in the medium of words, not the medium of sight.[3]

While the theology of Anabaptists stressed a more sanctificationist view of the Christian life, and varied in the way in which Scripture and the social order were to be understood, they were united with the reformed groups in rejecting the visual arts.

In England, the source of much of American Protestantism, the situation was slightly different. Works of art were removed and walls were whitewashed in the reign of Henry VIII and in the brief period of Edward. While a return to Catholicism prevailed in the reign of Mary, a return to Protestantism occurred under Elizabeth. Indeed, she stood against works of art in the churches with a vigor similar to that of the emerging Puritans. The difference between the early Anglicans and the emergent Protestants—Puritan congregationalists, Presbyterians, Methodists, Baptists—were not on the issue of the arts but on the nature of the church from an ecclesial perspective. While the Anglican Church rejected Rome, it maintained an Episcopal tradition and a revised Catholic liturgy. But among all these groups, the visual arts had no place in the life of the church. Only with the nineteenth-century Tractarian developments did the arts return to segments of the Episcopal Church.

The wounds of the reformations have not healed, nor has a new way of seeing been incorporated into the life of the churches. In various segments of the church, the cult of the saints has been abolished. In other parts, the traditional patterns have continued as if there had been no controversy at all. Missing is a way of seeing and of thinking that could make new sense of the saints.

We live in a visual culture, but it is hardly a disciplined seeing. We are taught to hear, to read, and to think. But with respect to seeing it is still possible to like what one likes, without having been taught to see. The visual as the bible of the illiterate or the unlearned, as the older tradition expressed it, has been transformed into the visual illiteracy of the learned.

Images have power, as David Freedberg has so compellingly shown in his volume *The Power of Images*.[4] It is interesting then, and distressing too that we have not come to terms with the role of seeing. For many, images have no power; they are only images. But the same persons who see images in that light can be deeply upset by works of art they do not like, confessing in an inadvertent way through iconoclastic acts that images are more than merely images. What is needed is a disciplined theory of images, one that like all our sensibilities belongs to our creation and needs to be learned and cultivated. Without that, we give away too much of what belongs to life and, therefore, also to the life of faith. At this level, it is important to overcome the legacy of the reformations through a disciplined, learned modality of seeing.

NOTES

CHAPTER I

1. For an instructive account of the different sensibilities reflected in Grünewald and Michelangelo, see the essay by Jane Daggett Dillenberger, "Northern and Southern Sensibilities in Art on the Eve of the Reformation," in *Image and Spirit in Sacred and Secular Art* (New York: Crossroad Publishing, 1990), 108–31. The same volume has an essay relevant to this study, "Lucas Cranach, Reformation Picture-Maker."

2. Patrick J. Geary, "The Ninth-Century Relic Trade: A Response to Popular Piety?" in *Religion and the People*, ed. James Obelkevich (Chapel Hill: University of North Carolina, 1979), 13; also, *Furta Sacra: Thefts of Relics in the Central Middle Ages* (Princeton University Press, 1978), 42.

3. Hans Belting, *Likeness and Presence: A History of the Image before the Era of Art* (Chicago and London: University of Chicago Press, 1994), passim.

4. Jeffrey Hamburger, "The Use of Images in the Pastoral Care of Nuns: The Case of Heinrich Suso and the Dominicans," *Art Bulletin* 71 (1989): 28.

5. Calvin, *Tracts relating to the Reformation*, vol. 1 (Edinburgh: Calvin Translation Society, 1844), 97.

6. G. J. C. Snoek, *Medieval Piety from Relics to the Eucharist: A Process of Mutual Interaction* (Leiden: E. J. Brill, 1995).

7. Two of the best books on prints and print are by R. W. Scribner and Mark U. Edwards Jr.: R. W. Scribner, *For the Sake of Simple Folk: Popular Propaganda for the*

German Reformation (Cambridge University Press, 1981); and Mark U. Edwards Jr., *Printing, Propaganda, and Martin Luther* (University of California Press, 1994).

8. Paul A. Russell, *Lay Theology in the Reformation: Popular Pamphleteers in Southwest Germany 1521–25* (Cambridge University Press, 1986); Miriam Usher Chrisman, *Conflicting Visions of Reform: German Lay Propaganda Pamphlets, 1519–1530* (New Jersey: Humanities Press International, 1996).

9. Miriam Usher Chrisman, op. cit., 10.

10. Steven Ozment, *Mysticism and Dissent: Religious Ideology and Social Protest in the Sixteenth Century* (Yale University Press, 1973).

11. See the 700-page volume, *Anticlericalism in Late Medieval and Early Modern Europe*, edited by Peter A. Dykema and Heiko A. Oberman (E. J. Brill, 1993), which includes 40 articles by scholars in the field, and which grew out of a conference in 1990 at the University of Arizona.

12. *The German Peasants' War: A History in Documents*, edited, translated, and with an introduction by Tom Scott and Bob Scribner (New Jersey and London: Humanities Press International, 1991), 9.

13. Research on the beliefs of lay people and popular religion have provided much-needed material for a more social understanding of the Reformation period. Generally, writers in this area justify their work on the basis that we have depended too much on the magisterial figures. While that is true, it is also evident, I think, that popular beliefs also are the context in which the work of the better known figures carried out their work. For them, both the outlook of the papacy and that of popular religion had to be transformed into a more consistent theological framework.

14. Preoccupation with the end of the world became more prominent after the middle of the sixteenth century.

CHAPTER 2

1. See Andrée Hayum, chapter 4 of *The Isenheim Altarpiece: God's Medicine and the Painter's Vision* (Princeton: Princeton University Press, 1989).

2. Paul Tillich, *On Art and Architecture*, ed. John Dillenberger and Jane Dillenberger (New York: Crossroad Publishing, 1987), 99, 117.

3. Jane Dillenberger, *Secular Art with Sacred Themes* (Nashville and New York: Abingdon Press, 1969), 88.

4. Adams, Doug, *Transcendence with the Human Body in Art* (New York: Crossroad Publishing, 1991), 85, 114–15, 154–55.

5. We have a similar problem with respect to Dürer, though in his case the titles of sermons are available. See p. 66.

6. See the article by Karl Adolf Knappe, "Grünewald, Matthias," *Theologische Realenzyklopaedie* 14 (Berlin, 1985): 281–82. In this article Knappe calls attention to various interpretations, ranging from radical groups to mystical strands to an affinity with Erasmus. But he is inclined to reject such interpretations. Stephen S. Kayser's article, "Grünewald's Christianity," *Review of Religion* 5 (1940): 3–35, covers the various interpretations up to his own time. James Luther Adams, in *An Examined Faith* (Boston: Beacon Press, 1991), 258–59, supports the suggestion that Grünewald was influenced by Giler von Keiserberg and perhaps by the "bitter-Christ" doctrine of Thomas Müntzer.

7. For a full account, see Andrée Hayum, op. cit., chapter on ". . . the Hospital Context."

8. James H. Marrow, *Passion Iconography in Northern European Art of the Late Middle Ages and Early Renaissance* (Kortrijk, Belgium: Van Ghemmert Publishing Company, 1979), 1.

9. Howard Creel Collinson, "Three Paintings by Mathis Gothart-Neithart, called Grünewald: The Transcendent Narrative as Devotional Image" (Yale University dissertation, 1986), 110.

10. James H. Marrow, op. cit., 319.

11. Richard Kieckhefer, "Major Currents in Late Medieval Devotion," in *World Spirituality*, ed. Jill Raitt (New York: Crossroad Publishing. 1987), 85–86.

12. Ibid., 92.

13. See the somewhat revisionist but compelling article by Jeffrey F. Hamburger, "The Use of Images in the Pastoral Care of Nuns: The Case of Henry Suso and the Dominicans," *Art Bulletin* 71 (1989): 20–46, on which I am largely dependent.

14. Sixten Ringbom, "Devotional Images and Imaginative Devotions," *Gazette des Beaux-Arts*, 6th series (1969), 159–70.

15. *Birgitta of Sweden: Life and Selected Revelations*, edited by Marguerite Tjader Harris (New York: Paulist Press, 1990), 227–28. Otto Benesch, in his book *The Art of the Renaissance in Northern Europe* (Cambridge, Mass.: Harvard University Press, 1947), page 30, quotes passages more in accord with Grünewald. But the problem is that he has pulled passages here and there, arranging them to fit Grünewald. In short, there is no single place in *Birgitta* in which one could find a description fitting Grünewald's painting.

16. E. Jane Dempsey Douglass, *Justification in Late Medieval Preaching: A Study of John Geiler of Keiserberg* (Leiden: E. J. Brill, 1966), 182.

17. *The Isenheim Altarpiece*, text by Georg Scheja (New York: Harry N. Abrams, Inc., 1969), 60.

18. Sixten Ringbom, op. cit., 165.

19. Georg Scheja, op. cit., 59.

20. Ruth Mellinkoff, *The Devil at Isenheim* (Berkeley: University of California Press, 1988), 19–31. Attention is called to the fact that Leo Steinberg also discovered the Lucifer figure in the Creation of Adam panel on the Sistine ceiling. See page 122.

21. While Mellinkoff suggests that the Lucifer tradition is not biblical (ibid.), there are interpretations that read Isaiah 14:12–13 as referring to Lucifer, who fell from the heavens but wanted to be above God. If that is correct, the case Mellinkoff makes is even stronger.

22. Gustaf Aulen, *Christus Victor* (London: Society for Promoting Christian Knowledge, 1931). See also chapter 12, "The Deception of Satan," in J. A. MacCulloch, *The Harrowing of Hell* (Edinburgh: T. & T. Clark, 1930).

23. Nikolaus Pevsner and Michael Meier, *Grünewald* (London: Thames and Hudson, 1958), 39. Also see Stephen S. Kayser, "Grünewald's Christianity," *Review of Religion* 5 (1940): 19.

24. Margaret R. Miles has called my attention to how popular that subject was. See her article "Santa Maria Maggiore's Fifth-Century Mosaics: Triumphal Christianity and the Jews" in *Harvard Theological Review* 86 (1993): 157–58.

25. Howard Creel Collinson, op. cit., 18.

26. Howard Creel Collinson, op. cit., 18 following, successfully refutes Edgar Wind,

"Studies in Allegorical Portraiture I," *Journal of the Warburg Institute* 1 (1937–38), 138-62 at two important points. First, he refutes Wind's early dating of sometime before 1518, and, second, that Albrecht was interested in St. Erasmus by interpreting interest in him through an analogy to the humanist Renaissance scholar. In spite of these defects in Wind's account, he nevertheless gives the fullest account of the context of the painting.

27. Pevsner, op. cit., 39.

28. Eugenio Battisti, "Reformation and Counter-Reformation," in *Encyclopedia of World Art*, vol. 11 (1965), 906; and James Luther Adams, *An Examined Faith* (Boston: Beacon Press, 1991), 258.

29. Eugenio Battisti, op. cit., 906.

CHAPTER 3

1. Mark U. Edwards Jr., "Reformation Spin Doctors," *Harvard Divinity School Bulletin Supplement* (summer 1993): 6–7.

2. Joseph Leo Koerner, *The Moment of Self-portraiture in German Renaissance Art* (Chicago and London: University of Chicago Press, 1993), 201.

3. Jane Campbell Hutchison, *Albrecht Dürer: A Biography* (Princeton: Princeton University Press, 1990), 116.

4. See Joseph Leo Koerner, op. cit., 103–4. It is interesting that Lorenzo Valla, responsible for seeing that the Donation of Constantine was a forgery, was credulous about this document. Further, here the hair is brownish hazelnut, while in the later centuries the Christ figure is blond.

5. The more an image is seen as power, the more it can be said to be akin to the role of relics. In that sense, the touching of relics, or even seeing them, can be said to be similar to the seeing of a painting. But the seeing of relics and images in the same light became the basis from which so many reformers looked at images as idols.

6. See Carl C. Christensen, *Princes and Propaganda: Electoral Saxon Art of the Reformation* (Kirksville, Mo.: Sixteenth Century Journal Publishers, Sixteenth Century Essays and Studies, Vol. 20, 1992). The entire volume documents this point.

7. Jane Campbell Hutchison, op. cit., 125, lists the documents.

8. See William Martin Conway, *The Writings of Albrecht Dürer* (New York: Philosophical Library, 1958).

9. William Martin Conway, op. cit., 159.

10. Ibid.

11. Craig Harbison, "Dürer and the Reformation: The Problem of the Re-dating of the St. Philip Engraving," *Art Bulletin* 58 (1976): 368–73.

12. See, for example, the discussion by Philipp P. Fehl, "Dürer's Signatures: The Artist as Witness," *Continuum* 1, no. 2, (winter/spring 1991): 21.

13. Jane Campbell Hutchison, op. cit., 179.

14. Gerald Strauss, *Nuremberg in the Sixteenth Century* (New York: John Wiley and Sons, Inc., 1966), 168.

15. Ibid., 170.

16. Ibid., 173.

17. One of the delights of going into St. Sebald and St. Lorenz is that they have neither the overstuffed feeling of many cathedrals nor the emptiness of the minster in Geneva

or Zurich. The buildings, of course, have been reassembled in the light of the destruction in World War II.

18. Thurman E. Philoon, "Hans Greiffenberger and the Reformation in Nuremberg," *The Mennonite Quarterly Review* 36 (1962): 61–75. For extensive quotations from Greiffenberger, see Paul A. Russell, *Lay Theology in the Reformation* (Cambridge University Press, 1986), 158–65, and Miriam Usher Chrisman, *Conflicting Visions of Reform* (New Jersey: Humanities Press International, 1996), 163–64.

19. Th. Kolde, "Hans Denck und die gottlosen Maler von Nürnberg," *Beiträge zur bayerischen Kirchengeschichte*, vol. 8 (1902), 1–31; Herbert Zschelletzschky, Die "Drei gottlosen Maler" von Nürnberg: Sebald Beham, Barthel Beham und Georg Pencz: Historische Grundlagen und ikonologische Probleme ihrer Graphik zu Reformations-und Bauernkriegzeit (Leipzig: 1975); Keith P.F. Moxey, "Sebald Beham's church anniversary holidays: festive peasants as instruments of repressive humor," *Simiolus* 12, no. 2/3 (1981–82).

20. Warnke, Martin, *The Court Artist: On the Ancestry of the Modern Artist* (Cambridge: Cambridge University Press, 1993), 230.

21. Carl C. Christensen, *Art and the Reformation in Germany* (Athens, Ohio: Ohio University Press, 1979), 185.

22. Gerhard Pfeiffer, "Albrecht Dürer's 'Four Apostles': A Memorial Picture from the Reformation Era," in *The Social History of the Reformation*, ed. Lawrence P. Buck and Jonathan W. Zophy (Columbus: Ohio State University Press, 1972), 271–96.

23. Erwin Panofsky, *The Life and Art of Albrecht Dürer* (Princeton: Princeton University Press, 1955), 230ff.

24. Carl C. Christensen, op. cit., 183.

25. William Martin Conway, op. cit., 134.

26. For an account of these views, see Carl C. Christensen, op. cit., "Excursus: Dürer's Four Apostles."

27. Gerhard Pfeiffer, "Albrecht Dürer's 'Four Apostles': A Memorial Picture from the Reformation Era," in *Social History of the Reformation* (New York: Columbia University Press, 1972), 271–96

28. Ibid., 283.

29. Carl C. Christensen, op. cit., 203.

30. Ibid., 204.

31. Jane Campbell Hutchison, op. cit., 204.

32. It may be added that there is additional evidence for this orientation to painting. In a 1512 version of *Virgin with Pear*, the Virgin has a headdress that veils all but the center of her face, and the Christ child is nude and full of energy, if not discomfort. In the 1526 version of the same subject, classical elements, this is, composure and contemplation, are evident in both Virgin and child.

33. Quoted from the translation provided by George Houston for Donald B. Kuspit, in "Melanchthon and Dürer: the search for the simple style," *Journal of Medieval and Renaissance Studies* 3 (1973): 185. The Latin text is found in Hans Rupprich, *Dürer: Schriftlicher Nachlass* (Berlin, Vol. I, 306). Attention should also be focused on a second article by Kuspit, "Dürer and the Lutheran Image," *Art in America* (1975): 56–61. There is some evidence that Melanchthon later talked of the plain style, which he associated with Dürer. But the point remains the same.

34. Donald B. Kuspit, "Melanchthon and Dürer: the search for the simple style," *Journal of Medieval and Renaissance Studies* 3 (1973): 191.

CHAPTER 4

1. Cranach is usually associated with the Reformation, so that his Catholic period is often neglected. This has been corrected in a recently published book by Andreas Tacke, *Der katholische Cranach* (Mainz: Verlag Philipp von Zabern, 1992).

2. Carl C. Christensen, *Princes and Propaganda: Electoral Saxon Art of the Reformation* (Kirskville, Mo.: Sixteenth Century Journal Publishers, Sixteenth Century Essays and Studies, vol. 20, 1992). Christensen has demonstrated this aspect through attention to woodcuts, paintings, coins, etc.

3. *An Appeal to the Ruling class of German Nobility as to the Amelioration of the State of Christendom*, *The Pagan Servitude of the Church*, and *The Freedom of a Christian*.

4. For a summary and account of the meaning of the Passion of Christ and the Antichrist, including texts and woodcuts, see R. W. Scribner, *For the Sake of Simple Folk: Popular Propaganda for the German Reformation* (Cambridge: Cambridge University Press, 1981), 149ff.

5. For illustrations from the September Bible and comments on its context, see Kenneth A. Strand, *Reformation Bible Pictures: Woodcuts from Early Lutheran and Emserian New Testaments* (Ann Arbor: Ann Arbor Publishers, 1963); and James Strachan, *Early Bible Illustrations* (Cambridge: Cambridge University Press, 1957).

6. Heimo Reinitzer, *Biblia deutsch: Luthers Bibelübersetzung und ihre Tradition* (Woolfenbüttel: Herzog August Bibliothek, 1983), 172.

7. In this late version of the law and gospel motif, the Hebrew encampment is on the side of the law. See the later discussion of the placement of the Hebrew encampment in this chapter. For a brief history of the various editions of Luther's translations, see James Strachan, op. cit., pp. 42–48. For an extensive account, see Philipp Schmidt, *Die Illustration der Lutherbibel 1522–1700* (Basel: Verlag Friedrich Reinhardt, 1962).

8. R. W. Scribner, op. cit., p. 15 following.

9. For an account of the political implications of Cranach's early portraits of Luther, see Martin Warnke, *Cranachs Luther: Entwürfe für ein Image* (Frankfurt am Main: Fischer Taschenbuch Verlag, 1984).

10. For a summary of the relation between Luther and Cardinal Albrecht from the Ninety-five Theses through the 1530s, see Mark U. Edwards Jr., *Luther's Last Battles: Politics and Polemics, 1531–46* (Ithaca and London: Cornell University Press, 1983), 165ff.

11. Ibid.

12. For an account of the creation of the Neue Stift, the extensive art works it contained, and the demise of the project, see Jeffrey Chipps Smith, *German Sculpture of the Later Renaissance c. 1520–1580: Art in an Age of Uncertainty* (Princeton: Princeton University Press, 1994), 72–81.

13. See Carl C. Christensen, *Princes and Propaganda: Electoral Saxon Art of the Reformation* (Kirksville, Mo.: Sixteenth Century Essays and Studies, vol. 20, 1992).

14. The best documentation is to be found in Carlos M. N. Eire, *War Against the Idols: The Reformation of Worship from Erasmus to Calvin* (Cambridge: Cambridge University

Press, 1986) 54ff; Carl C. Christensen, *Art and the Reformation in Germany* (Athens, Ohio: Ohio University Press, 1979), 42ff; Margarete Stirm, *Die Bilderfrage in der Reformation* (Gütersloh: Gütersloh Verlagshaus Mohn, 1977), 17–68. See also John Dillenberger, *A Theology of Artistic Sensibilites* (New York: Crossroad Publishing, 1986) 62ff. Among the above, Christensen, more than the others, has taken the chronology seriously; but he has not always marshaled the evidence that way.

15. *Luther: Lectures on Romans*, edited and translated by Wilhelm Pauck (Philadelphia: Westminster Press, 1961), 23–25

16. Ibid., 381.

17. John Dillenberger, ed., *Martin Luther: Selections From His Writings* (New York: Doubleday Anchor, 1961), 495, 499.

18. Luther's Works (Philadelphia: Westminster Press) 31, 199. Luther's works hereafter designated LW.

19. LW 45, 285–86.

20. John Dillenberger, op. cit., 443, 456–57.

21. Karlstadt is a congenial figure for revisionist historians. It is true that he ended his life as a respectable professor in Basle. Granted that Luther himself was blunt and critical of Karlstadt, he also tried to work out accommodations with him. But it is hard, I think, to justify Karlstadt's decisions and movements during his Wittenberg period. For a balanced account of Karlstadt, see Gordon Rupp, *Patterns of Reformation* (London: Epworth Press, 1969), 49–162.

22. LW 51: 81.

23. LW 51: 82,84.

24. LW 51: 85, 83.

25. LW 40: 68–69.

26. LW 40: 79–85.

27. LW 40: 99.

28. LW 53: 316.

29. LW 9: 80–81.

30. LW 53: 69.

31. LW 37: 371.

32. LW 43: 43.

33. LW 13: 375.

34. Dillenberger, op. cit., 102.

35. Ibid., 199.

36. Ibid., 145.

37. Ibid., 127, 130.

38. Ibid., 122.

39. Ibid., 136.

40. Ibid., 122.

41. Ibid., 120.

42. Ibid., 121.

43. For an extensive account of the relation of the Law and Gospel motif and Luther's ideas, see Friedrich Ohly, *Gesetz und Evangelium? Zur Typologie bei Luther and Lucas Cranach* Zum Blutstrahl der Gnade in der kunst (Münster: Aschendorff, 1985).

44. Joesph Leo Koerner, in his volume *The Moment of Self-Portraiture in German Renaissance Art* (Chicago: University of Chicago Press, 1993), suggests that the Prague version is closer to Luther's thought in placing the nude person, who represents all of us, in the posture of having to make a decision. He also relates the format to the history of the Judgment of Hercules. Later in the volume, however, Koerner develops Luther's understanding of law and gospel in such a way that this way of putting the issue, I think, is undercut.

45. The Wittenberg altarpiece has the brazen serpent on the back side of the altar, placing it as a side panel, along with the sacrifice of Isaac as another side panel. The central panel represents Christ slaying death and the devil.

46. Carl C. Christensen, *Art and the Reformation in Germany* (Ohio University Press, 1979), 137.

47. In the Thirty-Years War, the altarpiece was stolen, later found in Prague, and was eventually returned to Schneeberg. However, the altarpiece was never put up again in its original form. During World War II, the church was virtually destroyed, but also rebuilt. While the church was again being restored in recent years, the surviving panels were in restoration at the Denkmalpflege in Dresden. In 1996 they were reinstalled in the church. Two matters may be of interest. First, those involved in the restoration have shown that the original altarpiece had the format followed in our discussion, that the flood and Lot and his daughters were not movable, in the sense that they could cover the Crucifixion or the other panels as Thulin indicated or as partially implied by R. Steche. Moreover, it would not make theological sense to have these topics and the Lord's Supper predella visible on their own. Second, the church decided sometime after the return of the panels that it should be possible to see all of the panels at one time, having decided to do this by placing them around the church. Since the panels were painted on both sides, they sawed between the two painting sides. But in order to do this, they had to cut the panels in half, the saws not being long enough to reach through an entire panel. In a real sense, that was a destructive act. Even the pictures of panels in the 1887 edition of R. Steche show these effects, and of course it is very evident in the current restoration. For the most extensive work on the various altarpieces, see Oskar Thulin, *Cranach-Altäre der Reformation* (Berlin: Evangelische Verlagsanstalt, 1955). For Schneeberg, see also R. Steche, *Bau-und Kunstdenkmäler des Königreiches Sachsen* (Dresden: In Commission bei C.C. Meinhold & Söhne, 1887), 40ff.

48. Matthew 28:18–20, *The New Oxford Annotated Bible*.

49. Numbers 21: 4–9.

50. For the history of the blood of Christ flowing onto the bodies of some who are near the Cross, see Friedrich Ohly's extensive essay, entitled "Zum Blutstrahl der Gnade in der Kunst," *Gesetz und Evangelium* (Münster: Aschendorff, 1985).

51. For a charming duo of paintings done at the time of their wedding, see the versions at the Schlossmuseum in Weimar.

52. As indicated previously, the Dessau altarpiece, recently restored, now hangs on the side wall near the chancel in the St. Johannis church in Dessau.

53. "Sermon at the Dedication of the Castle Church in Torgau," October 5, 1544, in *Luther's Works*, vol. 51, Sermons I (edited and translated by John W. Doberstein, Muhlenberg Press, 1959), 333–54.

54. Sermon of 1531 on John 8:6 in *Luther's Works*, vol. 23 (edited by Jaroslav Pelikan, St. Louis: Concordia Publishing House, 1959), 310.

55. R. W. Scribner, *For the Sake of Simple Folk Popular Propaganda for the German Reformation* (Cambridge: Cambridge University Press, 1981), 100.

56. For the Torgau chapel as a whole, see Jeffrey Chipps Smith, op. cit. 87–94. Comments on the architecture of the chapel are based on my own observations.

57. Werner Schade, *Cranach: A Family of Master Painters* (New York: G.P. Putnam's Sons, 1980), 58. Schade interprets Judith as the symbol of a new possibility of resistance, as in the League of Schmalkalden in 1531. But this interpretation is challenged by Kristin E. S. Zapalac, "Judith 'Re-Formed,'" in *Renaissance, Reform, Reflections in the Age of Dürer, Bruegel, and Rembrandt* (Master Prints from the Albion College Collection) (University of Michigan-Dearborn, 1994), 57–65.

58. Christine Ozarowska Kibish, "Lucas Cranach's Christ Blessing the Children: A Problem of Lutheran Iconography," *Art Bulletin* 37 (1955): 196–203.

CHAPTER 5

1. See, for instance, Girolano Savonarola, *The Triumph of the Cross* (London: Hodder and Stoughton, 1868), 3 and 148.

2. Charles De Tolnay, *Michelangelo*, vol. 1 (Princeton University Press, 1943), 5–6.

3. Ibid., 24.

4. Margaret R. Miles, "The Revelatory Body: Signorelli's *Resurrection of the Flesh* at Orvieto," *Theological Education* 31, no. 1 (autumn 1994): 84. Miles also makes the case that Signorelli's source is St. Augustine.

5. The most detailed and comprehensive work on the Sistine chapel prior to the execution of the ceiling by Michelangelo is that of L. D. Ettlinger, *The Sistine Chapel before Michelangelo: Religious Imagery and Papal Primacy* (Oxford: Clarendon Press, 1965).

6. In *The Sistine Ceiling*, vols. 1, 2 (New York: Alfred A. Knopf, in association with Nippon Television New Work Corporation, 1991) Frederick Hartt, who has provided the text for the photographs of the recently restored/cleaned ceiling, provides his most recent account of the sources for the subject matter of the ceiling. His earlier work on the project is to be found as follows: "Lignum Vitae in Medio Paradisi: The Stanza D'Eliodoro and the Sistine Ceiling," *Art Bulletin* 32 (1950): 115–45; 181–218.

7. Esther Gordon Dotson, "An Augustinian Interpretation of Michelangelo's Sistine Ceiling," *Art Bulletin* 61 (1979): part 1, 223–56; part 2, 405–29.

8. One of the problems in art historical research is that while we need to understand background issues and the source of subjects, some scholars make the sources so dominant that they seem to take center stage. Artists then seem merely to be illustrating texts. In reading Hartt and Dotson, one becomes overwhelmed by the plethora of meanings and histories seen everywhere. It seems to me to be a kind of theological overkill.

9. Charles De Tolnay, *Michelangelo*, vols. 1–5 (Princeton University Press, 1943–60). On this point, see vol. 2, p. 20.

10. For an extensive account of the place of the Sibyls in the theological history of the period, see the chapter "The Proportion of Women" in Creighton Gilbert's volume,

Michelangelo, on and off the Sistine Ceiling (New York: George Braziller, 1994). The same can be said of his chapter on "The Ancestors" of Christ.

11. I am aware that this view conflicts with Staale Sinding-Larsen, "A Re-reading of the Sistine Ceiling," *Acta Archaeologiam et Artium Historiam Pertinentia*, vol. 4 (Roma: L'erma di Bretschneider, 1969), 143–57. While I find the use of liturgical materials immensely instructive in understanding the ceiling, I do not believe that the theological role of the papacy is as dominant as the author implies.

12. Charles Seymour Jr., ed., *Michelangelo: The Sistine Chapel Ceiling* (New York: W. W. Norton, 1972), p. 94, quoting from Augustine, *On the Spirit and the Letter.*

13. Edmund R. Leach, "Michelangelo's *Genesis* Structuralist comments on the paintings of the Sistine Chapel ceiling," *Times Literary Supplement*, 18 March 1977. In addition to instructive comments on Jonah, and on Judith and Holofernes, one should also mention the Noah, Adam, Cain, and Abel interrelations. ". . . Michelangelo's references to Noah are also references to Adam and . . . the panel representing the Sacrifice of Noah 'encompasses' the story of Cain and Abel." Indeed, Leach demonstrates structuralism at its best, that is, starting with what is before one, in this instance the painting, and using history as echoes that illumine but do not define the meaning.

14. Leo Steinberg, "Who's Who in Michelangelo's 'Creation of Adam': A Chronology of the Picture's Reluctant Self-Revelation," *Art Bulletin* 74 (December 1992): 552–66. In the *Art Bulletin* 75 (June 1993) 340–44, Marcia Hall suggests that Steinberg is wrong in the Eve identification, making the case that, instead, wisdom is personified. In a lengthy reply, Steinberg eloquently defends his identification, but then, on the basis of reexamination of the painting in the light of an unsigned post card, agrees with the anonymous writer that wisdom is personified behind Eve.

15. Loren Partridge, *Michelangelo The Sistine Chapel Ceiling, Rome* (New York: George Braziller, 1996), 42, 96.

16. Quoted from St. Bernard by Leo Steinberg, op. cit., 562. Steinberg, however, does not develop this aspect of what is going on. It may be that the deception involved in the Grünewald altarpiece is not a part of the Michelangelo scene; but that the bases are covered is certainly present, as Steinberg himself suggests.

17. That this way of thinking is part of the tradition is surely illustrated by the fact that the Lucifer motif is also present in Grünewald's *Isenheim Altarpiece*. Here, too, the discovery is the product of recent scholarship.

18. While books on Michelangelo are legion, two of the more recent are particularly noteworthy: *The Sistine Chapel: Michelangelo Rediscovered*, A. Chastel, et al. (London: Mueller, Blount and White, 1986); and *The Sistine Chapel*, vols. 1 and 2, with text by Frederick Hartt, commentary and plates by Gianluigi Colalucci, notes on the restoration by Fabrizio Mancinelli, and photographs by Takashi Okamura (New York: Alfred A. Knopf, in association with Nippon Telegraph Network Corporation, 1991). The latter work is an expensive limited edition, but does have excellent photographs of the cleaned/restored ceiling.

19. J. B. Ross, "Gasparo Contarini and his Friends," *Studies in the Renaissance* 17 (1970): 207.

20. Ibid., 214.

21. The most extensive and scholarly work on Contarini has just been published:

Elisabeth Gleason, *Gasparo Contarini: Venice, Rome, and Reform* (Berkeley: University of California Press, 1993).

22. *Luther's Works*, 34, Career of the Reformer IV, edited by Lewis W. Spitz (Philadelphia: Muhlenberg, 1960), 235ff. Luther's suspicions were right, for few reforms were instituted. Barbara McClung Hallman in her book *Italian Cardinals, Reform, and the Church as Property* (Berkeley: University of California Press, 1985), on the basis of extensive studies concludes that "Reform, as envisioned by the authors of the Consilium de emendanda ecclesia of 1537, seems largely to have failed where money and property were involved" (p. 164).

23. On the circulation of reforming documents from the north, see the following: Paul F. Grendler, "The Circulation of Protestant Books in Italy," *Peter Martyr Vermigli and the Italian Reformation* (Waterloo, Ontario: Wilfred Laurier University Press, 1980); Elisabeth Gregorich Gleason, "Sixteenth Century Italian Interpretations of Luther," *Archiv für Reformationsgeschichte* 60 (1969): 160–73; Marvin W. Anderson, "Luther's Sola Fide in Italy 1542–1551," *Church History* 38 (1969): 25–42; Delio Cantimori, "The Problem of Heresy: The History of the Reformation and of the Italian Heresies and the History of Religious Life in the First Half of the Sixteenth Century—The Relation between Two Kinds of Research," in *The Late Italian Renaissance 1525–1630*, ed. Eric Cochrane (London: Macmillan, 1970).

24. For a recent extensive account of the literature dealing with the spread of reforming ideas in Italy, see Elisabeth G. Gleason, "Italy in the Reformation," in *Reformation Europe: A Guide to Research II*, ed. William S. Maltby (St. Louis: Center for Reformation Research, 1992), 281–306.

25. The extant letters of Calvin to Renée, including some replies from Renée to Calvin, are found in the volume by F. Whitfield Barton, *Calvin and the Duchess* (Louisville: Westminster/John Knox, 1989). For an account of Renée's life and place in Ferrara, see the article by Charmarie Jenkins Blaisdell, "Renée de France between Reform and Counter-Reform," *Archiv fur Reformationsgeschichte* 63 (1972): 196–225.

26. Philip McNair, *Peter Martyr in Italy: An Anatomy of an Apostasy* (New York: Oxford University Press, 1967); Eva-Maria Jung, "On the Nature of Evangelism in Sixteenth-century Italy," *Journal of the History of Ideas* 15 (1953): 511–27.

27. For a comprehensive and balanced view of the issue of influences, south and north, see the article by Elisabeth G. Gleason, "On the Nature of Sixteenth-Century Italian Evangelism: Scholarship, 1953–1978," *Sixteenth Century Journal* 9, 3 (1978): 3–25.

28. While the issue of Michelangelo's homosexuality inevitably arises in any discussion of his relation to men and women, it is not directly relevant to the issues under consideration. In my view, we can reasonably assume that Michelangelo was confused both by his homosexual loves and by his attraction to Vittoria Colonna. Both were obsessions he could not shake that took over his passions. But there is no basis for assuming a sexual relation with Vittoria Colonna, whose propensity for the convent was pronounced. For a judicious account of Michelangelo's relation with Vittoria Colonna, see George Bull, *Michelangelo: A Biography* (New York: Viking, 1995), 272–92, 321–23. Bull's book is also helpful on the chronology of the relation between Michelangelo and Colonna.

29. Leo Steinberg alludes to the possibility that the *Last Judgment* is integrated with the architecture of the entire chapel, but I know of no evidence to the effect that he has

developed that aspect. See Leo Steinberg, "A Corner of the *Last Judgment*," *Daedalus* (spring 1980): 268, footnote 52.

30. Loren Partridge has examined each of the groupings of figures in his extended essay "Michelangelo's Last Judgment: An Interpretation" in *Michelangelo: The Last Judgment—A Glorious Restoration* (Harry N. Abrams, Inc., 1977). In discussing each separate section, he points out the arenas in which Michelangelo departs from tradition.

31. Leo Steinberg, op. cit., page 252, writes: "We are less likely to fall into anachronism if we allow Michelangelo's fresco to reflect the freedom of those loyal Catholics who, before the Council and the revived Inquisition, speculated in pious faith upon the Last Things." He then goes on to mention Valdes, Vittoria Colonna, Reginald Pole, Ochino, and even the more conservative Cardinal Cajetan.

32. Loren Partridge, op. cit., 9–10, has summarized the changes. "The problem of nudity was addressed in 1564, when the Congregation of the Council of Trent ordered that the most offending body parts be hidden from view. In at least three different sixteenth-century campaigns beginning in 1565, a year after Michelangelo's death, and one or more in the following centuries, two figures were repainted *a fresco*, and the genitals and buttocks of nearly 40 others were covered *a secco* by loincloths. Most of those added after the sixteenth century, about fifteen, were removed in the fresco's recent cleaning (1990–94).

33. In the Foreword to *Michelangelo: The Last Judgment: A Glorious Restoration*, Francisco Buranelli, Acting Director General of the Papal Museum, Monuments, and Galleries, writes: "The Last Judgment, full and luminous, has thus been returned to its original significance; it is no longer obscured by the veils laid over it by Counter Reformatory modesty and centuries of smoke, oils, and glue. During the restoration some of the loin cloths which had been added by later censors were removed, however, the decision was made to leave the evidence of the interventions by the Council of Trent in those places where it was not possible to change it (as in the fresco repaintings of the figures of SS Blaise and Catherine), and in the figures where the censorial additions could be documented to be from the sixteenth century" (p. 7).

While it is obvious that changes could not be made in St. Blaise and St. Catherine, it is strange that other interventions that could be corrected from the sixteenth century were not made. Does this mean that protecting Trent was more important than what Michelangelo painted, while Counter Reformation modesty could go?

34. On the issue of rapid changes in perception of nudity and sexuality, many of us remember the rapid changes in the opposite direction in the 1960s. Is that any more intelligible than the change between the 1530s and the 1540s? In addition, the idea that the nude leads to immorality is like the late eighteenth/nineteenth century argument that to provide facilities for orphans would only increase illegitimacy, or the argument used at the time of writing this account that the use of fetal tissue from voluntary abortions for medical research will only increase abortions. In some situations, all of these arguments have a modicum of truth; but it is not the whole truth, which could provide a quite different understanding.

35. In addition to the previously cited article by Leo Steinberg, see particularly his "Michelangelo's 'Last Judgment' as Merciful Heresy," *Art in America* 63.6 (1975) 49–63, and, on different works of Michelangelo, including the *Last Judgment*, also see Steinberg,

"The Line of Fate in Michelangelo's Painting," *Critical Inquiry* 6 (1980): 411–54. Marcia Hall's suggestive article is "Michelangelo's *Last Judgment*: Resurrection of the Body and Predestination," *Art Bulletin* 58 (1976): 85–92.

36. This point came to me as I read the article by Bernadine Barnes, "Metaphorical Painting: Michelangelo, Dante, and the Last Judgment," *Art Bulletin* 77 (1995). While it is not her point, I think it may be in line with the suggestiveness of her article.

37. An alternative reading with which I have reservations is the following: "Michelangelo's depiction of the Last Judgment in the Sistine Chapel reflects the pessimistic spirit of the reformers in its representation of Christ and demons cooperating in sending the damned to hell, while Mary turns away from the doomed sinners' desperate pleas for intersession with her son." Joseph Klaits, *Servants of Satan: The Age of Witch-Hunts* (Bloomington: Indiana University Press, 1985), 63.

38. Leo Steinberg, *Michelangelo's Last Paintings: The Conversion of St. Paul and the Crucifixion of St. Peter in the Cappella Paolina, Vatican Palace* (London: Phaidon Press, 1975), 42ff.

39. See the introduction to and the text of this document in *Reform Thought in Sixteenth-century Italy* (Scholars Press, 1981), edited by Elisabeth Gleason.

40. The term "Nicodemites" is the subject of considerable debate. But that it does include a movement in Italy by the late 1540s, a movement of self-identification, is clear. Delio Cantimori in his article "Submission and Conformity: 'Nicodemism' and the Expectations of a Conciliar Solution to the Religious Question," in *The Late Italian Renaissance 1525–1630*, edited by Eric Cochrane (Macmillan, 1970), 244–65, describes the situation in Italy. His student Carlo Ginzburg traced the term solely to Otto Brunfels in Strassburg, a controversial suggestion, even though his work unearths new material. A review article on the work of Carlo Ginzburg by Anne Jacobson Schutte is in *The Journal of Modern History* 48 (1976) 296– 315. For an excellent overall article on these issues, see Carlos M. N. Eire, "Calvin and Nicodemism: A Reappraisal," in *Sixteenth Century Journal* 10 (1979): 45–69.

41. Cantimori, op. cit., 248.

42. When the chances of success changed, he made negative remarks about some of the same women.

43. Charles de Tolnay, *Michelangelo: The Final Period*, vol 5 (Princeton: Princeton University Press, 1960, 1961), 68.

44. The identification of the figure as Joseph of Arimathea rather than Nicodemus is fairly dominant in art historical circles. Wolfgang Steckow's article, "Joseph of Arimathea or Nicodemus?" *Studien zur Toskanischen Kunst* (1963): 289–302, weighs all the evidence and concludes, as I think most other interpreters of the article agree, that the predominant weight goes to Nicodemus. Steinberg interprets Steckow as favoring Joseph of Arimathea. All the persons in the debate seem to ignore that the wide use of the term "Nicodemite" at this time is itself a part of the evidence.

45. The interlocking way in which the hands and bodies occur gives unity to the whole. In addition to Nicodemus, one can look at the whole with respect to each figure. Mary's left arm under Christ's left armpit and the right arm is not shown but can be imagined between Nicodemus and the Christ figure. Mary Magdalen's right arm holds the leg of Christ, while her left arm encircles Nicodemus at the buttock level.

46. Leo Steinberg, "Michelangelo's Florentine *Pieta*: The Missing Leg," *Art Bulletin* 50 (1968): 343–68.

47. Valerie Shrimplin-Evangelidis, "Michelangelo and Nicodemism: The Florentine *Pieta*," *Art Bulletin* 71 (1989): 58–66. See especially page 65. Further, see the article by Jane Kristof, "Michelangelo as Nicodemus: The Florentine *Pieta*," *Sixteenth Century Journal*, 20 (1989): 163–82.

48. Quoted from Robert J. Clements, *The Poetry of Michelangelo* (New York: New York University Press, 1965), 85.

49. Rolf Schott, *Michelangelo* (London: Thames and Hudson, 1963), 220. For another account that deals with the tensions in Michelangelo's life, see George Bull, "Michelangelo's True Colours," *The Tablet* 2, no. 9 (April 1994): 423.

CHAPTER 6

1. Commentators frequently refer to Dostoyevsky's shock at seeing the painting in Basel, concluding that only an atheistic-minded person could have executed it. While John Rowlands (*Holbein: The Paintings of Hans Holbein the Younger* [Boston: David R. Godine, 1985], 52–53, 274, no. 17) interprets the work as belonging to the emphasis on the passion of Christ, Dostoyevsky, it appears to me, had a point. The difference between Grünewald's Crucifixion and Holbein's figure is the absence of religious perception in the latter.

2. John Rowlands, *Holbein* 79–80.

3. Alison Weir, *The Six Wives of Henry VIII* (New York: Grove Weidenfeld, 1991), 279.

4. The latter scene needs clarification. Christensen, with respect to Cranach, refers to the subject as the Virgin receiving the infant Christ. Rowlands interprets the scene in Holbein's version as a continuation of the medieval tradition, in which the Virgin intercedes with Christ. Jane Daggett Dillenberger has convincingly demonstrated that the scene is a continuation on one medieval strand in which the Annunciation is depicted. Then, if one contrasts the two top figures, one has Moses receiving the Law on one side, the Annunciation on the other. Then the parallelism makes sense, for Moses represents receiving of the Law and the Annunciation, the beginning of the Gospel.

5. John Rowlands, op. cit. 86.

6. See Thomas A. Brady, "The Social Place of a German Renaissance Artist: Hans Baldung Grien (1484/85–1545) at Strasbourg," *Central European History* 8 (1975): 295–315. Brady provides an informed and balanced view of Baldung in relation to the reform movements in Strasbourg.

7. From the various essays on Baldung by Linda C. Hults, see especially "Baldung and the Reformation," in *Hans Baldung Grien: Prints and Drawings* (Exhibition and Catalogue, edited by James H. Marrow and Alan Shestack, National Gallery of Art, Washington, D.C., and Yale University Art Gallery, 1981), 38–59. For Joseph Koerner, see *The Moment of Self-Portraiture in German Renaissance Art* (Chicago: The University of Chicago Press, 1993).

8. Ibid., p. 52.

9. See Brian P. Levack, *The Witch-Hunt in Early Modern Europe* (New York: Longman, 1987) chapter 7; and Linda Hults Boudreau, *Hans Baldung Grien and Albrecht Dürer: A Problem in Northern Mannerism* (Ann Arbor: University of Michigan, 1978), 127.

10. For a particularly perceptive account of Baldung in this context, see Margaret R. Miles, *Carnal Knowing: Female Nakedness and Religious Meaning in the Christian West* (Boston: Beacon Press, 1989), 127–39

11. See the catalog *Altdorfer and the Fantastic Realism of German Art* (Paris: Guillaud Publications, 1984).

12. Entrance Hall to the Synagogue in Regensburg (Berlin Kupferstichkabinet) and Interior of the Synagogue in Regensburg (Museen der Stadt Regensburg).

13. James Snyder, *Northern Renaissance Art* (New York: Harry N. Abrams, Inc., 1985), 361.

14. *Schöne Marie of Regensburg* (National Gallery of Art, Washington, D.C.).

15. *Wild Man*, 1508, British Museum and *Wild Family*, 1510, Graphische Sammlung Albertina, Vienna.

16. The Louvre, Paris.

CHAPTER 7

1. Here I disagree with Michael Camille, *The Gothic Idol: Ideology and Image-making in Medieval Art* (Cambridge: Cambridge University Press, 1989), 346. His distinction seems to me to be too sharp.

2. *A Reformation Debate: Karlstadt, Emser, and Eck on Sacred Images: Three Treatises in Translation*, translated, with an introduction and notes, by Bryan D. Mangrum and Giuseppe Scavizzi (Toronto: Centre for Reformation and Renaissance Studies, 1991) 27–28. The passage is from "On the Removal of Images."

3. Ibid., 38–39.

4. Ibid., 33–34.

5. The most detailed analysis of the reformed tradition, particularly the position of John Calvin, is to be found in Carlos M. N. Eire, *War Against the Idols: The Reformation of Worship from Erasmus to Calvin* (Cambridge: Cambridge University Press, 1986).

6. See Lee Palmer Wandel, "The Reform of the Images: New Visualizations of the Christian Community at Zurich," *Archiv für Reformationsgeschichte* 80 (1988–89): 105–24, and *Voracious Idols and Violent Hands: Iconoclasm in Reformation Zurich, Strasbourg, and Basel* (Cambridge University Press, 1995).

7. For a particularly helpful account on Zwingli's views of the visual, see P. Auksi, "Simplicity and Silence: The Influence of Scripture on the Aesthetic Thought of the Major Reformers," *Journal of Religious History* 10 (1978): 343–64.

8. Lee Palmer Wandel, *Voracious Idols and Violent Hands*, 97–98.

9. Charles Garside Jr., *Zwingli and the Arts* (New Haven: Yale University Press, 1966), 160. I think Lee Palmer Wandel prefers the whitewash; I think I am closer to Stockbar. See Wandel, op. cit., p. 194.

10. For the Baden and Berne debates, see Irena Backus, *The Disputation of Baden, 1526, and Berne, 1528: Neutralizing the Early Church* (Princeton: Princeton Theological Seminary, 1993). For the Second Helvetic Confession, see *Reformed Confessions of the Soxteenth Century* ed. Arthur C. Cochrane (Philadelphia: The Westminster Press, 1966), 229–32.

11. For a summary of Calvin's views, see *Institutes* I, xi, 12. For a succinct account of the major reformers and the image question, see David Steinmitz, *Calvin in Context* (New York: Oxford University Press, 1995), 53–63.

12. Roland Bainton, *Women of the Reformation in France and England* (Minneapolis: Augsburg Publishing, 1973), 18.

13. Natalie Zemon Davis, "The Rites of Violence: Religious Riots in Sixteenth-century France," *Past and Present* (May 1973), 51–91.

14. Natalie Zemon Davis, "Holbein's Pictures of Death and the Reformation at Lyons," *Studies in the Renaissance*, vol. 3 (1956), 97–130.

15. See Margaret Aston, *Lollards and Reformers: Images and Literacy in Late Medieval Religion* (London: The Hambledon Press, 1984); Anne Hudson, *Lollards and Their Books* (London: The Hambledon Press, 1985); John Dillenberger, *The Visual Arts and Christianity in America* (New York: Crossroad, 1989), chapter 1; and John Phillips, *The Reformation of Images: Destruction of Art in England, 1535–1660* (University of California Press, 1973).

16. William Clebsch, *England's Earliest Protestants 1520–35* (New Haven: Yale University Press, 1964), 314.

17. For a more extensive account of the visual arts and the English scene, see John Dillenberger, "English Christianity and the Visual Arts," in *The Visual Arts and Christianity in America* (New York City: The Crossroad Publishing Company, 1989), and *The Visual Arts and the Church* (New York: Crossroad Publishing Company, 1986), 72–73. For the Lollards, see Margaret Aston, *Lollards and Reformers: Images and Literacy in Late Medieval Religion* (London: The Hambledon Press, 1984); and Anne Hudson, *Lollards and Their Books* (London: The Hambledon Press, 1985), and *The Premature Reformation: Wycliffe Texts and Lollard History* (Oxford: Clarendon Press, 1988).

18. Phyllis Mack Crew, *Calvinist Preaching and Iconoclasm in the Netherlands 1544–1569* (Cambridge University Press, 1978); David Freedberg, *Iconoclasm and Painting in the Revolt of the Netherlands 1566–1609* (New York: Garland, 1988); Alastair Duke, *Reformation and Revolt in the Low Countries* (London: The Hambledon Press, 1990); and Guido Marnef, *Antwerp in the Age of Reformation Underground Protestantism in a Commercial Metropolis* (Baltimore and London: Johns Hopkins University Press, 1996).

19. D. McRoberts, "Material Destruction Caused by the Scottish Reformation," in *Essays on the Scottish Reformation*, ed. D. McRoberts (Glasgow: Burns, 1962), 415–62.

20. Ibid., 458–59

21. See *The Scandinavian Reformation from Evangelical Movement to Institutionalisation of Reform*, edited by Ole Peter Grell (Cambridge: Cambridge University Press, 1995). On the issues of images and iconoclasm, see particularly pages 181 ff.

22. *A Reformation Debate*, op. cit.

23. Ibid.

24. Ibid., 111–12.

25. Ibid., 113.

26. Ibid., 111, 114.

27. H. J. Schroeder, *Canons and Decrees of the Council of Trent* (St. Louis and London: B. Herder, 1941), 216–17.

28. David Freedberg, "Johannes Molanus on Provocative Paintings," *Journal of the Warburg and Courtauld Institutes* 34 (1971): 241.

29. Ibid., 243.

1. John Dillenberger, *A Theology of Artistic Sensibilities: The Visual Arts and the Church* (New York: Crossroad, 1986).

2. See Carl C. Christensen, "Municipal Patronage and the Crisis of the Arts in Reformation Nuremberg," *Church History* 36 (1967): 140–50, and his "Reformation and the Decline of German Art," in *Central European History*, vol. 6 (1973), 207–32.

3. An eloquent statement of that position is to be found throughout the book by Lee Palmer Wandel, *Voracious Idols and Violent Hands* (Cambridge University Press, 1995), as well as in her previous article, "Envisioning God: Image and Liturgy in Reformation Zurich," *Sixteenth Century Journal* 24 (1993): 21–40

4. David Freedberg, *The Power of Images: Studies in the History and Theory of Response* (Chicago: The University of Chicago Press, 1989).

BIBLIOGRAPHY

MUSEUMS, CHURCHES, LIBRARIES IMPORTANT
TO THIS PROJECT

Aschaffenburg, Germany—Gemäldegalerie, Schloss Johannesburg; Stiftskirche.

Berkeley, California—Graduate Theological Union Library; University of California Doe Library.

Berlin, Germany—Dahlem Gemäldegalerie; Bode Museum, Gemälde-Galerie.

Boston, Massachusetts—Museum of Fine Arts.

Chicago, Illinois—Art Institute of Chicago.

Colmar, France—Musée d'Unterlinden.

Cologne, Germany—Schnütgen Museum of Ecclesiastical Art; Wallraf-Richartz-Museum.

Dessau, Germany—Anhaltische Gemäldegalerie, Schloss Georgium; St. Johannis Kirche.

Dresden, Germany—Gemäldegalerie Alte Meister, Staatliche Kunstsammlungen; Gemäldegalerie Neue Meister, Kunstsammlungen, Albertinum; Landesamt für Denkmalpflege Sachsen.

Erfurt, Germany—Cathedral; Augustinian Cloister.

Florence, Italy—Casa Michelangelo Buonarroti; Medici chapel; Museo Nazionale del Bargello; Uffizi Gallery; Pitti; Museo dell'Opera di Santa Maria del Fiore; Galleria dell'Accademia.

Frankfurt am Main, Germany—Städelsches Kunstinstitut und Städtische Galerie.

Freiburg im Breisgau, Germany—Augustiner Museum; Cathedral.

Gotha, Germany—Schlossmuseum, Schloss Friedenstein.

Isenheim, France—Monastic Community.

Kansas City, Missouri—William Rockhill Nelson Gallery and Atkins Museum of Fine Arts.

Karlsruhe, Germany—Staatliche Kunsthalle.

Kemberg, Germany—Evangelische Stadtkirche St. Marien.

Leipzig, Germany—Museum der Bildenden Künste.

London, England—National Gallery of Art; Courtauld Institute Galleries; Royal Academy of Arts; British Museum.

Milan, Italy—Pinacoteca di Brera; Museum of Ancient Art.

Munich, Germany—Alte Pinakothek; Neue Pinakothek.

Naples, Italy,—National Gallery of Naples.

New York City—Metropolitan Museum of Art; New York Public Library.

Nuremberg, Germany—Germanisches Nationalmuseum; Dürerhaus; St. Lorenzkirche; St. Sebalduskirche.

Palo Alto, California, Stanford University Library.

Paris, France—Louvre Museum.

Philadelphia, Pa.—Philadelphia Museum of Art.

Prague, Czech Republic—National Gallery.

Rome, Italy—Vatican Museums; Sistine Chapel; Pauline Chapel.

Sarasota, Florida—John and Mabel Ringling Museum of Art.

Schneeberg, Germany—St. Wolfangskirche.

Stuttgart, Germany—Neue Staatsgalerie.

Torgau, Germany—Schloss Hartenfels.

Vienna, Austria—Kunsthistorisches Museum; Graphische Sammlung Albertina.

Washington, D.C.—National Gallery of Art.

Weimar, Germany—Kunstsammlungen zu Weimar, Schlossmuseum; Cranach Haus; St. Peter and Paul Stadtkirche (Herderkirche).

Wittenberg, Germany—Stadtkirche; Schlosskirche; Lutherhalle; Cranach-Stiftung; Galerie im Cranach-Haus.

BOOKS AND ARTICLES

Abray, Lorna Jane. *The People's Reformation: Magistrates, Clergy, and Commons in Strasbourg 1500–1598*. Ithaca: Cornell University Press, 1985.

Adams, Doug. *Transcendence with the Human Body in Art: Segal, De Staebler, Johns, and Christo*. New York: Crossroad, 1991.

Adams, James Luther. *An Examined Faith*. Boston: Beacon Press, 1991.

Anderson, Marvin W. *Peter Martyr in Exile 1542–62*. Nieuwkoop: De Graaf, 1975.

———. "Rhetoric and Reality: Peter Martyr and the English Reformation." *Sixteenth Century Journal* 19 (1988): 451–69.

———. "Luther's Sola Fide in Italy 1542–1551." *Church History* 38 (1969): 25–42.

Ankarloo, Bengt, and Gustav Henningsen, eds. *Early Modern European Witchcraft: Centres and Peripheries*. Oxford: Clarendon, 1990.

Aprocryphal New Testament. Trans. by M.R. James. Oxford: Clarendon Press, 1924, 1980.

Aston, Margaret. *Lollards and Reformers: Images and Literacy in Late Medieval Religion*. London: The Hambledon Press, 1984.

Auksi, P. "Simplicity and Silence: The Influence of Scripture on the Aesthetic Thought of the Major Reformers," *Journal of Religious History* 10 (1978–79): 343–64.

Aulen, Gustaf. *Christus Victor: An Historical Study of the Three Main Types of the Idea of the Atonement*. London: Society for Promoting Christian Knowledge, 1931.

Backus, Irena. *The Disputation of Baden, 1526, and Berne, 1528: Neutralizing the Early Church*. Princeton Theological Seminary, 1993.

Bagghi, David V. N. *Luther's Earliest Opponents: Catholic Controversialists, 1518–1525*. Minneapolis: Fortress Press, 1991.

Bainton, Roland H. "The Role of Women in the Reformation: Introduction to the Following Three Papers." *Archiv für Reformationsgeschichte* 63 (1972): 141–42.

———. "Man, God, and the Church in the Age of the Renaissance," *Journal of Religious Thought* 11 (1954): 119–33.

———. *Women of the Reformation in France and England*. Minneapolis: Augsburg, 1973.

———. "Dürer and Luther as the Man of Sorrows." *Art Bulletin* 29 (1947): 269–72.

———. *Women of the Reformation in Germany and Italy*. Minneapolis: Augsburg, 1971.

Barker, Paula S. Datsko. "Caritas Pirckheimer: A Female Humanist Confronts the Reformation." *Sixteenth Century Journal* 26 (1995): 259–72.

Barnard, Leslie. "The Theology of Images." In *Iconoclasm*. Birmingham: Centre for Byzantine Studies, University of Birmingham, 1977, 7–13.

Barnes, Bernadine. "Metaphorical Painting: Michelangelo, Dante, and the Last Judgment." *Art Bulletin* 77 (March 1995): 65–81.

Baron, Frank, ed. *Joachim Camerarius (1500–1574)*. Munich: Wilhelm Fink Verlag, 1978.

Barton, F. Whitfield. *Calvin and the Duchess*. Louisville: Westminster/John Knox, 1989.

Battisti, Eugenio. "Reformation and the Counter Reformation." In *Encyclopedia of World Art* 11 (1965): 894–916.

Baxandall, Michael. *The Limewood Sculptors of Renaissance Germany*. New Haven: Yale University Press, 1980.

Bebb, Phillip N. "Humanism and Reformation: The Nürnberg *Sodalitas* Revisited." In *Process of Change in Early Modern Europe: Essays in Honor of Miriam Usher Chrisman*, edited by Phillip N. Bebb and Sherrin Marshall. Athens: Ohio University Press, 1988.

Behling, Lottlisa. "Neue Forschungen zu Grünewalds Stuppacher Maria." *Pantheon* 26, series 2 (1968): 11–20.

Behrend, Horst. *Lucas Cranach: Maler der Reformationszeit*. Berlin: Christlicher Zeitschriftenverlag, n.d.

Belting, Hans. *Likeness and Presence: A History of the Image before the Era of Art*. Chicago and London: The University of Chicago Press, 1994.

Benesch, Otto. *The Art of the Renaissance in Northern Europe*. Cambridge: Harvard University Press, 1947.

Blaisdell, Charmarie Jenkins. "Renée de France between Reform and Counter-Reform." *Archiv für Reformationsgeschichte* 63 (1972): 196–225.

Blickle, Peter. *Communal Reformation: The Quest for Salvation in 16th Century Germany*. New Jersey: Humanities Press, 1992.

———. *The Revolution of 1525: The German Peasants' War from a New Perspective*. Baltimore: Johns Hopkins University Press, 1981.

Blunt, Sir Anthony. *Artistic Theory in Italy 1450–1600*. Oxford: Clarendon Press, 1962.

Bossy, John. *Christianity in the West 1400–1700*. New York: Oxford University Press, 1985.

Boudreau, Linda Hults. *Hans Baldung Grien and Albrecht Dürer: A Problem in Northern Mannerism*. Ann Arbor: University of Michigan, 1978.

Bouwsma, William J. "The Peculiarity of the Reformation in Geneva." *Religion and Culture in the Renaissance and Reformation, Sixteenth Century Essays and Studies* 11 (1989): 65–78.

———. "Renaissance and Reformation: An Essay in Their Affinities and Connections." In *Luther and the Dawn of the Modern Era*, edited by Heiko Oberman. Leiden: E. J. Brill, 1974.

———. *Venice and the Defense of Republican Liberty: Renaissance Values in the Age of the Counter Reformation*. Berkeley: University of California Press, 1968.

———. "Venice, Spain, and the Papacy: Paolo Sarpi and the Renaissance Tradition." In *The Late Italian Renaissance 1525–1630*, edited by Eric Cochrane. New York: Macmillan, 1970.

Brady, Thomas A. *Protestant Politics: Jacob Sturm (1489–1553) and the German Reformation*. New Jersey: Humanities Press, 1995.

———. "The Social Place of a German Renaissance Artist: Hans Baldung Grien (1484/85–1545) at Strasbourg." *Central European History* 8 (1975): 295–315.

———. *Ruling Class, Regime and Reformation at Strasbourg 1520–1555*. Leiden: E. J. Brill, 1978.

Brady, Thomas A., Heiko A. Oberman, and James D. Tracy, eds. *Handbook of European History: Late Middle Ages, Renaissance and Reformation*. Vols. 1 and 2. Leiden: E. J. Brill, 1994 and 1995.

Brendler, Gerhard. *Martin Luther: Theology and Revolution*. New York: Oxford University Press, 1991.

Bridget of Sweden, Saint. *Revelations*. New York: Oxford University Press, 1987.

Brink, Jean R., Allison P. Coudert, and Maryanne C. Horowitz, eds. *The Politics of Gender in Early Modern Europe*. Sixteenth Century Essays and Studies 12 (1989).

Brown, George Kenneth. *Italy and the Reformation to 1550*. Oxford: Blackwell, 1933.

Bull, George, and Peter Porter, trans. and eds. *Michelangelo: Life, Letters, and Poetry*. New York: Oxford University Press, 1987.

Bull, George, "Michelangelo's True Colours." *The Tablet* 2/9/April (1994): 422ff.

———. *Michelangelo: A Biography*. New York: Viking, 1995.

Burkhard, Arthur. "The Isenheim Altar of Matthias Grünewald." *Speculum* 9 (1934): 56–69.

Calvin, John. *Tracts Relating to the Reformation*, vol. 1–3. Edinburgh: Calvin Translation Society, 1844.

Camille, Michael. *The Gothic Idol: Ideology and Image-making in Medieval Art*. Cambridge: Cambridge University Press, 1989.

———. "Seeing and Reading: Some Visual Implications of Medieval Literacy and Illiteracy." *Art History* 8 (1985): 26–50.

Cantimori, Delio. "Submission and Conformity: 'Nicodemism' and the Expectations of a Conciliar Solution to the Religious Question." In *The Late Italian Renaissance 1525–1630*, edited by Eric Cochrane. New York: Macmillan, 1970.

———. "Italy and the Reformation." In *New Cambridge Modern History, II, The Reformation 1520–59*, edited by G. R. Elton. Cambridge: Cambridge University Press, 1958.

———. "The Problem of Heresy: The History of the Reformation and of the Italian Heresies and the History of Religious Life in the First Half of the Sixteenth Century— the Relation Between Two Kinds of Research," in *The Late Italian Renaissance 1525–1630*, edited by Eric Cochrane. London: Macmillan and Co., Ltd., 1970.

Caro Baroja, Julio. *The World of the Witches*. Chicago: The University of Chicago Press, 1964.

Cartwright, Julia (Mrs. Ady). *Isabella D'este, Marchioness of Mantua 1474– 1539: A Study of the Renaissance*. London: John Murray, Albemarle Street, 1932.

Chrisman, Miriam U. "Women and the Reformation in Strasbourg 1490–1530." *Archiv für Reformationsgeschichte* 63–64 (1972–73): 143–67.

———. *Conflicting Visions of Reform: German Lay Propaganda Pamphlets, 1519–1530*. New Jersey: Humanities Press, 1996.

———. *Strasbourg and the Reform: A Study in the Process of Change*. New Haven: Yale University Press, 1967.

Christensen, Carl C. *Art and the Reformation in Germany*. Ohio University Press, 1979.

———. "The Significance of the Epitaph Monument in Early Lutheran Ecclesiastical Art (ca. 1540–1600): Some Social and Iconographical Considerations." In *The Social History of the Reformation*, edited by Lawrence P. Buch and Jonathan W. Zophy. New York: Columbia University Press, 1972), 297–314.

———. *Princes and Propaganda: Electoral Saxon Art of the Reformation*. Ann Arbor: Edwards Brothers, 1992, *Sixteenth Century Essays and Studies*, vol. 20.

———. "Dürer's Four Apostles and the Dedication as a Form of Renaissance Art Patronage." *Renaissance Quarterly* 20 (1967): 325–34.

———. "Municipal Patronage and the Crisis of the Arts in Reformation Nuernberg." *Church History* 36 (1967): 140–50.

———. "Iconoclasm and the Preservation of Ecclesiastical Art in Reformation Nuernberg." *Archiv für Reformationsgeschichte* 61 (1970): 205–21.

———. "The Reformation and the Decline of German Art," *Central European History* 6 (1973): 207–32.

———. "Reformation and Art." In *Reformation Europe: A Guide to Research*, edited by Steven Ozment. St. Louis: Center for Reformation Research, 1982.

Clasen, Claus-Peter. "Nuernberg in the History of Anabaptism." *Mennonite Quarterly Review 39*, 1965.

Clements, Robert J. *The Poetry of Michelangelo*. New York: New York University Press, 1965.

Cochrane, Eric. "New Light on Post-Tridentine Italy: A Note on Recent Counter-Reformation Scholarship." *Catholic Historical Review* 56 (1970–71), 291–319.

———. *The Late Italian Renaissance 1525–1630*. London: Macmillan, 1970.

————, ed. *Reformed Confessions of the Sixteenth Century*. Philadelphia: The Westminster Press, 1966.

Cohn, Norman. *Europe's Inner Demons: An Enquiry Inspired by the Great Witch-Hunt*. New York: Basic Books, Inc., 1975.

Collinson, Howard Creel, "Three Paintings by Mathis Gothart-Neithart, Called Grünewald: The Transcendent Narrative as Devotional Image." New Haven: Yale University dissertation, 1986.

Complete Paintings of Dürer. Notes and catalogue by Angela Ottino della Chiesa. London: Weidenfeld and Nicolson, 1971.

Conway, William Martin. *The Writings of Albrecht Dürer*. New York: Philosophical Library, 1958.

Cook, John W. "Picturing Theology: Martin Luther and Lucas Cranach." In *Art and Religion: Faith, Form and Reform*. Columbia, Mo.: University of Missouri Press, 1986.

Cowie, Murray A. and Marian L. "Geiler von Kaysersberg and Abuses in Fifteenth-Century Strassburg," *Studies in Philology* 58 (1961): 483–95.

Crew, Phyllis Mack. *Calvinist Preaching and Iconoclasm in the Netherlands 1544–1569*. Cambridge: Cambridge University Press, 1978.

Dahl, Ellert. "Heavenly Images: The Statue of St. Foy of Conques and the Signification of the Medieval 'Cult-Image' in the West." *ACTA* Roma: Geiorgio Bretschneider 8: 175–95.

Davis, Natalia Zemon. "Holbein's Pictures of Death and the Reformation at Lyons." *Studies in the Renaissance* 3 (1956): 97–130.

————. "The Rites of Violence: Religious Rites in Sixteenth-Century France." *Past and Present* (May 1973), 51–91.

De Tolnay, Charles. *Michelangelo*. Vols. 1–5. Princeton University Press, 1943–60.

Dickens, A. G. The Counter Reformation. London: Thames and Hudsson, 1968.

————. *The German Nation and Martin Luther*. New York: Harper and Row, 1974.

Dillenberger, Jane. *Secular Art with Sacred Themes*. Nashville and New York: Abingdon Press, 1969.

————. *Image and Spirit in Sacred and Secular Art*. New York: Crossroad, 1990.

Dillenberger, John, ed. *Martin Luther: Selections from His Writings*. New York: Doubleday Anchor, 1962.

————. *The Visual Arts and Christianity in America*. New York: Crossroad, 1989.

————. *A Theology of Artistic Sensibilities: The Visual Arts and the Church*. New York: Crossroad, 1986.

Dipple, Geoffrey. *Antifraternalism and Anticlericalism in the German Reformation*. Hants, England: Scolar Press, 1996.

Dixon, John W., Jr. *The Christ of Michelangelo: An Essay on Carnal Spirituality*. Atlanta, Georgia: Scholars Press (for the University of South Florida, University of Rochester, and Saint Louis University), 1994.

————. "The Carnal and the Spiritual: Michelangelo's Madonnas," *Cross Currents* 41 (summer 1991): 148–67.

Dotson, Esther Gordon. "An Augustinian Interpretation of Michelangelo's Sistine Ceiling." *Art Bulletin* 61 (1979): 223–56, 405–29.

Douce, Francis. *Holbein's Dance of Death* and *Holbein's Bible Cuts*. London: Henry G. Bohn, 1858.

Douglas, Richard M. *Jacopo Sadoleto 1477–1547: Humanist and Reformer*. Cambridge: Harvard University Press, 1959.

Douglass, E. Jane Dempsey. *Justification in Late Medieval Preaching A Study of John Geiler of Keiserberg*. Leiden: E.J. Brill, 1966.

Duerr, Hans Peter. *Dreamtime: Concerning the Boundary between Wilderness and Civilization*. Oxford: Basil Blackwell, 1985.

Duke, Alastair, *Reformation and Revolt in the Low Countries*. London and Ronceverte: The Hambledon Press, 1990.

Dunkerton, Jill, ed. *Giotto to Dürer Early Renaissance Paintings in the National Gallery*. New Haven and London: Yale and National Gallery, 1991.

Dürer, Albrecht. *Dürer: Diary of his Journey to the Netherlands*. London: 1970.

———. *Dürer: The Complete Engravings, Etchings and Woodcuts*. London: Thames and Hudson, 1965.

Dykema, Peter A., and Heiko A. Oberman, eds. *Anticlericalism in Late Medieval and Early Modern Europe*. Leiden: E. J. Brill, 1993.

Edwards, Mark U., Jr. *Luther and the False Brethren*. Stanford: Stanford University Press, 1975.

———. "Reformation Spin Doctors." *Harvard Divinity School Bulletin Supplement* (summer 1993).

———. *Luther's Last Battles: Politics and Polemics, 1531–46*. Ithaca: Cornell University Press, 1983.

———. *Printing, Propaganda, and Martin Luther*. Berkeley: University of California Press, 1994.

Ehresmann, Donald L. "The Brazen Serpent, A Reformation Motif in the Works of Lucas Cranach the Elder and His Workshop." *Marsyas Studies in the History of Art* 13 (1967): 32–47.

Eire, Carlos M. N. "Calvin and Nicodemism: A Reappraisal." *Sixteenth Century Journal* 10 (spring 1979): 45–69.

———. *War Againsst the Idols: The Reformation of Worship from Erasmus to Calvin*. Cambridge University Press, 1986.

Emmerson, Richard K., and Bernard McGinn, eds. *The Apocalypse in the Middle Ages*. Ithaca and London: Cornell University Press, 1992.

Ettlinger, L. D. *The Sistine Chapel before Michelangelo: Religious Imagery and Papal Primacy*. Oxford: Clarendon Press, 1965.

Evans, Austin Patterson. *An Episode in the Struggle for Religous Freedom: The Sectaries of Nuremberg*. New York: Columbia University Press, 1924.

Fehl, Philipp P. "Dürer's Signatures: The Artist as Witness," *Continuum* 1, no. 2 (winter/ spring, 1991): 3–34.

Fenlon, Dermot. *Heresy and Obedience in Tridentine Italy: Cardinal Pole and the Counter Reformation*. Cambridge: Cambridge University Press, 1972.

Finucane, Ronald C. *Miracles and Pilgrims: Popular Beliefs in Medieval England*. Totowa, N.J.: Rowman and Littlefield, 1977.

Firpo, Massimo (with John Tedeschi). "The Italian Reformation and Juan de Valdes." *Sixteenth Century Journal* 27 (1996): 353–64.

Freedberg, David. *Iconoclasm and Painting in the Revolt of the Netherlands 1566–1609*. New York: Garland, 1988.

———. *Iconoclasm and their Motives*. Maarssen: Gary Schwartz, 1985.

———. "The Structure of Byzantine and European Iconoclasm." Birmingham: *Iconoclasm Centre for Byzantine Studies*, 1977.

———. "The Representation of Martyrdoms during the Early Counter Reformation in Antwerp." *Burlington Magazine* 118 (1976): 128–38.

———. "The Hidden God: Image and Interdiction in the Netherlands in the Sixteenth Century." *Art History* 5 (1982): 133–53.

———. *The Power of Images: Studies in the History and Theory of Responses*. Chicago: University of Chicago, 1989.

———. "Johannes Molanus on Provocative Paintings." *Journal of the Warburg and Courtauld Institutes* 34 (1971): 229–45.

———. "The Problem of Images in Northern Europe and Its Repercussions in the Netherlands." *Hafnia* (1976): 25–45.

Freiberg, Jack. *The Lateran in 1600: Christian Concord in Counter-Reformation Rome*. New York: Cambridge University Press, 1995.

Friedlander, Max J., and Jacob Rosenberg. *The Paintings of Lucas Cranach*. Secaucus, N.J.: Wellfleet Press, 1978.

Ganz, Paul. *The Paintings of Hans Holbein the Younger*. New York: Phaidon, 1950.

Garside, Charles, Jr. *Zwingli and the Arts*. New Haven: Yale University Press, 1966.

———. "Ludwig Haetzer's Pamphlet against Images: A Critical Study." *Mennonite Quarterly Review* 34 (1960): 20–36.

Gauthier, Marie-Madeleine. *Highways of the Faith: Relics and Reliquaries from Jerusalem to Compostela*. Secaucus, N.J.: Wellfleet Press, 1986.

Geary, Patrick J. "The Ninth Century Relic Trade: A Response to Popular Piety?" In *Religion and People*, edited by James Obelkevich. Chapel Hill: University of North Carolina, 1979.

———. Furta Sacra: Thefts of Relics in the Central Middle Ages. Princeton: Princeton University Press, 1978.

Geisberg, Max. "Cranach's Illustrations of the Lord's Prayer and the Editions of Luther's Catechism," *Burlington Magazine* 43 (1923): 85–87.

Gero, S. *"The Libri Carolini and the Image Controversy." The Greek Orthodox Theological Review* 18 (1973): 7–34.

Giese, Rachel. "Erasmus and the Fine Arts," *The Journal of Modern History* 7 (1935): 257–79.

Gilbert, Creighton E. *Michelangelo, on and off the Sistine Ceiling*. New York City: George Braziller, 1994.

Gilman, Ernest B. *Iconoclasm and Poetry in the English Reformation*. Chicago: University of Chicago Press, 1986.

Gleason, Elisabeth G. *Gasparo Contarini: Venice, Rome, and Reform*. Berkeley: University of California Press, 1993.

———. "On the Nature of Sixteenth-century Italian Evangelism: Scholarship, 1953–1978." *Sixteenth Century Journal* 9 (IX 3, 1978): 3–25.

———, ed. and trans. *Reform Thought in Sixteenth-century Italy*. Scholars Press, 1981.

————. "Sixteenth Century Italian Interpretations of Luther." *Archiv für Reformations-geschichte* 60 (1969): 160–73.

———— "Italy in the Reformation." In *Reformation Europe: A Guide to Research II*, edited by William S. Maltby. St. Louis: Center for Reformation Research, 1992.

Gothic and Renaissance Art in Nuremberg 1300–1550. Metropolitan Museum of Art and Prestel-Verlag, Munich, 1986.

Gottesword und Menschen-Bild werke von Cranach und seinen zeitgenossen. Vol. 1. Schloss-museum Gotha, 1994.

Grell, Ole Peter, ed. *The Scandinavian Reformation from Evangelical Movement to Institu-tionalisation of Reform*. Cambridge: Cambridge University Press, 1995.

Grendler, Paul F. "The Circulation of Protestant Books in Italy." In *Peter Martyr Vermigli and the Italian Reformation*, edited by Joseph C. McLelland. Waterloo, Ontario: Wil-frid Laurier University Press, 1980.

Grendler, Marcell, and Paul Grendler. "The Survival of Erasmus in Italy." *Erasmus in English* 8 (1976): 2–22.

Grimm, Claus, Johannes Erichsen, and Evamaria Brockhoff. *Lucas Cranach: Ein Maler-Unternehmer aus Franken*. Verlag Friedrich Pustet, 1994.

Grimm, Harold J. "Lazarus Spengler, The Nürnberg Council, and the Reformation." In *Luther for an Ecumenical Age*, edited by Carl S. Meyer. Saint Louis: Concordia Publish-ing House, 1967.

Grossmann, Fritz. "A Religious Allegory by Hans Holbein the Younger." *Burlington Mag-azine* 103 (1961): 490–94.

Grossmann, Maria. *Humanism in Wittenberg 1485–1517*. Nieuwkoop: B. De Graaf, 1975.

Guillaud, Jacquelin and Maurice, eds. *Altdorfer and Fantastic Realism in German Art*. Paris: Guillaud Editions, 1984.

Hall, Marcia. "Who's Who in Michelangelo's '*Creation of Adam*' Continued." *Art Bulletin* 75 (1993); 340.

————. "Michelangelo's *Last Judgment*: Resurrection of the Body and Predestination." *Art Bulletin* 58 (1976): 85–92.

Hallman, Barbara McClung. *Italian Cardinals, Reform, and the Church as Property*. Berke-ley: University of California Press, 1985.

Hamburger, Jeffrey F. "The Use of Images in the Pastoral Care of Nuns: The Case of Heinrich Suso and the Dominicans." *Art Bulletin* 71 (1989): 20–46.

————. "The Visual and the Visionary: The Image in Late Medieval Devotions." *Viator* 20 (1989): 161–82.

Harbison, Craig. *The Last Judgment in Sixteenth Century Northern Europe: A Study of the Relation Between Art and the Reformation*. New York: Garland Publishing, Inc., 1976.

————. "Durer and the Reformation: The Problem of the Re-dating of the St. Philip Engraving." *The Art Bulletin* 58 (1976): 368–73.

————. "Visions and Meditations in Early Flemish Painting. *Simiolus* 15 (1985): 87–118.

————. *Symbols in Transformation*. Introduction and catalogue. Princeton University Press, 1969.

————. Introduction and catalogue entries, *Symbols in Transformation: Iconographic Themes at the Time of the Reformation*. Princeton University Exhibition Catalogue, April, 1969.

———. "Some Artistic Anticipations of Theological Thought." *Art Quarterly* 2 (1979): 67–89.

———. "Reformation Iconography." *Print Review* 5 (1976): 67–86.

Hare, Christopher. *A Princess of the Italian Reformation: Giulia Gonzaga, 1513–1566: Her Family and Her Friends*. London and New York: Harper & Brothers, 1912.

———. *Men and Women of the Italian Reformation*. London: S. Paul, 1914.

Harran, Marilyn J. *Luther on Conversion: The Early Years*. Ithaca: Cornell University Press, 1983.

Harris, Marguerite Tjader. *Birgitta of Sweden: Life and Selected Revelations*. New York: Paulist Press, 1990.

Hartt, Frederick. *Michelangelo's Three Pietas*. New York: Henry N. Abrams, Inc., 1975.

———. *Michelangelo: The Complete Sculpture*. London: Thames and Hudson, 1969.

Hayum, Andrée. *The Isenheim Altarpiece: God's Medicine and the Painter's Vision*. Princeton: Princeton University Press, 1989.

———. "The Meaning and Function of the Isenheim Altarpiece: The Hospital Context Revisited." *Art Bulletin* 59 (1977): 501–17.

Heller, Henry. "The Evangelicalism of Lefevre d'Etaples: 1525." *Studies in the Renaissance* 19 (1972): 42–77.

Hendrix, Scott H. *Tradition and Authority in the Reformation*. Great Britain: Variorum, 1996.

Henry, Patrick. "What was the Iconoclastic Controversy About?" *Church History* 45 (1976): 16–31.

Hieatt, A. Kent. "Hans Baldung Grien's Ottawa Eve and Its Context," *Art Bulletin* 65 (1983): 290–304.

Hillerbrand, Hans J., ed. *Radical Tendencies in the Reformation: Divergent Perspectives*. Sixteenth Century Essays and Studies, vol. 9, 1988.

———. *Landgrave Philipp of Hesse 1504–1567*. St. Louis: Foundation for Reformation Research, 1967.

Hoak, Dale. "Art, Culture, and Mentality in Renaissance Society: The Meaning of Hans Baldung Grien's Bewitched Groom." *Renaissance Quarterly* 38 (1985): 488–510.

Horne, P. R. "Reformation and Counter-Reformation at Ferrara: Antonio Musa Brasavola and Giambattista Cinthio Giraldi." *Italian Studies* 13 (1958): 62– 82.

Hsia, R. Po-chia. *The Myth of Ritual Murder: Jews and Magic in Reformation Germany*. New Haven: Yale University Press, 1988.

———. *Society and Religion in Münster 1535–1618*. New Haven: Yale University Press, 1984.

Hudson, Anne. *Lollards and their Books*. London: The Hambeldon Press, 1985.

———. *The Premature Reformation: Wycliffe Texts and Lollard History*. Oxford: Clarendon Press, 1988.

Hults, Linda C. "Baldung and the Witches of Freiburg: The Evidence of Images." *Journal of Interdisciplinary History* 18, no. 2 (n.d.): 249–276.

———. *Hans Baldung Grien and Albrecht Dürer: A Problem in Northern Mannerism*. Ann Arbor: University Microfilms International, 1979.

———. "Baldung's Bewitched Groom Revisited: Artistic Temperament, Fantasy, and the 'Dream of Reason.'" *Sixteenth Century Journal* 15 (1984): 259–279.

Humfrey, Peter, and Martin Kemp, eds. *Altarpiece in the Renaissance*. Cambridge: Cambridge University Press, 1990.

Hunt, R. N. Carew. *Calvin*. London: Centenary Press, 1933.

Hurstfield, Joel, ed. *The Reformation Crisis*. London: Edward Arnold, Ltd., 1965.

Husband, Timothy. *Luminous Image: Painted Glass Roundels in the Lowlands, 1480–1560*. New York: Metropolitan Museum of Art, 1995.

Hutchison, Jane Campbell, *Albrecht Dürer: A Biography*. Princeton: Princeton University Press, 1990.

Huysmans, J.K. *Grünewald*. Oxford: Phaidon Press Limited, 1976.

Images from the Old Testament: Historiarum Veteris Testamenti Icones by Hans Holbein. London: Paddington Press, 1976.

Janelle, Pierre. *The Catholic Reformation*. Milwaukee: Bruce Publishing, 1963.

Janzen, Reinhild. *Albrecht Altdorfer: Four Centuries of Criticism*. Ann Arbor: UMI Research Press, 1979, 1980.

Jeanneret, Michel. *A Feast of Words: Banquets and Table Talk in the Renaissance*. Chicago: University of Chicago Press, 1991.

Jorgensen, Johannes. *Saint Bridget of Sweden*. Vol. 1–2. New York: Longmans Green and Co., 1954.

Jung, Eva-Maria. "Vittoria Colonna: Between Reformation and Counter-Reformation." *Review of Religion* 15 (March 1951): 144–59.

———. "On the Nature of Evangelism in Sixteenth-century Italy." *Journal of the History of Ideas* 15 (1953): 511–27.

Kayser, Stephen S. "Grünewald's Christianity," *Review of Religion* 5 (1940): 3–35.

Kelley, Donald. *The Beginning of Ideology: Consciousness and Society in the French Reformation*. New York: Cambridge University Press, 1981.

Kibish, Christine Ozarowska. "Lucas Cranach's Christ Blessing the Children: A Problem of Lutheran Iconography." *Art Bulletin* 37 (1955): 196–203.

Kieckhefer, Richard. "Major Currents in Late Medieval Devotion." In *World Spirituality*, edited by Jill Raitt. New York: Crossroad Publishing, 1987.

Kingdon, Robert W. *Geneva and the Coming of the Wars of Religion in France 1555–1563*. Geneva: Librairie E. Droz, 1956.

———. *Church and Society in Reformation Europe*. London: Variorum Reprints, 1985.

Kittelson, James M. *Wolfgang Capito: From Humanist to Reformer*. Leiden: E. J. Brill, 1975.

———. "Wolfgang Capito, the Council and Reform Strasbourg." *Archiv für Reformationsgeschichte* 63 (1912): 126–40.

Klaits, Joseph. *Servants of Satan: The Age of Witch Hunts*. Bloomington: Indiana University Press, 1985.

Knappe, Karl Adolf, "Grünewald, Matthias" in *Theologische Realenzyklopädie*, vol. 14 (Berlin, 1985).

———. *Dürer The Complete Engravings, Etchings and Woodcuts*. London: Thames and Hudson, 1965.

Koerner, Joseph Leo. *The Moment of Self-portraiture in German Renaissance Art*. Chicago and London: The University of Chicago Press, 1993.

Kolde, Theodor. "Hans Denck und die gottlosen Maler von Nürnberg." Vol. 8 of *Beiträge zur bayerischen Kirchengeschichte* (1902), 1–31.

Krautheimer, Richard. *Three Christian Capitals*. University of California Press, 1983.

Kristof, Jane. "Michelangelo as Nicodemus: The Florentine *Pieta*." *Sixteenth Century Journal* 20 (summer 1989): 163–82.

Kuhn, Charles L. "The Mairhauser Epitaph: An Example of Late Sixteenth-century Lutheran Iconography." *Art Bulletin* 58 (1976): 542–46.

Kurth, Willi, ed. *The Complete Woodcuts of Albrecht Dürer*. New York: Arden Book Co., 1936.

Kuspit, Donald B. "Melanchthon and Dürer: the Search for the Simple Style." *Journal of Medieval and Renaissance Studies* 3 (1973): 177–202.

———. "Dürer and the Lutheran Image," *Art in America* (Jan.–Feb. 1975): 56–61.

Kusukawa, Sachiko. *The Transformation of Natural Philosophy: The Case of Philip Melanchthon*. Cambridge: Cambridge University Press, 1995.

Landes, Richard. *Relics, Apocalypse and the Deceits of History*. Cambridge: Harvard University Press, 1995.

Leach, Edmund R. "Michelangelo's Genesis, Structuralist comments on the paintings on the Sistine Chapel ceiling," *Times* (London) *Literary Supplement* (18 March 1977): 313.

Levack, Brian P. *The Witch-Hunt in Early Modern Europe*. London and New York: Longman, 1987.

Levi, Anthony. "Renaissance and Reformation." *Dublin Review* 239 (1965): 255–67.

Levy, Janey. "Popular Culture and the Early Lutheran Iconography in a Cranach *Last Judgment*." Kansas City: Nelson Atkins Museum, n.d.

Lewine, Carol F. *The Sistine Chapel Walls and the Roman Liturgy*. University Park, Pa.: Pennsylvania State University Press, 1992.

Locher, Gottfried Wilhelm. *Zwingli's Thought: New Perspectives*. Leiden: E. J. Brill, 1981.

Logan, O .M. T. "Grace and Justification: Some Italian Views of the Sixteenth and Early Seventeenth Centuries." *Journal of Ecclesiastical History* 20 (1969): 68–78.

M'Crie, Thomas. *History of the Progress and Suppression of the Reformation in Italy in the Sixteenth Century*. Edinburgh: William Blackwood, 1856.

MacCulloch, J. A. *The Harrowing of Hell*. Edinburgh: T & T Clark, 1930.

Mackensen, Heinz. "Contarini's theological role at Ratisbon in 1541," *Archiv für Reformationsgeschichte* 51 (1960): 36–57.

———. "The Diplomatic Role of Gasparo Contarini at the Colloquy of Ratisbon of 1541." *Church History* 27 (1958): 312–37.

Mangrum, Bryan D., and Giuseppe Scavizzi, eds. A *Reformation Debate: Karlstadt, Emser, and Eck on Sacred Images: Three Treatises in Translation*. Toronto: The Centre for Reformation and Renaissance Studies, 1991.

Marnef, Guido. *Antwerp in the Age of Reformation: Underground Protestantism in a Commercial Metropolis, 1550–1577*. Baltimore: Johns Hopkins University Press, 1996.

Marrow, James H. *Passion Iconography in Northern European Art of the Late Middle Ages and Early Renaissance*. Kortrijk, Belgium: Van Ghemmert Publishing Company, 1979.

Martin, Edward James. *A History of the Iconoclastic Controversy*. London: Society for Promoting Christian Knowledge, 1930.

McAuliffe, Dennis James. "Vittoria Colonna: Her Formative Years 1492–1525 as a Basis for an Analysis of her Poetry." Ph.D. diss, New York University, 1978.

McDonough, Thomas M. *The Law and the Gospel in Luther: A Study of Martin Luther's Confessional Writings*. London: Oxford University Press, 1963.

McLelland, Joseph C., ed. *Peter Martyr Vermigli and Italian Reform*. Waterloo, Ontario, Canada: Wilfred Laurier University Press, 1980.

McNair, Philip. *Peter Martyr in Italy: An Anatomy of an Apostasy*. New York: Oxford University Press, 1967.

McNally, Robert E. "The Council of Trent and the German Protestants." *Theological Studies* 25 (1964): 1–22.

———. "The Council of Trent, the Spiritual Exercises and the Catholic Reform." *Church History* 34 (1965): 35–49.

McNeill, John T. *The History and Character of Calvinism*. New York: Oxford University Press, 1954.

McRoberts, D. "Material Destruction Caused by the Scottish Reformation." In *Essays on the Scottish Reformation*. Edited by D. McRoberts. Glasgow: Burns, 1962.

Mellinkoff, Ruth. *The Devil at Isenheim*. Berkeley: University of California Press, 1988.

Michalski, Sergiusz. *The Reformation and the Visual Arts*. London and New York: Routledge, 1993.

Michelangelo: The Last Judgment—A Glorious Restoration. Texts by Loren Partridge, Fabrizio Mancinelli, Gianluigi Colalucci; photographs by Takashi Okamura. Harry N. Abrams, Inc., Publishers, 1997.

Midelfort, H. C. Erik. *Witch-hunting in Southwestern Germany 1562–1684: The Social and Intellectual Foundations*. Stanford: Stanford University Press, 1972.

Mielke, Hans. *Albrecht Aldorfer: Zeichnungen, Deckfarbenmalerei, Druckgraphik*. Reimer Verlag Berlin, 1988.

Miles, Margaret R. "The Revelatory Body: Signorelli's *Resurrection of the Flesh* at Orvieto." *Theological Education* 31 (1994).

———. *Carnal Knowing: Female Nakedness and Religious Meaning in the Christian West*. Boston: Beacon Press, 1989.

Moens, W. J. C. "Notes upon the Beginnings of the Reformation at Antwerp and the Field Preaching There." *Huguenot Society of London Proceedings* 1 (1885–86): 197–204.

Monick, Eugene. *Evil, Sexuality, and Disease in Grünewald's Body of Christ*. Dallas: Spring Publications, 1993.

Moxey, Keith. *Peasants, Warriors, and Wives: Popular Imagery in the Reformation*. University of Chicago Press, 1989.

———. "Sebald Beham's Church Anniversary Holidays: Festive Peasants as Instruments of Repressive Humor. *Simiolus* 12 (1981–82): 107–31.

———. *Pieter Aertsen, Joachim Beucekelaer, and the Rise of Secular Painting in the Context of the Reformation*. New York: Garland Publishing, 1977.

Mullett, Michael. *The Counter Reformation and the Catholic Reformation in Early Modern Europe*. London and New York: Methuen, 1984.

Nieto, Jose C., ed. Introduction to *Valdes' Two Catechisms: The Dialogue on Christian Doctrine and the Christian Instruction for Children*. Lawrence, Kansas: Coronado Press, 1981.

O'Malley, John W. *Praise and Blame in Renaissance Rome: Rhetoric, Doctrine, and Reform in the Sacred Orators of the Papal Court, c. 1450–1521*. Durham, N.C.: Duke University Press, 1979.

———. "Historical Thought and the Reform Crisis of the Early Sixteenth Century." *Theological Studies* 28 (1967): 531–548.

————. *Giles of Viterbo on Church and Reform*. Leiden: E. J. Brill, 1968.

————. *Rome and the Renaissance: Studies in Culture and Religion*. London: Variorum Reprints, Collected Studies Series, 1981.

Obelkevich, James, ed. *Disciplines of Faith, Studies in Religion, Politics and Patriarchy*. London and New York: Routledge, 1987.

————, ed. *Religion and the People 800–1700*. Chapel Hill: University of North Carolina, 1979.

Oberman, Heiko A. *Luther: Man between God and the Devil*. New Haven: Yale University Press, 1989.

————. "The Impact of the Reformation: Problems and Perspectives." In *Politics and Society in Reformation Europe*, edited by E. I. Kouri and Tom Scott. London: Macmillan Press, 1986.

————. "Teufelsdreck: Eschatology and Scatology in the 'Old' Luther." *Sixteenth Century Journal* 19 (1988): 435–50.

————, with Charles Trinkaus. *The Pursuit of Holiness in Late Medieval and Renaissance Religion*. Leiden: E. J. Brill, 1974.

————. "Die Gelehrten die verkehrten: Popular Response to Learned Culture in the Renaissance and Reformation," in *Religion and Culture*. Edited by Steven Ozment. Sixteenth Century Essays and Studies, vol. 11, 43–63.

————, with Thomas A. Brady Jr. *Itinerarium Italicum: The Profile of the Italian Renaissance in the Mirror of its European Transformations*. Leiden: E. J. Brill, 1975.

Ohly, Friedrich. *Gesetz und Evangelium: Zur Typologie bei Luther und Lucas Cranach: Zum Blutstrahl der Gnade in der Kunst*. Münster: Aschendorff, 1985.

Olin, John C. *Catholic Reform: From Cardinal Ximenes to the Council of Trent 1495–1563*. New York: Fordham University Press, 1990.

————. *The Catholic Reformation: Savonarola to Ignatius Loyola: Reform in the Church 1495–1540*. New York: Harper and Row, 1969.

Ong, Walter J. *The Presence of the Word: Some Prolegomena for Cultural and Religious History*. Minneapolis: University of Minnesota Press, 1967, 1981.

Osiander, Andréas. *Gesamtausgabe*. (Güutersloh: Güutersloher Verlagshaus Gerd Mohn) Band I, 1975; Band 4, 1981.

Ostrow, Steven F. *Art and Spirituality in Counter-Reformation Rome*. Cambridge: Cambridge University Press, 1996.

Overend, G. H. "Field Preachings at Antwerp in 1566," *Huguenot Society of London Proceedings* 1 (1885–56): 174–96.

Ozment, Steven. *Reformation Europe: A Guide to Research*. St. Louis: Center for Reformation Research, 1982.

————, ed. *The Reformation in Medieval Perspective*. Chicago: Quadrangle Books, 1971.

————. *Mysticism and Dissent: Religious Ideology and Social Protest in the Sixteenth Century* (New Haven: Yale University Press, 1973).

————. *The Reformation in the Cities: The Appeal of Protestantism to Sixteenth-century Germany and Switzerland*. New York: Yale University Press, 1975.

Pabel, Hilmar M., ed. *Erasmus' Vision of the Church*. Sixteenth Century Journal Publishers, Inc., vol. 33, 1995.

Panofsky, Erwin. "Comments on Art and Reformation." In *Symbols in Transformation: Iconographic Themes at the Time of the Reformation*. Princeton Exhibition Catalogue, April, 1969.

————. "Erasmus and the Visual Arts." *Journal of the Warburg and Courtauld Institutes* 32 (1969): 200–227.

————. *The Life and Art of Albrecht Dürer*. Princeton: Princeton University Press, 1955.

Parshall, Linda B., and Peter W. *Art and Reformation: Annotated Bibliography*. Boston: G. K. Hall, 1986.

Partridge, Loren. *Michelangelo: The Sistine Chapel Ceiling, Rome*. New York: George Braziller, 1996.

————. *Michelangelo—The Last Judgment: A Glorious Restoration*. New York: Harry N. Abrams, 1997.

Pascoe, Louis B. "The Council of Trent and Bible Study: Humanism and Scripture." *Catholic Historical Review* 52 (1966): 18–38.

Pauck, Wilhelm, ed. and trans. *Luther: Lectures on Romans*. Philadelphia: Westminster Press, 1961.

Perlove, Shelley Karen. *Renaissance, Reform, Reflections in the Age of Dürer, Bruegel, and Rembrandt*. Dearborn: University of Michigan-Dearborn, 1994.

Pevsner, Nikolaus, and Michael Meier. *Grünewald*. London: Thames and Hudson, 1958.

Pfeiffer, Gerhard. "Albrecht Dürer's 'Four Apostles': A Memorial Picture from the Reformation Era." In *The Social History of the Reformation*, edited by Lawrence P. Buch and Jonathan W. Zophy. New York: Columbia University Press, 1972.

Phillips, John. *The Reformation of Images: Destruction of Art in England 1535–1660*. University of California Press, 1973.

Philoon, Thurman E. "Hans Greiffenberger and the Reformation in Nuremberg." *Mennonite Quarterly Review* 36 (1962): 61–75.

Pickering, F. P. *Literature & Art in the Middle Ages*. London: Macmillan, 1970.

Plank, Karl A. "Of Unity and Distinction: An Exploration of the Theology of John Calvin with Respect to the Christian Stance toward Art." *Calvin Theological Journal* 13 (1978): 16–37.

Pole, Reginald. *Defense of the Unity of the Church*. Westminster, Md.: Newman Press, 1965.

————. *A Treatise of Justification 1569*. Vol. 281. English recusant literature.

Polizzotto, Lorenzo. *The Elect Nation: The Savonarolan Movement in Florence, 1494–1545*. Oxford: Clarendon Press, 1994.

Preus, James S. *Carlstadt's Ordinaciones and Luther's Liberty A Study of the Wittenberg Movement*. Cambridge: Harvard University Press, 1974.

Quaife, G. R. *Godly Zeal and Furious Rage: The Witch in Early Modern Europe*. New York: St. Martin's Press, 1987.

Reinitzer, Heimo. *Biblia deutsch: Luthers Bibelübersetzung und ihre Tradition*. Wolfenbüttel: Herzog August Bibliothek, 1983.

Reventlow, Henning Graf. *The Authority of the bible and the rise of the modern world*. Philadelphia: Fortress, 1984.

Ringbom, Sixten. "Devotional Images and Imaginative Devotions: Notes on the Place of Art in Late Medieval Piety." *Gazette des Beaux-Arts*, 6th series (1969): 159–70.

Ritter, Gerhard. "Lutheranism, Catholicism, and the Humanistic View of Life." *Archiv für Reformationsgeschichte* 44 (1953): 145–60.

Roelker, Nancy Lyman. "The Role of Noblewomen in the French Reformation." *Archiv für Reformationsgeschichte* 63 (1972): 168–95.

Ross, J. B. "Gasparo Contarini and his Friends," *Studies in the Renaissance* 17 (1970): 192–232.

———. "The Emergence of Gasparo Contarino: A Bibliographical Essay." *Church History* 41 (1972): 22–45.

Rothkrug, Lionel. "Popular Religion and Holy Shrines: Their Influence on the Origins of the German Reformation and Their Role in German Cultural Development." In *Religion and the People*, edited by J. Obelkevich. Chapel Hill: University of North Carolina, 1979.

———. "Religious Practises and Collective Perceptions: Hidden Homologies in the Renaissance and Reformation." *Historical Reflections* 7 (1980).

———. "Holy Shrines, Religious Dissonance and Satan in the Origins of the German Reformation." *Historical Reflections* 14 (1987): 143–286.

Rowlands, John. *Holbein: The Paintings of Hans Holbein the Younger*. Boston: David R. Godine, 1985.

———. *The Age of Dürer and Holbein: German Drawings, 1400–1550*. Cambridge: Cambridge University Press, 1988.

Ruhmer, E. *Cranach*. Greenwich, Ct.: Phaidon Publishers, Inc., 1963.

Rupp, Gordon, *Patterns of Reformation*. London: Epworth Press, 1969.

Rupprich, Hans. *Schriftlicher Nachlass*. Berlin: Deutscher Verein fur Kunstwissenschaft, vol. 1–3, 1956–69.

Russell, Paul A. *Lay Theology in the Reformation: Popular Pamphleteers in Southwest Germany, 1521–1525*. Cambridge: Cambridge University Press, 1986.

Saints and She-devils: Images of Women in the 15th and 16th Centuries. London: The Rubicon Press, 1985.

Santosuosso, Antonio. "Religion *More Veneto* and the Trial of Pier Paolo Vergerio." In *Peter Martyr Vermigli and the Italian Reformation*, edited by Joseph C. McLelland. Waterloo, Ontario: Wilfid Laurier University Press, 1980.

———. "The Italian Crisis at Mid-sixteenth Century: A Matter of Shift and Decadence." *Canadian Journal of History* 10 (1975): 147–64.

Savonarola, Girolano. *The Triumph of the Cross*. London: Hodder and Stoughton, 1868.

Saxl, Fritz. *A Heritage of Images: A Selection of Lectures*. Penguin Books, 1957, 1970.

Scavizzi, Giuseppe. *The Controversy on Images from Calvin to Baronius*. Toronto Studies in Religion, vol. 14, 1992.

Schade, Werner. *Cranach: A Family of Master Painters*. New York: G. P. Putnam's Sons, 1980.

Scheja, Georg. *The Isenheim Altarpiece*. New York: Harry N. Abrams, Inc., 1969.

Schleif, Corine, "Nicodemus and Sculptors: Self-reflexivity in Works by Adam Kraft and Tilman Riemenschneider." *Art Bulletin* 75 (Dec. 1993): 599–626.

Schmidt, Philipp. *Die Illustration der Lutherbild 1522–1700*. Basel: Verlag Friedrich Reinhardt, 1962.

Schoeffer, I. "Protestantism in Flux during the Revolt of the Netherlands." In *Britain and the Netherlands*, vol. II. Broningen: J.B. Wolters, 1964.

Schott, Rolf. *Michelangelo*. London: Thames and Hudson, 1963.

Schroeder, H. J. *Canons and Decrees of the Council of Trent*. St. Louis and London: B. Herder, 1941.

Schuchardt, Christian. *Lucas Cranach des älteren Leben und Werke*. Vols. 1–3. Leipzig, 1851, 1871.

Schutte, Anne Jacobson. *Pier Paolo Vergerio: The Making of an Italian Reformer*. Genève: Librarie Droz, 1977.

———. Review Article—Carlo Ginzburg. *Journal of Modern History* 48 (1976): 296–315.

Schwiebert, E. G. *Luther and His Times: The Reformation from a New Perspective*. St. Louis: Concordia Publishing House, 1950.

Scott, Tom, and Bob Scribner, eds. *The German Peasants' War: A History in Documents*. New Jersey and London: Humanities Press International, Inc., 1991.

Scribner, Robert, "Witchcraft and Judgement in Reformation Germany." *History Today* 40 (1990): 12–19.

———. "The Image and the Reformation." In *Disciplines of Faith: Studies in Religion, Politics and Patriarchy*, edited by Jim Obelkevich, Lyndal Roper, and Raphael Samuel. London: Routledge and Kegan, 1987.

———. *For the Sake of Simple Folk: Popular Propaganda for the German Reformation*. Cambridge: Cambridge University Press, 1981.

Seebass, Gottfried. "The Reformation in Nürnberg." In *The Social History of the Reformation*, edited by Lawrence P. Buck and Jonathan W. Zophy. Columbus: Ohio State University Press, 1972.

Seymour, Charles, Jr. ed. *Michelangelo: The Sistine Chapel Ceiling*. New York: W. W. Norton and Co., Inc., 1972.

Shestack, Alan, and James H. Marrow, with essays also by Charles W. Talbot and Linda C. Hults. *Hans Baldung Grien: Prints and Drawings*. National Gallery of Art and Yale University Art Gallery, 1981.

Shrimplin-Evangelidis, Valerie. "Michelangelo and Nicodemism: The Florentine *Pieta*." *Art Bulletin* 71 (March 1989): 58–66.

Sider, Ronald J. *Andreas Bodenstein von Karlstadt: The Development of His Thought 1517–1525*. Leiden: E. J. Brill, 1974.

Sinding-Larsen, Staale. "A Re-reading of the Sistine Ceiling." In *Acta Archaeologiam et Artium Historiam Pertinentia*. Vol. IV. Roma: L'erma di Bretschneider, 1969.

Singer, Charles L. *The Renaissance in Rome*. Bloomington: Indiana University Press, 1985.

Sistine Chapel: Michelangelo Rediscovered. A. Chastel, et al. London: Müller, Blunt & White, 1986.

The Sistine Chapel, Vols. 1 and 2. Text by Frederick Hartt; commentary and plates by Gianluigi Colaluccik; note on the restoration by Fabrizio Mancinelli; photographs by Takashi Okamura. New York: Alfred A. Knopf, in association with Nippon Television Network Corporation, 1991.

Slive, Seymour. "Notes on the Relationship of Protestantism to 17th Century Dutch Paintings." *Art Quarterly* 19 (1956): 3–15.

Smith, Alistair, and Angela Ottino della Chiesa. *The Complete Paintings of Dürer*. London: Weidenfeld and Nicolson, 1968.

Smith, Jeffrey Chipps. *Nuremberg: A Renaissance City 1500–1618*. Austin: University of Texas Press, 1980.

———, ed. *New Perspectives on the Art of Renaissance Nuremberg: Five Essays*. Austin: The University of Texas, 1985.

————. *German Sculpture of the Later Renaissance c. 1520–1580: Art in an Age of Uncertainty*. Princeton: Princeton University Press, 1994.

Snoek, G. J. C. *Medieval Piety from Relics to the Eucharist: A Process of Mutual Interaction*. Leiden: E. J. Brill, 1995.

Snyder, James. *Northern Renaissance Art*. New York: Harry N. Abrams, 1985.

Spelman, Leslie P. "Calvin and the Arts." *Journal of Aesthetics and Art Criticism* 6 (1948): 246–52.

————. "Luther and the Arts." *Journal of Aesthetics and Art Cricicism* 10 (1951): 166–75.

Spielvogel, Jackson. "Patricians in Dissension: A Case Study from Sixteenth-century Nürnberg." In *The Social History of the Reformation*, edited by Lawrence P. Buch and Jonathan W. Zophy. Columbus: Ohio State University Press, 1972): 73–90.

Spitz, Lewis, Jr. *The Religious Renaissance of the German Humanists*. Cambridge, Mass.: Harvard University Press, 1963.

————. *The Renaissance and Reformation Movements*. St. Louis: Concordia Publishing House, 1971.

Steche, R. *Bau-und Kunstmäler des Königreiches Sachsen*. Dresden: In Commision bei C.C. Meinhold & Söhne, 1887.

Stechow, Wolfgang, "Joseph of Arimathea or Nicodemus?" In *Studien zur Toskanischen Kunst*, edited by Wolfgang Lotz (1963) Prestel-Verlag München.

Steinberg, Leo. "The Metaphors of Love and Birth in Michelangelo's *Pietas*." In *Studies in Erotic Art*, edited by Theodore Bowie and Cornelia V. Christenson. New York: Basic Books, Inc., 1970.

————. "Who's Who in Michelangelo's 'Creation of Adam': A Chronology of the Picture's Reluctant Self-revelation." *Art Bulletin* 74 (Dec. 1992): 552–66.

————. "The Line of Fate in Michelangelo's Painting." *Critical Inquiry* 6 (1980): 411–454.

————. "Who's Who in Michelangelo's *Creation of Adam* Continued," "All About Eve," *Art Bulletin* 75 (June 1993): 340–44.

————. "All About Eve," *Art Bulletin* 75 (June, 1993): 340–44.

————. "Michelangelo's 'Last Judgment' as Merciful Heresy." *Art in America* 63.6 (1975): 49–63.

————. *The Sexuality of Christ in Renaissance Art and in Modern Oblivion*. New York: A Pantheon/October Book, 1983.

————. "A Corner of the *Last Judgment*." *Daedalus* (Spring 1980): 207–73.

————. "Michelangelo's Florentine *Pieta*: The Missing Leg." *Art Bulletin* 50 (December, 1968): 343–53.

————. *Michelangelo's Last Paintings: The Conversion of St. Paul and the Crucifixion of St. Peter in the Cappella Paolina, Catican Palace*. London: Phaidon Press, 1975.

Steinmetz, David. *Calvin in Context*. New York: Oxford University Press, 1995.

Stephens, W. P., *The Theology of Huldrych Zwingli*. Oxford: Clarendon Press, 1986.

Stinger, Charles L. *Humanism and the Church Fathers*. Albany: State University of New York Press, 1977.

————. *The Renaissance in Rome*. Bloomington: Indiana University Press, 1985.

Stirm, Margarete, *Die Bilderfrage in der Reformation*. Gütersloh: Gütersloher Verlalgshaus Gerd Mohn, 1972.

Stokes, Adrian. *Michelangelo A Study in the Nature of Art*. London: Tavistock Publications, Ltd., 1955.

Strachan, James. *Early Bible Illustrations*. Cambridge University Press, 1957.

Strand, Kenneth A. *Reformation Bible Pictures: Woodcuts from Early Lutheran and Emserian New Testaments*. Ann Arbor: Ann Arbor Publishers, 1963.

———. *Woodcuts to the Apocalypse in Dürer's Time*. Ann Arbor Publishers, 1968.

Strauss, Gerald. *Nuremberg in the Sixteenth Century*. New York: John Wiley and Sons, Inc., 1966.

Strieder, Peter. *Albrecht Dürer: Paintings, Prints, Drawings*. New York City: Abrams, 1989.

Strong, Roy. *Holbein and Henry VIII*. London: The Paul Mellon Foundation for the Arts, 1967.

Tacke, Andréas. *Der katholische Cranach*. Mainz: Verlag Philipp von Zabern, 1992.

Tedeschi, John. *The Prosecution of Heresy Collected Studies on the Inquisition in early Modern Italy*. Binghamton, N.Y.: Medieval and Renaissance Texts and Studies, 1991.

———. *Italian Reformation Studies in Honor of Laelius Socinus*. Florence: F. Le Monnier, 1965.

Theologische Realenzyklopädie. 14. Berlin/New York: Walter de Gruyter, 1985, 280 ff. (Grünewald).

Thulin, Oskar. "Luther in the Arts," *Encyclopedia of the Lutheran Church* 2 (1965), 1433–1442.

———. *Cranach Altäre der Reformation*. Berlin: Evangelische Verlagsanstalt, n.d.

Tillich, Paul. *On Art and Architecture*, edited by John and Jane Dillenberger. New York: Crossroad, 1989.

Trexler, Richard C. *Public Life in Renaissance Florence*. New York: Academic Press, 1980.

———. "Florentine Religious Experience: The Sacred Image." *Studies in the Renaissance* 19 (1972): 7–41.

Turner, V. and E. *Image and Pilgrimage in Christian Culture*. New York: Columbia University Press, 1978.

van Gelder, H. A. Enno. *The Two reformations in the Sixteenth Century: A Study of the Religious Aspects and Consequences of Renaissance Humanism*. The Hague: M. Nijhoff, 1961.

Verdon, Timothy Gregory, ed. *Monasticism and the Arts*. Syracuse: Syracuse University Press, 1984.

Verdon, Timothy, and Henderson, John. *Christianity and the Renaissance*. Syracuse: Syracuse University Press, 1990.

Vetter, Ewald M. "Wer war Matthias Grünewald?" *Pantheon* 35 (1977): 188–97.

von der Osten, Gert, and Horlst Vey. *Painting and Sculpture in Germany and the Netherlands, 1500 to 1600*. New York: Penguin Books, 1969.

von Hintzenstern, Jerbert. *Lucas Cranach d. A.: Altarbilder aus der Reformationszeit*. Berlin: Evangelische Verlagsanstalt, 1972.

Waetzoldt, Wilhelm. *Dürer and His Times*. London: Phaidon Publishers Inc., 1955.

Wallace, William E. *Michelangelo at San Lorenzo: The Genius as Entrepreneur*. Cambridge: Cambridge University Press, 1994.

Wallace-Hadrill, J. M. *The Barbarian West 400–1000*. London: Hutchison, 1967.

Wandel, Lee Palmer. *Voracious Idols and Violent Hands: Iconoclasm in Reformation Zurich, Strasbourg, and Basel*. Cambridge: Cambridge University Press, 1995.

———. "The Reform of the Images: New Visualizations of the Christian Community at Zurich." *Archiv für Reformationsgeschichte* 80 (1989): 105–24.

———. "Envisioning God: Image and Liturgy in Reformation Zurich." *Sixteenth Century Journal* 24 (1993): 21–40.

Warnke, Martin. *The Court Artist: On the Ancestry of the Modern Artist.* Cambridge: Cambridge University Press, 1993.

———. *Cranach's Luther: Entwürfe für ein Image.* Frankfurt am Main: Fischer Taschenbuch Verlag, 1984.

Weinstein, Donald. *Savonarola and Florence Prophecy and Patriotism in the Renaissance.* Princeton: Princeton University Press, 1970.

Weir, Alison. *The Six Wives of Henry VIII.* New York: Grove Weidenfeld, 1991.

Wiederanders, Gerlinde. *Albrecht Dürers Theologische Anschauungen.* Berlin: Evangelische Verlagsanstalt, 1976.

Wiesner-Hanks, Merry, ed. *Convents Confront the Reformation: Catholic and Protestant Nuns in Germany.* Milwaukee: Marquette University Press, 1996.

Williams, George Huntson. *The Radical Reformation.* Philadelphia: Westminster Press, 1962.

Wind, Edgar. "Studies in Allegorical Portraiture I." *Journal of the Warburg Institute* 1 (1937–38): 138–62.

Wittkower, R., with I. Jaffe. *Baroque Art: The Jesuit Contribution.* New York: Fordham University Press, 1972.

Wölfflin, Heinrich. *The Art of Albrecht Dürer.* London: Phaidon Press Ltd., 1971.

Wood, Christopher S. *Albrecht Altdorfer and the Origins of Landscape.* Chicago: University of Chicago Press, 1993.

Zapalac, Kristin Eldyss Sorensen. *"In His Image and Likeness": Political Iconography and Religious Change in Regensburg, 1500–1600.* Ithaca and London: Cornell University Press, 1990.

———. "Judith 'Re-Formed.'" In *Renaissance, Reform, Reflections in the Age of Dürer, Bruegel and Rembrandt.* Dearborn: University of Michigan, 1994.

———. " 'Item Perspective ist ein lateinisch Wort, bedeutt ein Durchsehung': A Reformation Re-Vision of the Relationship between Idea and Image." In *Meaning in the Visual Arts: Views from the Outside A Centennial Commemoration of Erwin Panofsky (1892–1968).* Princeton: Institute for Advanced Study, 1995.

Zika, Charles. "Hosts, Processions and Pilgrimages: Controlling the Sacred in Fifteenth-century Germany." *Past and Present* 118 (1988): 25–64.

Zschelletzschky, Herbert. *Die 'Drei gottlosen Maler' von Nürnberg: Sebald Beham, Barthel Behan und Georg Pencz: Historische Grundlagen und ikonologische Probleme ihrer Graphik zu Reformations—und Bauernkriegzeit.* Leipzig: Veb. E. A. Seemann Verlag, 1975.

CREDITS AND PERMISSIONS

INDEX

Adam and Eve (Baldung Grien), 159–160

Adam and Eve (Cranach the Elder), 110

Adam and Eve (Dürer), 158

Adam and Eve (Erasmus), 150

Adam and Eve (Fall) [Dürer], 59–60

Adam and Eve images, 122, 126, 153,
 158–159

Adams, James Luther, 52

*Against the Bishop of Brandenburg,
 Cardinal Albrecht* (Luther), 86

*Against the Heavenly Prophets in the
 Matter of Images and Sacraments*
 (Luther), *91*

Albrecht of Brandenburg, Cardinal, 5, 8,
 12, 26, 50, 52, 66, 86

*The Allegory of the Old and the New
 Testament* (Holbein the Younger),
 152–153

Altarpiece of the Holy Kinship (Cranach
 the Elder), 80, 81, 82

altarpieces
 Dessau, 105–106
 gospel and law themes of, 100
 Luther's views on, 72, 113
 Schneeberg, 98–99, 102, 103, 200n.47
 Weimar, 105–106
 Wittenberg, 102–104, 105–106

Altdorfer, Albrecht, 12, 161, 166–170

The Ambassadors (Holbein the Younger),
 155

Anabaptist movement, 112–113, 191

Anglican church, 184, 191

Anne of Cleves, 156

Anthonite order, 29–30, 41

Anthony, St., 28–31, 35, 41–42, 43

anticlericalism, 19–20

Apocalypse woodcuts (Dürer), 55–57

An Appeal to the Ruling Class (Luther), 90

Aquinas, Thomas, 4

Arande, Michel, 181

art
 Calvin on church and, 181
 Dürer on gift of, 63
 Gothic style of, 4
 identified with the Reformation, 12
 impact of Reformation on, 190
 Luther's understanding of, 190
 relationship between relic and
 imagery, 13–14
 use of devil figures in, 21, 43–45, 47,
 122, 123–124, 165, 195n.21
 use of ideal form in, 16
 use of princely figures in, 80–83
 See also images
Article sixteen (faculty of sacred
 theology, 1542), 14
Aschaffenburg palace, 26
*Assumption and Coronation of the
 Virgin* (Dürer), 61
Assumption (Sistine Chapel), 134
Athanasius, 28–30
Augustine, 121, 123
Augustinian order, 30, 65, 71
Aulen, Gustaf, 45

Bainton, Roland, 182
Baldung Grien, Hans, 12, 17, 157–165
Barbieri, Filippo, 118
Barth, Karl, 25
Bartholomew, St., 80
Basel image reform, 179–180
Battisti, Eugenio, 52
Beautiful Virgin (Altdorfer), 168
Beckmann, Max, 26
Beham, Barthel, 72
Beham, Sebald, 72
Belting, Hans, 13
Benefits of Christ (Flaminio), 129,141–142
Bernard of Clairvaux, 183
Bernard, St., 34
Bewitched Groom (Baldung Grien), 162,
 164

Beza, Theodore, 183
Biblical books
 Book of Revelation, 55, 83
 Galatians, 8, 94–95
 Hebrews (Luther translation), 83
 James (Luther translation), 83
 Jude (Luther translation), 83
 Numbers, 98, 105, 176
 Romans, 89, 94
 See also Scripture
biblical knowledge, 18–21
 See also popular culture
Birgitta of Sweden, 35
Blaise, St., 134, 135, 138
bleeding Christ image, 35
blood flowing image, 106
Bocklin, Arnold, 26
Body of the Dead Christ (Holbein the
 Younger), 150
Boleyn, Anne, 151, 156
Bonaventura, St. (Bonaventure), 4, 36
Bondage of the Will (Luther), 94
Borromeo, St. Charles, 187
Brady, Thomas A., 157
Brandt, Sebastian, 54
Briconnet, Guillaume, 181, 182
Bruges Madonna (Michelangelo), 117
Bucer, Martin, 130, 179
Bugenhagen, Johannes, 105
Bullinger, Heinrich, 14, 178–179
Buonarroti, Lionardo, 116

Calvin, John, 14, 21, 129, 130–131, 142,
 175, 180, 182–183
Camerarius, Joachim, 74
Carafa, Cardinal (Gianpietro) [Pope
 Paul III], 129, 142, 143
Cardinal Albrecht of Brandenburg
 (Cranach the Elder), 87
*Cardinal Albrecht of Brandenburg Kneel-
 ing before Christ on the Cross* (Cranach
 the Elder), 87

Carnesecchi, Pietro, 129, 143

Carrying of the Cross (Grünewald), 49, 50

Cassian, John, 29

Catejan, Cardinal, 135

Catherine of Siena, St., 35, 134–135, 138

Charles V, Emperor, 66, 88, 128

choleric tradition, 75

Chrisman, Miriam Usher, 18

Christ

 Basel and Karlsruhe images of, 37, 39–41

 in *Carrying of the Cross*, 49, 50

 depicted in Sistine Chapel, 118

 Dürer's self-identification with, 62

 identification with sufferings of, 32–34

 image of resurrected, 45–48

 Isenheim Altarpiece image of, 28, 29, 36–37

 in Karlsruhe Crucifixion, 49–50

 Last Judgment (Michelangelo) image of, 138

 Luther's developing theology on, 95

 in *Passional Scene*, 84

 Passion of, 109

 slung leg tradition and, 146

 Small Crucifixion image of, 37, 38

 symbols of, 47

 See also God

Christ Blessing the Children (Cranach the Elder), 112–113

Christ on the Cross with three Angels (Dürer), 68, 69

Christ Driving the Money Changers from the Temple (Cranach the Elder), 82, 83

Christensen, Carl, 75, 81, 82, 88, 89, 100, 106

Christian humanist ideal, 78

Christianity

 diversity of medieval, 4

 Isenheim Altarpiece depiction of, 47

 See also Protestant church; Reformation; Roman Catholic Church

Christ as the Man of Sorrows (Holbein the Younger), 150

Christopher, St., 66

Church of the Beautiful Virgin (Regensburg), 166–167

Cibo, Caterina, 129

Clebsch, William, 184

Cochlaeus, Johannes, 17

Collinson, Howard Creel, 33

Cologne Bible (1480), 83

Colonna, Vittoria, 129, 132, 141, 143, 182, 203n.28

Commentary on Deuteronomy (Luther), 92

A Commentary on St. Paul's Epistle to the Galatians (Luther), 94, 95, 96

concert of angels image, 44, 45

confession, 70

"Confession Concerning Christ's Supper" (Luther), 92

Consilium de emendanda ecclesia, 129

Contarini, Cardinal Gasparo, 4, 128, 132, 141, 182

Conversion of Paul (Michelangelo), 140, 141

The Coronation of the Virgin (Baldung), 157

Coronation of the Virgin (Baldung Grien), 157

Council of Frankfurt (794), 186

Council of Nicaea (787), 13

Council of Trent (1542–64), 8, 10, 11, 21, 116, 134, 139, 141–142, 143, 184, 187, 188

Coverdale Bible, 152

Coverdale, Miles, 151

Cranach the Elder, Lucas

 Adam and Eve by, 110

 Altarpiece of the Holy Kinship by, 80, 81, 82

 Cardinal Albrecht of Brandenburg by, 87

Cranach the Elder, Lucas *(continued)*
 *Cardinal Albrecht of Brandenburg
 Kneeling before Christ on the Cross*
 by, 87
 Christ Blessing the Children by,
 112–113
 *Christ Driving the Money Changers
 from the Temple* by, 82, 83
 Death of Holofernes by, 111–112
 depiction of Cardinal Albrecht by,
 66
 early career (until 1528) of, 80–88
 faith visualization by, 8–10
 individual works after 1530 by,
 109–113
 influence of Lutheran reformation
 on, 11, 12, 79, 84–86, 93–94, 113
 Judith at the Table of Holofernes by,
 111–112
 Law and Gospel by, 97
 Lot and his Daughters by, 103
 misogyny and eroticism in works of,
 17
 New Testament (Luther) illustrated
 by, 83
 Passional Scene by, 84
 Torgau Castle Church by, 107–109
 use of law and gospel in art of, 96–109
 use of princely figures in paintings
 by, 80–83
 Woman Taken in Adultery by, 109–110
 See also altarpieces
Cranach the Younger, Lucas
 association with Lutheran reforma-
 tion by, 12, 79
 Schneeberg altarpiece by, 98–99, 102,
 103
 use of law and gospel in art of,
 96–109
 Wittenberg altarpiece by, 102–104,
 105–106
 See also altarpieces

Cranmer, Archbishop, 156
Creation of the Sun and the Moon
 (Michelangelo), 126
Creation theme (Sistine Ceiling), 125
Cromwell, Thomas, 151, 156
cross image, 35
Crucifixion
 artistic renderings of, 25–26
 Isenheim Altarpiece, 31–32
 Karlsruhe, 49–50
 lamentation posture of, 51–52
Crucifixion (Dürer), 57, 58
Crucifixion (Grünewald), 37, 39, 40–41,
 49–50
cult of the saints, 177–178
 See also saints
Cumean Sibyl (Michelangelo), 120

d'Albret, Jeanne, 183
Dance of Death (Holbein the Younger),
 150, 183
Dance of Death symbol, 160–161
Danube school, 166
David (Michelangelo), 117, 145
Davis, Natalie Zemon, 183
Death with an Inverted Banner
 (Baldung Grien), 160
Death of Holofernes (Cranach the Elder),
 111–112
Death and the Maiden (Baldung Grien),
 161
Death and the Woman (Baldung Grien),
 161
de Dinteville, Jean, 154
*Defense and Christian Reply of a Lover of
 Divine Truth as Contained in Sacred
 Scripture, Against Several Opponents*
 (Spengler pamphlet), 69–70
Denck, Hans, 72
Denmark, 185
de Selve, Georges, 154
desert hermit, 28–29

d'Espeville, Charles (Calvin pseudonym), 130

De Tolnay, Charles, 119, 143–144

The Devil at Isenheim (Mellinkoff), 43

the devil (Lucifer) image, 21, 43–45, 47, 122, 123–124, 165, 195n.21

Diet at Worms, 66

Diet of Augsburg, 147

Diet of Regensburg (1541), 128

Diet of Worms of 1521, 83

Dominican order, 35

Dotson, Esther, 118, 119

Douglass, E. Jane Dempsey, 35

drum player image, 34

Dürer, Agnes, 55, 66

Dürer, Albrecht
Adam and Eve (Fall) by, 59–60
ambiguity in works of, 67–68
Apocalypse woodcuts by, 55–57
on artistic gift, 63
artistic style of, 77, 78
Assumption and Coronation of the Virgin by, 61
Christ on the Cross with three Angels woodcut by, 68, 69
Crucifixion woodcut by, 57, 58
diary of, 66
early interest in Luther by, 64–68
early life and work of, 54–55
on Erasmus to succeed Luther, 67
The Four Holy Men, 8, 9, 72–73, 75–76
Four Horsemen of the Apocalypse woodcut by, 55–57
Head of the Dead Christ charcoal by, 62
images used by, 59–60
Knight, Death and Devil engraving by, 60, 61
Large Passion woodcuts by, 57
Last Supper woodcut by, 67–68
Life of the Virgin woodcuts by, 57–58
Man of Sorrows engraving, 106

Melanchthon engraving by, 77
Melanchthon on, 74, 75, 76–78
northern sensibilities of, 4
paintings by, 60–61
Passion of The Man of Sorrows engraving by, 60
The Prodigal Son by, 59
Reformation in Nuremberg and, 69–78
relation to Protestant/Catholic ideas by, 53–54
St. Jerome in Penitence engraving by, 59
self-identification with Christ by, 62
self-identification with Luther by, 11, 12
self-portraits by, 61–63
Seven Sorrows of Mary by, 61
use of human body by, 16
The Virgin Worshipped by Angels and Saints woodcut by, 58

Ecclesia, the Church image, 45

Eck, Johannes, 186

Edwards, Mark U., Jr., 55, 86, 88

Edward VI, King (England), 156, 183, 191

E'Este, Duke Hercule, 130

Elizabeth I (England), 191

Emser, Hieronymus, 167, 186

Emser, Jerome, 84

English Protestantism, 173–174, 183, 184, 186, 191
See also Henry VIII, King (England)

engravings
Adam and Eve (Fall) [Dürer], 59–60
Knight, Death and Devil (Dürer), 60, 61
Man of Sorrows, 106
Melanchthon (Dürer), 77
Passion of The Man of Sorrows (Dürer), 60

engravings *(continued)*
 The Prodigal Son (Dürer), 59
 reformation agenda and, 15–16
 St. Jerome in Penitence (Dürer), 59
Erasmus, Desiderius, 4, 11, 20, 60, 66, 67,
 150, 151, 157, 174, 177, 180
Erasmus, St., 50–51
Ernst, John, 101
evangelism, 131
Eve and the Serpent (Baldung Grien), 159
Eve, the Serpent, and Death (Baldung
 Grien), 161
 See also Adam and Eve images
evil, 165
 See also Lucifer (devil) images
Exemplar (Suso), 34
Explanations of the Ninety-five Theses
 (Luther), 89

faith
 Cranach's visualization of, 8–10
 justification by, 8–9, 115–116,
 141–142, 184
 Luther on, 8–9, 184
 Michelangelo's conception of,
 143–145, 146
 Nicodemus as symbol of, 144–145
Fall, Adam and Eve (Baldung Grien),
 160
the fall images, 59–60, 122, 126, 160
Farel, William, 180, 181
Felix of Urgel, 186
Ferrara, Duchess of, 130–131
fife player image, 34
Fifth Lateran Council (1512), 5, 119
1 Corinthians 15:35–38, 135
1 Thessalonians 4:16–17, 135, 136
Flaminio, Marcantonio, 129, 141
Florentine Pieta (Michelangelo), 12,
 143–147
The Four Holy Men (Dürer), 8, 9, 72–73,
 75–76

Four Horsemen of the Apocalypse (Dürer),
 55–57
Francis I, King (France), 142, 154, 182
Francis, St., 32
Frederick, Sibyl, 106
Frederick the Wise, 5, 12, 60–61, 65, 80,
 81, 84, 85–86, 88
Freedberg, David, 191
The Freedom of a Christian (Luther), 8
Friedlander, Walter, 25

Geiler, John, 35–36, 163
Georg, Junker, 85
Gerson, John, 36
Giberti, Gian Matteo, bishop of Verona,
 129
Giles of Viterbo, 118, 119
God
 battle between devil and, 21, 47
 grace of, 75–76, 93
 image used in Sistine Ceiling,
 120–121, 123–125
 Spirit of, 74
 See also Christ
God Giving Life to Adam (Michelangelo),
 121
God's pointing finger symbol, 120–121
Gonzaga, Giulia, 129
the gospel
 Luther on the law and, 94–95
 motif used in Torgau Castle Church
 pulpit design, 108
 of the Old Testament, 98
 as theme in Sistine Chapel, 118, 119
 used in the art of Cranachs, 96–109
 See also the law
Gospel of John, 73
Gotha panel (Cranach the Elder), 97–98
Gothic style of art, 4
grace of God, 75–76, 93
Greiffenberger, Hans, 20–21, 72
Grote, Ludwig, 74

Grünewald, Matthias (Mathis Gothart
 Nithart)
 artistic influence of, 25–26
 Carrying of the Cross by, 49, 50
 Crucifixion by, 37, 39, 40–41, 49–50
 Lamentation by, 51–52
 life and death of, 26–27
 Meeting of St. Erasmus and St. Maurice
 by, 50–51
 The Mocking of Christ by, 33–34
 religious influences/context used by,
 1, 8, 12, 21, 52
 Small Crucifixion by, 37, 38
 Stuppach Madonna, 35, 47, 48
 See also Isenheim Altarpiece
 (Grünewald)
Guersi, Abbot Guido, 27

Haetzer, Ludwig, 176
Haguenau, Nicolas, 28
Hall, Marcia B., 135
Handbook of the Christian Soldier
 (Erasmus), 60
Hartt, Frederick, 118
Head of the Dead Christ (Dürer), 62
Hebrew encampment image, 98–100,
 198n.7
Heidrich, Ernest, 74
Henry VIII, King (England), 15, 129,
 149, 151–152, 153–154, 156, 183, 184,
 191
Hermsdorf, Stephen, 109
Hezekiah, 176
Hindemith, Paul, 26
Holbein the Younger, Hans, 12, 149–156
Huguenot groups, 182–183
Hults, Linda C., 157, 158
human body, 16, 116, 125–126, 134–135,
 138, 145–146, 147–148
human evil, 165
Hussite tradition (Bohemia), 173–174,
 183, 186

Huss, Jan (Hus), 186
Hutchison, Jane Campbell, 60, 68, 75

iconoclasm
 Luther on, 91–92, 174–175
 official and public removal of,
 178–180
 reformation theologians on idolatry
 issue of, 174–186
images
 of Albrecht as St. Jerome, 87
 associated with indulgences, 36
 associated with the law and gospel
 works, 96–109
 blood flowing, 106
 concert of angels, 44, 45
 contemporary debates of use of,
 189–190
 Council of Trent (1542–64) on, 187,
 188
 cross and bleeding Christ, 35
 culture of religion and, 21
 defense of Catholic tradition using,
 186–188
 developing contemporary view of,
 191
 during English Tractarian move-
 ment, 183–184, 191
 of Ecclesia, the Church, 45
 of the fall, 59–60, 122, 126, 160
 as forbidden by the law, 181
 Lamb, 28, 29
 Luther on Lord's Supper and, 93
 Luther on use of, 89–93
 Man of Sorrows, 36
 Middle Age symbolism of Christian,
 173–174
 official removal of Zurich church,
 178
 promotion of chaste, 187–188
 red dragon, 83, 84
 reform debates regarding, 5–7

images *(continued)*
 rejection of cult of the saints and,
 177–178
 resurrected Christ, 45–47
 of the rider, 60
 role of Virgin Mary, 47–49
 of St. Sebastian and St. Anthony, 41
 seen as power, 191, 196n.5
 seen as relics, 7–8, 13–15, 196n.5
 sensuality/sexuality, 160–161
 serpent, 105, 176
 Strasbourg and Basel reform and,
 179–180
 used by Dürer, 59–60
 use of devil, 21
 used in to represent papal church, 83
 Veronica veil, 13, 36
 witches, 161–165
 Wittenberg destruction of, 9
 See also relics; symbols
Images from the Old Testament (Holbein
 the Younger), 150
indulgences
 images associated with, 36
 Luther's attacks against, 86, 89
 power of relics drawn by, 6
 Protestant rejection of, 182
Inquisition, 10, 117, 129, 141, 142
 See also Roman Catholic Church
Institutes (Calvin), 130, 142, 181, 182
Isaiah 1:6, 32–33
Isaiah 7:10–15, 42
Isaiah 50:6, 33
Isenheim Altarpiece (Grünewald)
 beauty and influence of, 4, 5, 6,
 25–26, 29
 Christian theological foundation in,
 47
 Christ of, 31, 36–37
 commission of, 27–28
 concert of angels in, 44, 45
 description of, 28–30, 35

 figures in, 36–37
 hospital agenda of, 30–32, 41
 lamentation painting in, 51
 Lucifer in, 43–45, 148
 religious expression of, 36–37
 resurrected Christ image in, 45–47
 St. Anthony image in, 28–31, 35,
 41–42, 43
 themes in middle position of, 42–43
 Virgin Mary image in, 28, 29, 35, 37,
 45, 47
 See also Grünewald, Matthias
Italian religious reform movements
 development of, 127–132
 emergence of Nicodemites and, 10,
 12, 129–130, 141–143
 Inquisition suppression of, 10
Italian Renaissance, 3–4
 See also Renaissance

James the Greater, St., 80
Jerome, St., 28, 29, 87
Job 30:9, 34
John 1:29, 95
John 4:24, 177
John the Baptist, 28, 29, 37, 41, 95, 105
John the Constant, 85, 86
John the Evangelist, 41
John Frederick, 80, 81, 85, 101, 106
John (patrician), 47–49
John, St., 28, 29, 35, 73, 74
Judith at the Table of Holofernes (Cranach
 the Elder), 111–112
Judith symbol, 201n.57
Jud, Leo, 176
Julian of Norwich, 35
Julius III, Pope, 143
Julius II, Pope, 118, 119
Jung, Eva–Maria, 131
justification by faith doctrine
 The Benefits of Christ on, 141–142
 English Reformation on, 184

influence on Michelangelo by,
115–116
theological basis of, 8–9
See also faith

Karlstadt, Andreas, 9, 71, 91, 92, 113,
174–175, 181, 186
Karlstruhe Kunsthalle, 49
Katherine of Aragon, 151
key symbol, 105
Kibish, Christine, 113
Knight, Death and Devil (Dürer), 60, 61
Knox, John, 185
Koerner, Joseph Leo, 59, 157
Kuspit, Donald, 77

Lamb image, 28, 29
Lamentation (Grünewald), 51–52
Lamentation (Hermsdorf), 109
Lamentation (*Isenheim Altarpiece*), 31–32
Last Judgment (Michelangelo), 12, 116,
120, 130, 132–139, 204n.33
law and gospel themes used in, 119
Renaissance/Reformation influences
on, 4, 5, 12
sibyls and prophets on, 119–120
themes used in panels of, 122–126
use of nude figures in, 116, 125–126,
134–135, 138, 145
See also Michelangelo (Buonarroti)
Last Supper representations, 68
Last Supper woodcut (Dürer), 67–68
the law
in the art of the Cranachs, 96–109
Gotha and Prague panels use of,
97–98
images as forbidden by, 181
Luther on, 95–96, 98
motif used in Torgau Castle Church
pulpit design, 108
as theme in Sistine Chapel, 118, 119
See also the gospel

Law and Gospel (Fall and Redemption)
(Cranach the Elder), 97, 98, 99
Leach, Edmund R., 122
Lefevre, Jacques, 181
Leipzig Debate of 1519, 83
Levack, Brian P., 164
Liberius, Pope, 47–49
Libri Carolini, 13, 14
Life of the Virgin series (Dürer), 59–60
Linck, Wenceslaus, 65
Lives of the Artists (Vasari), 134
Lollard traditions (England), 173–174,
183, 186
Lord's Supper images, 93
Lot and his Daughters (Altdorfer), 168,
169–170
Lot and his Daughters (Cranach the
Elder), 103
Louis XII, King (France), 131
Lucifer (devil) images, 21, 43–45, 122,
123–124, 165, 195n.21
Luke 1:26, 43
Luke 2:41–42, 108
Luke 11:20, 122
Luther, Martin
Anabaptists movement and, 113
attacks against Albrecht by, 86
on Book of Revelation, 55
call for reform by, 4, 5, 20, 83, 128
developing theology of, 93–95
Dürer's early interest in, 64–68
on faith, 8–9, 184
Grünewald possession of sermons by,
26–27
on iconoclasm, 91–92, 174–175
influence on Cranach the Elder by,
84–86
influence of, 11, 12, 19
Italian reform and, 130
lectures on Romans (1515–1516) by,
89
New Testament translations by, 73, 83

Luther, Martin (continued)
 opposition to peasant's revolt by, 20
 painted as Junker Georg, 85
 papal bull excommunicating, 70
 regarding visual arts/images in
 church, 89–93
 relationship with Frederick the Wise,
 85–86
 on role of devil, 21
Luther, Martin (continued)
 on role of painting in church, 113
 stops Wittenberg destruction of
 images, 9
 struggle with evil by, 60
 Torgau Castle Church dedicated by,
 107–109
 understanding of art by, 190
 use of propaganda prints by, 17
 view on altars, 100
 on visual arts in the church, 72
Luther with Nimbus and Dove (Baldung
 Grien), 157
Luther as Seven Headed Monster
 (Brosamer), 17

McNair, Philip, 131
McRoberts, D., 185
Madonna and Child with St. Anne
 (Baldung Grien), 157
Madonna with the Parrots (Baldung
 Grien), 158
magic (belief in), 165
magisterial reformation figures, 21
Malraux, André, 16
Man of Sorrows (Dürer), 106
Man of Sorrows image, 36
Marguerite of Navarre, 182–183
Mark, St., 73, 74
Marrow, James H., 32, 33–34
Martinengo, Pastor, 142
The Martyrdom of Peter (Michelangelo),
 140–141, 143

The Martyrdom of St. Sebastian (Baldung
 Grien), 157
Martyr Vermigli, Peter, 129, 130, 131, 141
Mary Magdalen, 28, 29, 35, 37
Mary (Queen of England), 183, 191
Mary. See Virgin Mary
Mathis der Maler (Hindemith), 26
Matthew 12:28, 122
Matthew 24 and 25, 135
Matthew 28, 105
Maurice, St., 50–51
Maurus, Hrabanus, 118
Maximilian, Emperor, 66, 166
Medieval Piety from Relics to the
 Eucharist (Snoek), 15
Meditationes vitae Christi, 32
meditation on sufferings of Christ, 32
Meeting of St. Erasmus and St. Maurice
 (Grünewald), 50–51
melancholic tradition, 75
Melanchthon engraving (Dürer), 77
Melanchthon, Philip, 11, 74, 75, 76–78,
 83, 105
Mellinkoff, Ruth, 43, 44, 45, 47
Michelangelo (Buonarroti)
 conception of faith by, 143–145, 146
 Conversion of Paul by, 140, 141
 Creation of the Sun and the Moon by,
 126
 Cumean Sibyl by, 120
 David by, 117, 145
 Florentine Pieta by, 12, 143–147
 God Giving Life to Adam by, 121
 influence of Savonarola on, 115–116,
 119
 justification theories and, 115–116
 Last Judgment by, 12, 116, 120, 130,
 132–139, 204n.33
 The Martyrdom of Peter by, 140–141,
 143
 Nicodemus self-portrait by, 144–145,
 146

Pauline chapel painting by, 139–141

pre-*Sistine Ceiling* works by, 117

reform influences on, 10, 11, 12

relationship with Vittoria Colonna,
203n.28

Resurrected Christ by, 145

Rondanini Pieta by, 147

slung leg tradition and, 146

use of devil images by, 21

use of male human figure by,
147–148

use of nude body in art by, 116,
125–126, 134–135, 138, 145–146

See also Sistine Ceiling
(Michelangelo)

Miles, Margaret, 116

Miracle of the Snow (Grünewald), 47–49

The Mocking of Christ (Grünewald),
33–34

Molanus, Johannes, 187–188

More, Sir Thomas, 151, 156

Morone, Cardinal, 142

Moses, 118, 121, 153

Müntzer, Thomas, 52, 72

Neo-Platonist thought, 116

Netherlands, 184

Neudorffer, Johannes, 75

Neue Stift project, 88

New Testament, 98, 100
See also Scripture

New Testament (September Bible)
[Luther], 73, 83

New Year's Sheet (Baldung Grien),
161–162, 163

Nicodemites, 10, 12, 129–130, 141–143,
181, 205n.40

Nicodemus, 142, 144–145, 146, 205n.44

Ninety-five Theses of 1517 (Luther), 5,
8, 12, 27, 53, 65, 86, 89

Nithart, Mathis Gothart, 25
See also Grünewald, Matthias

Nolde, Emil, 26

Noli me tangere (Baldung Grien), 158

Noli me tangere (Holbein the Younger),
150

Norway, 185

Numbers 21: 4–9, 98, 105, 176

Nuremberg, 70–71, 72–73, 76

Nuremberg council, 72

Nuremberg Reformation, 69–78

The Oberried Altarpiece (Holbein the
Younger), 150

Ochino, Bernardino, 19, 131, 141

Oecolampadius, Johannes, 179–180

Old Testament
the law of the, 98, 100

Luther on images of, 92

the Passion and, 32–33

See also Scripture

"On the Nature of Evangelism in
Sixteenth-century Italy" (Jung), 131

*On Not Removing Images of Christ and the
Saints* (Eck), 186

"On the Old and New God" (anony-
mous 1523 pamphlet), 176

On the Removal of Images (Karlstadt),
186

On the Spirit and the Letter (Augustine),
121–122

Osiander, Andreas, 21, 72

Ostendorfer, Michael, 166

pamphlet literature, 17–19, 20, 69–70

Panofsky, Erwin, 25

papal figure (*Passional Scene* woodcut),
84

parrot symbol, 158

Partridge, Loren, 123

the Passion, 32–33, 34

Passional Chrisit und Antichristi, 83

Passional Scene (Cranach the Elder), 84

Passion of Christ, 109

Passion of The Man of Sorrows (Dürer), 60

Paul the Hermit, 28, 35, 41, 43

Paul III, Pope (Cardinal Carafa), 128, 132, 142, 143

Pauline chapel paintings (Michelangelo), 139–141

Paul IV, Pope, 129, 146

Paul, St., 29, 73, 74, 139, 140

Peasants' War (1524–1525), 20, 52, 72, 112–113

Pencz, George, 72

Peter, St., 73, 74, 105, 139

Pfeiffer, Gerhard, 73, 74

phlegmatic tradition, 75

Picasso, Pablo, 26

Pirckheimer, Charitas, 71

Pirckheimer, Willibald, 53–54, 64, 69, 70, 76

Pitti Madonna (Michelangelo), 117

Placards posting (1534), 182

Pole, Cardinal Reginald, 128–129, 132, 141–142, 143

Pope Adored as an Earthly God (Warburg Institute), 18

popular culture

anticlericalism within, 19–20

biblical knowledge and, 18–21

iconoclastic impulses and, 15–16

research on, 194n.13

use of propaganda prints reflecting, 16–19, 20–21

Portrait of Philip Melanchthon (Holbein the Younger), 154

The Power of Images (Freedberg), 191

Prague panel (Cranach the Elder), 97–98

The Praise of Folly (Erasmus), 66, 150

prints, 16–17, 20

The Prodigal Son (Dürer), 59

propaganda

prints used for, 16–17

through art in religious context, 81, 82

Protestant church

doctrinal developments leading to, 92–95

in France, 182

influence on Italian reform by, 130–132

rejection of indulgences and relics by, 182

on role of Scripture, 180–181

Torgau Castle Church as model for, 107–109

Psalm 111 commentary (Luther), 93

Publius Lentulus, 62

Puritan tradition (England), 184

red dragon image, 83, 84

Reformation

artistic depiction of leaders of, 80–83

artists identifying with, 12

Dürer and Nuremberg, 69–78

English response to iconoclasm during, 183–184

The Four Holy Men manifestation of, 76

iconoclasm/idolatry and theologians of the, 174–186

impact on artists by, 190

impact on visual arts by, 189–191

Last Supper representation prior to, 68

pamphlet literature used by, 17–19

popular culture during, 15–21, 194n.13

role of Saxon princes' in German, 81, 83

use of the Word during, 21

woodcut media used by, 15, 16, 55

See also religious reform

Reformation treatises of 1520, 8, 83

Regensburg shrine, 166–167

relics

images seen as, 7–8, 13–15, 196n.5

indulgences to draw power of, 6

Luther on Albrecht's collection of, 86

Protestant rejection of, 182

reform debates regarding, 5–7

sacrament and, 15

of St. Anthony, 31

of St. Sebald, 71

saints prepresented by, 14–15

used while taking oaths, 15

See also images

religious reform

artistic depiction of figures of, 80–83

Catholic Church thought on,
127–132

chronology of, 5–12

Italian, 10, 12, 127–132, 141–143

long history of, 4

nature of Italian, 116–117

Renaissance characterization of, 3–4

See also Reformation

Rembrandt, 190

Renaissance

Christian humanist group during,
64–65

four temperaments tradition of, 75

humanist vision of world during, 63

Italian compared to Northern, 3–4

Italian reform and humanism of,
116

Northern, 3–4, 54, 60

resurrection/immortality of soul
debate during, 135, 138

resurrected Christ image, 45–47

Resurrected Christ (Michelangelo), 145

resurrection of the body, 135, 138

Resurrection of the Flesh (Signorelli), 116,
138

Revelation 12 red dragon image, 83, 84

rider image, 60

Riemenschneider, Tilman, 52

Roman Catholic Church

Cranach/Melanchthon collaboration
on Scripture and, 83

emergence of movements outside the,
8, 11

Inquisition of, 10, 117, 129, 141, 142

Italian psyche in relation to, 131–132

Luther's reforms rejected by, 8

need for reform felt within, 116–117

negative images used to represent, 83

reform debates within, 5–7

reforms in life and thought of,
127–132

on role of Scripture, 180

theologian defense of image tradition
by, 186–188

use of the Word by, 21

Rondanini Pieta (Michelangelo), 12, 147

Roussel, Gerard, 181

Russell, Paul A., 18

sacrament

Luther on confession and, 70

reformation theologians's debate
over, 175

relic and, 15

Sadoleto, Bishop Jacopo, 129, 182

St. Anthony's fire, 31, 32

St. Jerome in Penitence (Dürer), 59

St. Peter's Chapel (Rome), 88, 89, 119

saints

Dürer's work on, 67

emphasis upon grace through, 6–7

Neue Shift project to rehabilitate
place of, 88

rejection of cult of the, 177–178

relics and theory of power of, 14–15

Second Helvetic Confession of Faith
on, 178–179

See also relics

sanguine tradition, 75

Santa Maria Maggiori (Rome), 47, 49

Savonarola, Girolamo, 4, 10, 115–116,
119

Schade, Werner, 88

Scheja, Georg, 36

Scheurl, Christoph, 65

Schmid, Heinrich Alfred, 25

Schneeberg altarpiece (Cranach), 98–99, 102, 103, 200n.42

Scholastic theologies, 4, 174

Schott, Rolf, 148

Schribner, R. W., 20, 85, 109

Schröter, Simon, 108, 109

Scotland, 184–185

Scott, Tom, 20

Scripture
 Catholicism compared to Protestant view of, 180–181
 Cranach/Melanchthon collaboration on papal church and, 83, 88
 debate over visual images of, 176–186
 impact of Reformation on view of, 191
 Last Judgment (Michelangelo) and, 138
 Luther on illustrations of, 92–93, 113
 Luther on using the, 175–176, 180
 New Testament on law, 98, 100
 Old Testament, 32–33, 92, 98, 100
 used in Cranach art, 96–97
 See also Biblical books

sculpture, 15–16

Sebald, St., 71

Sebastian, St., 41, 157

Second Helvetic Confession of Faith, 178–179

II Chronicles 9:6–8, 152

II Corinthians 5:21, 95

Self-Portrait at the Age of Twenty-two (Dürer), 61–62, 63

self-portrait, oil, 1500 (Dürer), 62, 64

sensuality/sexuality images, 160–161

September Bible (Luther), 55, 83–84

serpent image, 105, 176

Seven Sorrows of Mary (Dürer), 61

Seymour, Charles, Jr., 120–121

Seymour, Jane, 156

Ship of Fools (Brandt), 54

Shrimplin-Evangelidis, Valerie, 147

the sibyls, 119–120

Sieben Köffe Martini Luthers (Cochlaeus), 17

Signorelli, Lucas, 116, 138

silverpoint self-portrait (Dürer), 61, 62

Sistine Ceiling (Michelangelo)
 central panels of, 7
 chapel containing, 117–118
 Creation of the Sun and the Moon from, 126
 Cumean Sibyl from, 120
 God figure from, 123
 God Giving Life to Adam from, 121
 God's pointing finger in, 120–122
 Ignudi figure from, 127
 Jesse and bronze nudes in, 124

Sistine Chapel, 119, 126–127

Sixteen Revelations (Julian of Norwich), 35

Sixtus IV, Pope, 118

slung leg tradition, 146

Small Crucifixion (Grünewald), 37, 38

Snoek, G.J.C., 15

Society of Jesus, 141, 143, 189

Sodilitas Martiniana group, 65

Sodilitas Staupitziana group, 65, 69

Solomon and the Queen of Sheba (Holbein the Younger), 151–152

The Solothurn Madonna (Holbein the Younger), 150

soul immortality, 135, 138

Spalatin, Georg, 65, 85, 86

Spengler, Lazarus, 64, 69–70

Spirit of God, 74

Stagel, Elsbeth, 35

Steinberg, Leo, 122, 123, 135, 141

Stigel, John, 106

Stockbar, Hans, 178

Strasbourg image reform, 179

Stuppach Madonna (Grünewald), 35, 47, 48

sufferings of Christ, 32–34

Suger, Abbot, 183

Susanne and the Elders (Altdorder), 169, 170

Suso, Henry, 13, 34–35

Sweden, 185

symbols
 Dance of Death, 160–161
 of God's finger with Spirit, 120–121
 of grace in Old Testament, 98, 100
 Judith, 201n.57
 of the Madonna and Christ, 47
 Middle Age use of Christian, 173–174
 Nicodemus as faith, 144–145
 parrot as virginity, 158
 role of pastor and key, 105
 See also images

Taddei Madonna (Michelangelo), 117

Temptation of St. Anthony (*Isenheim Altarpiece*), 31

That One Should Not Remove Images of the Saints from the Churches Nor Dishonour Them, and That They Are Not Forbidden in Scripture (Emser), 186

Three Ages of Woman (Baldung Grien), 161

Thulin, Oskar, 106

Tillich, Paul, 25

Torgau Castle Church (Cranach design), 107–109

Torgau Castle Church pulpit, 108–109

Toussaint, Pierre, 181

Tractarian movement (England), 183–184, 191

Trinity with the Virgin and St. John (Baldung Grien), 157

The Triumph of the Cross (Savonarola), 115

Valdes, Juan, 129, 131

Vasari, Giorgio, 134

Vatican II, 190

Veni Creator Spiritus (Luther translation), 155

Vergerio, Pier Paolo, 129

Veronica veil, 13, 36

Vigerio della Rovere, Marco, 118

Virgin Mary
 of Dürer vs. Grünewald, 57–58
 Geiler and Grünewald depiction of, 36
 image role of, 47–49
 Isenheim Altarpiece image of, 28, 29, 35, 37, 45, 47
 in Karlsruhe Crucifixion, 50
 slung leg tradition and, 146
 symbols of, 47

The Virgin as the Mater Dolorosa (Holbein the Younger), 150

The Virgin Worshipped by Angels and Saints (Dürer), 58

Vita Christi (Ludolph of Saxony), 32

von Staupitz, Johann, 65

Wandel, Lee Palmer, 176–177

Weimar altarpiece (Cranach), 98, 100

Wild Family (Altdorder), 169

Wild Man (Altdorder), 169

Witch and Dragon (Baldung Grien), 162

Witches' Sabbath (Altdorfer), 169

Witches' Sabbath (Baldung Grien), 161

witch images, 161–165

Wittenberg altarpiece (Cranach), 102–104, 105–106

Wittenberg images destruction, 9

Wolfflin, Heinrich, 25

Wolgemut, Michael, 54

Woman Taken in Adultery (Cranach the Elder), 109–110

woodcuts
 Apocalypse series (Dürer), 55–57

woodcuts *(continued)*
 ascribed to Cranch the Elder, 79–80
 Beautiful Virgin (Altdorfer), 168
 Bewitched Groom (Baldung Grien),
 162, 164
 Christ on the Cross with three Angels
 (Dürer), 68, 69
 Large Passion series (Dürer), 57
 Last Supper (Dürer), 67–68
 Life of the Virgin series (Dürer),
 59-60
 Luther with Nimbus and Dove (Bal-
 dung Grien), 157
 Passional Scene (Cranach the Elder), 84
 reformation agenda and, 15, 16, 55
 of September Bible (Cranach), 83–84
 *The Virgin Worshipped by Angels and
 Saints* (Dürer), 58
 Witches' Sabbath (Baldung Grien),
 161
the Word, 21
 See also Scripture
Word of God, 75–76
Worringer, Wilhelm, 25
Wycliffe, John, 186

Zurich münster art destruction (1524),
 10, 178
Zwingli, Ulrich, 4, 9–10, 19, 113, 130,
 174, 175, 176, 177, 178